D0065476

WHY COMICS?

ALSO BY HILLARY CHUTE

Graphic Women: Life Narrative and Contemporary Comics

Outside the Box: Interviews with Contemporary Cartoonists

Comics & Media: A Critical Inquiry Book
(co-editor with Patrick Jagoda)

Disaster Drawn: Visual Witness, Comics, and Documentary Form

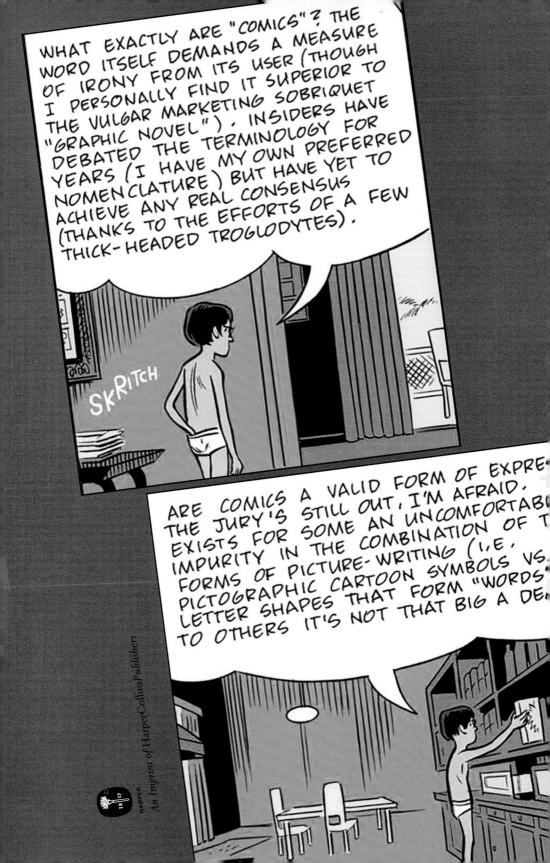

WHAT EXACTLY ARE "COMICS"? THE WORD ITSELF DEMANDS A MEASURE OF IRONY FROM ITS USER (THOUGH I PERSONALLY FIND IT SUPERIOR TO THE VULGAR MARKETING SOBRIQUET "GRAPHIC NOVEL"). INSIDERS HAVE DEBATED THE TERMINOLOGY FOR YEARS (I HAVE MY OWN PREFERRED NOMENCLATURE) BUT HAVE YET TO ACHIEVE ANY REAL CONSENSUS (THANKS TO THE EFFORTS OF A FEW THICK-HEADED TROGLODYTES).

SKRITCH

ARE COMICS A VALID FORM OF EXPRE[SSION?] THE JURY'S STILL OUT, I'M AFRAID. [THERE] EXISTS FOR SOME AN UNCOMFORTABL[E] IMPURITY IN THE COMBINATION OF T[WO] FORMS OF PICTURE-WRITING (I.E. PICTOGRAPHIC CARTOON SYMBOLS VS. LETTER SHAPES THAT FORM "WORDS") TO OTHERS IT'S NOT THAT BIG A DE[AL.]

HARPER
An Imprint of HarperCollins/Publishers

WHY COMICS?

FROM UNDERGROUND TO EVERYWHERE

HILLARY CHUTE

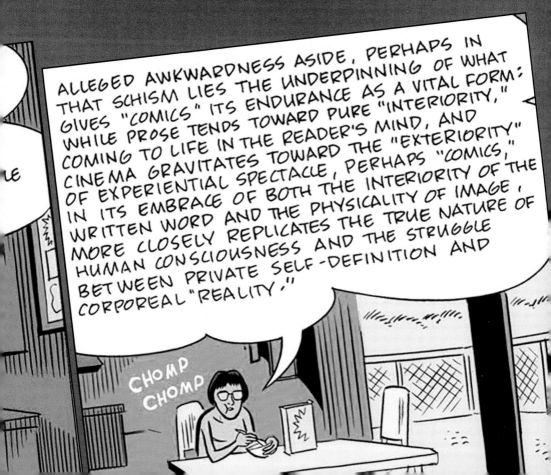

ALLEGED AWKWARDNESS ASIDE, PERHAPS IN THAT SCHISM LIES THE UNDERPINNING OF WHAT GIVES "COMICS" ITS ENDURANCE AS A VITAL FORM: WHILE PROSE TENDS TOWARD PURE "INTERIORITY," COMING TO LIFE IN THE READER'S MIND, AND CINEMA GRAVITATES TOWARD THE "EXTERIORITY" OF EXPERIENTIAL SPECTACLE, PERHAPS "COMICS," IN ITS EMBRACE OF BOTH THE INTERIORITY OF THE WRITTEN WORD AND THE PHYSICALITY OF IMAGE, MORE CLOSELY REPLICATES THE TRUE NATURE OF HUMAN CONSCIOUSNESS AND THE STRUGGLE BETWEEN PRIVATE SELF-DEFINITION AND CORPOREAL "REALITY."

CHOMP CHOMP

HarperCollins books may be purchased for educational, business, or sales promotional use. For information, please email the Special Markets Department at SPsales@harpercollins.com.

FIRST EDITION

DESIGNED BY WILLIAM RUOTO

Library of Congress Cataloging-in-Publication Data
Names: Chute, Hillary, author.
Title: Why comics?: from underground to everywhere / Hillary Chute.
Description: First edition. | New York: Harper, 2017. | Includes bibliographical references and index.
Identifiers: LCCN 2017020053 (print) | LCCN 2017020416 (ebook) | ISBN 9780062476814 (ebk) | ISBN 9780062476807 (hardback)
Subjects: LCSH: Comic books, strips, etc.–History and criticism. | Comic books, strips, etc.–Influence on mass media. | Graphic novels–History and criticism. | Superheroes in literature. | Cartooning. | BISAC: LITERARY CRITICISM / Comics & Graphic Novels. | ART / Techniques / Cartooning.
Classification: LCC PN6710 (ebook) | LCC PN6710 .C48 2017 (print) | DDC 741.5/9–dc23
LC record available at https://lccn.loc.gov/2017020053

17 18 19 20 21 LSC 10 9 8 7 6 5 4 3 2 1

To my cartoonist friends, for being so
fascinating and making my life better
because of it.

And to the undergraduate and graduate
students I met while writing this book—
including Chris—whose enthusiasm and ideas
have inspired me so much.

ents

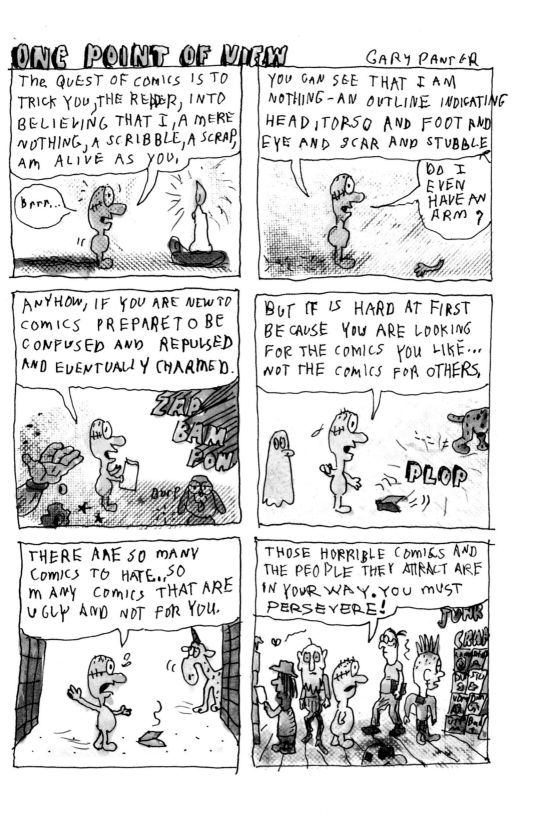

WHY COMICS?

INTRODUCTION: **COMICS FOR GROWN-UPS?**

It's like learning a new syntax, a new way of ordering ideas.

–Alison Bechdel, in *The Comics Journal*, 2007

In 1995, a few years after his two-volume book *Maus: A Survivor's Tale* won the Pulitzer Prize, cartoonist Art Spiegelman spoke to *The Comics Journal* about his chosen medium. "It seems to me that comics have already shifted from being an icon of illiteracy to becoming one of the last bastions of literacy," Spiegelman suggested. "If comics have any problem now, it's that people don't even have the patience to decode comics at this point." When I tell people about Spiegelman's contention—comics is actually *one of the last bastions of literacy*—they are usually surprised. It is the polar opposite of what many are used to thinking about comics—or still might think.

Despite a few globally very well-known works, like *Maus*, about Spiegelman's parents' experience in the Holocaust, the whole comics medium still often gets mistaken for its most popular genre: superheroes. Fantasy is a *genre*, humor is a *genre*, romance is a *genre*—a style, a

category that comes with a set of approaches and expectations. Comics, on the other hand, is a *medium* in its own right—not a lowbrow genre of either art or literature, as it is sometimes understood—and it can be about anything. (For this reason, however awkward "comics is" can sound in a sentence, I use "comics" with a singular verb when appropriate.) And while it can be about anything, there are some things that comics is particularly good at. Scott McCloud, the son of a blind rocket scientist from Lexington, Massachusetts, told me about the dominant view with which he contended when he set out to write his 1993 book *Understanding Comics*: "'Comics, they have staples and superheroes and funny animals, the end, what else is there to talk about?' . . . And I thought, '. . . Look how much bigger the territory is, and look how many cool things come in.'" On YouTube, in the comments section for the video of my 2015 public conversation with McCloud, one viewer wrote: "I show it to arty friends to show comics are not just Spider-Man and nerds." Twenty-five years after *Understanding Comics*, an ingenious treatise on comics itself composed in comics form, made its claims, old associations persist despite the huge diversity of contemporary comics. Comics today is an art form with an ever-increasing popularity and range.

Today, works of comics—although many are—don't need to be about superheroes, a genre that began in 1938 with Superman, a character created by two high school friends from Cleveland, Jerry Siegel and Joe Shuster, when they were teenagers. Comics works also don't need to be funny, although of course many of them are. This is understandably confusing to those who don't happen to know the history because comics are, after all, in the United States and United

Superman's debut in the comic book *Action Comics* #1, by Jerry Siegel and Joe Shuster, cover by Shuster, June 1938, published by Detective Comics, Inc. (later DC Comics). A mint copy sold on eBay in 2014 for $3,207,852, the most ever paid for a single comic book.

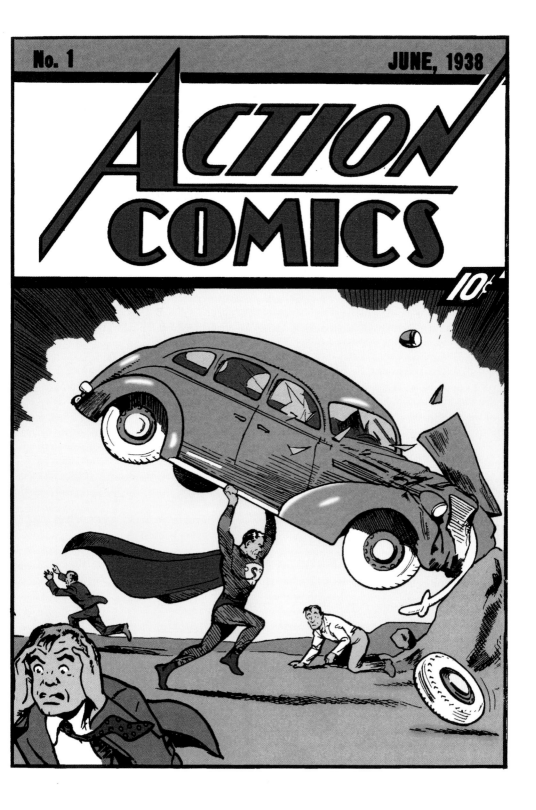

Kingdom, called "comics." For . . . presumably some reason. In Italy the form is called *fumetti*, which means "little puffs of smoke" and refers to speech balloons. In France the form is called *bandes dessinées*, which means "drawn strips." Both of these designations, unlike the English iteration, refer to formal elements.

Comics has branched out from the realm of the specialized and the cult into countless corners of culture in the twenty-first century. Comics today seizes the public imagination in books and periodicals, in museums and galleries, at massively populated comics conventions like San Diego's Comic-Con, and even on Broadway, with the multiple Tony Award–winning 2015 musical adaptation of cartoonist Alison Bechdel's graphic memoir *Fun Home: A Family Tragicomic*, the story of a lesbian cartoonist and her closeted, suicidal father. Speaking of Broadway: Lin-Manuel Miranda, the megastar creator of the rap musical *Hamilton*, told the *New York Times's* "By the Book" column in 2016 that the last great book he read was *Saga*, the galactic war–love story graphic novel series by Brian K. Vaughan and Fiona Staples. Miranda had also tweeted about the series, and a new interest and audience was born. (Online mash-up: Saga4Ham.) In 2015, the North American comic-book industry raked in an estimated $1.03 billion from print and digital comic-book and graphic novel sales, a new twenty-year high. And graphic novel sales in bookstores rose 22 percent in 2015, according to comics industry site *The Beat* (the article ran with a big image of *Saga* volume 4). In a time when many lament the decline of the print book, comics maintains crucial attention to the book as object (not that it neglects online platforms, where it is also flourishing). In 2016, even as sales of adult fiction in bookstores fell, sales of graphic novels continued to rise.

Comics is a feature not only of mainstream popular culture, but also of university culture, the art world, and even global politics. While there were actually comic-book burnings in the late 1940s and

1950s, when many adults saw comics as a loose and dangerous form of youth culture—a role later absorbed by rock 'n' roll, and then video games—librarians and professors are now outspoken champions of the form. A Columbia University librarian, Karen Green, recently stated that "graphic novels are the most frequently requested material in our Ivy League request system." One can now get an accredited undergraduate or graduate degree in comic art—and today cartoonists like Spiegelman are sought-after public intellectuals. Comics is unprecedentedly popular in the art world, a fact marked by a special issue of the world's most influential art magazine, *Artforum*, on comics and fine art in 2014. There have been numerous high-profile gallery and museum exhibits featuring comics around the world. And comics has persistently been in the news since January 2015, in controversial contexts. The debate provoked by the *Charlie Hebdo* massacre in Paris brought the practice of cartooning and what it means into the global spotlight, with dozens and dozens of demonstrations around the world featuring pens held up into the air, making the drawing pen a potent symbol of freedom. People may not have agreed with the *Charlie Hebdo* cartoonists' satirical aims, but everyone had to acknowledge that hand-drawn lines on paper, even in the age of the Internet, have enormous power.

Comics also has substantial resonance in cultural debates in America. This is particularly the case in education, because of the affective force of its visuals, a feature of especial concern in the age of "trigger warnings" and censorship dustups. Comics made national headlines in the summer of 2015 when a group of freshmen at Duke University refused to read Bechdel's *Fun Home*, which was the suggested common first-year read for incoming students, because of its explicit—and gay—content. One of those students even published an op-ed in the *Washington Post* online titled, "I'm a Duke Freshman. Here's Why I Refused to Read 'Fun Home.'" The idea of comics as common reading—which is to say, the idea of literature

that *shows* something, for instance, sex, in addition to describing it verbally—sparked numerous conversations in print and online about the goals of college education and the differences between looking and reading, activities the medium of comics productively intertwines.

THE ORIGINS OF "COMICS"

So far I've been writing about comics in a broad sense. But comics consists of distinct popular formats with their own conventions that can help us see how and where the very idea of comics for grown-ups emerged. This idea, even today, might not seem intuitive to the casual observer, but it motivates *Why Comics?* and its focus on what comics can do for audiences everywhere of all ages. *Comics* encompasses the newspaper *comic strip*, which began in the United States in the 1890s; the *comic book*, which began in the 1930s; and the so-called *graphic novel*, which began as such in the 1970s. So where does *comics* come from? It is connected to how the term *cartoon* came to take on new meaning in the nineteenth century.

Cartoon used to designate—and still designates, in an art historical context—any preparatory sketch for tapestries, or for frescoes, or for paintings. It was first used to indicate "humorous drawing," which is how people widely think of it today, in 1843, in London's *Punch* magazine, which ran cartoons throughout the nineteenth century and beyond. It might not seem very funny to contemporary eyes now, but *Punch*'s "Substance and Shadow: Cartoon, No. 1" was a then-humorous political commentary *about* cartoons in the traditional sense of a preparatory sketch. Apparently, in many reports, the public howled with laughter at the joke of the cartoon—which goes to show changing mores. Longtime *New Yorker* cartoon editor Bob Mankoff is especially funny about "Substance and Shadow": "I won't try to exhume the humor of this illustration," he writes in his autobiography,

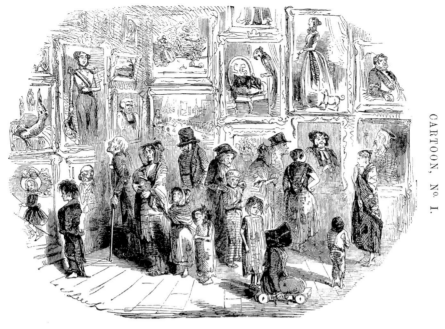

SUBSTANCE AND SHADOW.

John Leech, "Substance and Shadow: Cartoon, No. 1," in England's *Punch*, July 15, 1843.

"except to say that there was some, it was satiric, and you had to be there in England in 1843 to get it."

In the image, impoverished civilians, children and adults alike, view an exhibition of cartoons for a competition for patriotic paintings to be commissioned for the newly rebuilt New Palace of Westminster. The joke is that the government needs to address the poverty of its citizens instead of addressing the issue of decorating the palace. After 1843, when "Substance and Shadow" appeared and was massively popular, nomenclature changed: people came to equate "cartoon" with the idea of a funny drawing, and hence came the modern meaning of the word and terms like *cartoonist*.

In the United States, weekly humor magazines imitated *Punch*, with titles like *Puck*, *Judge*, and *Life*, which began in the 1880s and

were called "comic weeklies," or even, sometimes, simply "comics." Then the sensational newspaper press in New York City, in the 1890s, began printing "Sunday supplements" to increase their circulations and to compete with the magazines. These Sunday supplements, led by the newspaper the *New York World*, which was published by Joseph Pulitzer, concentrated on comical artwork, and eventually on *comic strips*, which is to say, narrative series of pictures with words, which began to appear in the mid-1890s.

The comic strip widely regarded as the first, Richard Felton Outcault's 1895 sensation known as *The Yellow Kid*, about a resident of a Lower East Side tenement, was so popular as to inspire the term "yellow journalism" when William Randoph Hearst and Pulitzer struggled over who would ultimately buy Outcault out from whom. These comic strips became known as the comics, which developed out of the "comic weeklies" and then the comical supplements. They were often referred to as the "funnies," short for the funny papers or funny pages of a newspaper. The format of the stand-alone comic book began in the late 1920s, as a way for publishers to reprint newspaper comic strips. These comic books were also, as the strips themselves often were, called the funnies.

But as the brilliant cartoonist Winsor McCay demonstrates—his comic strips *Dream of the Rarebit Fiend* and *Little Nemo in Slumberland* began in 1904 and 1905, respectively—comic strips almost from their inception cast off the idea that they had to be comical. Many from this early period are dark and even ominous. In one *Rarebit Fiend* installation from 1905, the protagonist dreams he is being buried alive. We see from his point of view: dirt falls upon his face from within the grave and he hears his wife remark, "At last my hopes are realized." But regardless of the content, the term "comics" had stuck as a description of drawn sequential narrative work with multiple panels. A "cartoon," on the other hand, remained, like in "Substance and Shadow," a single-panel image, as in what we would recognize today

as an editorial cartoon or a political cartoon (later "cartoon" came to mean animated content as well). Yet people who draw "comics" are also called "cartoonists," which can be a little confusing. Like all art forms, especially newish ones, this one has a lexicon that can be idiosyncratic. (I switch back and forth from referring to people who create comics as "authors," "artists," and "cartoonists," as they themselves do.) So while "Substance and Shadow" is an amusing *cartoon* about marginalized people encountering a dominant visual culture that highlights their exclusion, Alison Bechdel's "The Rule," published almost 150 years later, is an amusing work of *comics*, in ten sequential panels, about marginalized people encountering a dominant visual culture that highlights their exclusion. "The Rule," which appeared in Bechdel's first *Dykes to Watch Out For* comics collection in 1986, is the source for the celebrated Bechdel Test, a feminist barometer for film and now a pop culture icon.

COMICS FOR GROWN-UPS?

Comic strips had been introduced in the sensational newspaper press by Hearst and Pulitzer, among others, in order to drive circulation— many comic strips were meant to appeal to children, and to immigrant readers of newspapers—an explicit goal. (Picasso was a fan of *The Katzenjammer Kids*, German cartoonist Rudolph Dirks's strip featuring a pair of naughty children who speak with an accent, which ticked off both those boxes.) Yet these same newspapers also ran comics meant to draw in sophisticated adult audiences, such as by Winsor McCay and by George Herriman, the cartoonist behind the existential, absurdist mouse-cat-dog strip *Krazy Kat*, which ran from 1913 to 1944, and is the subject of a famously loving 1946 encomium by e. e. cummings, among many other tributes (T. S. Eliot was also a fan). To Art Spiegelman, therefore, himself the son of two Polish immigrants to New York City, comics has always "been a tug of war between

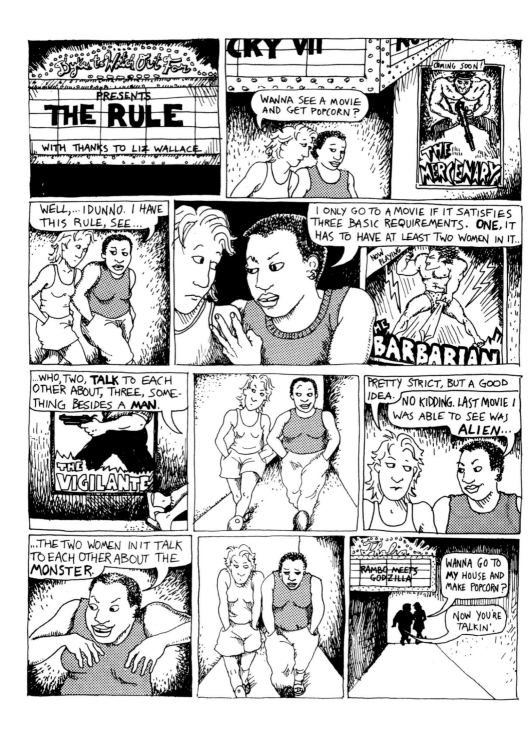

Alison Bechdel, "The Rule," *Dykes to Watch Out For* (Ithaca: Firebrand), 1986, source of the Bechdel Test, and replete with funny fake phallic movie posters.

Used by permission of Alison Bechdel.

the vulgar and the genteel." He adds: "I'm not here to champion the vulgar, I'm here to champion the tug-of-war." Many of the early newspaper comic strips, which appeared, ironically, on ephemeral, cheap paper meant for fishwrap and other workaday conveniences, are considered aesthetic benchmarks in the history of comics, their techniques still emulated and admired. There is something impressive about the craft and sophistication produced by the creators of the early comics for an utterly disposable format.

The comic book, however—at least in its first few decades—was firmly associated with youth culture. While there were early proto-types of the comic book, such as 1929's *The Funnies*, which featured original drawn strips and appeared from Dell on newsstands on tabloid-size newsprint, the publication that set the format for comic books as we know them conventionally was 1934's *Famous Funnies* #1. In the intervening years between the large-size *Funnies*, which had sputtered out quickly, and *Famous Funnies*, manufacturers had regularly reprinted newspaper comic strips as promotional premiums in grocery stores—giveaways tied to specific products. *Famous Fun-nies* #1, however, wasn't free: it appeared on newsstands, cost 10 cents, and was printed in four-color. It was a saddle-stitched sixty-eight-page newsprint pamphlet, smaller at roughly 7 by 10 inches, and it set the standard for the format for years to come.

Famous Funnies was published by Max C. Gaines (born Maxwell Ginzberg), a pioneering figure who was then working for Eastern Color Printing Company. It reprinted strips such as Bud Fisher's *Mutt and Jeff,* which began in 1907 and is referenced in what is perhaps the twentieth century's most famous work of art, Marcel Duchamp's *Fountain* (1917), a urinal that is signed "R. Mutt." A few years later, in 1938, Superman inaugurated the so-called Golden Age of comic books, making comic books wildly commercially successful. He was joined by a proliferating group of superheroes driving massive sales, including Batman the following year in *Detective Comics* #27, and

Captain America, whose debut in 1941 on the cover of *Captain America Comics* #1 shows him punching Hitler in the face (and inspired Michael Chabon's Pulitzer Prize–winning novel *The Amazing Adventures of Kavalier & Clay*). Jules Feiffer, in his book *The Great Comic Book Heroes*, edited by E. L. Doctorow, notes how comic books in their original Golden Age were churned out like Ford Model Ts in what were known as comics sweatshops. By 1952, nearly a hundred million comic books were sold every week.

The Golden Age ended in 1954, after psychiatrist Fredric Wertham's best-selling study *Seduction of the Innocent*, which aimed to establish a link between comic-book readership and juvenile delinquency, brought the comic-book industry to a halt. *Seduction of the Innocent* provoked hearings by the Senate Subcommittee on Juvenile Delinquency, at which Wertham testified as an expert witness. Wertham, a German Jew and a complex figure, was involved in numerous progressive causes. A friend of Ralph Ellison and Richard Wright, he helped to found, with Wright, the Lafargue Clinic, a low-cost psychiatric clinic in Harlem for black teenagers, and his research on the negative effect of racial segregation on children was used as evidence in the *Brown v. Board of Education* Supreme Court decision. Yet Wertham objected to the violence and the sexuality he saw lurking in comic books. The result was the censorious Comics Magazine Association of America "Comics Code." Notoriously, the grossly over-hygienic code contained such now-hilarious strictures as "In every instance good shall triumph over evil and the criminal be punished for his misdeeds."

How many interesting stories, in any medium, can exist with those guidelines? A few comics titles, such as the satire title *Mad*, which began in 1952, escaped the chilling effects of the Code. And despite the devastation of the Code, comic books did enter a commercial "Silver Age." So began a second superhero boom in the 1960s that with Stan Lee (né Stanley Lieber) on board at Marvel Comics widely

disseminated comics of an appealing ilk: those that represented superheroes as flawed and neurotic. But many cartoonists correctly felt they would have to work outside of mainstream systems of publication and distribution if they were going to take comics seriously as a form of expression and develop its capacities.

"COMICS WITHOUT PUNCHLINES"

That brings us to underground comics, a vital movement with literary, artistic, and popular force that profoundly shaped contemporary comics. The underground comics revolution of the 1960s and '70s, which took place largely in New York and San Francisco, set the foundations for every kind of serious comics field we have today. Comics that emerged from the underground were independently created and produced works, without commercial strictures. They were often rechristened "comix," with an *x*, to indicate their adult edge. Cartoonist R. Crumb's *Zap* #1 kick-started the movement in 1968 with this salvo on its cover: "For adult intellectuals only!" A friend of Crumb's, Don Donohue, had traded away his tape recorder for use of another friend's printing press to produce several thousand copies of the comic book that Crumb and Donohue then assembled, folded, and hand-stapled, and Donohue published under the name Apex Novelties. Crumb sold *Zap* #1, which had a print run of four thousand, directly out of a baby carriage for 25 cents on San Francisco's Haight Street with his pregnant wife, Dana. While mainstream comics in this period did not market themselves this way, titles such as DC's *Green Lantern/Green Arrow* (1970) pressed for social relevance and showcased dark themes. A few years later, comic books such as Justin Green's confessional *Binky Brown Meets the Holy Virgin Mary* (1972), the inaugural work of comics autobiography, offered the exact *opposite* of what people would expect from comics. While Superman wore a costume and saved lives, Green's autobiographical character

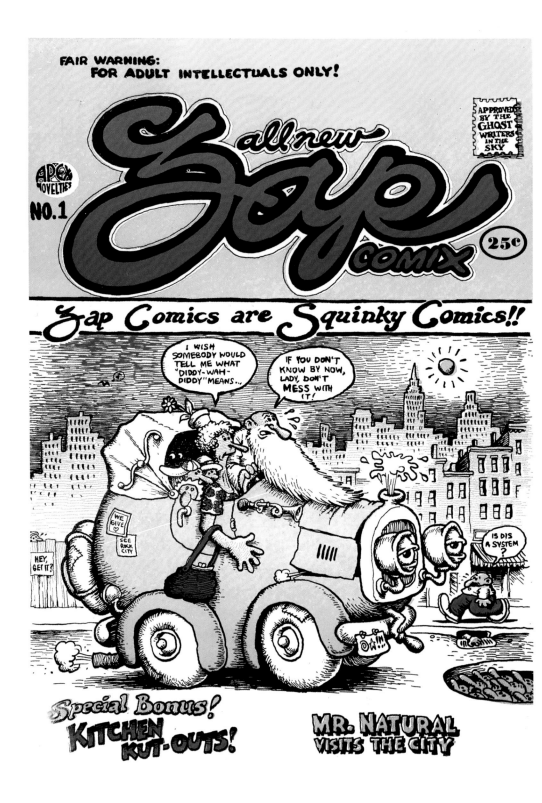

Binky miserably masturbated with his underwear at his ankles. Comics were reinvented, as Spiegelman put it in a famous, often-reprinted 1981 image of a painter wielding a fountain pen, "as a medium for self-expression."

In the comics underground, which was connected to the left-wing underground press established in the 1960s, creators shifted away from the notion that comics had to be action-packed, silly, formulaic, or even slightly inclined toward children. They produced complex, textured, and even absurdist storylines, and also showcased the art form's "secret language" (a phrase popular with several cartoonists). "Comics without punchlines" is how Spiegelman saw the massive shift enacted by Crumb and the underground movement. Underground comics were avant-garde; they were political; they were taboo-shattering; and they were formally experimental. In fact, children weren't even allowed to read them.

Comics got remade for adults in the underground. In response to the huge attention elicited by comics like *Zap*, more and more titles proliferated—including specifically feminist and gay titles—and independent publishing companies and cartooning collectives blossomed. Green's *Binky Brown Meets the Holy Virgin Mary*, which directly influenced Spiegelman to create the three-page story "Maus" in 1972 (the seed for his later, game-changing *Maus*), was, perhaps, the first work that looked ahead to the "graphic novel." It is a forty-four-page, sustained, stand-alone narrative about Catholicism, sexuality, and obsessive-compulsive disorder that demonstrated comics could tackle head-on what most would consider the realm of the absolutely

Robert Crumb, cover of *Zap* #1, 1968. The logo that is shaped like the logo of the Comics Code Authority in the upper right reads, "Approved by the ghost writers in the sky." Crumb's iconic character Mr. Natural responds in the dialogue to a woman with the same remark musician Fats Waller reportedly uttered when a woman asked him, "What is jazz?"

interior and private. But it wasn't until 1978 that a book was published that proclaimed itself a "graphic novel." The first book to have the words "graphic novel" on the cover was Will Eisner's *A Contract with God*, published by Baronet Press in 1978. *A Contract with God* is a series of four linked vignettes about immigrants in a Bronx tenement in the 1930s.

"Graphic novel" was coined in a 1964 newsletter circulated at the Amateur Press Association, but had never before been used in a commercial context. Eisner recounted in several interviews that he invented the term—he hadn't heard it before—on the spot, in a bid to sell his work to mainstream publishers. He wanted *A Contract with God* to be received in bookstores alongside "regular" books—which it was—as opposed to published and sold by the specialized comics industry, so he came up with the description "a graphic novel" to emphasize its literary qualities. The term picked up steam in the 1980s to identify the auteurist, individually driven artistic work in which this book is centrally interested. As the cases of Harvey Pekar, Brian K. Vaughan, and many others demonstrate, however, collaboration in comics provides compelling models for thinking about authorship. In the auteur model, one person both writes and draws the comics, so that the work represents one person's artistic vision.

But even the concept of the *auteur*—a French term from the 1960s that literally means "author" and refers to a film director who shapes cinema through an all-pervasive artistic vision—indicates less control

Will Eisner, cover of *A Contract with God and Other Tenement Stories* (New York: Baronet Press), 1978. The trade paperback from Baronet was the first book to have "graphic novel" on its cover. Eisner's cover reveals how lettering in comics has narrative qualities, as in the switch from Roman lettering to Hebraic lettering for the word "God" in the title.

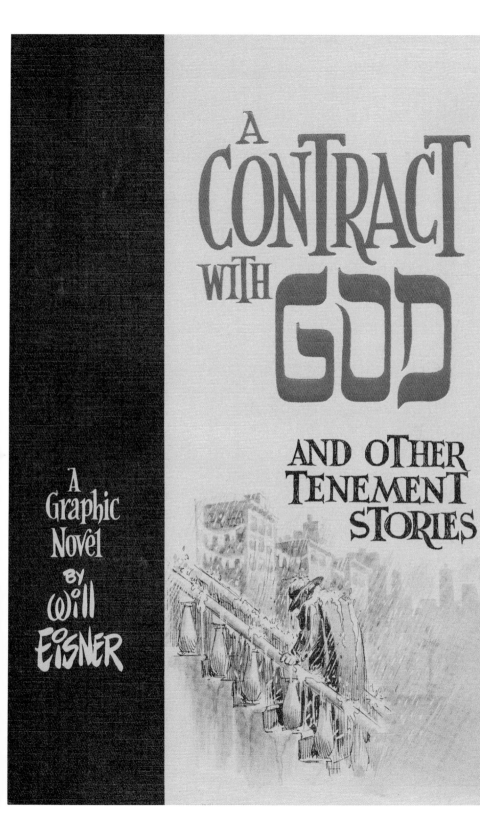

A CONTRACT WITH GOD

AND OTHER TENEMENT STORIES

A Graphic Novel BY Will Eisner

than a cartoonist has to create a visual and verbal world. An auteurist film director—for instance, say, a Quentin Tarantino—works with a team to create his final product. Auteurist comics, on the other hand, can be a front-to-back solo enterprise. "In comics," says cartoonist Daniel Clowes, "if you really have mastery over what you're doing, you can control absolutely everything and make it exactly what you want, exactly what you're seeing in your own head. You're transferring that to the page." Although comics of all kinds are flourishing in the twenty-first century, there has been a dramatic uptick in auteurist comics, which offer the singular intimacy of one person's vision of the world across words and images. They are therefore often consumed alongside similar forms like novels that spring, largely, from one person's aesthetic sensibility.

"Graphic novel" took shape largely as a publishing and marketing term, sometimes to irritating effect, in its trendiness, and sometimes to great positive effect. The field opened up widely because of the appeal of that umbrella category, for instance, when comics industry insiders, including Spiegelman, lobbied the Book Industry Study Group (BISG), the group that standardizes book categories for booksellers, to give graphic novels their own BISAC codes in 2002. Through these institutional changes, comics and graphic novels instantly became more accessible and available to readers. In the early 2000s, titles released by comics publishers started to be distributed by big-name presses to land in bookstores, shifting many comics outside of the realm of the esoteric. Seattle-based independent comics publisher Fantagraphics, for example, founded in 1976, is now distributed by W. W. Norton. Because of this distribution, a person fascinated by the Middle East can now find Joe Sacco's *Palestine* at the bookstore, as well as at a specialty comic-book shop (I found it, too, in the gift shop of Jerusalem's American Colony Hotel). These industry changes mark comics's success and reach—and more broadly, they demonstrate how the definition of

"literature" today is expanding productively to be more creative and more inclusive.

As comics's status has grown, I have noticed a polite anxiety about terms: many people assume, for instance, that "graphic novel," a description that seems to confer a certain bookish sophistication, is preferable to something baser like "comics." Most cartoonists I know don't love the phrase "graphic novel," for several reasons, although they accept it as a kind of shorthand for what they do: expressive, long-form narrative comics. One reason is that it can seem pretentious, like a bid for prestige that attaches to the term "novel." (It is worth noting, again, changing mores: while the novel is prestigious *today*, back in the eighteenth century it was itself considered a "low," popular form.) The novelist and comics writer Neil Gaiman, the creator behind *The Sandman*, among many other titles, has famously recounted a publisher correcting his own description of his work by insisting, "Oh, you don't write *comics*, you write *graphic novels*." Gaiman felt uncomfortably, in his words, like a prostitute who had just been referred to as a "lady of the night." The Iranian cartoonist Marjane Satrapi, whose *Persepolis* series has sold almost two million copies worldwide, also shuns "graphic novel": "I don't very much like this term of graphic novel. I think they made up this term for the bourgeoisie not to be scared of comics. Like, Oh, this is the kind of comics you can read."

The term can also be unpopular because "novel" implies fiction, and much of today's important book-length comics work is nonfiction, like *Persepolis*, *Maus*, *Fun Home*, and Joe Sacco's groundbreaking "comics journalism," in which he reports from war and conflict zones in the Balkans and the Middle East. So *graphic novel*, to the extent that it indicates fiction, isn't always the best descriptor. I tend to prefer *graphic narrative*, which is inclusive of both fiction and nonfiction. But if someone says "graphic novel," chances are I know what that person means, even if he or she is referring to nonfiction. "Graphic novel" is still the most commonly known phrase that indicates book-length comics for a

sophisticated adult audience. (Despite the fact that there are now also plenty of smart graphic novels for kids and young adults.)

The comics produced in the underground, which were created with complete artistic and intellectual freedom to represent an artist's personal vision, established the field of comics for adults. This kind of work became known as "independent" or "literary" comics. Today these comics are published by numerous "above-ground" presses, including Random House and Abrams Books. Independent or literary comics, generally created by one person who both writes and draws, function in distinction from "commercial" or "mainstream" comics created by teams for companies. The two most prominent comics companies, both giants in the entertainment industry, are DC Comics, currently owned by Time Warner, and its rival Marvel Comics, currently owned by Disney. DC, began in 1934, takes its most recent name from the original *Detective Comics* issue that featured Batman's debut, and it also features Superman, Wonder Woman, Green Lantern, and the Flash, among others. The company we now know as Marvel began in 1939, and is the home of the Hulk, Spider-Man, Iron Man, the X-Men, and the Avengers, among others.

Mainstream comics are generally created by at least two people, one writing, one drawing—and typically by many more, for instance, people inking and lettering the comics. (One inexact but useful metric to deduce if a work is independent or mainstream is whether the panel borders are hand-drawn, which is immediately legible in the febrility of the line, an index of the hand of the individual artist—or whether the borders are the result of clean, computer-generated lines.) But whether or not a work functions in the model of a literary novel—a universe created by one person's aesthetic, sensitivity, and worldview—or is a commercially expedient team effort, both kinds of comics have appealed to adult audiences. The year 1986, for instance, is widely understood to mark the popular ascendency of comics for adults with the publication of three key works that fall across the

spectrum of literary and commercial outlined above: *Maus I: A Survivor's Tale: My Father Bleeds History* (Pantheon), by Art Spiegelman; *Watchmen* (DC Comics), by writer Alan Moore, with art by Dave Gibbons, along with colorist John Higgins; and *Batman: The Dark Knight Returns* (DC Comics), by writer Frank Miller, with art by Miller and Klaus Janson, along with letterer John Costanza and colorist Lynn Varley. In this year one started to see headlines with titles like "Wham Pop Zap! Comics Grow Up."

READING COMICS

Comics may now be for grown-ups, but how one ought to read them still isn't always clear and can be a source of confusion. Comics readers encounter the space of the page in a different way than they would a novel, and in a different way than they would a canvas. Students tell me often they aren't sure whether to read all the words first, and then go back and look at the images, or whether to look at all of the images first, and then the words. Or to take in the words and images together, panel by panel. Comics is not an illustrative form, in which the words and images match, but rather one that Marjane Satrapi has called "narrative drawing," and Art Spiegelman has called "picture writing," in which the words and the images each move the narrative forward in different ways the reader creates out of the relationship between the two. How one ought to read comics often feels like an open question—which it is. For a reader navigating the space of the page, reading comics (even highly conventional comics) can feel less directive and linear than reading most prose narrative.

Spiegelman has a quip I've always found funny about Ernie Bushmiller's comic strip *Nancy*. He says it takes more time to *not* read *Nancy* than to read it. A tiny installment of *Nancy*, which began in 1933, even appears, he points out, in the *American Heritage Dictionary* to illustrate "comic strip" (its definition: "a narrative series of car-

toons"). Historically, there has been an association between comics and a kind of subpar literacy, as if comics reading could not be "real" reading. This is because of the widespread notion that visual literacy, which comics requires, is somehow less complicated than verbal literacy, which comics also requires. In this line of thinking, which is prevalent today, the visual is immediate, and therefore sensual, and obvious. Contemporary comics, however, asks us to reconsider several dominant commonplaces about images, including that visuality stands for a subpar literacy. One glance at a comics page by Chris Ware, as we will see shortly, will disabuse any reader of the idea that visual literacy is easy.

In *Seduction of the Innocent*, Fredric Wertham memorably called comics reading "an evasion of reading and almost its opposite." Book series like *Classics Illustrated*, which began in the 1940s and offered shorter, comics adaptations of famous literary works—like the comics version of *Moby-Dick*—helped to underline the idea that comics were easier versions of a harder, worthier thing. Wertham even cites the *Classic Comics* version of *Dr. Jekyll and Mr. Hyde* and *Uncle Tom's Cabin* in *Seduction of the Innocent*. But in comics the combination of words and images, and how this narrative exists laid out in space on the page, requires an active and involved literacy. It is one to which we can attach a high engagement of reading and looking for meaning, as in Spiegelman's sense that comics have already shifted from being an icon of illiteracy to becoming one of the last bastions of literacy. Several prominent thinkers about comics, including the late literary critic Edward Said, have used the word *decode* to describe reading comics. Comics, in fact, is a medium that involves a substantial degree of reader participation to stitch together narrative meaning. And the visual content of comics that once signaled a "lesser-than" literacy is now an integral part of our contemporary daily lives, as so much of our primary media intake, especially online, combines the verbal and the visual, often with complexity we have learned to navigate quickly.

As a speaker on a 2017 San Diego Comic-Con panel titled "The Secret Origin of Good Readers" affirmed, "Being able to decipher a story that's coming at you in words and images is crucial. It's part of functioning in society today."

Alison Bechdel puts it well when she says that making comics "is like learning a new syntax, *a new way of ordering ideas.*" Comics has its own fascinating vocabulary: gutters, panels, tiers, balloons, bubbles, bleeds, splashes—all elements that exist meaningfully in relation to one another in space on the page. The "gutter," for instance, which is the space in between panels, is crucial for comics making and reading. The gutter is an absent space that is part of the story—it is where the reader fills in the blank between pictured moments, participating imaginatively in the creation of the story. And different readers do this and experience this blank differently. Comics is as much about what is *outside* the frame as what is *inside* it—what can be pictured, and what cannot be or won't be pictured, and is left to the reader's imagination.

In the encounter with the gutter, we see how comics gestures conspicuously to the reader's active and involved reading. This level of readerly engagement is the reason that Marshall McLuhan named comics, which he designated "a highly participational form of expression," a so-called cool medium in his classic study *Understanding Media: The Extensions of Man.* In *Understanding Media*, first published in 1964, McLuhan—who had a famously nonsensical cameo in Woody Allen's *Annie Hall*—categorizes different media as "hot" or "cool"; a cool medium is "low definition" and requires completion from the audience.

Comics, a sequence of selected frames, is about distillation and condensation—one of the reasons that it sometimes gets compared to poetry. In *Understanding Comics*, McCloud describes the art of comics as subtractive. When I pushed him in an interview on a phrase he and others use, "the secret language of comics," he clarified that

in part it was about making work that is economical and dense at the same time. "Nobody picks a comic up off the stands," he told me, "and gasps in admiration at all the unnecessary panels that were left out. You don't see that—it's secret, it's hidden—but that process does go on." He came up with the joke that comics, because it is an art of subtraction, is "secret labor in the aesthetic diaspora." In an artist's statement from 1974, Spiegelman wrote, "The comix I like, and try to do, can be read slowly and often. . . . I try to make every panel count and sometimes work as long as a month on a page. . . . I'm excited by the 'secret language' of comics—the underlying formal elements that create the illusions."

At its most basic, we can say that comics is a spatially site-specific form of literature. In this way, too, comics can also be like poetry, in which the line breaks and stanzas and arrangement of words on the page all carry meaning. Comics works, most fundamentally, "choreograph and shape time," to invoke a striking phrase of Spiegelman's. In the vocabulary of the comics, the other key element aside from the gutter is the panel, also known as the frame. Comics shapes time by arranging it in space on the page in panels, which are, essentially, boxes of time. McCloud amusingly reminds us in *Understanding Comics* that the conventions of comics would seem to dictate that each panel is a moment, and then he says time in comics . . . is *weirder than that*. The *weirdness* of time in comics is part of the medium's force as a storytelling form.

Comics has the ability to powerfully *layer* moments of time, like in a single panel from Spiegelman's *Maus*, in which the legs of girls hanged in Auschwitz in the 1940s dangle from the tops of trees in the Catskills as the Spiegelman family drives to the supermarket in the 1970s. The Belgian cartoonist Hergé, creator of *The Adventures of Tintin*, one of the most famous comics series in the world, which has been translated into over seventy languages, has said that a panel from his 1943 *Crab with the Golden Claws*, which pictures battling troops in the Sahara, is

among his favorite panels in all of his work, because it is, in his words, "an entire sequence in one." It could be, in his view, multiple men fighting, scattered in different positions across a hill, or it could be one man, during the fight, over time, who gets up from shooting to retreat across and down the hill. Panels are how the cartoonist gets to experiment with presenting time, with duration and motion. Richard McGuire's monumental, nonchronological graphic novel *Here*, which offers on every page a fixed-perspective view of the same space—a ground-floor room in Perth Amboy, New Jersey—links the experience of space with the experience of time. McGuire multiplies and layers panels, each of which represent a different time frame, within the same space on every page, opening up dimensions of time. One page depicting 1949, which is about breaking as a general matter, features a spatialized smattering of verbal insults from the 1940s to the 1980s—and also, terrifyingly, water pouring in the room's window, suggesting a totally destructive natural disaster in the year 2111.

Panels are also how the cartoonist gets to experiment with directions of reading. Comics does not propose linear reading in the same way prose does. Cognitively, one's eye usually first takes in the whole page, even when one decides to start in the upper left corner and move left to right. This is sometimes called comics's "all-at-onceness," or its "symphonic effect." In comics, reading can happen in all directions; this open-endedness, and attention to choice in how one interacts with the pages, is a part of the appeal of comics narrative. One simple but arresting example is in Daniel Alarcón and Sheila Alvarado's *City of Clowns* (2015), adapted as a graphic novel from an earlier story by

Richard McGuire, double-spread page from *Here* (New York: Pantheon), 2014. *Here* is based on a six-page story, "Here," published twenty-five years earlier in *Raw* magazine. It was the subject of an exhibit at the Morgan Library & Museum in New York.

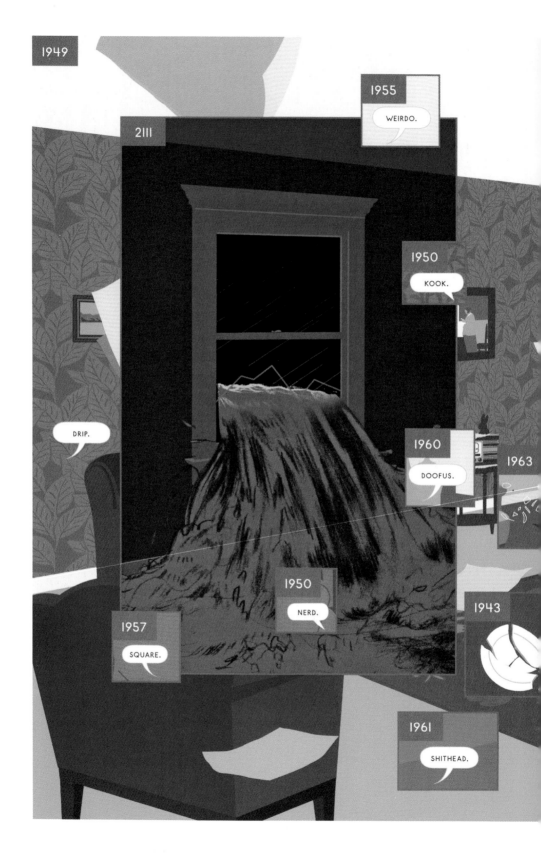

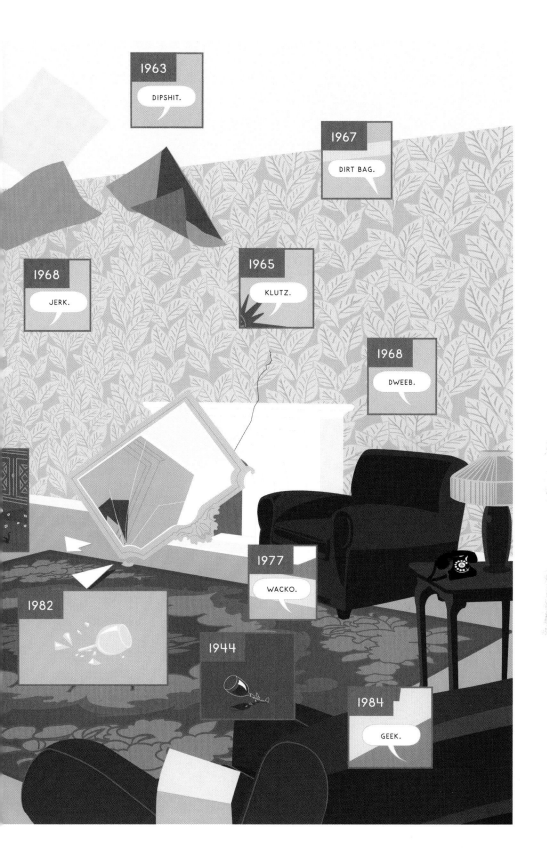

Alarcón about a young journalist in Lima, Peru. One nine-panel page suggests that readers both read in succession—the page "works" if you read it left to right, row by row, top to bottom—and also that they grasp the page as a whole and read it diagonally, based on how the black panels with large letters draw the eye: "iN LiMA DYiNG iS the Local Sport." Because of the pattern produced by color, one can't help but read it this way immediately. Comics puts productive pressure on what "normal reading" is—not because it is so easy, or immediate, but rather because paths of reading and different moments of time can compete as alternatives.

While comics is still sometimes cast as escapist and diversionary—and plenty of comics can be like that, quite pleasurably—today it is clear that many comics gesture toward the opposite: a participatory, even slowed-down practice of consumption. The prominence of comics may actually rhyme with the current cultural valuation of "slowness" happening all over. Joe Sacco conceives of his comics journalism, for instance, as "slow journalism." And Spiegelman's primary goal when he set out to make the watershed *Maus*, as he has repeatedly stated, was to make comics "that needed a bookmark."

Houghton Mifflin Harcourt now publishes *The Best American Comics*, which they added to the stalwart *Best American* series in 2006—the same year the best-selling *Fun Home*, their first graphic novel, was named *Time* magazine's #1 book of the year. PEN established a Graphic Literature award in 2010. Margaret Atwood has even penned a graphic novel, *Angel Catbird,* which she will continue as an ongoing series. And in 2017 it was announced that a graphic adaptation of Harper Lee's classic *To Kill a Mockingbird*, with the full encouragement of the Lee estate, is in the works; the very same week,

Daniel Alarcón and Sheila Alvarado, page from *City of Clowns* (New York: Riverhead), 2015.

iN LiMA

Those who die in phantasmagoric fashion, violently, spectacularly, are celebrated in the fifty-cent papers beneath gory headlines.

I don't work at that kind of newspaper, but if I did, I would write those headlines too. Like my father, I never refuse work.

I've covered drug busts, double homicides, fires at discos and markets, traffic accidents, bombs in shopping centers.

DYiNG iS

I've profiled corrupt politicians, drunken has-been soccer players, artists who hate the world.

But I've never covered the unexpected death of a middle-aged worker in a public hospital.

Mourned by his wife. His child. His other wife. Her children. My father's dying was not news.

THE LOCAL SPORT

the *New York Times Magazine* published their first all-comics issue, which even boasted hand-lettering for elements like the crossword puzzle. Cartoonists are in the spotlight with more and more regularity as their graphic work is nominated for prestigious prizes alongside prose. *New Yorker* cartoonist Roz Chast's *Can't We Talk About Something More Pleasant?*, a moving exploration of parental bonds, won the National Book Critics Circle Award for Autobiography in 2015, competing against all nongraphic titles in that category. In 2014, Bechdel caused a sensation when she became the second cartoonist, joining Ben Katchor, to win the MacArthur Foundation "genius" grant. In 2016, the cartoonist Gene Luen Yang (*American Born Chinese*) and the unclassifiable artist-writer-journalist Lauren Redniss (*Radioactive*) won the award in the same year—a first. Redniss, who created an experimental biography of scientists Pierre and Marie Curie that literally glows in the dark and meditates on the nature of visual evidence, and Yang, who created a dark young-adult work that visualizes racial stereotypes in order to tell a story about fearing versions of one's own ethnicity in the context of assimilation, exploit the relation of word and image in comics to both tell and show compelling stories in fresh ways.

A hybrid form that can be abstract and surreal, and also immediate and direct, comics is surprisingly versatile—and the fascination comics inspires continues to grow as new vibrant work crops up across a wide range of formats and genres. Today one can find comics in very specialized stores—comic-book shops with names like Forbidden Planet, Floating World, Secret Headquarters, and Desert Island—and also wherever books are sold: everywhere, as the subtitle of this book suggests. The venerable *New York Review of Books*, for instance, a literary mainstay, just began a new imprint, New York Review Comics, with a mission to introduce reprints of classic works of comics to freshly receptive audiences. NYRC's first title is Mark Beyer's dreamlike *Agony*, a beautiful, 5-inch-square book with French

flaps and an introduction by novelist Colson Whitehead. In March 2016, the long-running magazine *World Literature Today* published a special issue on international comics, opening the field to new readers. Today we have actual book reviews in comics format; Bechdel created the *New York Times*'s first such review in 2009. We have amicus briefs filed by lawyers in comics form, comics adaptations of *The Diary of Anne Frank* and *The 9/11 Report*, and graphic nonfiction about everything from Hurricane Katrina to Congressman John Lewis's struggle for civil rights (the third volume of Lewis's *March*, a collaborative work, won a National Book Award for Young People's Literature). A movement focusing on "graphic medicine"—the benefit of comics both by and for doctors, nurses, and patients—has taken off globally.

———————

To present the vibrant comics landscape, *Why Comics?* is organized by the ten biggest themes in today's comics and graphic novels. It offers a set of overlapping but meaningfully distinct themes, one per chapter (with one exception!), that are framed as guiding questions on the value of comics today. The chapters are posed as questions because they are investigations into the unique power of comics. Why does comics have a purchase on insights about sex, or about the suburbs, for instance? What do its boxes of time reveal, what does its world of hand-drawn marks do differently? Reading from theme to theme, you can explore the concerns of comics as a contemporary medium, access the history of famous cartoonists and genres, and encounter the force of comics form and style to convey something surprising, moving, striking—something that changed the way people express themselves or recognize themselves in stories. The themes, which are loosely linked but not strictly chronological, mix gravity and humor, the dark and the light: disaster; superhe-

roes; sex; the suburbs; cities; punk; illness and disability; girls; war; and queerness. Written to be read as a whole—although one presumably could start with a favorite theme—*Why Comics?* is a guide to what comics does best.

Each chapter focuses on the lives of fascinating comics creators who have made contemporary comics what it is today. These cartoonists have produced the most significant work on a key theme—or themselves started a major, enduring genre, as Sacco did with war journalism, or Gary Panter did with punk comics. Some chapters highlight the career of two or even three artists, while some keep the focus on one generative figure; all also offer anecdotes from my career in the comics world, in which I've collaborated with Art Spiegelman and Alison Bechdel, among other cartoonists. Ware, a poet of contemporary social and architectural space, shows up in both the chapters on superheroes and on the suburbs. Here you'll find classic themes that you might expect, such as superheroes, and also the biggest emerging topics in comics right now, such as illness and queerness. And while you might expect a book on comics to open with the superhero, a type of character that is one of comics's most enduring and successful creations, the story starts with disaster, the foundational theme of the comics.

WHY DISASTER?

Maybe Western civilization has forfeited any right to literature with a big "L." Maybe Goethe and Mozart were not the patron saints of Germany. Maybe Wilhelm Busch—with Max and Moritz' amusing bones ground up into a meal—is a more appropriate figure—though far too benign and avuncular. Anyway maybe vulgar, semiliterate, unsubtle comic books are an appropriate form for speaking of the unspeakable.

—Art Spiegelman, notebook entry, 1970s

The most famous graphic novel in the world, without a doubt, is Art Spiegelman's *Maus: A Survivor's Tale*. If you've only heard of one graphic novel, I'm guessing it's probably *Maus*. Spiegelman is an internationally celebrated figure; he has been named one of *Time* magazine's 100 most influential people in the world. The *Maus* series won a Pulitzer Prize in 1992; the previous year, it was the subject of a Museum of Modern Art exhibit. There are over a million copies of *Maus* in print in America alone. It has been translated into forty-plus languages, including Chinese, Pashto, and

Croatian. Not coincidentally, *Maus* is unflinchingly about disaster—the Holocaust. Further, comics's most famous genre—the one that so often comes to stand in for the entire art form—is predicated on disaster: superhero comics. Disaster undergirds the entire enterprise, from front to back. Superman, the first superhero, comes with an origin story about the total destruction of his planet. Origin stories for superheroes are about collective, or at the least personal, disaster, whether it's an exploding planet or a young Bruce Wayne witnessing the murder of his parents and henceforth vowing to fight crime as Batman. And then, of course, there is all the prospective disaster that they fight in the present tense of their storylines: endless plots to destroy cities, planets, the universe. Disaster is foundational to comics.

As a verbal-visual art form, comics is inherently about the relationship of word and image, which is to say, about different ways of communicating. It makes readers aware of limits, and also possibilities for expression in which disaster, or trauma, breaks the boundaries of communication, finding shape in a hybrid medium. With its juxtaposed frames, comics constantly calls readers' attention to what they see, or don't see, and why. What can be seen within the frame—and what can't be seen, or isn't *supposed* to be seen? Comics is a form about visual presence, a succession of frames, that is stippled with absence, in the frame-gutter sequence. We can say that its very grammar, then, evokes the unsaid, or inexpressible. Comics highlights the relation between words and images—and therefore addresses itself to the nature of the difficulty of representing extreme situations and experience.

What, for example, can be visualized, but cannot be explained in words by a character or narrator? The layers of meaning in handmade images often convey, strikingly, what words alone cannot. Close to the beginning of Josh Neufeld's book about the natural and social disaster of Hurricane Katrina, *A.D.: New Orleans After the Deluge*, he offers readers, for instance, a page whose only words are a simple identification—a date boxed in the upper left—and a piece of graffiti

etched onto a rooftop: five names with the proclamation "WE'RE ALIVE." The page takes an aerial view. In the opening frame, which spans the whole tier, readers encounter a wide, detailed image of a flooded residential street in which the water is rising toward almost a dozen rooftops. The page's final two panels, evenly sized to complete its bottom row, have no words. In the first, six people struggle through the water toward the front of the frame, small bodies seen near submerged cars. In the second, in the center of the panel, a body floats facedown in the water. The visual juxtaposition—verbally unremarked upon—of the two rhyming panels gives the page its force: while some are struggling through the water, others have already ceased to struggle. The concluding image of the corpse, small from our bird's-eye view and floating along with other debris in the waterways of the street, is also a contrast with the rooftop words proclaiming collective life. In comics, images that represent extreme experience can feel powerfully immediate and direct, which often gives them an emotional force when they are expressing what can't be put into words. Images of disaster in comics are drawn from one person's pen, not captured through a mechanical device. As one *makes* a picture but *takes* a photograph, in the idiomatic convention, images in comics are created out of whole cloth by a living, breathing body.

Cartoonist Joe Sacco, a self-described comics journalist whose comics explore genocide, among other issues, suggests, "I think there is an inherent power in the immediacy of an image." And Art Spiegelman explains, "The compression of ideas into memorable icons gives cartoons their ability to burrow deep into the brain." One reason for comics's growing popularity in the years since 9/11 is likely the fact that we exist in the most visually amplified era in recent memory, through our regular interaction with countless different kinds of images, including videos, GIFs, digital photographs, and myriad visual interfaces online, in addition to print. Further, the media spectacle of that day ushered in a new, intensified global visual culture heavily

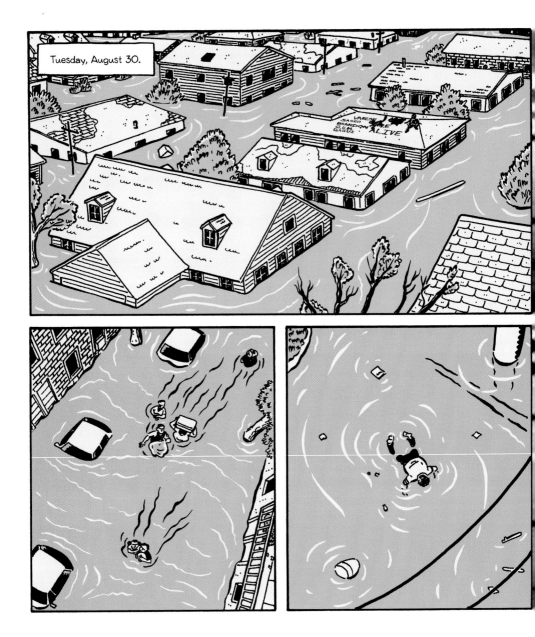

Josh Neufeld, page from *A.D.: New Orleans After the Deluge* (New York: Pantheon), 2009.

invested in articulating—and often actually documenting—disaster and violence. There has been a proliferation of certain types of graphic novels: personal narratives that track loss, war, and displacement, such as Marjane Satrapi's international best seller *Persepolis* (translated from the French in 2003), documentary comics such Sacco's *Safe Area Goražde* and Neufeld's *A.D.*, and even sci-fi fantasies riveted to political destabilization and disaster, such as the wildly popular Japanese series *Attack on Titan*, in which humanity has almost been wiped out by giant creatures called Titans and lives uneasily within three concentric circular walls to keep the monsters out.

Spiegelman memorably confessed after the publication of *In the Shadow of No Towers*, his comics volume about witnessing 9/11, "Disaster is my muse." Especially in the personal realm, comics can be so powerful because it presents the texture of real-life disaster and war without sensationalizing violence—and yet without turning away from it. Spiegelman, and Japanese cartoonist Keiji Nakazawa, a Hiroshima survivor, both started making comics in the 1970s about their families' wartime experiences. Their comics sit at the boundary that Spiegelman, in *No Towers*, calls "that fault line where World History and Personal History collide." And they have been among the most successful cartoonists of all time.

Spiegelman's Polish-Jewish parents, Vladek and Anja, both survived Auschwitz, and gave birth to Art in Sweden in 1948 before settling in Rego Park, Queens, to raise their only child. Vladek and Anja's first son, Richieu, had been killed in the war. Postwar, Anja had multiple miscarriages before conceiving Art (his given name was Itzhak Avraham ben Zev). While Spiegelman and I were working on completing *MetaMaus*, a book about the creation of and research for *Maus* that I helped to edit over a period of five years, I asked him what the first entry in the book's chronology should be. "My chronology would start with: When was Kristallnacht?" he responded. In other words, history is so deeply etched into Spiegelman's sense of the shape

of his own life that he feels his life begins with the 1938 pogrom in Nazi Germany that is often seen as the beginning of the onslaught of the Holocaust. In "Prisoner on the Hell Planet," a 1973 comics story about Anja's suicide, Spiegelman draws himself as a child, and throughout, wearing the striped uniform of concentration camp inmates—his stripes are a birthright, the story suggests, as he inherits his parents' trauma simply by existing.

Spiegelman has loved comics his entire life. He became obsessed with *Mad* at age seven when he saw the 1954 Basil Wolverton cover titled "Beautiful Girl of the Month Reads *Mad*," a famous satire of *Life*. "I studied *Mad* the way some kids studied the Talmud!" Spiegelman cracks in his experimental comics autobiography *Breakdowns: Portrait of the Artist as a Young %@&*!*. At age twelve, he started producing his own comics stories, some with an adorably anglicized name, Art Speg. In this Spiegelman briefly joined the ranks of Stanley Lieber aka Stan Lee, Jacob Kurtzberg aka Jack Kirby, Alfred Caplin aka Al Capp, and Robert Kahn aka Bob Kane, among many others. A local Queens newspaper where he shopped his work as a kid even printed an article about him titled "Budding Cartoonist Wants Attention." Ardently committed to the form, he published in his junior high school newspaper, literary magazine, and yearbook, and also began seeing his work in print in fanzines. (*Fanzine* is short for "fan magazine," and often gets abbreviated to the simple *zine*.) At fourteen, Spiegelman published his own hilariously sophisticated-sounding comics satire magazine, *Blasé*, in editions of about fifty with a hectograph (an inexpensive printing apparatus also known as a gelatin duplicator). Later, while attending Manhattan's High School of Art and Design, from which he graduated in 1965—and which also counts Calvin Klein, Harvey Fierstein, Gerard Malanga, Fab Five Freddy, Lorna Simpson, Marc Jacobs, and the rapper Fabolous as alumni—Spiegelman went back to the local Queens paper, *The Long Island Post*, and this time got hired as a weekly cartoonist.

While as a teenager Spiegelman's comics career was burgeoning,

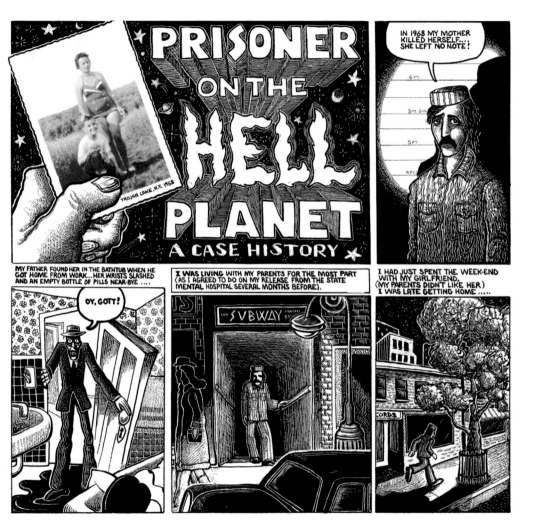

Art Spiegelman, beginning of story "Prisoner on the Hell Planet," *Short Order Comix* #1, 1973, and re-printed within the pages of *Maus I: A Survivor's Tale* (New York: Pantheon), 1986, and *Breakdowns: Portrait of the Artist as a Young %@&*!* (New York: Pantheon), 2008.

his awareness of what he would later call "the oxymoron of life in a death camp" was too. Vladek and Anja Spiegelman, in their postwar life, did not explain to their son what had happened to them, and to others, including many, many relatives, in what was then usually called, simply, "the War" ("Holocaust" gradually entered the lexicon in the 1970s). References to their experiences, Spiegelman told me, would surface during his childhood, mostly as confusing "absolutely unconnected moments that invaded my daily life at random." We see this in the remarkable episode Spiegelman draws in *Portrait* in which Vladek and Anja discuss a former *sonderkommando* with whom they had just attended a party, who was rumored to have "put to the ovens his own wife and son," in the company of a deeply perplexed eight-year-old Art. But in 1961, when the Adolf Eichmann trial in Jerusalem became an international televised event, Spiegelman, then thirteen (and recently bar mitzvahed), started looking through his parents' "forbidden bookshelf" and discovered images of Holocaust atrocity.

Crucially for the field-inventing cartoonist he was to become, Spiegelman didn't only encounter photographic images. Wrestling with the photographic documentation of atrocity is a common loss-of-innocence experience that many including the late Susan Sontag have recounted (she explained in *On Photography* her life existed in two halves—one before she saw Holocaust photos, and one after). Spiegelman, in addition to photos, also found drawings of life in the camps, done by survivors, which were published in humbly printed small-print-run booklets right after the war. The booklets featuring drawn art that bore witness to daily life during the Holocaust—two of which were named, simply, *Auschwitz* and *Ravensbrück*, the names of Nazi camps—fascinated Spiegelman. The booklets, which were largely published by postwar Jewish organizations, showed him for the first time what life must have been like for his parents—and they were, in essence, in comics form. The images drawn by prisoners doc-

umented information about daily life that could not have been photographed; there weren't cameras in Auschwitz for inmates. And the images are accompanied by captions, bearing witness in images and words, as Spiegelman's *Maus* would years later, to the disasters of war. This formative 1961 encounter with atrocity drawings, as we might think of them, is when Spiegelman became the specific cartoonist he would become—someone who would dare to make a comic book about the Holocaust and who could claim "disaster is my muse."

The summer after graduating high school, Spiegelman showed some of his comics to the recently launched Manhattan underground weekly paper *The East Village Other*, which helped define the ethos of the counterculture. The editor asked him if he could do some strips about sex and drugs. In Spiegelman's account, he didn't know about either, so he enrolled in college to learn about both—while also dodging the draft. (Eventually, his comics started appearing in *EVO*—and in other underground press publications—around the time he began publishing and distributing unsigned psychedelic leaflets.) Spiegelman's drive to be a cartoonist—despite his father's express desire for him to be a doctor, or at the very least a dentist—held steady at Harpur College (now SUNY Binghamton), where he majored in art and philosophy, kept contributing to fanzines, and was the editor of the college humor magazine, whose name he immediately changed from *Toady* to *Mother*. The industrious Spiegelman also, at age eighteen, started work as a creative consultant at Topps Chewing Gum, Inc. His work for Topps lasted twenty-plus years, through the publication of *Maus I: A Survivor's Tale* by Pantheon in 1986. Spiegelman has been a force on many different fronts of American culture: in addition to work like *Maus*, which opened the fields of contemporary art and literature to include comics, he developed major fads for Topps like the commercial novelty items Wacky Packages and Garbage Pail Kids.

Few readers of *Maus*, the best-selling book about genocide and its

effects, probably know Spiegelman is the man behind "Leaky Lindsay," "Smelly Kelly," and "Itchy Richie." Garbage Pail Kids "appealed to the inner beast in all kids," as Spiegelman sees it. It was a massive cultural phenomenon in the 1980s. Garbage Pail Kids satirized Cabbage Patch Kids dolls by featuring a series of grotesque child characters identified by their first names; each package contained five stickers and one stick of bubble gum. Topps was Spiegelman's "Medici"—his day job, a commodity enterprise that allowed him to subsidize his own artwork as an avant-garde cartoonist. My favorite GPK, and the most resonant one, is "Adam Bomb." It's the first one Spiegelman sketched and it is not only gross—the standard—but, further, naturally, this kids' novelty item is also about disaster. In the sticker, a blue-eyed child in a rep tie and short suit, like a mock adult, sits on the ground and presses the big red nuclear button as a mushroom cloud billows out of his head, splitting it to pieces above a cracked earth. "A kid literally going nuclear" is how Spiegelman explained the image, which graces the cover of the series's first package. His prototype for what became an enormous commercial fad is yet inflected by the devastation of the atomic bomb in World War II, offering up an exploding child. In Japan, Keiji Nakazawa, Spiegelman's peer in real-life disaster comics—and himself a child survivor of Hiroshima's atomic bomb blast—captured in comics form the on-the-ground perspective of the bombed child in his masterworks *I Saw It* and *Barefoot Gen*.

In college in 1967, Spiegelman wrote an art history paper about a highly unusual comic-book story about the disaster of World War II, 1955's "Master Race." His first attempt to articulate the aesthetics of comics was inspired by artist Bernard Krigstein's eight-page work about a Nazi commandant pursued by a Holocaust survivor in a New York City subway (adapted from a script by Al Feldstein). "Master Race" was a rare product of the 1950s that actually addressed the Nazi trauma; it appeared in the mainstream comic-book series *Tales Designed to Carry an Impact*, #1, published by EC Comics, and along

with Anja's postwar survivor-drawn pamphlets, it had a profound effect on Spiegelman's sense of how drawing, and how comics, specifically, could address disaster through formal experiment. Admiring Krigstein's rigorous attention to form, and the composition of the page, Spiegelman quoted the artist in his college paper: "It's what happens *between* these panels that's so fascinating." While his paper went on to be republished in the college literary magazine and later the EC Comics fanzine *Squa Tront*, Spiegelman went on to write about Krigstein decades later in the *New Yorker*. That the war was addressed in comics was a revelation to him; it was like "being struck by lightning." Spiegelman, after all, had grown up in what he once called "the overheated bunker of my traumatized family," with two survivor parents and a ghostly dead brother whose formal portrait loomed prominently in his parents' bedroom. In a commencement speech at SUNY Binghamton, Spiegelman described his experience leaving for college: "Until I left home I thought that all adults screamed in their sleep as my parents did." Harpur kicked him out after he had a nervous breakdown in 1968, during which he spent a month in the Binghamton State mental hospital, where he collected bits of string, paper, and other trash, echoing his father's experience in the camps. On May 21, 1968, Spiegelman's mother, Anja, committed suicide in the family's Rego Park, Queens, home, with pills and a razor blade. She left no note.

A few years after Anja's death, with its shocking perversity—she survived the most notorious Nazi death camp of the Holocaust only to choose to take her own life—Spiegelman was deep into the world of underground comics, living in San Francisco, its center. Some of his dark, taboo-breaking work, while in sync with other transgressive underground titles, feels related to the weight of his parents' history in his life: in one 1971 *Viper* comic by Spiegelman, a child kills his father and rapes his mother ("Look creep! This tears it!—You've been cramping my style long enough!!!"); in another, a deracinated immi-

grant character named Willie Wetback (in America Vladek Spiegelman went by William) is himself murdered and raped, in the neck, by the villain the Viper.

In 1972, a friend of Spiegelman's, the confessional cartoonist Justin Green, was editing an underground comics title called *Funny Aminals*—an adult, edgy take, hence the spelling, on the "funny animals" genre of comics, in which animals live and act like humans (think Donald Duck and his pet dog). The only stipulation for the story was anthropomorphic animals. Spiegelman initially bowed out of the assignment. Encouragement from Green came in the mail in the form of a tab of speed taped to the letter (which supposedly remains, never detached, in Spiegelman's files), and eventually Spiegelman relented. He created a three-page comics story, "Maus," inspired by Green's own autobiographical comic book *Binky Brown Meets the Holy Virgin Mary*, the first autobiographical comics story, which appeared earlier in 1972 as a forty-four-page stand-alone comic book. "Maus" opens with the frame narrative of a father, drawn as a mouse, telling his son, also a mouse, a bedtime story in Rego Park, about his experiences with his mouse wife, "in the old country" during the war. After seeing early racist animated Farmer Gray cartoons in a film class he audited, Spiegelman had hit on the idea of doing a piece about race in America with Ku Klux Kats, before turning to a metaphor closer to the actual experience of his family—one borrowed, in fact, from Hitler himself, whose racist Nazi propaganda machine proposed Jews were vermin.

"Maus" is a work of testimony, although Vladek Spiegelman is unnamed in the piece. To research the three-page story, Spiegelman visited his father in New York, interviewing him extensively with a reel-to-reel tape recorder over four days. This interview produced the plot of "Maus," and became the core of Spiegelman's interest in his parents' wartime experiences. Anja Spiegelman had often told her son that when he grew up, someday he might be interested in her diaries,

in which she chronicled what had happened to her in Poland and Germany. And now, after having earlier tried to escape the weight of his parents' legacy, he was. Although the short "Maus" in *Funny Aminals* was met with little response—Spiegelman says that his cartoonist friends didn't know how to handle the Holocaust theme, and his father's survivor friends reacted to the story as though it wasn't actually comics, or even visual—Spiegelman realized in his parents' history he had found his voice as a cartoonist.

By 1974, Spiegelman's father-as-mouse, stuck in the wheel of history, had become one of the key characters in his developing comics repertoire. In a drawing for *The Apex Treasury of Underground Comix*, Spiegelman created an homage to Ernie Bushmiller's 1942 self-portrait in which the artist approaches his characters Fritzi, Nancy, and Sluggo, asking "Who's got a gag for me today?" Spiegelman's take on it perfectly represents the hybrid comics idiom that he enduringly created: high and low, serious and funny, his stable of characters who might provide him with a "gag" are a Cubist-style Picasso woman, a hard-boiled detective named Ace Hole, Nancy, and a wary-eyed Vladek-Spiegelman-as-mouse in a concentration camp uniform. Spiegelman reinvented comics to be not only, as in Crumb, an art form that didn't need punchlines, but further to be an art form that could uniquely express disaster even for an everyday "gag."

With the realization that he had found, within his own family, a story worth telling—and a story that was connected to the open wound of his mother's suicide—Spiegelman began working in earnest on the long form version of *Maus* in 1979. "I didn't have the stamina to devote myself to a one-hundred-, two-hundred-, three-hundred-page book just to serve up a lot of yuks or escapist melodrama," he told me. He had moved from San Francisco back to New York City, closer to Vladek, whom he continued to interview, and he immersed himself in every shred of Holocaust research he could find, from books and magazines to photographs to films to drawings

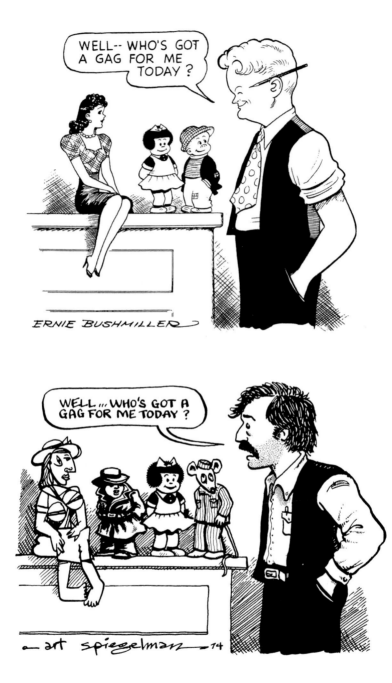

Ernie Bushmiller cartoon self-portrait, 1942, and Art Spiegelman homage, 1974.

by survivors. Spiegelman also changed the style of the story for the expanded version. While the three-page "Maus" has a detailed style, with fine lines and cross-hatching, so that the texture of a Nazi coat, or the fur on a mouse's face, is evident, for the longer project Spiegelman spent time developing a looser, sketchier style, which he felt made the work more accessible, and less "masterful" or virtuosic—an aesthetics associated with Nazi ideology. Spiegelman decided to make this accessibility part of the very material production of the work, too: he purchased his supplies for *Maus*, such as regular typing paper, at a common stationery store, and used one fountain pen for the writing and the drawing. Perhaps most important, in *Maus* Spiegelman worked at a one-to-one ratio to emphasize the story's immediacy and intimacy—its diary-like, manuscript-like quality. An unusual practice for cartoonists, working at a one-to-one ratio means that the cartoonist draws at the same size at which the work is printed, forfeiting a level of control of detail that composing larger than print offers. *Maus* clearly reveals comics style as a series of deliberate choices, not simply one person's default way of drawing.

The first chapter of *Maus: A Survivor's Tale* appeared in the second issue of Spiegelman and Françoise Mouly's *Raw* magazine, which serialized the entire work over the next eleven years, minus the very last chapter. Driven by Vladek's testimony, *Maus* focuses on Spiegelman's parents' journey through the war, and also on how the survivor father and cartoonist son endeavor to understand each other in the wake of shattering experience. *Raw*, an oversize publication, was founded in 1980 by Spiegelman and his French wife, Mouly, in order to showcase avant-garde "comix and graphix" by presenting them with meticulous, art-book production values. *Raw*'s first subtitle—they changed with every issue—is, movingly, "The Graphix Magazine of Postponed Suicides," a description that cannot help but evoke Anja Spiegelman's suicide, positing comics as a kind of literal lifeline for a son who had also suffered a mental breakdown. *Maus* appeared in *Raw* as a small

insert booklet within the larger-scale magazine, deliberately evocative of the humble postwar survivor-drawn pamphlets that bore witness to the war, which Anja Spiegelman had brought to the United States from Europe.

Spiegelman and Mouly printed *Raw* themselves in their Soho loft with a secondhand, thousand-pound printing press that Mouly had purchased and installed in the living room of their fourth-floor walkup. Spiegelman shopped *Maus*, his work in progress, around to "every reputable publisher" and was rejected by all of them. (*MetaMaus* reprints about a dozen of the rejection letters.) "You can imagine the response I've gotten from the sales department," one editor explained. "I can't see how to advance the thing into bookstores." Finally, Pantheon—which had already previously rejected *Maus*—signed the work on after its art director, a friend of Spiegelman's, brought it directly to publisher André Schiffrin. Pantheon released *Maus* in two book volumes in 1986 and 1991, instead of waiting to collect the entire work after its serialization in *Raw*. A worried Spiegelman had urged Pantheon that the Steven Spielberg–produced animated kids' film *An American Tail*, if released before *Maus*, would overshadow it: both portray Jewish mice, and Spiegelman was convinced that his concept had been lifted for the Hollywood film. Pantheon relented, agreeing to get a *Maus* volume out into the world before *An American Tale* hit theaters, after the *New York Times* ran an unusual feature on *Maus* that resulted in a flood of public interest. It was unusual because it covered a work in progress; a work in progress in a small press magazine; and, further, a *comics* work in progress in a small press magazine. Critic Ken Tucker wrote of the originality of the first six chapters of *Maus*, claiming that Spiegelman's triumph in *Maus* is that he "tempts sentimentality . . . and then thoroughly denies that sentimentality with the sharp, cutting lines of his drawing and the terse realism of his dialogue."

Maus couldn't exist meaningfully in any other form but comics.

Its black line drawing is key to how it creates a compelling world into which the reader is easily invited. Its animal faces and tails—for Spiegelman's characters are clearly humans overlaid with a visual metaphor—provide a crucial level of abstraction that creates a compelling tension with the book's deeply researched historical specificity. And the structuring of the comics page in *Maus*—what a cartoonist might call its panelization—shows how comics can express the effects of real-life disaster through experiments with time and space. Spiegelman has suggested, "I think anybody who liked what I did in *Maus* had to acknowledge that it couldn't have happened in any other idiom."

The central proposition of *Maus* and all of Spiegelman's work is intimately related to representing disaster: it's that the past is never really past. While Spiegelman had the Faulkner quote "writing consists primarily of killing your little darlings" taped above his drawing table when making *Maus*, to encourage economy, the Faulkner quote in my mind forever tied to *Maus* is "The past is never dead. It's not even past" (from Faulkner's *Requiem for a Nun*). In its structure, *Maus* suggests this, shuttling back and forth between the 1930s and '40s, and the 1970s and '80s, intermixing them, sometimes even on one page, as it delivers both a story of death camp survival in Poland and of an artist son struggling to represent something unimaginable in America. Within the pages of *Maus*, the horror of Vladek's past—the murderous disaster of the Holocaust that Spiegelman has called "the center of history's hell"—invades the present, refusing to stay separate or closed off. The subtitle of *Maus*'s first volume is *My Father Bleeds History*.

Maus's form is indissociable from what it suggests about history, testimony, and the war. One of the most forceful formal devices of comics is how it can dramatically collapse or crush different moments of time together. In *Maus*, the past and present bleed into each other, just as the Art character makes his father "bleed history"

And so...

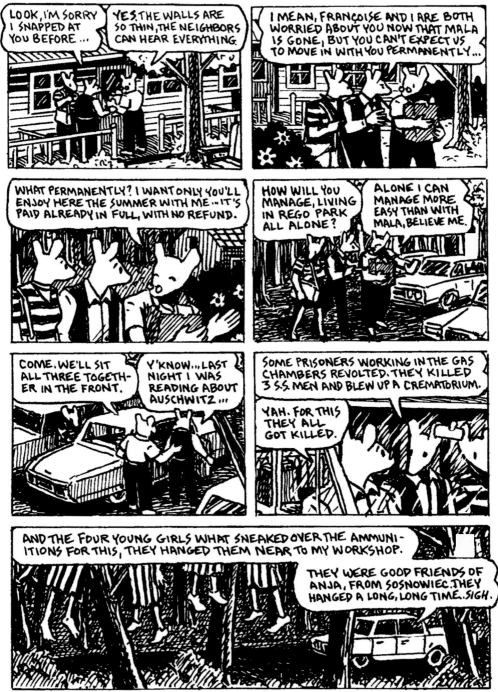

in their interviews. In some instances, Spiegelman creates a physical connection between panels set in the past and panels set in the present, linking them, as in the panel in which Art's cigarette smoke is figured as the smoke coming out of an Auschwitz crematorium chimney directly below it on the page. But in others, he exploits the language of comics—the convention that each panel represents a distinct moment of time—to make two different time periods literally intertwine. We see this in the striking page in which Vladek, Art, and Françoise—herself a character in *Maus*—converse in the Catskills during a summer visit to Vladek's bungalow. On their way to the supermarket in the car, Art changes the topic from his stepmother, Mala, to Auschwitz, asking his father about a prisoner revolt. The last panel of the page, in which Vladek describes its fallout, is its largest: as the family car weaves through dense rural roads, the legs of four Jewish girls hanged in Auschwitz after the revolt—witnessed firsthand by Vladek—suddenly appear dangling from the trees. The 1940s and the '70s collapse, as Spiegelman shows, wordlessly, how the traumatic past lives on in the present.

Instead of trying to reproduce the camps visually, as many films do, Spiegelman sees that *Maus*, as he told me, rather "creates [the camps] as a mental zone." In the reader's first encounter in the book of being inside the gates of Auschwitz, Spiegelman divides the page vertically. Here, unlike the page set in the Catskills, one is prompted to read top to bottom instead of left to right. In the first slim vertical column, in the 1980s, he and his father converse about the camps while walking outside. If one follows the page's panel structure one is next quickly dropped into Auschwitz in another vertical configuration, as

Art Spiegelman, page from *The Complete Maus: A Survivor's Tale.*

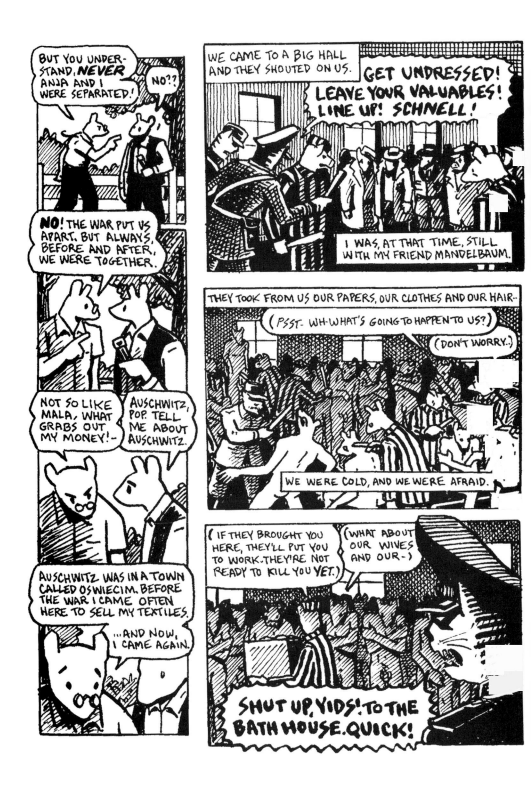

though dropping down a chute, into larger spaces in which screaming is immediate and the movement of the reader from panel to panel follows the movement of dressed individuals helplessly becoming naked. A Nazi guard anchors the lower right corner, where the page ends, impeding any sense of relief, as though blocking our optical exit with his body. Spiegelman traps a reader's eye in the camps, using the space of the page to create a feeling of claustrophobia. *Maus* exploits what Spiegelman calls "the secret language of comics" to express the fear his father felt. "I was at the Frankfurt Book Fair when [*Maus*] came out," Spiegelman told me, "and was aggressively barked at by a reporter, 'Don't you think that a comic book about Auschwitz is in bad taste?' I liked my response. I said, 'No, I thought Auschwitz was in bad taste.'"

After *Maus*, it took another disaster on a global scale—the terrorist attacks of 9/11—to inspire Spiegelman to create another major comics work. Spiegelman had hardly been slacking off: he illustrated *The Wild Party*, a 1928 narrative poem; he became a staff artist for the *New Yorker*; edited several collections of work; wrote meaningful essays; and published a kids' book, among other projects. But as he told the *New York Times*, "So far it has been the painful realities that I can barely grasp that force me to the drawing table."

Spiegelman, who lives in lower Manhattan close to the World Trade Center, and whose daughter Nadja attended high school three blocks away from Ground Zero, was an eyewitness to the attacks in New York City on the morning of September 11, 2001, watching the North Tower collapse before his eyes as he and his family ran. In the days after the attacks, most New York City—and national—media

Art Spiegelman, page from *The Complete Maus: A Survivor's Tale*.

outlets struggled with what aesthetic choices felt tonally appropriate to the gravity of the situation. Spiegelman produced, in collaboration with Mouly—who is currently art editor of the *New Yorker* and chooses and edits its cover every week—his iconic "black-on-black" 9/11 cover. At a loss for how to represent this disaster, the *New Yorker* top brass had considered publishing a photographic cover for the first time in its history. Spiegelman and Mouly's ghostly cover is a masterpiece of simple, striking graphic design by a cartoonist who had thought for decades about how to maneuver between presence and absence. The Twin Towers are silhouetted in black against a black background, almost like two empty comics panels with a gutter between them. One of the most important features of comics and graphic novels since 9/11—a feature that began with the field-defining *Maus* in the 1980s—is their insistence on doing the work of picturing, however complicated or contingent. This investment in revealing through showing pushes back against a culture that often valorizes traumatic absence and censorship (as the censorship from American newspapers of the "falling man" photograph of the man who had jumped from the North Tower, by the Associated Press's Richard Drew, demonstrates).

Running from a toxic cloud in downtown Manhattan on 9/11, Spiegelman encountered the feeling that his Auschwitz survivor parents' fear and fatalism were well founded. "Because I grew up with parents who were always ready to see the world grid crumble," he told NPR, "and when it started feeling that that was happening here and now, it wasn't a total surprise. . . . I think the one thing I learned from my father was how to pack a suitcase. You know? It was the one thing he wanted to make sure I understood, like how to use every available

Art Spiegelman and Françoise Mouly, "9/11/2001," cover of the *New Yorker*, September 24, 2001.

PRICE $3.50

THE NEW YORKER

SEPT. 24, 2001

centimeter to get as much stuff packed into a small space as possible. The ice might be thinner than one would like to think." Spiegelman felt freshly, painfully connected to disaster, in addition to furious at the United States government's hypocritical discourse, cheap patriotism, and international policy. (Around this time, he quit the *New Yorker* because he felt it was too politically complacent.)

Spiegelman started making ten large-scale comics pages called *In the Shadow of No Towers*: "If I thought in page units," he recounted thinking, "I might live long enough to do another page." Spiegelman found that his comics probing the effects of the 9/11 disaster on one person and on a nation were rejected by editors who had previously solicited his work. His "shrill, sky-is-falling voice," as he describes it, caused American editors to flee. Spiegelman's pages were originally published serially and sporadically in European venues such as *Die Zeit* in Germany; and in a few United States venues, like the *Forward*, the Jewish weekly; and the *LA Weekly*, an alternative paper. While over fifteen years after 9/11 the content of Spiegelman's critiques have become part of regular political discourse, he stood out in the aftermath, along with others like Sontag, as a media voice willing to openly critique American attitudes. The ten pages, large, dense, and colorful, were collected as a heavy oversize board book in 2004. *In the Shadow of No Towers* is 10 by 14.5 inches, and folds out so that each page is 20 inches tall, evocative of a newspaper broadsheet. The ten twenty-first-century comic strips are followed by reprints of seven old newspaper comic strips from the turn of the century. As ever, Spiegelman is motivated to articulate the links between the present and the past, something we see even in the book's structure.

Spiegelman absorbs his father's lesson on how to use a suitcase's every centimeter in *In the Shadow of No Towers*, transfiguring a mandate based in traumatic history into a formal principle that conveys traumatic experience in its density. *No Towers* offers complex, swarming pages with tightly packed panels that pressurize linear reading.

Comic strips are embedded within other strips; in some cases, one has to turn the book upside down to read it, suggesting that no one perspective can ever be correct. And the style changes throughout, even in the space of one page, frequently mimicking early twentieth-century cartoonists like Winsor McCay (*Little Nemo in Slumberland*) and George McManus (*Bringing Up Father*). The tenth and final *No Towers* page looks, perhaps, its cleanest—its basic composition evokes Spiegelman's black-on-black *New Yorker* cover. Yet this page dramatically expresses the feeling of time that attends to disaster: how time can be both scrambled, and also "stopped."

When one looks at this page, one can recognize right away that Spiegelman has drawn the Twin Towers of the former World Trade Center—the iconic antenna spire of the North Tower conspicuously pokes up out of the space of the page on the right-hand side. He draws them, it seems, as two big juxtaposed comics panels, and each is subdivided by its own panel. The sets of panels within panels each tell a narrative that moves forward in time, descending downward from the top, from left to right. In the first, Spiegelman describes a disappointing post-9/11 television interview; in the second, he morphs into earlier American comics characters, including from his own *Maus* story.

While the strip offers two narratives that move forward within the space of buildings, it also, outside of its enclosed collection of frames, displays one moment suspended in time. The building panels stand against a blue sky; a plane swoops in through the blue of the gutter in between the buildings, frozen in the moment before it hits the North Tower. We have at least three temporalities, or time periods, here: the left series of frames, the right series of frames, and the moment happening in the gutter between the buildings, which itself

Art Spiegelman, double-spread page from *In the Shadow of No Towers* (New York: Pantheon), 2004.

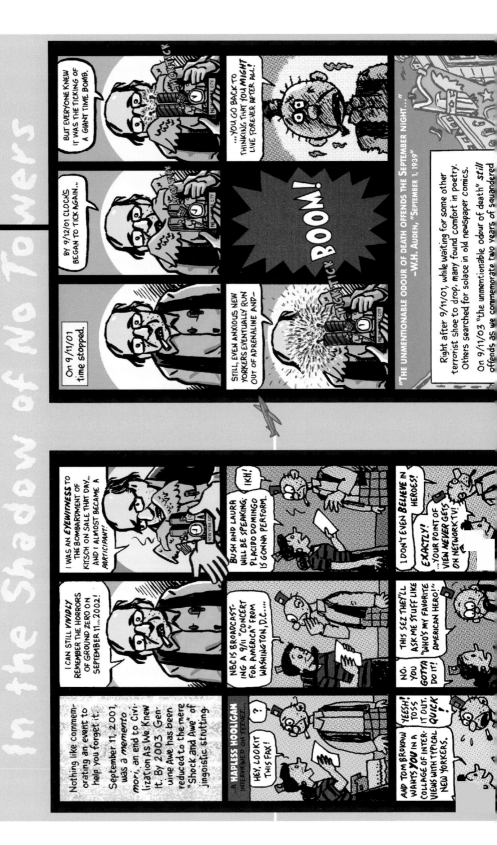

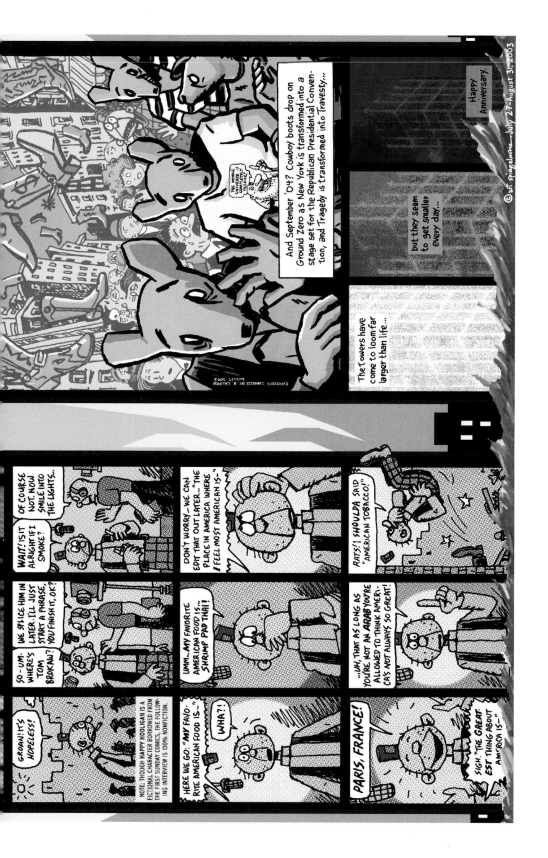

is multiplied: the North Tower, the first one to be struck, is *about* to be hit but below on the ground the fires have already begun. While narratives generally move forward in time, here time is arrested and reversed. In this way the page makes overt the symptoms of trauma, specifically time as both frozen, and as "aiming backwards instead of forwards," as Spiegelman put it in a talk about 9/11 titled "Ephemera vs. the Apocalypse." There's an indication of a "fade to black" ending *within* the sequence of frames, but *outside* of them the towers are still unceasingly burning. Through the play of internal and external space on the page, Spiegelman splinters time and states of reading: the page suggests movement and stillness at once; it asks us to recognize its elements as one integrated image—an image of the Twin Towers—and also, its set of cues asks us to follow its successive frames within them. Spiegelman slows the reader down in order to convey the effects of trauma and disaster.

While in America Spiegelman demonstrated how comics expresses real-life disaster in forceful ways other forms cannot, in Japan Keiji Nakazawa, a Hiroshima survivor, created comics about the atomic bomb that changed the way people looked at comics—and nuclear power. Nakazawa and Spiegelman—an atomic bomb survivor and a second-generation Holocaust survivor, respectively—are the cartoonists who, from opposite ends of the globe, re-created contemporary expectations for comics. Nakazawa, a *hibakusha*, which literally means "explosion-affected person," was born in 1939, in Hiroshima City. Nakazawa became a best-selling antinuclear crusader through his comics before dying in 2012 of lung cancer in Hiroshima. He inaugurated so-called atomic bomb manga, which changed cultures of expression in Japan and across the globe. *Manga*—the term translates loosely to "whimsical pictures"—refers, as a general matter, to comics from Japan; it has been in use for centuries. Nakazawa's pioneering documentary work, beginning in the 1970s, made comics a form that could bear witness to the trauma of atomic warfare. In 1972, the

same year as Spiegelman's short "Maus," Nakazawa published *Ore wa Mita*, or *I Saw It*, Japan's first autobiographical comic book about the atomic bomb. Nakazawa's title evokes Spanish artist Francisco de Goya's caption ("Yo lo vi") that appeared in his nineteenth-century series of etchings, *The Disasters of War*, which has become famous as a profound work of witness to violence. The related, ten-volume series *Barefoot Gen* (like Spiegelman's full-length *Maus*, a continuation of his earlier work) is Nakazawa's semiautobiographical story about the bomb that was the very first book-length manga ever translated into English, in 1978. It was translated by an all-volunteer, international group of peace activists working under the name Project Gen.

August 6, 1945, 8:15 a.m.: At the moment the B-29 *Enola Gay* dropped the atomic bomb code-named "Little Boy" on Hiroshima, Keiji Nakazawa, age six, was walking to school from his home in the Funairi Hommachi neighborhood. By chance, the mother of a classmate asked Nakazawa a question when he was just outside his schoolyard's concrete wall (and less than one mile from the bomb's hypocenter). When the bomb detonated, Nakazawa was spared: the wall fell on him, absorbing the shock and shielding him from the heat, while she and many thousands of others died immediately. Over seventy thousand people were killed instantly, with as many perishing afterward from radiation sickness. Nakazawa's father, Harumi, older sister Eiko, and younger brother Susumu died that day. The Nakazawa house collapsed on them, and then went up in flames, while Keiji's pregnant mother, Kimiyo, watched helplessly. Kimiyo, known as Kimie, gave birth that day, induced by shock, to a baby girl who died of malnutrition four months later. (Two of Keiji's older brothers were away from Hiroshima that day and survived.)

As a boy after the war, Nakazawa could not afford paper to draw on, so he tore down movie posters from city streets and handcrafted books from them. He would cut the posters to size, stitch them into notebooks, and pencil in his comics illustrations on their white backs—

his own homemade comic books. Upon graduation from junior high school, Nakazawa started work as a sign painter. In 1961, at age twenty-two, he moved to Tokyo in order to start a career as a cartoonist. Nakazawa found, in Tokyo, which had been firebombed during the war, that the prevailing mode of managing the legacy of the atomic bomb was silence and disengagement. In the early and mid-1960s, Nakazawa met many Tokyo residents who were openly disdainful of *hibakusha*, and believed, mistakenly, in the rumored transmissibility of radiation—"atomic bomb disease" in which one could "catch" radiation. Nakazawa resolved while in Tokyo, indeed, he would never again say "atomic bomb" out loud; he even refused to read newspaper articles with the characters "atomic bomb," and decided to hide the fact that he was a *hibakusha*. In his early career in comics, Nakazawa worked in conventional genres. As he describes it, "Sci-fi, baseball, samurais . . . I'd try my hand at anything." He eventually refigured the boys' action genre to include large-scale real-life disaster.

Kimie Nakazawa died in 1966 from the leukemia so common to *hibakusha*; she suffered a cerebral brain hemorrhage during ongoing treatment at the Atomic Bomb Survivors Hospital in Hiroshima. In a standard Japanese funeral, after a body has been cremated, relatives pick out the major bones and place them in an urn. When Nakazawa went to the crematorium to collect his mother's ashes, he explained, he was shocked that "there were no bones left in my mother's ashes, as there normally are after a cremation. Radioactive cesium from the bomb had eaten away at her bones to the point that they disintegrated. The bomb had even deprived me of my mother's bones." The atomic bomb had taken every vestige of his mother, not only her life but her very bones, her materiality, leaving Nakazawa nothing to hold on to. After his mother's death, Nakazawa reimagined his mission as a cartoonist: the atomic bomb would be his central subject.

His earliest narratives about Hiroshima, in the late 1960s, were fiction. Nevertheless, they were seen as so radical that the only place

Nakazawa could print them was in "adult" (meaning "erotic") magazines. (Immediately after World War II, the United States occupation of Japan imposed censorship on publications depicting suffering. Mandated by the US administration but endorsed by both sides, it persisted long past the end of the US occupation of Japan in 1952.) If he was to publish comics about the bomb, it would have to be in "third-rate" magazines, what were known as "lowbrows."

In 1970, still motivated by the urgency of addressing the bomb, Nakazawa published the fictional *Suddenly One Day*, an eighty-page story about a second-generation bomb victim, in *Boys' Jump* (*Shōnen Jump*). *Boys' Jump* was, to quote two critics writing on Nakazawa, "at that time disdained as an extremely vulgar medium," but a popular one: in 1970, *Boys' Jump* sold a million copies each week. *Suddenly One Day* produced, to Nakazawa's surprise, a large reaction—he describes that "mail poured in virtually every day, from all over Japan." The reaction emboldened Nakazawa, even if it brought the criticisms of his neighbors, who accused Nakazawa and his wife, whom he had married in 1966, of bringing shame on their families. Nakazawa resolved to continue creating comics about war, aided in part by supportive editors. In 1972—the very same year that Spiegelman was spurred on by Justin Green persistently knocking on his door, asking for a contribution for *Funny Aminals*—an encouraging Japanese magazine editor planned to publish a series of autobiographical manga, and asked Nakazawa to be the first in the series. *I Saw It*, Nakazawa's eyewitness account of August 6, 1945, was published as a black-and-white, stand-alone, forty-five-page issue of *Boys' Jump Monthly* in October 1972. With this publication, Nakazawa forcefully invented comics in Japan as a form of witness to disaster.

I Saw It is the first autobiographical comics work about the atomic

Keiji Nakazawa, page from *I Saw It*, 1972, English-language edition (San Francisco: Educomics), translated from the Japanese, 1982.

Used by permission of Misayo Nakazawa, arranged with Japan UNI Agency, Inc.

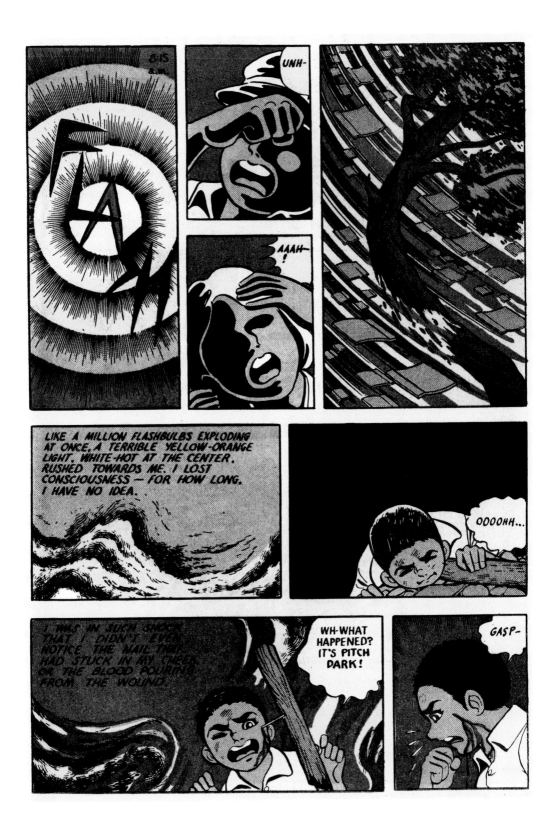

bomb, and it established a significant, unflinching visual idiom of disaster, detailing harsh suffering on the ground. A landmark work in Japanese documentary comics, *I Saw It* challenged a national culture that viewed the atomic bomb with distortion, stigma, and silence. *I Saw It* begins and ends within that present-day culture, in 1970s Tokyo: in a frame narrative, an adult Nakazawa walks through the streets, replaying his mother's painful final years. Abruptly, the frame narrative shifts back to the year 1945, but not to August 6 or the bomb: *I Saw It* presents scenes of the Nakazawa family's everyday life, of joy amidst hardship, of routines in a Hiroshima beset by air raids and scarcity.

But those rhythms of daily life are eventually disrupted by the events of August 6, 1945, a day which takes up thirteen pages of *I Saw It*'s forty-five, starting with Keiji's first sighting of the *Enola Gay* approaching, and the bomb's fall, detonation, and flash. (In Japan, the bomb blast became known as *pika* or *pika-don*—*pika* means brilliant light, and *don* means boom.) The page that shows the bomb detonating illustrates how comics narrative can capture what we might think of as both exterior and interior trauma. As we can see on this page, *I Saw It* races back and forth between perspectives: if one panel pictures the narrator's body on the page, the very next pictures his own optical perspective. To depict the tremendous, white-hot flash of the bomb's detonation, Nakazawa draws it overpowering a narrow, elongated panel, which is stamped in the upper-right corner with the explosion's exact time: 8:15 a.m. Simultaneously, the image records one young boy's act of eyewitnessing and acts as a historical marker of a momentous event. On the upper-right corner of the page, in the same tier as the flash, is an even more commanding panel that captures the expressionistic sights Keiji saw just before falling unconscious: a tree severs in two, a torrent of roof tiles rushes by. It is the kind of image that can't be photographed, and that is seared into one's memory. As with the drawings of the camps Spiegelman found on his parents' bookshelf, drawing can capture the vividness of memory—especially

memory formed during sudden traumatic events—in a way photography cannot. Comics, in Spiegelman and Nakazawa's hands, becomes a form of witness to unphotographable events.

In *I Saw It* the detonation is overwhelming, unthinkably accelerated—the aftermath, conversely, plays out slowly, with Nakazawa gradually, assiduously taking in all of Hiroshima's drastic changes, from his child-eyewitness's terrified perspective. *I Saw It* is famous for its unflinching drawings of wrecked bodies. No artist had drawn images quite like Nakazawa's before: on the one hand, they might seem to recall science fiction (in censorship-era Japan, a hugely successful genre) in their unconcealed, straightforward horror. But in the devastated Hiroshima of *I Saw It*, that horror is real: "Everybody's turned into monsters!" Keiji exclaims. Nakazawa's commitment to clarity, to presenting the grotesque in all its fidelity, is what makes *I Saw It* powerful. His direct, unadorned style—his images are neither abstractly stripped down, nor are they ornamentally detailed—showed the world how comics could relay the terror of an event like the atomic bomb blast from the first-person perspective of one of its victims.

In the wake of the disaster wrought by weapons technology, Nakazawa responds by engaging the humble technology of paper and ink. He counters the most high-tech of high technology, the atomic bomb, and the menacing march of scientific progress it represented, with the deliberately low-tech, primary practice of hand-drawing. His intervention, like Spiegelman's, resides not only in the political content of his work, but also in his invention of a confrontational, revealing graphic idiom for disaster. *Barefoot Gen*, the longer work inspired by *I Saw It*, is one of the most famous, and by some accounts the most popular, manga in Japanese history; it has sold over eight million copies. Now a monumental work in Japanese culture—it was the first manga used in

Gary Panter, sketch. Published in *Satiro-Plastic: Sketchbook Facsimile* (Montreal: Drawn & Quarterly), 2001.

Used by permission of Gary Panter.

85. Where was the Air Force

ROOF 153 ROEBLING BKLN WMSBRG 9-11-2001
STARTED ABOUT 15 MINUTES AFTER FIRST PLANE HIT WTC

Japanese schools in the 1970s—it is also one of the few manga in translation worldwide, available in over twenty-one foreign editions.

The connection that Spiegelman and Nakazawa reveal between comics and disaster shifted not only how the comics field saw itself, and how the public viewed comics, but also, even more important, how people think about the creative practice of communicating difficult, or traumatic, experience. In the wake of their influential works, there exist many, many comics about trauma—and for a good reason. This handmade form is able to explore violence without sensationalizing it. It can express the multifaceted experience of trauma—and the disaster of history—in its grammar of boxes, gutters, and lines. Since Spiegelman and Nakazawa's major works have been published, many more Holocaust comics, 9/11 comics, and atomic bomb comics have appeared. (And as the historian author of the book *Atomic Comics* points out, atomic radiation specifically has been foundational to American comic books, as we see in the origin stories of heroes across the decades from Buck Rogers to Spider-Man to *Watchmen*'s Dr. Manhattan.)

Now, for instance, there is a whole subfield of comics about Anne Frank, including three separate works from Japan. In the United States, comics treating 9/11 have also come into view as a distinct subfield, from superheroes to the comics adaptation of the official 9/11 Commission Report to memoirs like Alissa Torres and Sungyoon Choi's *American Widow*. One of the most moving, to me, is cartoonist Gary Panter's series of real-time, rapid pen drawings of what he was seeing unfold from his Brooklyn rooftop on the morning of September 11, 2001. It is published, like *Maus*, at a one-to-one ratio. Known for introducing an expressively shaky line in comics, these drawings, he said, are the shakiest he's ever done. Unlike a photograph, the drawings encode the passage of time, the urgent race to capture what the eye, improbably, sees before the cityscape disintegrates. "I was actually crying and screaming and falling down while I was drawing those drawings," Panter said. "It is like, 'Okay you are going to die in a minute, what do you want to do?' I'm going to draw."

WHY SUPERHEROES?

While cartoonists Gary Panter and Art Spiegelman captured their experiences of 9/11 in highly personal comics, the mainstream comic-book companies Marvel and DC, which specialize in superheroes, also addressed the disaster. Both Marvel and DC were then headquartered in New York, and their writers and artists worked hard to respond and to quickly produce work that would engage 9/11 head on. Marvel's *The Amazing Spider-Man* #36, written by J. Michael Straczynski and illustrated by John Romita Jr., appeared a few months after 9/11 with the large white letters of the title and a plain black background—likely a nod to Spiegelman's black-on-black *New Yorker* cover. It became famous for having its titular hero admit a new kind of helplessness. And Superman, in a collection of 9/11 stories published by DC, speaks directly to readers: "The one thing I cannot do . . . is break free from the fictional pages where I live and breathe . . . become real during times of crisis." In the wake of the 9/11 attacks, what feels salient isn't that a genre of fiction featuring fantastical disaster-averting crime-fighters was under pressure, but rather that the public after 9/11 even looked to superhero

comics at all for any kind of official response, especially—or maybe because of—the fact that so many ordinary, real-life citizens during the attacks were designated heroes.

Since the invention of the comics superhero in America in 1938 and right up to the current moment, the appeal of superheroes has not only persisted through wars, global crises, and shifting social values, but it has flourished. Whether superpowered, like Spider-Man (Peter Parker), or "just" a regular human, like the superrich and superfit Batman (Bruce Wayne), the figure of the superhero has become a deep, integral feature of American culture. This is regardless of the percentage of the public who has actually read a comic or seen the outsize, blockbuster movies (several superhero films, including two *Avengers* films, are on the top ten list of the world's highest grossing films of all time; Patty Jenkins's 2017 *Wonder Woman* is the highest-grossing live-action movie ever from a solo female director). Superheroes are a typological category and a cultural truth. The permeation of American culture with the superhero is so profound that even the genre's seemingly esoteric lexicon has been publically adopted. It has become standard for people of all sorts to refer to "kryptonite," for instance, as a synonym for a potential weakness (one of countless examples ripped from the headlines: in 2016 Kobe Bryant told the *New York Times* a public embrace early in his basketball career "would have been kryptonite"). Kryptonite is, of course, material from Superman's home planet Krypton—the only real threat to his invulnerability, with the ability to debilitate him, leeching away his powers.

Perhaps the enduring appeal can be traced to the origin story of superheroes themselves, which itself feels like an archetypal superhero storyline. The world's inaugural superhero is Superman, also known as Clark Kent (birth name: Kal-El, likewise the name actor Nicolas Cage gave his son), and as a character he had modest beginnings. Superman was the brainchild of two shy, bespectacled, lower-middle-class Jewish teenagers from Ohio, Jerry Siegel and Joe Shuster, whose first incar-

nation of the character appeared in their own self-published magazine (or "zine") in the 1930s—before Superman began his iconic and field-creating reign as the world's first superhero and comic-book star. Siegel, the youngest of six children born in Cleveland to Jewish Lithuanian immigrants, met Shuster at age sixteen, when both were students at Glenville High School. Siegel, an active science fiction fan, worked at the student paper. Shuster, an artist, had come to Cleveland from Toronto with his own Jewish immigrant family at about age ten (his father, born Shusterowich, hailed from the Netherlands, and his mother from Ukraine). Shuster, as a child, drew on the walls of the cash-strapped family's home, and scrounged for paper that had been thrown out in the garbage of Toronto shops. He described finding unused wallpaper rolls, with their blank backs, as a "gold mine" (a description reminiscent of Keiji Nakazawa searching the street for paper for his own comics).

In 1932, Siegel's father, Mitchell (whose given surname was Segalovich), died when his secondhand-clothes store in Cleveland was robbed at night. While the family was told he died of a robbery-induced heart attack, bystanders heard shots, and the exact cause of his death remains a mystery. The following year, Siegel and Shuster collaborated on "The Reign of the Superman"—a prose story by Siegel illustrated by Shuster in their fan magazine *Science Fiction*. In this earliest version, which explored the idea of superhuman power, Superman was a villain (and bald!). In 1934, reportedly at night when he couldn't sleep, Siegel imagined the Superman hero as we know him today, and Shuster in turn drew him. It took the two a couple of years to sell their Superman work, but finally, in 1938, Superman appeared on the cover of *Action Comics* #1, published by Detective Comics, the company later known as DC. (Sadly, Siegel and Shuster sold all rights "forever" to their character to DC for $130; after he became a success, their legal battles over years with DC for money and credit yielded very little, although the actual $130 check itself sold at auction in 2012 for $160,000, none of which came to them, either.)

Superman's invulnerability—including to bullets—and the loss of his family and homeland resonate directly with Siegel's experience losing a father to crime. Some of the earliest sketches of the character include him intervening in robberies involving guns. The writer Brad Meltzer, whose novel *The Book of Lies* fictionalizes Mitchell Siegel's murder, points out that in fifty years of interviews, Siegel never once mentioned his father died during a robbery. "But think about it. Your father dies in a robbery, and you invent a bulletproof man who becomes the world's greatest hero."

Superman was immediately hugely popular, selling out the print run of *Action Comics*. Siegel and Shuster cast him as a "champion of the oppressed"—he has been called a junior New Dealer. In his first storyline, for instance, Superman saves a falsely accused prisoner from a lynch mob, produces evidence that frees an innocent woman from death row, and defends a woman about to be abused by her husband. In other stories, he does things like demolish an unsafe housing project and destroy a car factory that uses cheap, dangerous materials. Superman became the first comic-book character to merit his own title: *Superman* was launched in 1939. In the wake of his success superheroes proliferated: Batman, a more noirish figure, appeared in 1939, and the Flash in 1940, both from DC. In 1941, in March, Captain America appeared, punching Hitler on the famous cover; he was joined that same year by Wonder Woman (whose invention by the Harvard-educated psychologist William Moulton Marston, also the creator of the polygraph test, is the subject of Jill Lepore's 2014 book *The Secret History of Wonder Woman*). Superheroes joined the war effort in full force, fighting Nazis even before the United States entered the war, as we see with Captain America, and afterward influencing GI culture and boosting patriotism at home. In 1942 there were fifteen million comic books sold each month, and this number grew steadily for the next decade.

Despite the censorious Comics Magazine Association of America

Comics Code brought on by Senate hearings in 1954, which all but erased certain genres like horror comics, superhero comic books did arrive at a commercial Silver Age. In the Silver Age, which was responsive to postwar social conflict and change, superheroes were represented as essentially neurotic. The Fantastic Four, created by Stan Lee and Jack Kirby in 1961, offered the world a team of angsty superheroes, and Marvel continued the trend by introducing the Incredible Hulk, known for his anger, and Spider-Man, a worried teenager, in 1962; the X-Men and Iron Man in 1963; and Daredevil, a blind superhero, in 1964. While DC has the classic "Big Three"—Superman, Batman (now perhaps more profoundly associated with the amusing term *manpain* than any other superhero), and Wonder Woman—Marvel has a lockdown on a stable of characters whose anxieties about identity and inclusion continue to resonate deeply. And while sometimes DC can seem like the staid sister to Marvel, DC was responsible for *Watchmen* and *Batman: The Dark Knight Returns*. These two works marked a shift, in 1986, toward pessimistic, brooding—and in *Watchmen*'s case, near or fully psychopathic—superheroes, a shift that created an uptick of attention to the figure of the superhero in popular culture.

Watchmen takes place in an alternate, dystopian United States in 1985 during the height of the Cold War. In this version of history, the United States won the Vietnam War with help from the irradiated superhero Dr. Manhattan, along with a fleet of "Costumed Adventurers," some of whom wield their power with abandon, some of whom don't ("Who watches the watchmen?" a recurring phrase in the story, refers to Roman poet Juvenal's famous question). Nixon is still president. *Watchmen*, which is deeply violent, is about the nature of authority and morality—superheroes, in the present tense of the book, have been outlawed, but many do their (dirty? necessary?) work anyway. It is also a dense self-reflexive comic book about the creation of the superhero concept and comics, bringing a complex richness to the superhero enterprise.

Yet while the superhero genre continues to be popular, and to evolve, a significant feature of the very notion of comics for grown-ups is a rejection of the idealization of men in tights (and women in leotards). The prevalence of superheroes in the United States—indeed, their glutting of the mainstream industry—guides perceptions of comics in America as largely for a juvenile market. Historically, Europe, for instance, despite a rich comics tradition, can claim no indigenous superhero comics on a par with the popularity of American super-heroes. The critic Pascal Lefèvre, remarking in an online discussion list for comics scholars, reveals a common disdain for the oppressive ubiquity of the superhero: "In Europe, more precisely Belgium, we have a quite different comics culture. American superheroes were—thank God!—over here never big." (What was big: *The Adventures of Tintin*, by Belgian cartoonist Hergé, which began in 1929.) That other countries have not participated to the same degree in the United States' superhero obsession may be one reason comics is taken much more seriously by readers and critics in other parts of the world, like Japan and across Europe. (French philosopher Roland Barthes wrote of the potential of comics in 1970; at the Sorbonne in Paris, comics was introduced as an area of study at the Institut d'Art et d'Archéol-ogie in 1972, and university degrees in the study of comics are avail-able throughout Europe.) Another critic puts it well in stating of the superhero that its "very familiarity . . . makes it the medium's curse."

Cartoonist Daniel Clowes, the creator of *Ghost World* and one of the most celebrated proponents of the literary graphic novel, once told me, laughing, about carving out a space for nonsuperhero comics in the 1990s. "I just felt like the comics I was doing had nothing at all to do with the marketplace I was being thrown into," he explained, "and I'd find myself having to go to these comic-book conventions, and sitting next to some guy who was drawing, like, twentieth-rate super-hero comics, and he'd have a line out the door, and I'd have *nobody*. I thought I was doing stuff that would draw as big an audience as some

really specific weird superhero, and yet, no. I was wrong." The comics output of many of today's literary cartoonists, Clowes among them, was and continues to be positioned against superheroes. For some creators, superheroes remain vital. Comics writer Grant Morrison, for example, describes their enduring and widespread appeal movingly. "In a secular, scientific rational culture lacking in any convincing spiritual leadership," he writes, "superhero stories speak loudly and boldly to our greatest fears, deepest longings, and highest aspirations. They're not afraid to be hopeful, not embarrassed to be optimistic, and utterly fearless in the dark." For other creators, though, including Clowes, investigating failure and doubt is an alternative to such storylines.

But superheroes have not gone away in today's graphic novel world. Instead they remain as a force to counteract, often motivating its storylines about failure and antiheroic figures. The literary graphic novel's angle might be called anti-superheroic. We see this in the work of two of the cartoonists at the forefront of the rise of the auteurist graphic novel—in other words, comics as a high-literary form created by a single artist, unlike the commercial, team-driven production of superhero comics. Chris Ware, whose experimental graphic novels (and short-form *New Yorker* pieces) have forcefully staked out space for comics's literary complexity, and Clowes, whose vast accomplishments across the realms of comics, fine art, and film include the prestigious PEN Literary Award for Graphic Literature (awarded by the American branch of the world's leading literary and human rights organization), were obsessed with superheroes as kids, and take them on in their adult graphic novels, revealing how comics for grown-ups enlist the superhero figure—in order to reject it.

Superheroes are a major theme of Ware's first graphic novel, the breakthrough *Jimmy Corrigan: The Smartest Kid on Earth*, released by Pantheon, the publisher of *Maus*, in 2000 as a lavish, colorful hardcover. *Jimmy Corrigan* was received in ways that mark it as much,

much different than a superhero comic: original pages from *Jimmy Corrigan* were exhibited as part of the 2002 Whitney Biennial, the first time comics were included in the museum, and it won Britain's prestigious Guardian First Book Award—the only graphic novel ever to have done so—as well as an American Book Award. *Jimmy Corrigan* made even noncomics fans gasp at its intricacy, stunning graphic design, and emotional texture, ushering in widespread excitement about the future of the graphic novel in the twenty-first century—and it engages with the figure of Superman in unexpected ways. "There may never be another graphic novel as good as *Jimmy Corrigan*, even by Ware himself," wrote the *New Yorker* art critic Peter Schjeldahl.

Before *Jimmy Corrigan* became a phenomenon, Clowes's renowned *Ghost World*, which appeared from independent comics publisher Fantagraphics in 1997 and remains their best-selling title of all time, showed audiences how sensitive, funny, and true-to-life a graphic novel could be. It was made into a film starring a teenage Scarlett Johansson and Thora Birch in 2001 with Clowes's participation; he was nominated for an Oscar for Best Adapted Screenplay. Clowes went on to publish a series of successful, savvy, and wry graphic novels, including the satirical *Ice Haven* (2005), which unfolds the mystery of a small-town kidnapping, and the grim *Wilson* (2010), a portrait of a middle-age misanthropist that was adapted for film. In 2011 Clowes published *The Death-Ray*, a graphic novel that features a dark, teenage superhero. For years he had explained what his work was about by describing it "as opposed to the mainstream comics—'Mainstream comics are about superheroes, my work is about other stuff. You know, the opposite of superheroes!'" But with *The Death-Ray*, Clowes came clean about the fact that that wasn't really true. With his own take on a superhero comic, and with Ware's, we see how two exemplars of sophisticated comics for grown-ups—spokespeople, practically, for the phenomenon—actually engage the genre of superheroes in order to create comics that focus on anti-superheroes.

Chris Ware, at forty-nine, is the most celebrated cartoonist since Spiegelman and Robert Crumb, the artists who spearheaded the field of literary comics. Ware got his big break in Spiegelman and Françoise Mouly's *Raw* magazine (which ran from 1980 to 1991). In addition to serializing *Maus*, *Raw* launched Ware's career along with that of Charles Burns, Ben Katchor, Gary Panter, and many, many, others. Born in Omaha, Nebraska, and raised by his mother and, intermittently, a stepfather, Ware was discovered while he was still a student at the University of Texas at Austin when Spiegelman saw his comics on the reverse side of a tear sheet review of *Maus* in the college newspaper, *The Daily Texan*. Spiegelman was so impressed that he called Ware on the telephone, deeply freaking Ware out, and invited him to contribute to *Raw*, a publication Ware admired. Ware, who at first thought the call was a prank, said he wasn't ready. Eventually, Ware did contribute to *Raw*, with "Waking Up Blind," in 1990, which featured a potato-shaped protagonist trying to keep his eyes in his head (Ware dislikes this work so much now that he has requested that I not reprint it when I've asked). Ware's artistic breakthrough came with "Thrilling Adventure Stories (I Guess)," his second story in *Raw*, in 1991, the same year he began grad school at the School of the Art Institute of Chicago. (The shy Ware, a printmaking major, dropped out in 1993, because he could not bear, by his own account, to give a required oral presentation.) The six-page black-and-white story, published at this early stage in Ware's career, reveals his inclination to experiment with the basic form of comics, and his abiding interest in the figure of the superhero as a stand-in for an absent father, a theme evident in the creation of the ur-superhero himself, Superman.

"Thrilling Adventure Stories (I Guess)": The title says it all. The valiant, brave, honorable, protective male that is the figure for American manhood—superhero or father alike—isn't so great or thrilling, after all, in the adventure of one's childhood. Ware riffs on a superhero comic to tell a first-person story about a boy growing up with a

doubtful stepfather. It opens with a splash panel that displays a Superman figure, firm and tall, in a bodysuit, cape, and boots, preceding huge block letters that then spell out "I GUESS," so that the words themselves, as a visual figure, function as a literal second-guessing of the handsome erect superhero. (The splash panel, a convention of comic books, is a visually striking oversize frame at the beginning of a story that encapsulates its themes.)

The words and images deliberately don't match in "Thrilling Adventure Stories (I Guess)." Instead they offer two distinct stories, one ordinary and verbal, and one superheroic and visual, that work against each other to create a rich narrative whole about a child's hopes, desires, and realities. Ware demonstrates how comics, fundamentally, is not a medium of illustration in which the words and images synthesize, but rather something even more sophisticated. "Thrilling Adventure Stories," which Spiegelman once compared to a master's thesis on comics form, reveals potently how comics storytelling works.

The first-person prose begins conventionally, with "When I was really young . . ." and immediately sets up the problem of vision, misconception, and genre, as the narrator describes thinking that the world itself used to exist in black and white, like in the movies. It recounts the narrator's family—his mother, grandparents, and stepfather—along with his friends and his childhood love for comic books and superheroes, focusing on uncomfortable events that made him feel "weird" or "gross." This prose is roving: it weaves in and out of the comic-book frames, appearing in text boxes, in speech balloons, as sound effects, and on surfaces depicted within the world of the story, like chalkboards and newspapers. It appears continuously both

Chris Ware, page from "Thrilling Adventure Stories (I Guess)," originally in *Raw* #2.2, 1991, reprinted in color in *Quimby the Mouse* (Seattle: Fantagraphics), 2003.

Used by permission of Chris Ware. Image courtesy Chris Ware.

as narration and as dialogue, fluidly intermixing out of the mouths of different characters.

Meanwhile, the images present a completely different story, an action-based comic-book cliché plotline about a mad scientist kidnapping a pretty female reporter who is then saved by the superhero. In its placement of prose and also in the disjunct of its verbal and visual elements, "Thrilling Adventure Stories (I Guess)" suggests both as a theme and a practice of reading that nothing is as it seems: the reality of experience doesn't match the image; how people appear and what they say are shifting and unstable. Crucially, the figure of the superhero in the story is aligned with the figure of the father the boy desires: the hero who will be his role model and save his mother from her marriage to a dubious man. But the narrator also explains he and his friend dressed up like superheroes, even coloring their "Jockey shorts with fabric crayons to make those trunks or whatever those things are called that superheroes wear," pretending to be forceful men.

The last page of the story plays with aesthetic conventions of the action comic book to reveal an emotional truth about families. In the sequence of images, we see the superhero defeat the mad scientist (stepfather), whisking away the pretty reporter (mother) after the scientist detonates a bomb (which at the top of the page we can read, in the prose narration, to be the stepfather's racist attitudes). But in the story's last tier of frames—in a shift enacted by an enormous explosion with the block letters "WHEN" emerging as a sound effect—the child has himself become the superhero for his mother. In one of the graphically simplest sequences in the story, in which the words and images finally seem to collapse together, and the superhero carries the pretty reporter off into the sky, the narrator writes of the loss of his stepfather, "That was okay with me, since I liked things better when it was just my mom and me, anyway." The strip closes with the two alone, embracing.

Ware obsessed over, and drew, superheroes as a kid. As an inter-

view with radio host Ira Glass in a "Superpowers" segment of *This American Life* reveals, the details of the story are autobiographical: Ware confesses to Glass that as a shy, unpopular kid he desperately wanted a superpower. Ware, as in the story, did create his own superhero called the Hurricane. His mom, a reporter at the *Omaha World Herald*, did make him a mask for his own superhero costume. And he did in fact often dress in his costume—he even wore it to school under his uniform, with parts poking out. In "Thrilling Adventure Stories (I Guess)" Ware engages the visual conventions of a superhero comic in order to ironize the promise those fantasy stories hold out, setting the model man (hero) against the reality of the awkwardness of lived life.

But in *Jimmy Corrigan*, his first graphic novel, the superhero is no longer superheroic, even if the idea of triumph is ironically set against a more complicated reality. Instead, in the signal work that arguably singularly represents the flourishing of the graphic novel in the twenty-first century, the superhero is a figure for profound loss and disappointment. If the comic books glamorized and continue to glamorize the superhero, today's graphic novel engages them to reveal their antiheroic qualities. Ware wanted to be a superhero when he was little: "I just looked at pictures of the muscle-y men and tried to copy them figuring that I had better prepare myself," he explained in an interview. Hence the melancholy fantasy that prevails in "Thrilling Adventure Stories": the little boy who colored-in his underwear for a costume and needed his mom to make him a mask finally becomes the solitary superhero to whisk his mom away from danger in a romantic action, an oedipal collapsing of son and lover. Ware never met his real father growing up. His father left him and his mother when Ware was a baby.

As a child Ware was fixated on Superman, the original flying, leaping, bulletproof, red-and-blue-suited caped crusader. A superhero who was himself the creation of a teenager, Jerry Siegel, who had just

lost his father. In the character's actual genesis and in Ware's attachment to him, he stands in for a history edged with loss. Even in *Jimmy Corrigan*, creating comics for a serious literary audience, Ware remains fixated on Superman, as a way to meditate on fathers and filial inheritance. Superman's image in various guises haunts Ware's work from the 1990s and beyond. In "Thrilling Adventure Stories" and in *Jimmy Corrigan*, a graphic novel that features generations of fathers painfully abandoning their sons, Superman is a father figure. But he shifts from being an icon of longing and desire in the former—"a powerful World War II arrogant man, basically, who is just unstoppable," Ware has said of what Superman classically represented—to being pitiful and disappointing in the latter, a failure. So pitiful, in fact, Superman even commits suicide in *Jimmy Corrigan* by jumping off a downtown Chicago building after waving at the title character, who is a stand-in for Ware himself.

Ware's comics are widely known for being emotionally devastating, particularly in depicting social cruelties and the loneliness of children and marginalized adults. "The Chris Ware Sadness Scale" is even an entry, hilariously, in the popular infographics book *Super Graphic: A Visual Guide to the Comic Book Universe*, appearing there alongside charts for "Lifespans of Characters in *The Walking Dead*" and "Joker's Utility Belt." In "The Chris Ware Sadness Scale," a large double-spread, the explanation reads: "Chris Ware's work blends succinct, emotional storytelling with high-end illustration and graphic design. His work is beautiful, colorful . . . and really, really sad." The scale opens, at "SAD," with Ware's funny animal collection *Quimby the Mouse* (sadness level: "rodent angst"), and ends, topping the scales, at "SOUL-CRUSHING DEPRESSION" with *Jimmy Corrigan* ("Relationship angst, loneliness angst, Dead Superman angst, daddy-issue angst, angst angst"). As Ira Glass glosses the plotline of *Jimmy Corrigan*, "things go from sad to worse to worse."

Jimmy Corrigan, which takes place over generations in Chicago,

where Ware currently lives with his wife and daughter, is a straight-up graphic novel, with all of the deliberately fictional artifice implied by the term "novel." But it is based in part on Ware's actual life, in which he grew up without knowing his estranged father, and met him for the first and only time, like Jimmy Corrigan, in his thirties. *Jimmy Corrigan* was serialized from 1993 to 2000, appearing in weekly Chicago newspapers and in individual comic books of various sizes that Ware published under the title The Acme Novelty Library before it appeared, with fanfare, as a 380-page full-color book. (Its editor was Random House designer and Batman fanatic Chip Kidd.) *Jimmy Corrigan* tracks filial misery across four generations of Corrigan men, shuttling back and forth between the nineteenth century and the 1980s. Of the four generations, it focuses primarily on the experiences of two characters, both named James or "Jimmy" Corrigan, with their fathers. Grandfather and grandson, these two only meet each other very briefly toward the book's conclusion.

The older James Corrigan, as he first appears in the story, is an eight-year-old in Chicago in the early 1890s whose mother had died in childbirth. His cold, single father, a Civil War veteran and the son of Irish immigrants, has a low tolerance for him that steadily decreases. Ultimately, his father abandons him at the 1893 Chicago World's Fair atop the Manufactures and Liberal Arts Building—at that time the largest building ever constructed. In *Jimmy Corrigan*, Ware presents comics, with its boxes of time and memory, as its own kind of emotional architecture, in addition to rendering built spaces with stunning detail and precision. "I followed him like a loyal animal right up to the edge of the largest building in the world," tiny black cursive explains, floating in the sky above the father and son looking out from the top of the building before the father flees, never to return. The younger Jimmy Corrigan, the stand-in for Ware, is an isolated thirty-six-year-old who lives in Chicago around the 1980s and travels to Michigan to meet his father for the very

first time. He is a virgin, an office employee, and a guileless Super-man fan.

The full-color *Jimmy Corrigan* calls attention to the book as a material object and to the beauty of the printed page of comics. Its elaborate cover folds out into a poster, and its dense endpapers include "exam" questions such as: "When you read comic books about costumed heroes, you liked to imagine that you were a. a costumed hero b. a costumed hero's young sidekick c. the artist d. the writer e. not unhappy." Ware harnesses the unique properties of comics form to mimic processes of remembering, dreaming, and imagining on the page: we see, visualized, characters' reveries and fantasies. Different typefaces—from neat script within panels to stylized block letters framed as taglines in colorful blue and red boxes ("Later," "Anyway," "Suddenly") give readers access to characters' interiority and also a sense of the complete control of the storyteller as a visual artist orchestrating every detail. Every panel, drawn in clean, precise black lines that practically look mechanical, exists in meaningful relation to other panels on the page to create a story and also to create a graphic whole. Ware uses color as patterning to great effect, so that readers experience each page as a complete aesthetic unit—he has said that he wanted the colors to be beautiful, even as the story was horrible. Ware told me that he "wanted to make the book as beautiful as I possibly could to make it almost something of a counterargument to the story itself."

The book opens with a prologue that encapsulates its jaundiced engagement with the superhero—which is to say, the superhero as father figure. Jimmy Corrigan's mother takes her small, chubby son to a classic car show at a civic auditorium to meet the washed-up actor who played Superman on TV. At the sparsely attended performance, the excited Jimmy earnestly laughs at all of "Superman"'s corny jokes and enthusiastically stands in line for an autograph from the masked man, who greets him reassuringly: "Hello, son." Superman fancies

Jimmy's mother, takes the two to a diner, comes home with them, and spends the night. In the early morning, trying to sneak out undetected, Superman—in his regular clothes—runs into the child eating cereal alone at the kitchen table. Both are startled. He pulls out his red mask from his jacket pocket, and in an attempt to distract and mollify, hands it to the thrilled Jimmy. In the story's last panels, Jimmy's mother emerges from the bedroom, covering herself up, to encounter her son sitting at the table wearing the departed superhero's mask. *"Mom!"* Jimmy says. "He said to tell you he had a *real good time*!" As Ira Glass points out to Ware, when Superman shows up in Ware's comics he's always trying to con kids; he's always a disappointment. "He's more like a real dad that way," Ware responds.

The superhero theme develops as the book progresses, amplifying to deliver an even stronger refutation. Less than twenty pages into the story, after the adult Jimmy, at his downtown office building, has received a shocking letter from his long-lost father ("Dear Son, I think it's about time we fellas got to know each other; what do you say?"), the figure of Superman reemerges. At the bottom of a page that is broken up into many small moments in as many panels, Jimmy returns to his desk from the office snack room, sits in his depressing cubicle under the foam-core ceiling, and notices Superman, through the window, standing at the top of a tall historic building on the other side of the street, waving to him. Jimmy stands up, looks again, and then smiles for the first time since the prologue. Superman, whose primary-colors costume stands out strikingly from the dreary space of the office, continues to wave, a spot of hope and cheer in a grim and confusing day. In the last panel, Jimmy, still smiling, waves back.

When one turns the page, one is confronted with the most dramatic image of the book: Superman dies in Chicago. The page is evenly divided into two fixed-perspective panels of the building that sits at a busy street corner. The juxtaposition is striking. In the first panel, Superman—his costume still a bright speck of color contrast-

ing with a drab cityscape—prepares to jump, and, we assume, fly. In the second, a few moments later, he lies facedown in the street, dead. Passersby pause at the body. As Jimmy, in the next page, keeps looking out of his office window with horror at the body on the street, we notice the passersby linger over the body. When it starts to rain, however, they disperse. The body, now lit under a streetlight, lies alone in the street. Repetitively, Ware offers this image, the lifeless, supine body with the bright cape and red boots, looking small and helpless from above, pounded by rain. Eventually, through the window we see an ambulance arrive (for in Ware's framing the readers' gazes merge with Jimmy's), and in our next view of the street corner, it's empty. Later, after Jimmy takes his father up on the offer of a visit, and sits anxious and alone, waiting to be picked up after deplaning in the Michigan airport, with a broken foot and single crutch, holding an embarrassing beribboned basket of fruit, he sees the large newspaper headline: "'Super-Man' Leaps to Death; Mystery Man Without Identification Falls Six Stories in Colored Pantaloons; Mask." The sub-headline notes, "Definitely Not the Actor, Authorities Say." The book, then, leaves open the possibility that the "real" Superman, also a fraud like the actor, dies within its covers.

When Jimmy anxiously looks for the ever-absent father he finds the ever-disappointing superhero, one who died ignominiously, the opposite of invincible and heroic. *Jimmy Corrigan* doesn't dismiss the superhero genre, since Superman haunts the text throughout, even after this death. Rather, it takes on the superhero, the romanticized figure for American manhood, in order to reject the idealization that superheroes stand for across the board. This shift mirrors the shift away from comic books as action-oriented entertainment populated

Chris Ware, page from *Jimmy Corrigan: the Smartest Kid on Earth* (New York: Pantheon), 2000. Superman leaps . . . to his death.

Used by permission of Chris Ware. Image courtesy Chris Ware.

by heroes and toward graphic novels, longer works about the interiority and reality of all-too-human characters, which tend to reflect their creators' subjectivity more than they do cultural archetypes. If superhero comic series like *Watchmen* or *The Dark Knight Returns* give us dark, self-aware superheroes, they remain invested, on some level, in trafficking in the notion of good and bad superheroes in the first place. The literary graphic novel, on the other hand, offers up a slew of hapless protagonists—like the lonely fathers and sons of *Jimmy Corrigan*—who are nothing at all like any kind of superhero (in fitness, ability, or confidence) but have become the protagonists of the comics.

Instead of expressing an ideal—or even an ideal gone wrong, like in *Watchmen*—literary graphic novels tend to focus on the interiority of their characters, how these characters see and experience the world guided by their particular hopes, fears, and desires. The superheroic horizon is part of this desire. No one transforms into a glorious action idol in *Jimmy Corrigan*; rather, the book enacts the opposite: the harsh demystification of that ideal for someone who is constantly, desirously searching for male role models. When Jimmy gets hit by a truck while visiting his father, Ware ingeniously switches the perspective on the page so that readers look down on Jimmy lying in the road from the perspective of the worried driver, and then suddenly the perspective flips to show us Jimmy's own optical viewpoint. In a flash, Jimmy sees that the person above him is the Superman of the story, wearing the red mask, there to save him, until in the next panel he's quickly replaced by the driver. Instead of turning into Superman, or having his father do so, in *Jimmy Corrigan* Jimmy borrows his deadbeat dad's old Superman sweatshirt. Jimmy's father dies during their visit, like

Chris Ware, page from *Jimmy Corrigan: the Smartest Kid on Earth*. The first panel represents Jimmy's reverie.

Used by permission of Chris Ware. Image courtesy Chris Ware.

Superman, briefly emerging in Jimmy's life before disappearing again. The book's cover, underneath the dust jacket—like the reveal of a core under the surface—has a simple, small color drawing in its center of *Jimmy Corrigan*'s driving fantasy: Superman, slightly pudgy and aged ("more like a real dad," to quote Ware again) valiantly carrying the child Jimmy, who clings to his neck, through the air to safety. This image is repeated, alone in the space of the page but for dense swirls of snow, at the book's conclusion. The desire for the figure of the patriarch-superhero is there—but the unrecuperated loss, as one Ware critic suggests, is everywhere.

If Chris Ware's graphic novel represents the DC end of the super-hero spectrum—the square, manly, paternal heroes like Superman—his friend Daniel Clowes's *The Death-Ray* is very Marvel. It features a dark, teenage superhero, a type not unlike the young, neurotic superheroes such as Spider-Man that Marvel made popular in the 1960s. Clowes, who presciently announced to his parents as a child he wanted to be a cartoonist, read all the comics he could as a kid, including superheroes. "As a teenager I read the early Spider-Man comics, where he becomes a skinny, angry, disturbed superhero, and I thought, 'That's how it would be.' As a kid you look at Clark Kent who is still a big jock with glasses and think, 'I don't relate to him at all.' But the original Spider-Man was really 120 pounds and a total loser, and I was so inspired by that." Clowes grew up in Hyde Park, Chicago, and has described frequently getting beat up on the way to school—Chicago's famous Lab School, the alma mater of Sasha and Malia Obama.

Clowes's grandfather, with whom he was close, was a medieval historian at the University of Chicago. His mother, rebelling against the academic lifestyle, became an auto mechanic. Young Clowes had weekly dinners in Hyde Park with writer Norman Maclean, a family friend, and attended art school at Pratt in Brooklyn (his acerbic satire "Art School Confidential," from 1991, remains totally relevant and is

one of the funniest comic pieces of all time). Clowes's post–art school solo comic-book series *Eightball*, with stories like "I Hate You Deeply" and "Why I Hate Sports," was a major motor defining alternative culture in the 1980s and '90s. Clowes's savvy, controlled comics aesthetic became famous and recognizable across venues associated with smart, sharp alternative culture—he did album art for punk bands, an animated video for the Ramones, and created movie posters for bleakly funny films like Todd Solondz's indie hit *Happiness*. But it was in *Eightball*, Clowes's own comics title, which ran from 1989 to 2004, that Clowes achieved his best-known work. *Ghost World*, the touching investigation of teenage girl friendship, was first serialized in the pages of *Eightball*, as were numerous other works later collected as books like *David Boring, Ice Haven*, and *The Death-Ray* (which first appeared as a stand-alone issue of *Eightball* in 2004).

The Death-Ray dives directly into staples of superhero storytelling—the origin story and the vexed question of vigilantism—and also replicates superhero aesthetics in its page layouts. It pays homage to comic-book artists like Jack Kirby, who drew the Fantastic Four and Silver Surfer, and to Steve Ditko, the artist behind Spider-Man and Doctor Strange. Clowes explained his love of certain old superhero comics to me, calling the early Kirby Marvel comics "actually really beautiful and crazy and strange" with a "Pop Art intensity . . . [that] is still really appealing to me." We see this in layouts in *The Death-Ray*, like the double-spread bleed—the term for when the image runs off the page—of best friends Louie and Andy, in which Andy is dressed in a thrift-store costume as the titular Death-Ray. This page portrays large, stylized sweeping bodily movements (and violent contact) with graphic swaths of color, simple but dramatic movement lines

Daniel Clowes, double-spread from *The Death-Ray*, 2004, reprinted (Montreal: Drawn & Quarterly) 2011.

Used by permission of Daniel Clowes. Image courtesy Drawn & Quarterly.

and onomatopoeia ("BAF!"), and a slew of aesthetic effects including a smattering of small overlaid panels that each distinctly represent how the lines of a panel's borders, whether jagged, wavy, spiky, or round, convey action in comic books. The page, then, marks a kind of distance from the superhero story—in the self-conscious, overlaid panels, Louie and Andy are comically devoid of any action, instead debating silly details about how to find it—at the same time that it beautifully produces conventional superhero action-based aesthetics.

The Death-Ray is deeply enmeshed in superhero comics, then, from its structure to the composition of its pages. But *The Death-Ray*, as Clowes himself points out, enlists these features to tell a different kind of story than those that actually appear in superhero comics: it is the dark story of an antihero whose actions are not, in fact, redeemable or motivated by righteous revenge. No one is murdered in the world of *The Death-Ray* aside from those whom Andy himself obliterates, unlike in the world of Peter Parker, whose kindly foster parent Uncle Ben is murdered, paving the way for Peter to emerge as an avenging Spider-Man. The title itself, as the name for the book and the super-hero, underlines this unseemliness in openly naming *death*—many superheroes, like Superman and Batman, don't kill, as a rule. Clowes told me that he first got the idea for the character when he himself was a teenager, but his teenage version, with shades of Spider-Man, was much more idealistic. Returning to the character as an adult, Clowes gave him what he calls "a story I would actually want to read": one that takes stock of the idealism that attaches to superheroes in order to unambiguously deflate it. In other words, Clowes, while honoring the superhero aesthetic, creates comics specifically for grown-ups.

Andy is a quiet, picked-on sixteen-year-old white kid, an orphan (that classic superhero trope) raised by his grandfather, Pappy, whom he loves, and a black housekeeper, Dinah, whom he also loves, in 1970s Chicago. After smoking a cigarette proffered by his also-outcast friend Louie—a rite of passage in which the two try to look

cool and adult—he realizes cigarettes give him superhuman strength. This amusing move by Clowes pushes against the squeaky clean fitness ideal; cigarettes aren't only not bad here, they're well-nigh magical. During Andy's first night scouring the city, he imagines his gym teacher seeing him lifting parked cars. All he has to do is puff a cigarette and wait for the strength to kick in. Andy and Louie, in a sidekick role, viciously beat up high school bullies, to everyone's astonishment, but long for bigger fish to fry. Eventually, the origin story is revealed: Andy's late father, a scientist, through fancy lab work, deliberately created this reaction to cigarettes in his son, assuming from his own experience that he would need the help. He also left behind a ray gun, which only works for Andy, and which instantly vanishes, forever, any object, animate or inanimate, at which Andy shoots. In the comic book *Spider-Man*—which we know found a teenage fan in Clowes—one line in particular, attributed to the character Uncle Ben, has become widely famous, describing what is often a dilemma for superheroes across the board: "With great power comes great responsibility."

But while Spider-Man struggles to match great responsibility to his great powers, Andy falls short. Andy's superpowers do not lead to great responsibility, or barely any responsibility at all, although he fights to stay grounded. They make him a worse person, and they make the world a worse place. Andy dispenses power on a whim, and certainly disproportionately: he kills people for offending his specific moral sensibility, as we see when he is young, and also on into middle age. Eventually, he also kills Louie. Andy and Louie, stable middle-class kids, long for a superhero plot to befall them, like a revenge situation that would authorize their violent action (Andy even imagines Pappy's murder), but none does. The violent action of the Death-Ray, then, comes from Andy's inner violence. Clowes has even mentioned the backdrop of the Iraq War, noting it was "a hubristic show of force by this country, which seemed like it was not a vital player anymore

but kind of a dying cranky old man, and that's kind of where the older version of the Andy character came from. . . . He was sort of the perfect stand-in for America as it existed in 2004." Underlining this point, one of the book's last episodes is even titled "The United States of Andy." As with Ware, all of the idealism, and idealization, is gone. As in *Jimmy Corrigan*, *The Death-Ray* produces a world permeated by superhero symbolism and aesthetics that is yet full of unredeemed loss in which the very concept of the superhero is rejected.

From Superman onward, superhero comics, whatever else they may be doing, have offered an idealized, normative platform for readers to admire representative bodies. They have remained, then, a cultural stage for which the question of representation matters deeply: the representation of different kinds of bodies in superhero comics resonates as a register of mainstream acceptability. The world of superhero comics, as also with the world of auteurist graphic novels, is right now filled with energy and excitement, because it reflects inclusion and diversity on an unprecedented scale. Some of my favorite examples: *Ms. Marvel*, a funny, charming, and even moving series in which the title character, Kamala Khan, is a sixteen-year-old Pakistani-American girl from Jersey City, New Jersey, who gains superpowers like shapeshifting after sneaking out to a party. The first Muslim character to headline her own comic book, Khan—alias Ms. Marvel—who first appeared in 2014, is an unexpected commercial success: the comic book moves around a hundred thousand physical copies monthly, and is Marvel's #1 digital best seller. (The first Ms. Marvel character, dating from the late 1970s, is named Carol Danvers.) And in April 2016, Marvel released *Black Panther* #1, drawn by Brian Stelfreeze, colored by Laura Martin, and written by Ta-Nehisi Coates, the *Atlantic*

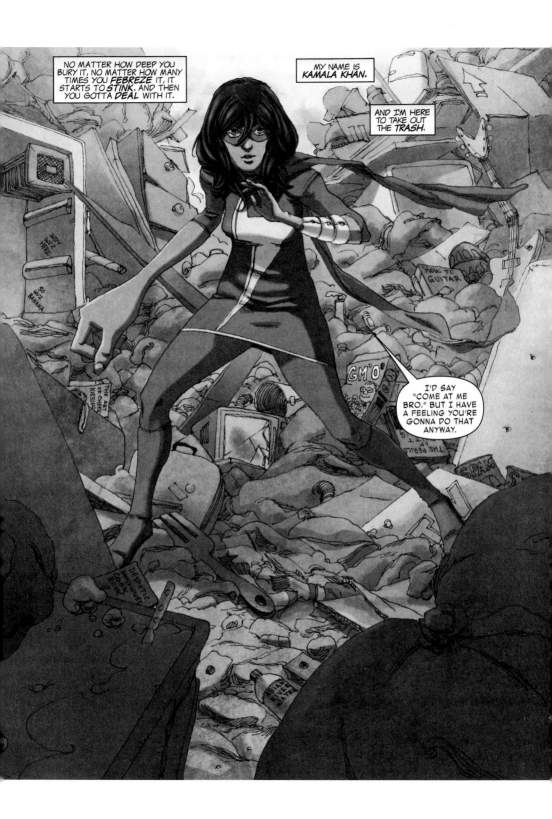

columnist and one of the most acclaimed public intellectuals of the past decade, winning a MacArthur "genius" grant, and a National Book Award for his 2015 meditation on race and America, *Between the World and Me*. *Black Panther* #1 sold out quickly and Coates has already signed on to write a second installment after the end of his first twelve-issue story arc. A Marvel Studios movie, rumored for years but first officially announced in 2014, is set to appear in 2018, hot on the heels of Coates's success.

That the in-demand Coates, a serious longtime comics fan, decided in the wake of the celebrated *Between the World and Me* to write a comic book is a marker of the growing prestige of comics—its interlacing, today, with other forms of culture like journalism and literary nonfiction. Coates has said, "My approach to comic books ultimately differs little from my approach to journalism." But more significantly, it's also a sign that the world of superheroes is still vital—and that it is becoming, appealingly, more responsive, open, and accurate in reflecting readers and their desire for inclusion and identification. Some readers have always recognized, even in the figure of the normative white male superhero, a resonant complexity around identity. As cartoonist Gene Luen Yang told the *New York Times*, "Superman is literally an alien and an immigrant. And a lot of the superhero genre is about negotiating between two identities, which really mirrored my own life. I used one name at home, another one at school, had one language at home, another one at school." On the other hand, as Yang points out, "The larger readership wants our stories to reflect what America is today." He is currently scripting *New Super-Man* for DC, whose titular hero is a working-class Chinese teenager.

Black Panther—whose comic-book appearance predates the Black Panther Party by a few months—is the first black, and first African, superhero in mainstream American comics. He was introduced in July 1966 in *Fantastic Four* #52, created by Stan Lee and Jack Kirby. Black Panther, whose given name is T'Challa, is the king of the fic-

tional African nation of Wakanda. (A spin-off series written with Roxane Gay and Yona Harvey, *Black Panther: World of Wakanda*, was announced in the summer of 2016.) In Coates's hands, *Black Panther* offers a meditative world (can a superhero be a king, and does a technologically advanced, democratic society want either one?) and one that is, significantly, populated entirely by black characters, many of whom—and this is not a given in mainstream comics—are female (and complex!). Coates told the *New York Times*, "The book is probably much more concerned with gender than it is with race." *World of Wakanda*, whose first issue hit the stands in November 2016, delivers the story of two queer characters, members of Black Panther's all-female security team, who fall in love (from the Marvel website: "What happens when your nation needs your hearts and minds, but you already gave them to each other?"). There has been a slow but steady increase of gay superheroes in mainstream comics in the past decades, and now trans characters are also part of the landscape: both DC and Marvel have featured trans characters in secondary roles, and now Chalice, a trans superhero from publisher AfterShock, is taking center stage in the title *Alters*. The world of the superhero comic, always about what kinds of bodies matter, is changing with the times— it's a mainstream barometer that is proving to be more expansive than it may have seemed even a few decades ago.

We see this on a formal level, too. Chris Ware steals motifs from superhero comics to reject them . . . and in our current cultural moment, characterized by hybridity, mixing, and dynamism, the superhero comics are now in turn themselves influenced by Ware, as we see in Marvel's recent *Hawkeye* run, written by Matt Fraction with art by David Aja. Named for the master marksman superhero created in 1964, *Hawkeye* steals openly from Ware. Take *Hawkeye: Little Hits*, a trade paperback released in 2013 that collects six issues of the comic. The entire volume—how the stories relate to one another through distinct perspectives in piecemeal fashion—conspicuously resonates

with Ware's oeuvre, as do individual issues, such as the opener, "Six Days in the Life of," which focuses on the quotidian passing of moments and the slicing of time into panels in gridded pages directly similar to Ware's 2012 graphic novel *Building Stories*. Strangely for a superhero comic, it is so invested in the quotidian, as Ware distinctively is, that it even allows multiple fight scenes, usually the bread and butter of superhero comics, to happen in the gutter.

The volume's last story, "Pizza Is My Business," however, is the one that most obviously cites Ware's aesthetic, evident in its complex, nonlinear page compositions, for instance, in its assortment of small round and square panels, associatively linked, that float over an image on the page. If Ware uses the hybridity of comics to express the perspective of an infant in his *Jordan Wellington Lint* (2010), and the life of a bee in *Building Stories*, *Hawkeye* in turn experiments with Ware's formal grammar to create an innovative superhero comic that is also about individual cognition and perception: "Pizza Is My Business" expresses the point of view of Hawkeye's dog, who knows himself as Pizza Dog.

The story offers readers only words a dog would recognize, like "don't" and "stay." And it offers a world in the colors the dog sees (he and his friends are color-blind). It presents the interiority, if you will, of Pizza Dog. "There's an element of deciphering a code as you start to realize what the symbols mean and where they lead and how they interact with the story taking place behind and around them; and then at some point you realize that, without noticing, you've started to think like Pizza Dog," a *Comics Alliance* reviewer wrote, proclaiming it could be "the best single issue of comics you've read." The superhero comics are now responding to the comics that responded to them

"Pizza Is My Business," written by Matt Fraction with art by David Aja and color by Matt Hollingsworth, from *Hawkeye: Little Hits* (New York: Marvel), 2013.

to tell and show their more action-oriented plotlines. In this porous example of exchange, dogs, in a sense, can be the new superheroes—and they can have all the interiority of the protagonists of graphic novels. We see that graphic novels not only share attention with superhero comics to the powerful bodies found on their pages, but they also share with them the force of powerful storytelling in words and images.

WHY SEX?

I
f comics is known for representing real-life world-historical dis-
aster, and for superheroes (who in alternate realities avert those
kinds of disasters) it is also known for representing sex. When
Chris Ware first discovered the comics magazine that would launch
his career, it was in the back room of his hometown Omaha, Ne-
braska, comic-book shop, and he thought—or rather, hoped—it was
pornography. One day the store owner, Ware recalls, "started letting
me back there, and eventually I came across a big magazine sticking
up out of the bins that I'd never heard of before called *Raw*. Thrilled,
I thought, 'Wow! That must be really filthy!' So I pulled it out and
thumbed through it but of course I was disappointed because, well, it
wasn't all that filthy."

It's not surprising Ware thought a comic called *Raw* in the back
room of a comic shop was pornography. There are, and have always
been, plenty of comics about sex and sexuality. Comics have long
been connected to the sexually taboo—and still are. As I noted in
the introduction, Alison Bechdel's comics memoir *Fun Home*, about
a gay girl growing up with a closeted gay father, made headlines in

2015 when some students at Duke refused to read the book because of its graphic content. One student, Brian Grasso, wrote in the *Washington Post* that he was opposed to the "cartoon drawings of a woman masturbating and multiple women engaging in oral sex." He noted something true: "There is an important distinction between images and written words." People react much, much differently to an image, drawn or photographed or filmed, than they do to prose. Images produce affect very quickly—they feel immediate. The ability of comics to *picture* has long produced its sense of the illicit and forbidden. It's no coincidence that "graphic novel" can be a confusing term: Daniel Clowes has pointed out that it sounds as though it refers to books like *The Story of O* and *Lady Chatterley's Lover* (*The Story of O* was actually adapted into comics). "Graphic" in many contexts simply means sex. I laughed out loud when a book publisher years ago suggested I title one of my books *Graphic Encounters*—which sounds like soft-core porn.

We see the connection between comics and the sexually taboo during the 1930s and '40s, the time of so-called Tijuana Bibles, popular and anonymously produced under-the-counter pornographic comics pamphlets, which were often parodies featuring celebrities and established comic strip characters—think along the lines of Olive Oyl fellating Popeye. One of the few identified artists, Wesley Morse, went on to create the ultravanilla *Bazooka Joe* bubble-gum strips for Topps. And *Superman*'s Joe Shuster, who created the look of the most square, do-gooder superhero in existence, created erotic artwork in the early 1950s—unsigned fetish art in magazines that were also sold under the counter. From superheroes to bondage mavens, comics has always delivered an intense focus on the bodies within its frames.

We also see this connection in publications such as *Playboy*, which launched in 1953 and has published gag cartoons and sequential strips by some of the century's top cartoonists, including Jack Cole,

who had created the beloved superhero Plastic Man; Harvey Kurtzman, the comics genius who started *Mad* magazine; Jules Feiffer, arguably America's first literary cartoonist; and Art Spiegelman, among many others. *Little Annie Fanny*, the sexy ongoing comics story by Kurtzman, who collaborated on it with *Mad*'s Will Elder, ran for over twenty-six years. We also see this during the flourishing of mainstream comic books in the 1950s that were thought to fulfill sweaty adolescent lust; psychiatrist Dr. Fredric Wertham accused cartoonists of embedding secret sexual images, like vaginas, in comic books. And we also see this in the defiantly sexually explicit underground comics of the 1960s and '70s, which largely bypassed most obscenity laws by virtue of being drawn rather than photographed or filmed (although they fell afoul of some laws too).

Cartoonist Robert Crumb's unfiltered depictions of explicit sex inspired an entire movement of underground cartoonists to shred taboos—both verbally *and* visually, with paper and ink—as one of the central missions of the aesthetic and publishing revolution known as underground comics, or "comix." (The *x*, as mentioned, denotes edgy adult content.) Crumb is also highly controversial for the preponderance of graphic sex in his comics, and for his openness in talking about the sexual proclivities and fantasies that he pictures on his no-holds-barred pages. Veteran cartoonist Lynda Barry remembers the "sex stuff . . . scared the hell out of me" when she first saw Crumb's work as a kid, but she copied the entire contents of Crumb's *Zap* #0 anyway, mesmerized by the detail of the comics. Her friend the writer Dan Chaon, now a professor at Oberlin College, actually buried *Zap* in his backyard because it freaked him out so much.

Tijuana Bible, creator unknown, likely 1930s, starring Olive Oyl, Wimpy, and Popeye. Note that the last panel depicts "three-way" sexual activity in which Wimpy and Popeye engage in intercourse. Image courtesy *Tijuana Bibles*, ed. Bob Adelman (New York: Simon & Schuster, 1997).

"What R. Crumb gave me," Barry says, "was this feeling that you could draw *anything*."

The 1994 documentary *Crumb*, directed by Terry Zwigoff and produced by famed movie director David Lynch (*Blue Velvet*), finds Crumb candidly confessing to harboring a sexual attraction to "cute cartoon characters" as a child. The Taschen editor Dian Hanson, an ex-girlfriend, notes in the film that he told her he even masturbates to his own comics, an amazing example of how powerful drawing can be as a world-building enterprise for a cartoonist. To me the incredible part of what the film reveals about comics and sexuality isn't that a man was attracted to humorous male animal cartoon characters as a child, but rather that he masturbates to something he drew for himself. He seems to have always taken his drawing seriously enough to be able to construct a viably erotic paper-and-ink fantasy with his own lines on paper. Since the 1960s, Crumb has been an icon of the American counterculture, in addition to his current status as one of today's foremost artists—he is perhaps, along with Spiegelman, the most famous cartoonist in the world, and certainly the most notorious. Through *Crumb*, which was unexpectedly popular, and through his reputation from the underground scene, Crumb is also known specifically as an artist fixated on the female form, particularly the backside, legs, and feet of sturdy women. He breaks down his particular sex obsessions most clearly in the autobiographical comics stories "Footsy" and "My Troubles with Women," in which he reveals his childhood fascination with strong women like the title character of the television show *Sheena: Queen of the Jungle*. When I was in Miami a few years ago participating in a book festival with his wife, the cartoonist Aline Kominsky-Crumb, whose own pioneering work created a space for picturing women's sexuality, she surreptitiously snapped photos of the large behinds of strangers to send to her husband.

Almost as famous as his fascination with large backsides is Crumb's style, known for its meticulous yet fluid crosshatched lines inspired in

part by nineteenth-century engraving techniques. (Cross-hatching is the practice of shading an area with an intersecting set of parallel lines.) Crumb is one of the most virtuosic, if not *the* most virtuosic, draftspersons in comics. He is acknowledged across the board, and worldwide, as a master of drawing. Part of his renown as a cartoonist resides in his content—what Lynda Barry identifies as his game-changing demonstration by example that "you could draw *anything*" in comics, however dark, unpleasant, goofy, or private. But a large part of his appeal is how this content appears, which blends comfort and discomfort together on the page.

Recalling the reaction in the late 1960s to the appearance of his comics, Aline Kominsky-Crumb describes a paradoxical mixture. "Robert's work was really interesting because he had an aspect of the old comics from the twenties that we all loved," she explained to me. "It was very reassuring, but also charged with this total psychedelic vision. It touched something so deep. . . . And it definitely set off a whole other set of possibilities for a lot of people. It was definitely a supercharged moment there. Robert's work and everything that came after it changed graphic art forever. . . . But it really changed the way everything *looked*, you know, instantly." The "bigfoot" style of cartooning Crumb adopted, characterized by the rubbery exaggeration of certain human features like noses and feet, hearkened back to old cartoons from the 1920s, '30s, and '40s, but reintroduced this stylized posture and springy line for radically adult content set against a teeming modern landscape, which often appears quite impersonal. Crumb's "Keep on Truckin'" image and slogan, a riff on the Southern blues song called "Truckin' My Blues Away," features people seemingly led by their feet marching through comics frames, and became an emblem of the 1960s counterculture and beyond. In *Understanding Comics*, Scott McCloud provides an apt description of his style: "In R. Crumb's world, the curves of innocence are betrayed by the neurotic quill-lines of modern adulthood, and left painfully out of

place." When Crumb's attentive pen lines fall to sexual subjects, particularly, the result evokes strong reactions.

Crumb was born in Philadelphia, and raised Catholic as one of five siblings by his housewife mother, Beatrice, and a military father whom his brother Charles, in the film, straightforwardly describes as a "sadistic bully." His parents fought often. Both of his brothers appear in the *Crumb* documentary; both of his sisters declined to. Crumb was a so-called "base baby" because his father moved his family around to tract houses on different military bases often during his twenty-year service in the US Marine Corps. (Charles Crumb Sr. was a soldier in World War II and was sent into Hiroshima ten days after American forces dropped the atomic bomb on the city—an experience about which he never spoke.) Crumb's father was a stern authoritarian with a temper who intimidated his children, including by striking them. He broke Robert's collarbone when he was five. Like a cruel dad out of central casting, he was even the author of a book called *Training People Effectively*.

Charles Crumb considered his sons, who drew comics together, "sissies." Crumb recalled in an interview with the late *Time* magazine art critic Robert Hughes that his father always told his sons they'd grow out of drawing and get into football in their teens. "He was just totally bewildered by us," Crumb explained. "He saw us as Martians. We'd be lying on our beds in the fetal position, reading comics. . . . 'Get off your duffs!' We broke his heart. He had three sons and they all turned out to be complete defective weirdos." The cartoonist brothers were led in their comics efforts by the eldest brother, Charles Jr., who critiqued their work and pushed them to produce three issues of their own comic, *Foo*, which they distributed to the comics fanzine community and sold door-to-door with little luck. Crumb routinely confirms that his brother, as he once put it, was "actually a much stronger artistic visionary than I was" and has often explained how he was an inspiration. In a Crumb drawing that lists his influences,

divided by "Cartoonists/Illustrators" on the left side of a page, and "Fine Art!" on the right, Charles Crumb Jr. is the very first entry in the former. The film *Crumb* shows Charles to be evidently brilliant, with a literary sensibility, wryly funny—and an artistic mastermind who pushed his little brother into greatness. Charles lived with his mother his entire life, struggled with mental illness, and committed suicide in 1992 at age fifty. Filming for *Crumb* had recently wrapped.

Crumb grew up on a steady diet of popular culture as a child in the '40s and '50s, watching television and reading comic books. At fifteen, he became profoundly interested in blues and jazz records from the 1920s through the 1940s, and went door-to-door offering to buy old 78-rpm records in black neighborhoods. Crumb's passion for twentieth-century American culture that generally preceded his birth—from blues to comics—is reflected in his style, which openly refers to popular visual modes from the interwar period, and in his detailed, reverent portraits of blues and jazz musicians (as in his book *R. Crumb's Heroes of Blues, Jazz, & Country*). After high school, Crumb left home to find work. His first job was for the American Greetings card company in Cleveland, drawing novelty cards for their Hi-Brows line. He managed to draw images that are cuter (and therefore more commercial) than his comics and yet are still edged with something that feels like it's longing to break the surface. In 1964, Crumb married Dana Morgan, a young Jewish woman from Cleveland who had just graduated high school. "My dad always said I'd marry the first one who came along," Crumb reports in "My Troubles with Women." He was twenty-one, and felt trapped quickly. Crumb escaped Cleveland, and his rocky marriage, and finally ran away to San Francisco in 1967. Dana eventually followed him; their son Jesse was born in 1968.

It was in San Francisco that Crumb would publish the comics that inaugurated and defined the era of underground comix. Crumb took LSD and fell in with the hippie scene in San Francisco, be-

coming friends with figures like Janis Joplin. He even created the cover for the 1968 album *Cheap Thrills* by her band Big Brother and the Holding Company. In a "fuzzy period for a few months" Crumb had "visionary" experiences on acid dreaming up some of his most famous characters—and recording them in his sketchbook—such as Mr. Natural, Angelfood McSpade, Flakey Foont, Shuman the Human, and the Snoid. His LSD visions, he says, were the "psychotic manifestation of some grimy part of America's collective unconscious." Crumb channeled a deep-seated disgust and malaise provoked by contemporary America that manifested on the sketchbook page as seething psychedelic landscapes both amusing and horrifying. In his own words, he was "making a drawing of the horror of America," as though irrigating something dark and spooky from below the surface.

These drawings and characters became the basis for Crumb's stand-alone, fully designed comic book *Zap*. Cartoonists all over the world talk about where they were when they saw *Zap* for the first time. Frank Stack, who published the underground comic *The Adventures of Jesus*, describes the effect of first seeing *Zap* "as like a rush of adrenaline—a deep psychic, almost erotic thrill." Crumb had previously published short comics pieces in the underground press, but he galvanized underground publishing and kick-started the phenomenon of underground comics with the first issue of *Zap* in 1968. Underground comics, through Crumb, enacted a massive cultural shift away from the idea that comics had to be for kids. And it was a massive shift in part because of just how explicitly "adult" Crumb's material was in the late 1960s and early '70s—and with the overt framework of the *intellectual* to boot. Cartoonist Phoebe Gloeckner, known for her own sexually explicit semiautobiographical comics, revealed to me that she literally learned what happens physically when men and women have sex from reading Crumb's comic "Joe Blow." Reactions to Crumb's provocative comics were diverse but always ex-

treme. Charles Crumb Sr. saw one of Robert's underground comics and never spoke to him again (he died in 1982).

Crumb drew and designed the first two legendary, field-defining issues of *Zap*, #1 and #0, entirely by himself (starting with the third issue, he made *Zap* a collective endeavor, bringing in other artists including S. Clay Wilson, whose densely packed comics are famous for disturbing violence and graphic sex). The earliest, all-Crumb issues both call attention to their comic-book format with stories and drawings *about* comics, and work heavily in the mode of satire—even trafficking in recognizable, outmoded racial stereotypes and putting the sexualized body on the page. In *Zap* #1 the stories carry a sense of sex always about to burst the surface of propriety and decorum: the first long story, "Whiteman," and the later "Mr. Natural Visits the City" both feature conventional, white, fifties-style buttoned-up men who long for sex and see it as a problem to control. *Zap* itself represents a mode of letting go. There's something openly carnal and scatological about these two issues, both of which routinely reveal naked bodies, bodily fluids and waste, and detailed drawings of male and female genitals. In the very first *Zap*, in the story "Abstract Expressionist Ultra Super Modernistic Comics," an up-close drawing of a vagina, replete with a thatch of thick, dark, wiry public hair, emits a single musical note in a speech balloon.

Hand-drawn comics—positioned against the repression of mid-century America—became with Crumb a medium for overturning censorship. In his comics, anything could be pictured and nothing needed to be held back. Comics is still often associated with "dirty pictures," because as an art form composed of words and images—as well as one enduringly connected to the lowbrow—it has the power to exhibit the hidden or the improper, like a kid in class drawing his teacher without clothes. A visual technology that can make the unseen concrete and easily conjures the improper, there is something *illicit* about drawing. Crumb calls attention to this on the back cover of

Zap #0, in which he draws an angry mother tearing up a comic book in front of her dismayed son: "Did you ever receive warnings about how comic books were going to RUIN your MIND? Were you given lectures about how comics were CHEAP TRASH put out by evil men? Do you feel a spark of GUILT every time you pick up a comic book?" The ability of comic books to picture the unsavory is why they became forbidden in the first place—by concerned parents, Dr. Fredric Wertham, and the Comics Code Authority, a severe, publisher-mandated content code formed in order to circumvent government regulation. Crumb reinvented comic books in the underground as a new, vital, confrontational contemporary register of the forbidden for adults, willfully diving into taboos.

The pen can reveal what is kept out of sight, or can give tangible form to rampant imagination. In this, of course, comics differs from visual media like photography, in which one "takes" pictures from life, as opposed to making them from whole cloth on a blank piece of paper. In comics, one can draw what one wouldn't be able to record through a lens, but can imagine in the so-called lizard brain we all share: the oldest part of our brain that's not "correct," not socialized, not regulated. Also sometimes called the "crocodile brain," it's the primal, reptilian part of our brain that is responsible for instincts. Comics in Crumb's hands became a practice, and a space, where the pen could concretize the cartoonist's wildest fantasies and the most forbidden thoughts and images. Crucially, this meant not only bucking convention, and focusing on breaking taboos, but also making comics a practice in which even one's own private taboos could be broken. Crumb describes the terms of underground comix as "total liberation from censorship, including the inner censor!" And with Crumb, not holding back results in openly sexual, explicit material. Crumb became famous for his graphic, and in some cases violent, depictions of sex.

In the third issue of *Zap* (*Zap* #2—the chronology is #1 followed

by #0 followed by #2), Crumb pushes hard on taboos along race and gender lines with his story "Angelfood McSpade: She's Sock-a-Delic," titled after his recurring black female character of the same name. Angelfood is here named "'ZAP COMIX' DREAM GIRL OF THE MONTH" in an opening splash panel in which her large breasts point at the viewer below a face drawn like a Sambo cartoon from the early 1900s with large white lips. Crumb mocks how *others* portray black women—hence the recognizably racist caricature that refers to preexisting cartoon stereotypes. Angelfood is marked as a literal cartoon performer in the psychic imaginary of the scrawny, bespectacled white male character who searches her out in the story ("she has been confined to the wilds of darkest Africa. The official excuse being that civilization would be threatened if she were allowed to do whatever she pleased!"). This nameless narrator provides the skewed lens through which we as readers encounter the visual imagery—in the story, we're seeing what he imagines, even if he's not physically there observing it. Of course, in his fantasy, which is clearly ridiculous, Angelfood enjoys being fondled by examiners while in captivity, and accepts his company and attention. He is the ridiculed character of this strip, standing in for legions of clueless white men searching out their idea of black female sexuality. The final panel shows another man in glasses leaving "Schmarvard School of Law" with a suitcase that says "Darkest Africa or Bust!" It is telling that on the last two pages of the story Angelfood McSpade wears the conventional white gloves of the cartoon performer (think of Mickey Mouse and countless other Disney characters). She understands she is entertainment for the white male gaze of the adventurer characters, and readers. She's in on the joke, so to speak: we're not actually seeing her "natural" impulses, bodily or otherwise, but rather her ability to perform for the expectations of her debased audience.

Crumb isn't mocking black women, but rather he's mocking a public discourse that either implicitly or explicitly itself mocks black

women. And yet Crumb always makes tricky or unclear the line between the act of satirizing something and embodying it. In satirizing something, is one giving it the kind of time and space and attention that tips over into something else? Angelfood is virtually naked throughout the story and shown several times having intercourse with men; she is drawn as an openly sexual character who beckons with her skillful tongue, flexes her thighs, shakes her ass, proffers her breasts. In the story, her vagina has a strong smell. She pants. Her behind shines brightly—lovingly cross-hatched and stippled by Crumb. Even as he mocks the fantasies of skinny white men, Crumb, a skinny white man, participates in the creation of a sexually powerful, if ridiculous, character and a set of images that are explicit and unsettling.

Crumb went on in the late 1960s to publish countless other sex comics in underground publications with titles he created, such as *Snatch Comics*, *Big Ass Comics*, and *Jiz Comics*, among many others. (Even if Crumb had wanted them to, no "above-ground" commercial printer would have printed this kind of work, even though by that point he was a celebrity.) His comics often portray sexual acts like intercourse and fellatio in graphic detail, in addition to depicting certain sexual behaviors Crumb has talked of favoring: riding women's backs and behinds, pounding their behinds, squeezing their faces, mauling them as part of sex. *Big Ass* #1, from 1969, features stories such as "Like to Ride? Then Climb Aboard the Big Ass," "Anal Antics," and "All Meat Comics," which features meticulously drawn fleshy and scatological actions in precisely detailed, up-close images with large stylized sound effects: "squirt" for a penis inside a vagina; "Bzzzzt" for a finger pressing on a clitoris; "slorch" for penetration, pictured from behind, of a woman's vagina while she sits on top of a man's penis. There's ejaculation, biting, shitting, face squeezing, and lots more.

Yet the Angelfood McSpade comics, and those featuring incest—"The Family That Lays Together Stays Together!" and "Joe Blow"—

The family that LAYS together STAYS together!

GOO

R. Crumb, "The Family That Lays Together Stays Together!" *Snatch Comics #2*, 1969.

© R. Crumb. Used by permission.

along with the violent "A Bitchin' Bod"—which stars a woman with her head capped as unwilling sex object, are among Crumb's most controversial stories and images and get at the heart of his work, which combines social satire with giving the id free rein. Crumb published "The Family That Lays Together Stays Together!" in 1969 as a one-page set piece in which everyone in an extended family is having sex. "The Family That Lays Together Stays Together!" is like Will Elder's famous *Mad* satire "Visiting the Grandparents," but with a much, much harder edge: while in the earlier story a family drinks beer, and even bottle feeds beer to a baby in parody of a Norman Rockwell image of familial perfection, in Crumb's story he draws the whole family, including the grandparents, having intercourse with each other. The dog is even having sex with the toddler next to, naturally, the lit television screen. The son, while having sex with his sister,

reads "Kunt Comix" and "Dick the Prick." Even the big-eyed waif children in the living room painting above the couch are having sex.

Incest was definitely a taboo to break in underground comics—Spiegelman did it in 1971 with his Viper story "Pop Goes the Poppa!" And in a sea of explicit comics, Crumb's "Joe Blow," from 1969's *Zap* #4, stands out. *Zap* #4 was even the source of an obscenity trial in New York, in which it was declared "legally obscene." All of the comics about sex published in the underground were unprecedented in terms of the explicit acts pictured and the adult frameworks the cartoonists gave their stories about sex and drugs (drug-taking was another big theme of underground comics). Comics reinvented themselves in the underground as for grown-ups in their formal ambition, presenting an avant-gardism, and in their related ambition to provoke thought, to satirize and critique through the combination of words and images. To this effect, they became a cornerstone of the counterculture in the 1960s and '70s. But they also self-consciously doubled down on the "adult" theme as it pertains to explicit sex. The attention to drawing the wildness and messiness of bodies and desires was a new idiom, one that could be outrageous and disgusting. But even in that context, "Joe Blow" was shocking when it was published in the sixties, and it is still shocking today. (One of my students correctly, I think, pointed out to me that none of this work could be published now without outcry. In 2011 Crumb canceled an invited appearance at the prestigious Sydney Opera House after media in Australia branded his comics depraved and perverted.)

"Joe Blow" is a six-page story featuring incest. And while it is clearly a satire, a comment on the dark underbelly of seemingly shiny and perfect 1950s suburban nuclear families, its plot, which features sex between parents and their children, is drawn so explicitly that

R. Crumb, page from "Joe Blow," *Zap* #4, 1969.

the story is striking. When the story begins, model wife Lois enters her immaculate living room to find her husband, Joe, pretending to watch a blank television, because he "can think up better shows than the ones on TV." When he goes to check in on daughter Sis, he finds her masturbating, pops a pill called "Compoz," heads back into her room, unzips his fly and takes out his penis, and demands a blow job in a close-up frame that shows one hand holding his erect penis (which confrontationally looks like it is being proffered to readers), and the index finger of his other hand pointing at it. "That's it! Pretend it's *candy*," he says to his eager daughter in the next frame, while she exclaims "Yummy nums!" Joe Jr. finds them having sex, runs away in confusion, and winds up having a sexual encounter with his mother. On the last page, Joe Blow proclaims, "I never realized how much fun you could have with your children!" Crumb draws a story that could only take shape in comics, delivering both prurient, almost forensic images and deliberately flat comic-book conventions in order to create an uneasy mix that is a satire of American consciousness.

Crumb met his match in 1972 with a woman who also had no inner censor, Aline Kominsky (later Aline Kominsky-Crumb). Born to a Jewish family she called "postwar jerks," and hailing from Woodmere, part of the Five Towns of Long Island, Kominsky-Crumb (née Goldsmith) loathed her family's materialistic values and their callous treatment of her and one another. In an episode that recurs in her comics, her father once noticed his daughter putting on makeup and said, "Ya can't shine shit!" Always inclined toward art, as a child she found she was able to paint replicas of famous works of art, which her family would literally throw money at her to do. As a teenager, she often ran off to New York City, including to the Museum of Modern Art (MoMA), where she thought while staring at Cubist art, "If I figure this out I can escape from Long Island." Kominsky-Crumb got pregnant at eighteen, ran away to the Lower East Side at the height of the hippie era, and by her own account "had wild sex and took lots of

drugs right up until the minute I was ready to give birth." She gave birth to a healthy baby boy she placed with a Jewish adoption agency.

Eventually Kominsky-Crumb got married and graduated with a degree in fine art from the University of Arizona in 1971. But she was disenchanted with the "macho" brand of abstract expressionism that was then dominant. And her own young marriage, which began when she was nineteen, was flailing. In Tucson, her friend Ken Weaver, of the legendary 1960s band the Fugs, introduced her to underground comics, and to underground cartoonists like Spain Rodriguez and Kim Deitch. Comics gave her an entirely new outlook and sense of possibility. Kominsky-Crumb writes in her memoir *Need More Love* that she was "turned on by this new, daring, outrageous art form. I read the works of R. Crumb and Justin Green for the first time, and it changed the course of my life." Justin Green had just published *Binky Brown Meets the Holy Virgin Mary*, the first autobiographical comics work. *Binky Brown* painfully probes Green's sexuality as a child and young man, and in particular his sexual guilt arising from his Catholic background. Directly inspired by Green, Kominsky-Crumb started drawing her own comics. Soon afterward she left Tucson and her marriage, got in her car, and drove to San Francisco intent on publishing her comics.

Kominsky-Crumb and Crumb met at a San Francisco party that year and instantly felt a connection. Without any knowledge of Kominsky, Crumb had created a sexy comics character named HoneyBunch Kaminski, who looked like her, and even seemed to have her name. Others pointed out the similarity between Kominsky and another Crumb invention: Dale Steinberger, the Jewish Cowgirl. (Crumb obviously has a thing, in comics and in real life, for tough Jewish women.) Crumb was still married, although tenuously. He and Dana had moved to a farm outside the city, in Potter Valley, to raise Jesse. The two cartoonists did not immediately become partners in crime; Kominsky-Crumb was wary of entering into a complicated

entanglement. In the meantime, she made her name publishing explicit stories about her own sexual experiences, both good and bad, partnered and solo, bringing subject matter—the reality of lived female sexuality—to the comics for the first time.

Kominsky-Crumb's first comics story, "Goldie: A Neurotic Woman," appeared in the 1972 premier issue of the groundbreaking underground title *Wimmen's Comix*, an underground comic book by and about women, which was published by an all-female cartooning collective. *Wimmen's Comix*, which ran for twenty years, was one of the longest-running underground publications, and dramatically changed the tenor of underground comics production by adding so many women's voices to what had been a largely male field. "Goldie" is a woman's response to *Binky Brown*, which explores the protagonist's sexual angst from childhood. It concisely tracks Goldie's life from childhood to the present, with the narrator admitting that as a teenager "I was always horny and guilty." It shows the title character masturbating with vegetables, losing her virginity, sleeping around, getting married, and pursuing pleasure "compulsively" with confusion before regaining pride at age twenty-two. The kind of sex depicted in "Goldie" was new to the comics: unfiltered, vulnerable, uncensored views of women's sexual realities, including ones that would seem too "private" to show, or just simply too abject to dwell on. If Crumb shows how admitting explicit sex into comics could give the id free rein and open up imaginative possibilities, Kominsky-Crumb shows how admitting reality into comics includes depicting sex and sexuality.

"Goldie," as with all of Kominsky-Crumb's comics, eschews perspective, and clean fluid lines—despite, or in spite of, her art training. Its style, which features a shaky line, is one she calls scratched, or scrawled—drawing for her is something primal, deep, and untutored. She understands her work in the context of Expressionism, in which feelings are reflected in a dark style. In her comics, she told

me, "the drawing isn't pretty or accurate; a lot of it has little to do with what reality looks like. It's an emotional reality." Kominsky-Crumb's comics reveal how comics at its essence is not about illustration, about fine rendering, but rather about *expressivity*. As Art Spiegelman once told curators at the MoMA who had called him about collecting his work, "It's just an accident when it makes a nice drawing." Kominsky-Crumb's deliberate scrawl, which refuses to be pretty, even though many, including me, find it utterly compelling, echoes her subject matter in her line. (Her painting, which takes on different subject matter, is much more ornamental.) She aims to reveal the everyday sexuality of women, namely herself, deliberately stripping sex of its glamour, and instead focusing on its ups and downs, on desire and degradation, pleasure and shame—on the realities of lived experience.

We see this in the story "Hard Work and No Fun," from 1973, which features explicit masturbation and intercourse. The opening panel of the story shows Goldie, as in her first story, naked and masturbating, touching herself with spread legs and looking directly out of the panel at readers. Here Goldie wears only knee-high boots and a Star of David necklace. Her body is depicted in orgasm. "I'm coming," reads one of her speech balloons, while thought balloons picturing the faces of three men (including one who looks like Robert Crumb) float out of her head. Here we see how the realities of everyday sexuality (lonely masturbation) can be the dramatic action usually accorded a splash panel. The story is about the right to claim sexual pleasure with a partner: the "no fun" of the title refers to a sexually selfish man with whom she spends the night who only cares about his own sexual fulfillment. In the early 1970s, led by figures like Kominsky-Crumb and other female cartoonists, comics became a form for demonstrating— for picturing—the sexual desires of women. In addition to *Wimmen's Comix*, there were comic books like *Tits & Clits*, an ongoing title focusing on female sexuality, later known briefly as *Pandora's Box*—

its editors changed the name in 1973 in order to avoid an obscenity charge.

A groundswell of attention to sexuality and subjectivity came out of the underground: one could express things in comics that one couldn't express anywhere else. But there was disagreement over politics and aesthetics. Eventually, Kominsky-Crumb was rejected from *Wimmen's Comix*—nominally because her "feminist consciousness hadn't been raised," but more likely a) because she was dating Robert Crumb, considered a noxious sexist by many female cartoonists; and b) because her comics went against the grain, even in the underground. While today confessional comics in which no detail is off limits are hugely popular, until Green and Kominsky-Crumb this idiom didn't exist. Both of them focused on the less-than-romantic side of sex. While other contributions to *Wimmen's Comix* were understandably pro-woman, in Kominsky-Crumb's view, they also idealized women. And that was exactly what she wanted to avoid; it wasn't her version of what feminism should look like.

"I would completely deconstruct the myth or romanticism around being a woman," Kominsky-Crumb described to me. "I got a lot of flak from everyone," Kominsky-Crumb recalled, even among other feminist cartoonists. She noted that many feminist comics of the period idealized woman almost in the vein of superheroes. The feminist underground cartooning collectives were, she sees it, "influenced by traditional comics. They had images of women being glamorous and heroic. I didn't have that background." The anti-glamorous cover to Kominsky-Crumb's own comic book *Twisted Sisters*, created with Diane Noomin, even depicts Kominsky-Crumb sitting on the toilet. (The band Twisted Sister, she attests, got the name from the comic.)

In the introduction to a *Twisted Sisters* book collection from the

Aline Kominsky-Crumb, page from "Hard Work and No Fun," *Wimmen's Comix* #2, 1973.

Used by permission of Aline Kominsky-Crumb.

1990s, sex activist Susie Bright claims, "There is literally no other place besides comix where you can find women speaking the truth and using their pictures to show you, in vivid detail, what it means to live your life outside of the stereotypes and delusions we see on television, in shopping malls, and at newsstands." The complete artistic freedom of underground comics gave cartoonists the chance to use comics to express aspects of sex and sexuality that weren't able to be communicated aboveground, or in slicker media forms. An NPR host once described it succinctly; he noted sex is "secret, gross, and our number-one biological imperative." For Kominsky-Crumb, owning desire did not mean idealizing herself in her comics, but rather the opposite, expressing a full range of feelings and experience.

Kominsky-Crumb moved to Potter Valley in 1973 to live with Robert as his girlfriend on the commune at the farm; she moved into a trailer on the property, Robert lived in a shack, and Dana and Jesse, among others, lived in the "big house." Crumb and Kominsky-Crumb began collaborating on comics together, for which they would each draw themselves within a given panel or page, and portray themselves interacting. They called their comic-book series *Dirty Laundry*, and dirty it was—they often drew themselves having sex, and having sex in the particular ways that they enjoy that might be considered "perverse," or at least eccentric, by others. (They continued to collaborate in the pages of *Weirdo*, the important comics anthology Robert Crumb founded in 1981, which Kominsky-Crumb edited for a number of years—and which published explicit comics about sexuality, including, of course, theirs.)

Sometimes, the depicted sexual activity of Kominsky-Crumb and Crumb is violent, but it's always consensual—Kominsky-Crumb draws eccentric sex as part of her domestic daily routine. In the first issue of *Dirty Laundry*, from 1974, the artist couple published "Let's Have a Little Talk," a one-pager in which Kominsky-Crumb draws herself speaking to readers, announcing: "I also want you to know I

thought up the most depraved panel where he pushes my head in the vomit!" A small arrow points at her with the announcement: "Proud of being gross." More to the point, Kominsky-Crumb made comics a form for elaborating sex positivity, but not just to celebrate sex and transgression. Her comics about women's realities involve sexuality, but aren't always "sexy." She reveals rape in her life, along with intimate details about what she enjoys about her sex life. And her exuberantly messy style is a register of the exuberantly messy bodies she puts on the page: coital, masturbating, defecating, bathing. Cartoonist Alison Bechdel, famous for her own confessional, and occasionally sexually explicit comics, cites *Dirty Laundry* as an inspiration. Crumb and Kominsky-Crumb, she says, "are very much an inspiration in terms of trying to be as honest as I can, especially about sexual stuff." And yes, she too, as a child, masturbated to her own drawing, as her memoir *Fun Home* discloses.

Kominsky-Crumb and Crumb moved off the commune in 1976, Robert and Dana divorced in 1977, and the year after, Kominsky-Crumb asked Crumb to marry her. In 1981, they had a daughter, Sophie, and they now live in southern France. One of the reasons they moved, at Kominsky-Crumb's instigation, was her impatience with a culture of censorship in which both were criticized as pornographers by right-wing feminists. Kominsky-Crumb and Crumb encouraged each other to push away the inner censors in their comics, and have become the two people perhaps most directly responsible for creating comics as a medium for a certain kind of intimate, body-focused self-expression. Comics excels at this, with its hand-drawn, intimate diary-like properties; capacity for capturing detail; and ability to give shape to the darkest or wildest imagination. And while many women saw and still see Crumb as misogynist, Kominsky-Crumb points out he has always supported her work. When she showed him "Goldie," back in 1972, "he really cracked up and from that moment on he has always been my best audience," she explains in *Need More Love*.

"He always 'gets it' . . . Our relationship could never have worked if we didn't share this admiration for each other's work." Kominsky-Crumb even encouraged Crumb to keep drawing "A Bitchin' Bod," one of his most controversial stories.

In the story, Mr. Natural brings a woman, Cheryl Borack (or "Devil Girl"), who has a magnificent body, to Flakey Foont, a hapless everyman, and "gives" her to Flakey. She has no head—it's pushed inside her body, and the top is capped. She doesn't talk: the person has become simply a body. Flakey has thrilling sex with the headless body before being wracked by guilt and returning her to Mr. Natural, where her head is restored, she figures out what happened, and becomes enraged, threatening to kill them. Devil Girl bears a striking resemblance to Aline Kominsky-Crumb. The movie *Crumb* lingers on this story—it's harshly criticized as irresponsible and dangerous by several critics. As Crumb recalls, his wife pushed him to do it: "I got two pages into it and I thought, 'Ah, this is just too, this is just too negative. It's too twisted. It's too upsetting. I gotta stop this.' So I quit working on it and I threw the pages in the garbage can and at some point Aline came into my studio for something and I decided, well, I'll show her this and see what she thinks about it, so I pulled them out of the garbage can and I said 'Aline, I, this thing, pff, what do you think about this? I, I, threw it away. I decided I don't want to continue with this. It's too weird. It's just too disturbing.' She read it and said, 'You have to finish this. It's, you just have to do it. Obviously you just gotta see this through.'" Asked in the film about how her husband depicts women in his comics, she responds, "He just depicts his id in its purest form. I think, you know, the dark side of human nature that's in every person. That's what I was drawn to in his work to begin

Aline Kominsky-Crumb and Robert Crumb, "A Couple a' Nasty, Raunchy Old Things," *Self-Loathing* #2, 1997.

with." Kominsky-Crumb and Crumb are committed to the comics page as an uncensored space: whether it's autobiography (her) or giving form to inchoate sexual fantasies (him), both reveal comics as a way to transcribe sexual realities, however complicated, to the page.

Around the time she was fifteen, Phoebe Gloeckner discovered *Twisted Sisters*—the frank, funny underground comic book Kominsky-Crumb created with Diane Noomin—literally hidden under her mother's bed. It inspired the young cartoonist to draw her own uncensored comics about her own teenage sexuality. Gloeckner, who was born in 1960 and grew up in San Francisco, had seen underground comics, particularly *Zap*, early in her life. Her mother (who had Phoebe when she was seventeen) was friends with Robert Crumb and other underground cartoonists, who would sometimes visit Gloeckner's home after gigs with Crumb's band the Cheap Suit Serenaders. Gloeckner was fascinated by works like "Joe Blow," the style of which she found appealing, but it was *Twisted Sisters* that inspired her the most. She even wrote Aline Kominsky, as she was then known, a fan letter (Kominsky wrote her a postcard back, noting she had never received a fan letter from a girl before). Over two decades later, in the introduction to Gloeckner's book *A Child's Life*, Crumb notes that she confessed to him that she had dreams of running away to actually live with him and Kominsky. "We were some kind of underground-cartoonist-heroes to her," he writes. And it's no coincidence that both of them frankly take on the complexities of sex in their comics.

Gloeckner was kicked out of four high schools during her wild San Francisco youth, but went on to graduate from college and earn a graduate degree in biomedical communications. Her rigorous graduate training included cadaver dissection and observing surgeries, and prepared her for what was an established career in medical illustration. For many years, even while publishing her comics on the side, Gloeckner worked as a professional medical illustrator—which

means that her *hand*, as cartoonists refer to style, can be photorealistic, if she wants it to be. Some of her most powerful early experimental work in fact uses the hyperrealistic stylings of medical illustration, and its conventions, such as cross sections and detailed insets, to point up charged content, such as in her cross-section depictions of fellatio. In "Direction of Impact," a one-page piece first published in a 1990 edition of novelist J. G. Ballard's *The Atrocity Exhibition*, a naked woman, crouching, inserts a diaphragm into her vagina—we see her fingers and the diaphragm pushing up inside her body, with "vagina" and "uterus" labeled and visible. Two inset medical diagrams, in framed squares, float around the central image illustrating the "direction of impact" to tibia (shin bone) and fibula (calf bone). Here Gloeckner plays with tropes of medical illustration to represent a corporeal interior, and also to imply an ominous narrative. Was this woman—assuming the page's diagrams map her arrangement of contraception and also map her broken bones—injured by someone who assaulted her after a sexual encounter? Gloeckner's experimental medical illustrations give readers bodily information—we can see inside and outside of the woman's body—but leave us to figure out how the threatening layered moments pictured add up.

In the 1990s, at a meeting about a medical illustration job with Frog/Atlantic, a Berkeley-based independent publisher run by Richard Grossinger (the father of artist and writer Miranda July), the publisher asked her about her comics. Frog/Atlantic published Gloeckner's first comics collection, *A Child's Life*, in 1998. Cartoonist Bill Griffith (*Zippy the Pinhead*), who published Gloeckner's work in underground publications when she was in her late teens, told the *New York Times*: "Phoebe is one of the most accomplished artists in terms of mastery of the medium." She is also acknowledged as one of the most impressive draftspersons in comics. But because much of her work is about sexuality, Gloeckner's work, until recently, hasn't been widely known.

Like Kominsky-Crumb, Gloeckner has faced censorship from

Patella

Comminuted
fractures
of tibia
and
fibula

Direction
of impact

Posterior
dislocation
of left
tibia

Femur

Impact

Uterus

Vagina

printers who refused to actually print her work. (Frog/Atlantic ended their fifteen-year relationship with their printer over Gloeckner's work.) And Gloeckner's work has been labeled child pornography—a very hard designation to accept when one is producing work about one's own experiences of abuse. In 1995, British customs seized a book collection that included Gloeckner's story "Minnie's 3rd Love, or, Nightmare on Polk Street," as child pornography. *A Child's Life* has never been allowed in France—where Crumb and Kominsky-Crumb sought refuge from puritanical censorship standards.

"Minnie's 3rd Love" is a semiautobiographical twelve-page comics story that features a plotline—and images—Gloeckner has returned to across several of her books: a young girl, at fifteen, is seduced by her mother's boyfriend, who takes her virginity, and with whom she starts a relationship that is both titillating and horrifying for her. She longs for her mother's intervention and protection, which never comes (when Minnie's mother finds out about the affair, she is not outraged—she doesn't press charges or even cut off her friendship with the perpetrator). Miserable at home, Minnie runs off and joins the drug-fueled gay subculture of San Francisco, and in one particular incident she is drugged and raped, pimped out by her junkie girlfriend. "Minnie's 3rd Love," while its content is shocking, is a gripping story of ambivalent emotions, perilous experience, and complicated self-understanding. Journalist Peggy Orenstein, in her profile of Gloeckner in the *New York Times*, noted that Gloeckner is "creating some of the edgiest work about young women's lives in any medium."

Perversely, Orenstein writes, the triple marginalization Gloeckner's career represents (cartoonist, literary cartoonist, female literary cartoonist) produces an artistic practice "free from the pressures of the

Phoebe Gloeckner, "Direction of Impact," 1990, reprinted in *A Child's Life and Other Stories* (Berkeley: Frog), 1998.

Used by permission of Phoebe Gloeckner.

marketplace . . . [where she] can explore taboo aspects of girls' lives with the illusion of safety." The most notorious image from "Minnie's 3rd Love" has become known as the laundry room panel. In it, we recognize Gloeckner's signature comics style, which can produce an uncanny, disturbing effect. She combines a medical illustrator's precision—which is to say, a certain kind of mimetic realism—with disproportion in the size and shape of bodies. The laundry room panel depicts her mother's boyfriend, with his pants at his ankles, holding his penis out in front of Minnie's face, while she cries and clutches a bottle of wine. There is plenty of upsetting dialogue. When Minnie asks, "You love me, don't you?" he responds, "Of course I love you—what man wouldn't give anything to be fucking a 15-year-old?" The style of the image amplifies the disturbing power of the panel, because realism—say, the detailed hair on his body, the texture of her denim shorts—combines with the confrontationally, disproportionately large erect penis he wields. His body is drawn as so big, and menacing, that it barely fits in the panel—his head sticks out of its uppermost border, and his backside, dotted with stray hairs, spills out into the right-hand margin. Responding to accusations of "pornography," Gloeckner has emphasized that she is drawing true scenarios: "But there are children who experience this, who have the penis in front of their faces. They see it, so why can't I show it to make the impact clear?"

To "make the hidden visible" has long been a rallying cry of feminist and other social justice movements. In comics, even the most private or hidden moments can be reconstructed and revealed. On the other hand, as the photography scholar Ariella Azoulay points out, there exist in the public sphere very few photographs of rape. In comics, "making the hidden visible" for a public isn't simply rhetorical. Events and actions—what happens inside your body during sex, what happens in the laundry room, what happens when a girl is raped—can be shown in detail. Gloeckner believes that the medium

Phoebe Gloeckner, panels from "Fun Things to Do with Little Girls," 1993, reprinted in
A Child's Life.

Used by permission of Phoebe Gloeckner.

of comics, with its word-and-image dimensions, allows her to com-
municate difficult subjects while also maintaining a sense of agency
and control. "It allows me to put humor in, and rise above projecting
myself as a victim," she explained in an interview. "The form of a
'comic' sets up a tension that I like." We see this in "Minnie's 3rd
Love," for instance: the adult artist labeled the bottle of wine wielded
in the drawing by a stand-in for her younger self—in a scene of stat-
utory rape—"The kind of good cheap California wine that makes
girls cry and give blowjobs to jerks." And in Gloeckner's books, which

include 2002's *The Diary of a Teenage Girl*, we see the author using words and images to reveal painful sexual experiences—but also, as in Kominsky-Crumb's work, pleasurable ones. *The Diary of a Teenage Girl*, about a year in Minnie's life at fifteen, features statutory and other forms of rape along with long elaborations of Minnie's sexual desire. A live-action movie of *Diary* was made in 2015, starring Alexander Skarsgård and Kristen Wiig, among others. It accurately translates this complexity to film (and earned a lot of headlines for doing so). The first line, happily delivered by Minnie, is: "I had sex today." Aline Kominsky-Crumb (along with a copy of *Twisted Sisters*) appears as fairy godmother throughout—as an animated drawing interacting with actors, as if to underscore her power as a figure for art and creativity in Minnie's life.

Gloeckner had a tumultuous youth, but today she currently holds the most stable, mainstream job of practically any cartoonist I know, as a tenured professor at the University of Michigan. She is working on a long project about the serial-sexual murders of young women in Juárez, Mexico, which like her earlier work will visualize events (rape, murder) deliberately kept out of the public eye. Aline Kominsky-Crumb and Robert Crumb, who have been publishing their collaborative comic strips in the *New Yorker* since 1995, live in a nine-story medieval home in Sauve, France, where I visited them in 2009, and observed their appealingly calm domestic life: we sat down to Aline's home-cooked meals (Robert drank a glass a milk with dinner); their daughter, Sophie, a cartoonist, came over to draw with Robert; Aline took me to my first-ever yoga class, which she teaches in their tiny village (Robert, of course, makes the flyers). These cartoonists, however settled their lives now seem, have fought hard against their inner and outer censors to demonstrate that comics is a form that can show both illicit fantasy and hard-to-take truths.

Many, many comics about sex have been published since the underground era. In the Japanese market, *hentai*—a word that trans-

lates loosely in context as "perverse," and is an umbrella designation for a genre of hard-core pornographic manga and anime—is prolific and popular (in 2000, it was the forty-first most-searched term on the Internet). Significant recent works have taken the topic of sex and sexuality in new directions. Melinda Gebbie and Alan Moore (her husband, of *Watchmen* fame) collaborated on *Lost Girls*, which stars three grown-up protagonists of fantasy literature—Alice, Wendy, and Dorothy—having lots of sex in order to suggest that real-life sexuality and fantasy adventures are similar, even synonymous. In France, the graphic novel *Blue Is the Warmest Color*, a raw, sexually explicit lesbian coming-of-age story, was hugely successful and was adapted into a 2015 film that won the Palme d'Or at Cannes. One of today's most buzzed-about comic books is Matt Fraction and Chip Zdarsky's genre-aware sex dramedy *Sex Criminals*—which like *The Diary of a Teenage Girl* investigates sexuality as a confusing determinant of adolescent and adult identity, but with a fantasy element thrown in: its protagonists can freeze time, and hence rob banks, when they orgasm (like *Diary*, it will also become a movie). And Fraction also collaborated with artist Howard Chaykin (creator of the dystopian political comic book *American Flagg!*) on their own faux eight-page Tijuana Bible—a giveaway with an installment of their *Satellite Sam* series in 2014—demonstrating the enduring crude vitality of even one of comics's earliest sex-driven formats.

There's also Erika Moen's charming *Oh Joy Sex Toy*, now out in three book volumes, which is a weekly resource-rich webcomic that features sex toy reviews—banking on comics's show-and-tell properties to produce informative, educational comics stories about seeking pleasure. In an excerpt from the review of a "sex machine" called a Love Glider, we see the X-ray vision of Gloeckner's comics, the ability of comics drawing to show what is happening on the outside and the inside of a body simultaneously. Here, though, the context—and the bright pink colors that characterize each of Moen's installments—

But fucking yourself is only the start of the fun!

aims to be accessible, friendly, and unintimidating. The three distinct taboo-breaking cartoonists of this chapter laid the groundwork for how diverse comics about sex can now be—a field that includes Charles Burns's explicit graphic novel *Black Hole*, which presents a sex-laced suburban landscape.

Erika Moen, "Oh Joy Sex Toy–Love Glider," ohjoysextoy.com, 2013.

WHY THE SUBURBS?

Many of the most iconic comic strips and comic books in comics history—the ones that large numbers of people, when they hear the word "comics," think of right away—picture suburban life. To name just a few: *Blondie*, *Archie*, *Peanuts*, and *The Family Circus*—which first appeared in 1930, 1941, 1950, and 1960, respectively—are pop culture classics. *The Family Circus*, a daily comic strip that features a loving nuclear family and their gentle hijinks, is a favorite of the alternative cartoonist Lynda Barry, who wrote in *The Best American Comics 2008*: "I loved the very world of it, a world that I could watch through a portal edged in ink." (My college even offered a student-run course on *The Family Circus*, "Mommy! Jeffy's Lookin' at Me!"—titled after a complaint out of the mouth of daughter Dolly about her brother.) The form of the daily comic strip, published in newspapers, lent itself to the routines of suburban life, sometimes in a comforting, reliable way, as Barry explains, and sometimes in an aspirational way. Referring to the archetypally suburban strip *Blondie*, which features the beautiful, ditzy Blondie Bumstead and Dagwood, her wealthy sandwich-loving husband, one

critic points out how the strip modeled "keeping up with the Bum-steads." These serial strips presented middle-class regularities—even of the lightly vexing sort—and their characters inhabited controlled and appealing universes.

From these classics on forward, comics has addressed itself to the ins and outs of suburban life. There are new syndicated strips that have become beloved modern classics, such Bill Watterson's *Calvin and Hobbes*, which ran for ten years starting in 1985 (it features a six-year-old and his imaginary tiger friend in an unnamed suburb), and Aaron McGruder's *The Boondocks*, which ran for ten years starting in 1996 (it features a politically radical boy who moves to the fic-tional suburb of Woodcrest, Maryland). In the contemporary world of comic books, Brian K. Vaughan and Cliff Chiang's stylish on-going series *Paper Girls*, a suburban sci-fi adventure that began in 2015, stars a gang of twelve-year-old newspaper delivery girls. And *Beverly*, a loosely linked collection of comics stories about teenagers and families in suburban Illinois, by Nick Drnaso, was one of the most celebrated graphic novel debuts in recent memory. Today the suburbs generate some of the most complex comics published—and from masters of the field like Chris Ware and Charles Burns. With its apparent middle-class blandness masking either malaise or dark secrets, suburban life, and the sense of self it produces, occupies many contemporary graphic novels.

One of the field's most dramatically talented cartoonists, Charles Burns creates comics that are most often described as *twisted*. Matt Groening reportedly named villainous *Simpsons* executive Charles Montgomery Burns (known widely as "Mr. Burns") after his college buddy—who happens to be, despite his namesake and the intense creepiness of his work, one of the nicest people I have ever met. (There are other Evergreen State College references on *The Simpsons*, includ-ing the family house at 742 Evergreen Terrace.) Known for the dark drama of his precisely inked black line, Burns was already a big fig-

ure in the comics world, and the illustration world, when his graphic novel *Black Hole*, about a fictional sexually transmitted disease afflicting suburban Seattle teenagers in the 1970s, hit in 2005. The horror-suspense story had been serialized in twelve separate comic books of the same title, with arrestingly beautiful glossy color covers, from 1995 to 2004. Many readers encountered a graphic novel for the first time with the publication of the ten-years-in-the-making book volume of *Black Hole*, which develops rich, complex characters over time and displays Burns's stunningly virtuosic style. As one of Burns's publishers puts it, his "ice-cold artwork polishes a 'conventional' comic look to the *n*th degree, underlying the artificiality of what we take for normal." While he inherited some of the preoccupations of the underground cartoonists, Burns's rendering, unlike Robert Crumb's, produces a clean, bold style that heavily contrasts black and white.

With its unflinching, up-close graphic depiction of sex, including female desire, and bodies all presented with Burns's signature precision, *Black Hole* moves into a space that underground comics opened up—a space for complex and explicit stories—and extends it into the age of the full-blown graphic novel. Most underground comics of the 1960s and '70s offered pungent but short pieces; the lengthiest is Justin Green's *Binky Brown Meets the Holy Virgin Mary*, the ambitious, fully-fleshed-out comic-book story from 1972 that clocks in at forty-four pages. Robert Crumb profoundly influenced Burns—but unlike Burns, he has never produced an original novel-length story. Burns, on the other hand, turns his eye on the Seattle suburbs with the detailed attention and sensitivity of a novelist for almost four hundred pages. "When I started *Black Hole* I really just wanted to tell a long, well-written story," Burns, who himself grew up in Seattle, told an interviewer. "The themes and ideas that run throughout the book had been turning around in my head for years and I wanted to finally get them all out—put them down on paper once and for all."

The son of an oceanographer and a homemaker who studied mu-

sic, Burns moved around frequently as a child. His first-grade report card noted that he "does very mature crayon work." Burns told me that drawing comics was one of the things he got attention for: "I may have been socially inept, but I could draw good monsters." In grade school he would force his friends to join him in executing parodies of superhero comics; by the time they were in junior high, they were producing parodies of underground comics. Burns explained how Crumb shifted his sense of the possibilities in comics by hitting on an idiom—one Burns would later interpret in his own fashion—"that was incredibly personal and strange, and yet hearkened back to classic comics of another era." Burns taught himself how to do professional comics by taking cartooning books out of the public library that specified techniques and tools. Lynda Barry, who attended high school in Seattle with Burns, described how he would paint murals inside of their high school. "He was the best artist I had ever seen in real life, ever," she raved. "I mean *ever*, and he blew my mind."

At the Evergreen State College, a hippie school in Olympia, Washington, also attended by Barry and Groening, Burns did comics for a school paper, *The Cooper Point Journal*, where Groening was the editor. Pointing up the façade of the suburbs was on Burns's mind early as a college cartoonist. In one of his comics parodies of *The Family Circus* for the student paper, Jeffy, the middle son in the ultra-square suburban strip, turns to his mother and says "Shut the fuck up, Mommy, we're trying to watch TV!" An art major at Evergreen, Burns went on to earn his MFA at the University of California, Davis, where he discovered punk music—and punk comics in the inspirational work of cartoonist Gary Panter. After art school, Burns moved to the East Coast, hoping to find commercial illustration jobs and continue making comics. He landed his first commercial job, for a nursing magazine in Philadelphia, and shopped his "little meager, sad portfolio" around with few successes.

Burns's big break came in 1980. Like Ware, he was discovered

by Spiegelman, but unlike Ware, he actively tried to be. One day, in Manhattan, Burns saw the first issue of *Raw*. In the issue, Spiegelman and Mouly had listed their address along with a notice about how to send submissions. Burns located the address and literally showed up on the doorstep on Greene Street in Soho, ringing Spiegelman and Mouly's apartment doorbell. As he describes it, a frazzled Art Spiegelman came down and answered the door: "'What? What? What do you want?'" Afterward, Burns sent in Xeroxes of his work, and he and Spiegelman arranged to meet properly. "He was the first cartoonist I ever talked to," Burns told me. "And he was the first person who really figured out what I was trying to achieve." Burns, as did Ware ten years later, made his name publishing in *Raw*. His first comics appeared in the magazine in 1981.

To cut to the underbelly of middle-class suburban existence, Burns revivifies genre comics—specifically, horror and romance, the two dominant genres of the postwar period. From his earliest comics, Burns has been preoccupied with plumbing the dark depths of middle-class suburban existence. Born in 1955, Burns is influenced specifically by the trendsetting suburban culture of the 1950s, which flourished during the massive increase of the North American suburban population after World War II. Across his work, Burns frequently draws domestic interiors—bedrooms, kitchens, and living rooms—and suburban neighborhoods that are a sort of ground zero for havoc to break loose. His comics take inspiration from both the white—and specifically "whitebread"—middle-class culture in which he grew up, and the horror comics and romance comics of the 1940s and 1950s that were both a reflection of and a reaction to that culture. Horror comics—particularly those published by the company EC, which came under fire in 1954 for its lurid content—and romance comics were two of the most successful genres of the postwar period. Burns doesn't hearken back to these genres to be camp, or just stylishly retro, although his work, which borrows visual conventions like panel com-

positions from both horror and romance comics, is often described as looking retro. Rather, as he told an interviewer, his source material "got imprinted in my brain. . . . I'm dipping into it in a very serious way." Burns refigures midcentury comic-book genres like horror and romance to critique the homogeneity, and the social dichotomies, to which suburban life gives rise.

In Burns's work, the uncontrollable, the messy, and the violent, which is often bodily and sexual, break through bland, domestic, conventional exteriors. In his first appearance in *Raw*, Burns published "Dog-Boy," a story about a nice blond suburban man who leads an "almost normal existence" but for his transplanted dog heart, which causes him to exhibit odd behaviors like licking women's faces (it became an ongoing series, and was even adapted for MTV's *Liquid Television*). Something is always about to rupture below the surface in Burns's work. In "A Marriage Made in Hell," from a 1984 issue of *Raw*, Burns turns genre conventions on their head to produce a gruesome send-up of postwar married life that includes accidental body swapping: a soldier returns from World War II and marries his high school sweetheart, but he is actually that man's overseas girlfriend trapped in her male lover's body after a sudden explosion and a misidentification of bodies at the hospital. His *Big Baby* stories, which appeared in *Raw* and elsewhere beginning in the mideighties, evoke the seething below the suburbs' artificial surfaces. "Big Baby" is the nickname of Tony Delmonte, a kid who lives in "Pastoralville" and runs back to his cookie-cutter home with its perfectly manicured lawn in order to hide his horror comic books from his mom. Meanwhile, his teenage babysitter obsesses over *Ozzie and Harriet*, a television show that symbolizes normative fifties ideals, telling her boyfriend she hopes they will "live in a house just like theirs." Comic books themselves here, as a media form, signify

Charles Burns, "The Smell of Shallow Graves," *Raw* #2.2, 1990.

Used by permission of Charles Burns.

the rupture to the perfect surface; they reveal decay, monsters, aliens. And the suburbs in Burns's world are always already sinister, so that his comics merge fantasy horror with real-life horror.

When I asked Burns about the creepiness of the suburbs in *Big Baby*, he explained, "They're a reflection of the typical American dream-home world. . . . It was what was presented in *Better Homes and Gardens*, or whatever those magazines were, where you'd leaf through and see all the products and the food and the abundance of everything. I was always interested in the façade of the American way of life, and what was hidden behind the façade." In one classic *Big Baby* story, "Curse of the Molemen," Big Baby becomes obsessed with a television show about monsters. Burns told me the story deals with "the fake things on TV—and then the real monster that's living next door who is beating his wife. A kid coming to terms with made-up television horror that's kind of fun to watch, and the reality of abusive adults that's not so fun." The real horror in *Big Baby*, as Burns once put it, "is the horror of the adult world."

And so goes a major theme of Burns's work, which draws on the stuff of popular culture to point up the holes in the façade. Burns visualizes, through gorgeous and terrifying images, how creepy the normal people are, and how normal the creepy people can be. We see this succinctly in the first of two stories about teen plague that Burns published in *Raw*—"The Smell of Shallow Graves" and "Teen Plague"—in the lead-up to *Black Hole*. In the short, four-panel color comic "The Smell of Shallow Graves," we see "sad teenagers who won't stay dead"—who wear cardigans and ties but have decaying faces and bodies—sneak back into their parents' home to do comforting, banal, daily things, like watch TV and make a sandwich. Small rituals of everyday suburban domesticity recur in Burns's work, like preparing

Charles Burns, Eliza eating a sandwich, cover of *Black Hole* #4, 1995.

Used by permission of Charles Burns.

and eating food. The zombie teens long for domestic normalcy, but they can't quite fit back in.

There is a lot of sandwich-making and TV-watching, along with pot-smoking and beer-drinking, in Burns's magnum opus. *Black Hole* focuses on white, 1970s middle-class suburban youth. The book is self-conscious about its characters' whiteness: one teenager is teased as being "lily white"; another, who has caught the sexually transmitted disease, is described as having skin so white it almost looks transparent. The graphic novel merges tropes of old horror comics—like teen plague—with the textured sensibility of novels; Hemingway is an influence (his short story "Big Two-Hearted River," which was itself influenced by Paul Cézanne's paintings, is even directly referenced by a character). *Black Hole* makes clear Burns's interest in "real-life horror," as he calls it, a kind of social horror, in addition to the dark fantasies that he creates that are inspired by the midcentury horror comics. These include a mouth, complete with teeth, that appears on a teenager's neck and speaks in his sleep—and moans during sex. The idea of mouths sprouting on the body is a preoccupation of Burns's that we see even in his early work. It represents the fear of losing control—something that the heavy artifice and infrastructure of conventional suburban culture, with its homogenous self-replicating communities, seeks to avoid. The unwanted mouth makes noises and articulates sentences that betray one's innermost thoughts and fears; it's unsocialized and uncontrollable—unlike the mouth on one's face.

In *Black Hole*, Burns focuses on teenagers and their polarized social world to explore the stratification engendered by white middle-class suburban culture. A mysterious, unnamed STD known as "the bug" causes bizarre physical deformities in teenagers—such as the additional mouths. The bug is an out-of-control physical stamp; it inscribes and divides. This teen plague, whose manifestations give Burns an opportunity to demonstrate his skills as an innovator of the creepy, is a marker of social division on every level. It represents *us*

versus them writ large: it is a literalization of grotesque proportions, a physical magnification of alienation, ensuring that a teen's desire to "fit in," his or her striving for normalcy, is forever out of reach. The 2014 film *Dawn of the Planet of the Apes*, directed by Matt Reeves, uses *Black Hole* as a plot point: a teenage boy protagonist shows and reads the graphic novel out loud to an ape he befriends in the woods. Like *Black Hole*, the *Planet of the Apes* films are about the divide between proximate but sharply differentiated (human and animal) social communities. Here, the patient graphic attention the book reveals to detailing the bodies and the desires of the healthy and sick kids alike is a democratizing move, a refusal on a visual level to posit one group as less worthy than the other.

The storyline of *Black Hole* shifts perspective throughout: it follows a group of four teenagers from the same high school who all wind up with the bug. The central character is Chris Rhodes, a kind, pretty, popular straight-A student, who literally sheds her skin. She gets the bug after romantically pursuing equally popular and easygoing Rob Facincanni—whose neck has sprouted a second mouth—at a party. Meanwhile, Keith Pearson, a mild-mannered stoner, starts to sprout tadpole-shaped bumps on his torso after electing to have sex with Eliza, a beautiful, troubled artist who has grown a tail.

In *Black Hole* the plague causes a wide range of physical deformation: some teens' faces decay; others become overgrown with cysts. The bug is a figure for inner turmoil; bodies are radically, externally out of control. Characters talk about "showing" and "passing"— "She's still trying to pass," someone remarks of a girl with webbed hands. (Critics have suggested the bug is a response to AIDS, or an allusion to pregnancy, but while it is relevant to both, it is a figure

Charles Burns, back endpapers, "after" portraits, *Black Hole* (New York: Pantheon), 2005.

Used by permission of Charles Burns.

for something more generalized than either of these alone suggest.) Kids go to their suburban Seattle high school and live relatively normal lives until their deformity is unavoidably clear—after which they literally fall out of the holding pen of suburban space, many of them running away from their parents' homes to live in secret in the thick woods outside of town. In Burns's clever "before and after" endpapers—which demonstrate how the graphic novel is designed as a single object front to back—the opening endpapers offer drawings of yearbook photos of "clean" teens, while the concluding endpapers show the same teens, in the same poses, deformed by the bug.

In a key early episode, Keith and two of his stoner buddies are smoking pot in the woods, a place they name "Planet Xeno"; *xenos*, in Greek, means "stranger" or "foreigner," as in xenophobia. In the woods, they find a tent filled with personal belongings. The ensuing scenes demonstrate the tonal range of *Black Hole*, its brilliant twisting together of sadness and horror. Leaving his friends to sift through the tent, Keith wanders a bit further and finds a length of human skin. He holds it up by the shoulders, and breasts, with their perfectly intact nipples, stare him and us in the face. As he stands holding the skin, overcome by sadness, deeply deformed plague-ridden teenagers who live in the woods approach, shooing him away.

Keith drops the skin and turns back to his friends, who have trashed the tent. "*Look!* Can you *believe* this shit? We found his *yearbook!*" one of his buddies exclaims. ". . . And check it out! It's *Holstrom*! Rick 'The Dick' Holstrom!" When Keith asks, "How do you know it's his?" the buddy replies, "The guy wrote his *name* in the front of it! What a *dweeb*!" The accompanying panel closes in on the yearbook photo: Richard Holstrom, in a jacket and tie, with a side part, and a slightly bulbous nose, smiling good-naturedly. Of course, as we learn later, Rick Holstrom is also a comics fan: "You'd see them in the lunchroom, playing chess, reading comics . . . getting food thrown at them," Chris recalls. "Why'd you have to trash all his

stuff?" Keith asks his buddies. The answer: "'Cause he's a fucking *geek*! He *deserves* to live out here!" The last panel of the chapter shows a teenager with a misshapen head staring at the trio from behind a tree as they make their way out of the woods.

So there we have it: the popular kids like to kick the sick kids when they're down. Sick kids are losers, losers are sick kids. When Keith finds out that the pretty, popular Chris is sick, he thinks miserably: "How could she *do* it?. . . . The only way you could get the bug was by having sex with a sick kid. I just couldn't see her *doing* something like that." But as *Black Hole* shows, despite this fear and disgust, kids do it, all the time. Chris gets the bug by accident, but she also, in a deep way, is courting it. Burns presents her as overcome with a literally overwhelming desire for the handsome Rob, despite his protestations. And Keith, who early in the graphic novel is repulsed by "sex with a sick kid," later willingly loses his virginity to Eliza—her tail, in fact, turns him on. It's easy to be disgusted, *Black Hole* suggests, but it's also easy to let passion, however dark and confusing, take over your thinking. *Black Hole* presents a stratified social universe and then turns it upside down, blurring and confusing the dividing lines. The "real-life horror" that Burns marries with popular horror conventions, like a mysterious plague, is both the horror of the mistreatment of nonconforming people, and the horror of social dichotomies losing meaning. In Burns's comics world, in which the high-contrast graphic style itself thematizes difference, the darkness bubbles to the surface incontrovertibly.

Burns's comics turn on the relationship between external and internal states of being, surface and depth. His suburban teens manifest on the outside what they feel on the inside: ashamed of their desires, cast out, different, unable to assimilate. *Black Hole* reveals how surfaces don't always hold up. Burns writes of comics in an early one-page comics piece for *Artforum*, "I wanted to break through all of those rigid panels . . . To pierce the surface and see a richer, more complex

structure below." He succeeded. *Black Hole* exposes, underneath the regular patterning of suburban life, a more complicated and often dark structure in which we access characters' innermost, and often troubled, thoughts. Burns draws the woods, for instance, as a state of mind that preoccupies Keith, in long vertical panels that show him in space with his friends and also exhibit his interior fantasies at the same time. His mind is elsewhere—and we see where. This play of surface and depth is also evident through the book's attention not only to externalized states of being, as in the bug, but also to what Burns has identified as his primary interest, "a more personal internalized horror."

Comics—a medium whose panels enclose and juxtapose space—is perfectly suited to reveal how the suburbs fence out the undesirable, and how geographical and social spaces are linked. In *Black Hole*, both interior and exterior space become their own characters in the story. This is particularly striking in the case of the woods, which lie outside of the story's suburban center. "If you're looking at the texture of the woods in *Black Hole*, that starts to be a real element of the story, part of the character of the story," Burns told me. Burns's eye for detail locates readers in sharply realized domestic interiors, which he draws continually. We are also placed outside of those tightly bound-aried and policed spaces in the geography of the woods, where page after page reveals the density of the forest: its branches, leaves, the de-bris on the ground. In *Black Hole*, there is no gray middle ground, but only pure black and white. "I try to achieve something that's almost like a visceral effect," Burns told me. *Black Hole* took over a decade to produce, in part because of Burns's meticulous attention to detail. He gives all of the images in the teenage universe of Washington State a full, deep, almost clinically meticulous texture: trees, sand, rocks, the water, the sky, a burning cigarette, a chicken bone, thatches of pubic

Charles Burns, page from *Black Hole*, Keith imagining the woods.

Used by permission of Charles Burns.

...BUT IT *DIDN'T* GET ME WHERE I WANTED TO GO. I WANTED TO BE SOMEWHERE NICE. SOME PLACE WHERE I WOULDN'T HAVE TO LISTEN TO A BUNCH OF BURNT OUT COLLEGE DIPSHITS TALKING THE TALK.

I WANTED TO BE DEEP IN THE WOODS, LEANING UP AGAINST A TREE... ZONED OUT, STARING DOWN INTO ALL THE LEAVES AND BRANCHES... LOOKING AT SOMETHING NATURAL AND BEAUTIFUL,

IT WAS ALWAYS THE SAME STORY. TODD AND DEE WERE CONSTANTLY GIVING ME GRIEF ABOUT IT... NO MATTER WHERE I WAS, I ALWAYS WANTED TO BE SOMEWHERE ELSE.

...SO HE'S SITTING OUT IN THE MIDDLE OF THE INTERSECTION, TRIPPING HIS BRAINS OUT...

IT WAS FUNNIER THAN *SHIT!* HE'S SO WACKED OUT HE DOESN'T EVEN NOTICE WHEN A COP CAR PULLS UP!

THEY'RE ASKIN' HIM FOR I.D. AND HE'S JUST SITTIN' THERE STARING UP AT 'EM WITH THIS BIG GOOFY GRIN ON HIS FACE...

hair. Burns's line is so controlled some have suggested it looks me-
chanical, but Burns is simply an expert craftsman. Just laying down
all of the black ink in his work takes a long time—much longer than
one might think. When I asked him about the process of creating
Black Hole's images, he noted, "I was literally drawing every little
grain of sand and every pebble and twig." The contradictions the
characters feel—grandiosity and terror, for instance—are inscribed
in Burns's style. *Black Hole*, for all of its imagery of decomposed faces,
is masterfully gorgeous.

If Charles Burns uses the conventions of romance and horror gen-
res to expose the bleak underbelly of the suburbs, his friend Chris
Ware is the opposite: Ware offers perhaps the prime example of how
comics today express realism, capturing the texture of perception and
the experience of time. Ware's graphic novel *Building Stories*, which
appeared in 2012, is a love letter to the suburban ordinary that takes
on all of the ambivalence the suburbs generate for its characters. One
might consider Ware the Alice Munro, or the John Updike, of com-
ics (minus the controversial sexual politics). His fastidiously detailed
comics, beautiful enough to be collected by museums, present a po-
etry of white middle-class loneliness.

Ware's entire comics oeuvre is about solitude, loss, and disappoint-
ment. Art Spiegelman once told me that Ware was the only cartoonist
he knew whose work is about *a sensibility.* He didn't specify which
one, but loneliness is the dominant sensibility of Ware's achingly
pretty books. As an unpopular, often lonely child himself, Ware de-
veloped a profound sensitivity and ability to connect to the loneliness
of others. He felt attached to Charles Schulz's *Peanuts* from a young
age—in addition to reading the comic strips, Ware recalled to me, he
would watch the holiday specials on TV, and he used to kiss the tele-
vision set when the *Charlie Brown Christmas* special was almost over
because he knew he wouldn't get to see it again for a whole year. Ware
even sent Charlie Brown a valentine in the mail as a child, because he

felt so sorry for Charlie Brown for not getting any valentines (one of the strip's recurring plot points). In his amusing illustrated collection *Key Moments from the History of Comics*, French cartoonist François Ayroles includes "Chris Ware sends a card to Charlie Brown" as one of the historic moments in comics he imagines across the world. (Matt Groening and Charles Burns drawing comics together also makes the list.)

Ware's graphic novel *Jimmy Corrigan* is about lonely boys and men who lack stable or comforting families (remember it ranks highest on "The Chris Ware Sadness Scale," on the "soul-crushing depression" side of the chart, in Tim Leong's *Super Graphic*). The later *Building Stories*, on the other hand, while it continues to explore loneliness, features a never-named woman who eventually becomes a suburban mother, presenting her life over decades. It is about expressing the everyday experience of a woman from within the space of a stable family (something wholly absent from *Jimmy Corrigan*). *Building Stories*, like *Black Hole*, took ten years to complete. In one of its key moments, the protagonist searches for a book to read from her home's own shelves. She considers, and rejects, classics by Melville, Joyce, Proust, Dostoyevsky, and Nabokov, and thinks: "*Fuck!* Why does every 'great book' have to always be about criminals or perverts? Can't I just find one that's about *regular* people living everyday *life*?" *Building Stories* is that book. And it is a "great book," too, both in its ambition and its scale, and according to its reception. Widely acclaimed as well as popular (it quickly sold out its first print run with Pantheon, and with a sticker price of $50), *Building Stories* has been a sensation. It shows how comics can, in fact, present moving stories about regular people living everyday lives and make these stories feel vivid and intimate. It was named *Publishers Weekly*'s Best Book of the Year, and appeared on the annual top ten lists of dozens and dozens of publications, including the *New York Times*, *Washington Post*, *Time*, *Newsday*, and *Entertainment Weekly*.

Building Stories is a 12-by-17-by-2-inch carton that weighs six pounds. Inside the *Building Stories* box are fourteen different comics narratives, all in beautiful color, in formats of all sizes, from the small pamphlet to the full-size newspaper to the gold-spined hardcover book that evokes the classic Little Golden Books children's series. The stories that appear across the book's distinctly formatted objects are loosely interlinked, crisscrossing time and space. The story takes place in Illinois; most of it features the central protagonist, a dark-haired woman with one leg and an art degree, either living alone in a Chicago walk-up apartment, or in a single-family house in the suburb of Oak Park, Illinois, with her architect husband and young daughter. (Ware, who was born in Omaha and now happily lives outside of Chicago, has a great line about America: he has said that if New York is the brains of the country, and Los Angeles is its asshole, then Chicago is its heart.) In *Building Stories*, there is no "correct" order in which to read the parts that make up the whole. In fact, even though the character ages in the book—we see her as a toddler and a mother, for instance—the parts cannot be constructed to form a linear trajectory, since the individual pieces of the book themselves intertwine temporalities copiously, across their pages, and frequently in the space of one page itself. One striking "silent" page without narration or dialogue pictures the protagonist sleeping at various ages and concludes with her as a baby, her tiny body floating in space.

The title *Building Stories* asks readers to think about built space, particularly domestic dwelling spaces, and how they affect and are affected by people: the stories that come from buildings. The three-story apartment building is even a speaking character in *Building Stories*; it tallies the number of orgasms and broken radiators and so forth it has witnessed. But "building" functions in the title as both a noun

Chris Ware, final page of a clothbound hardcover book within the box, *Building Stories* (New York: Pantheon), 2012.

Used by permission of Chris Ware. Image courtesy Chris Ware.

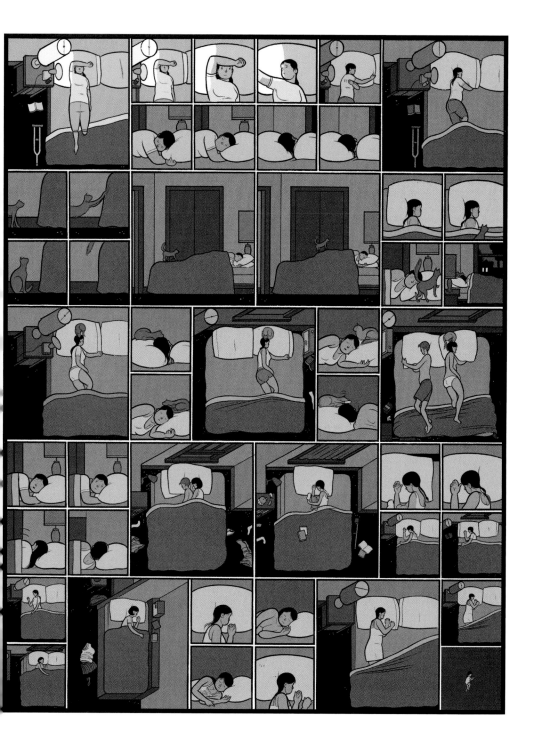

and a verb. The title also asks readers, with its three-dimensional collection of loose objects in a box, to think about the book itself as a kind of built space that gets completed through the individual process of reading: How does one build a story? *Building Stories* is a space, and a story, that readers themselves construct.

The back of the rigorously designed box presents the author's description of the book—and gives no direction whatsoever as to any correct reading order of the book's "14 distinctively discrete books, booklets, magazines, newspapers, and pamphlets," which it reproduces in miniature images. Crucially, the back cover also presents a blueprint-style drawing of a house, diagrammed with various pieces of the book scattered widely across the spaces of the home. One piece is on the shelf, one is open on a chair, one is under a table. The experience of reading *Building Stories* is as nonlinear as wandering into a house, as interactive as handling objects in space—objects you could take with you, misplace, leave out next to the cereal. Ware deliberately places his book, on its own back cover, within the very suburban spaces that the story examines. In a jokey but accurate address to the reader, Ware writes: "Whether you're feeling alone by yourself or with someone else, this book is sure to sympathize with the crushing sense of life wasted, opportunities missed and creative dreams dashed which afflict the middle- and upper-class literary public." The next and last paragraph then refers to the diagram of the house, noting that it makes suggestions "as to appropriate places to set down, forget or completely lose any number of its contents within the walls of an average well-appointed home." Well-appointed, and feeling alone: the classic disappointment of the suburbs. *Building Stories* addresses its reader, claims suburban existence as its domain, and shows from the

Chris Ware, *Building Stories* back cover showing the book's various elements along with a diagram of those elements in an "average well-appointed home."

Used by permission of Chris Ware. Image courtesy Chris Ware.

EVERYTHING YOU NEED
to read the new graphic novel
BUILDING STORIES:

14 distinctively discrete
Books, Booklets, Magazines, Newspapers, and Pamphlets.

With the increasing electronic incorporeality of existence, sometimes it's reassuring — perhaps even necessary — to have something to hold on to. Thus within this colorful keepsake box the purchaser will find a fully-apportioned variety of reading material ready to address virtually any imaginable artistic or poetic taste, from the corrosive sarcasm of youth to the sickening earnestness of maturity -- while discovering a protagonist wondering if she'll ever move from the rented close quarters of lonely young adulthood to the mortgaged expanse of love and marriage. Whether you're feeling alone by yourself or alone with someone else, this book is sure to sympathize with the crushing sense of life wasted, opportunities missed and creative dreams dashed which afflict the middle- and upper-class literary public (and which can return to them in somewhat damaged form during REM sleep).

A pictographic listing of all 14 items (260 pages total) appears below, with suggestions made as to appropriate places to set down, forget or completely lose any number of its contents within the walls of an average well-appointed home. As seen in the pages of *The New Yorker*, *The New York Times* and *McSweeney's Quarterly Concern*, *Building Stories* collects a decade's worth of work, with dozens of "never-before published" pages (i.e., those deemed too obtuse, filthy or just plain incoherent to offer to a respectable periodical).

$50 USA $55 CANADA
ISBN 978-0-375-42433-5
55000
9 780375 424335

outset, with its diagram of domesticity, how comics can reveal the intricacies, and the psychological importance, of space.

A move to the suburbs marks a major shift for *Building Stories*'s protagonist. As the book's various pieces reveal, when living in Chicago, she worked as a florist, with ambitions to become an artist or writer. She attended art school, during which time she met her first boyfriend, Lance. They were engaged in a passionate and serious relationship until he fled, devastatingly, soon after she agreed to an abortion. Her husband Phil is an architect (and her former classmate in art school). When their daughter Lucy is a baby, sometime in the early years of the twenty-first century, Phil suggests they move to the suburbs for familiar reasons: they can't afford to buy the same amount of space in Chicago, and they're concerned about decent schools for Lucy.

"Personally," the protagonist confesses to readers about city life, "I'd imagined us in some sort of raw loft space that Phil could renovate and redesign." An accompanying fantasy, pictured in blueprint, shows her painting on a large canvas in an open space where Phil also sits at his work desk with a ruler and the baby plays on a blanket between them. (She often thinks in blueprints when she imagines alternate lives, seen by an external viewer.) In Oak Park, which she dismisses as full of "professionally maintained lawns and bland restaurants," they move into an appealing Prairie-style home, nicer than the house she'd grown up in, the narrator notes. The move either itself enacts, or coincides with, her shift away from identifying as an artist to identifying as a full-time mother. "Had I really just signed my life away as a *suburbanite*? Was I really ready to give up that easily?" she despairs.

Ware's comics invoke the details of the family's suburban life, down to brand names and mildly conspicuous consumption: the protagonist, who disdains what she sees as the elitist culture around food consumption, yet reads the blog Epicurious to keep up with trends in

cooking. We learn they have a Williams Sonoma club chair (a feature, perhaps, of an "average well-appointed home"). Ware even particularizes their pasta: "Just then, for no good reason at all, while staring into my plate of Trader Joe's Tortiglioni Parmagianno, something came loose inside of me and floated to the surface," the protagonist recounts at one point. The consumer self-consciousness arrives in the book once the family is in Oak Park. And while a connection to the stuff of middle-class life develops, a certain kind of disconnect sets in between husband and wife, despite their essentially good rapport.

One of the central visual motifs of *Building Stories*, which repeats throughout the book, is the pair of husband and wife, alone together—sharing space, each attending to a device. "Spending time together" often means occupying the same space on individual computers that almost look appended to their bodies. Most often we see them in their living room, each on a computer, each lit by the glow of the screen. But in a small rectangular booklet that compiles vignettes of family life, on a beautiful summer night husband and wife sit outside on the back stairs each looking at their phones, which light their faces, while Lucy plays with a different kind of light-producing entity: fireflies. The book makes clear that the protagonist and her husband don't have sex very often; twice in the book she calls sex "overrated." In a single devastating image that reveals a marriage drained of spark—and which occupies a rare, dramatic full page in *Building Stories*—we see the protagonist, facing readers and her husband, naked, her clothes in an unceremonious pile around her feet. Phil lies on their bed, also naked, legs crossed, his flaccid penis hanging limply to the right, while he stares intently at his iPad, its light bathing his face. Ware offers up sex—but unlike the unruly teenage passion depicted by Burns, it is a torturously premeditated middle-age suburban parental sex date that is probably the least sexy image of a precoital couple anyone may have ever seen.

Most saliently, though, with the move to the suburbs, the unnamed

protagonist slides into a life of child-dressing, sandwich-making, and playdates that replaces writing and painting; the daily labor of her suburban life eases her artistic aspirations out the window. The fundamental dilemma the book poses is how to maintain a sense of self while raising a child. The narrator imagines a bird's-eye view of her own home, the space that encapsulates this life in which she can't always recognize herself: "Phil, Lucy, the house, and me . . . or *was* it me? Some dormant version of myself had sparked back into existence and called a time-out, saying, 'Hey, weren't you supposed to be an artist? Or a writer? Or *something*? 'But look at you: you're just a mom . . . nothing but a suburban *mom* . . .'."

Yet *Building Stories* is what I think of as a love letter to suburban ordinary. It is focused on giving form to the texture of experience. *Building Stories*, then, is about capturing the everyday passage of time. This is something the pace of the suburbs allows Ware's protagonist to notice—and Ware himself to meticulously represent through a medium, comics, that itself turns on the division of time through boxes of space on the page. *Building Stories* is unlike many comics this book covers for many reasons, chief among them its relation to the event, to things happening. Although in her twenties, as an art school student, the protagonist had a bad breakup, and an abortion, over the course of the narrative, whichever way you read it, there isn't a central event or central plot point or even central conflict in *Building Stories*; it's a book about the ordinary life of an unnamed woman, and her neighbors, friends, and family. Ware is even featured in a new academic book with the amusing title *What Happens When Nothing Happens: Boredom and Everyday Life in Contemporary Comics*, which sports a Ware image on its cover. The primary focus of *Building Stories*—its *eventness*—resides in its obsession with the ordinary lived experience of time.

Chris Ware, page from 9×12 pamphlet, *Building Stories*.

Used by permission of Chris Ware. Image courtesy Chris Ware.

Chris Ware, consecutive facing pages moving from winter to spring in a 3-by-6-inch booklet, *Building Stories*.

Used by permission of Chris Ware. Images courtesy Chris Ware.

Comics expresses the perception of time through its rhythm-producing arrangement of frames and gutters, which can speed or slow or stop its movement. In *Building Stories*, those frames capture the quiet, small moments that constitute everyday life. One booklet without words accumulates routine moments as the seasons change and Lucy gradually ages: on one page the protagonist changes a diaper; on another she watches Lucy on a playground slide; on another the mother and toddler sit in silence eating breakfast; in another she watches her daughter raise her hand in class through the window of her school. Comics as a medium traffics in the moment: each frame, conventionally, represents a moment of time, a beat. In *Building Stories*, Ware divides and freezes moments into even littler moments: a glance, a posture, a hand ascending or descending to point. In collecting and juxtaposing the moments of daily life, Ware reveals their cadence as beautiful, despite, or in spite of, the protagonist's understandable fears.

Building Stories is about the grain of individual experience—which is to say, about perception and how time passes. Rather than weighing in on the suburbs—*Building Stories* is not polemical or critical—it presents a poetics of the suburbs, which is to say it seeks to present the experience of space and duration, including the conflicting feelings that any regular person generates over time. Ware, then, captures his characters' ambivalence. In one scene, the protagonist looks at her husband, and her thought balloon—rather than her speech balloon—offers readers her silent address to him: "God I fucking hate you," she thinks. In another moment, her speech balloon presents this thought: "I have the best family in the world." *Building Stories* presents a domestic comics realism made up of prosaic shifts of mood and tone:

Chris Ware, newspaper-style foldout page with a life-size baby at the center, *Building Stories*.

Used by permission of Chris Ware. Images courtesy Chris Ware.

the texture of everyday life, in which sometimes you hate your husband and sometimes you feel lucky to have him; in which your child is incontrovertibly and joyously the center of your life even as you feel a pervasive sense of loss and awareness of sacrifice. With its ability to slow down, split, isolate, and juxtapose quotidian moments in panels of all different shapes and sizes, the comics medium in Ware's hands captures how these moments create a sense of a life. Explaining once what *Building Stories* is about, Ware simply said it is about empathizing with other people. In a poster he made for a 2012 conference I organized on comics, Ware named it "a conference addressing the art of the empathetic doodle." Burns's *Black Hole* is also about empathy for the other, but his 1970s suburbs provide a starker backdrop for critique, whereas Ware's suburbs, à la Updike, seek to make the experience of them vivid. Updike, for his part, an avid cartoonist into his twenties, saw comics as a model for creating a living, breathing world in fiction: "One can continue to cartoon, in a way, with words," he noted. "For whatever crispness and animation my writing has I give some credit to the cartoonist manqué." *Building Stories* shows us the texture of a life, from one person's point of view, and asks for our attention and participation in adding the pieces together.

Building Stories calls readers' attention to how we build our own lives, which is to say, how we build a narrative of our own lives from bits and fragments and images and feelings. In a page with its own title, "Browsing," the protagonist recounts a dream to a college-age Lucy, who wants to go to art school. In a bookstore she finds her own book, and, to her surprise, she likes it: "Everything I'd forgotten or abandoned or thrown out was there . . . everything." It's illustrated, too, in lines "so precise and clean it looked like an architect had drawn them." While browsing in her own book, which keeps growing, she realizes it was "in pieces . . . like, books falling apart out of a carton, maybe . . . But it was *beautiful* . . . it made *sense*." Her husband is an architect, a professional one, but this page suggests readers see her

as equally architect—of her past, and of her memories, and of her dreams, despite her sense of disappointment. *Building Stories* itself is the dream book, a book of memory. Ware has built a story; his unnamed character has built a story, a collection of her memories; and readers too build their own story out of the shared pieces they assemble.

Building Stories reveals comics as an art of memory. Art Spiegelman has claimed, "Comics work the way the brain works: picture signs mixed with little bursts of language. PAST, PRESENT, and FUTURE all scrambled and butted up against each other—the perfect medium for depicting memory." *Building Stories* makes prominent use of the nonlinearity of comics reading, using the center of the page to focus readers' eyes on an image prominent in its protagonists' minds, while associated bits of narrative, in words and images alike, float nearby. This technique is an aesthetic centerpiece of the book. Our eye is drawn to all sorts of objects that appear at the center of pages: a flower, a notebook, a vagina, a photograph, a face, a mask, hands, a baby—drawn at life-size in one of Ware's 32-by-22-inch fold-out pages. This makes the page, like the book in a box itself, one in which the eye wanders and assembles moments without a clear beginning or end—in which we as readers build the pieces of a life together out of fragments—fragments of images, like in the process of memory itself. The page design often evokes the psychic, interior landscape of a character. The different formats in which the elements of the story appear—like the Little Golden Books, a popular children's book format, or the Sunday-style newspaper—are themselves evocative of *how* people narrate their own lives to themselves through popular forms and idioms. The golden-spined books even have a space for the reader to insert his own her own name. In a book about space, Ware invites the reader in.

WHY CITIES?

All the hours I'm awake, I'm drawing. I'm walking down the street, I'm drawing in my head, I'm drawing that street in my head.

—Jaime Hernandez, in *Comic Book Artist*, 2001

Comics in the United States were born in cities, in cheap, sensational newspapers published by Hearst and Pulitzer. They were born in the alleys of New York. The first comic strip, in 1895, titled *Hogan's Alley* but known as *The Yellow Kid*, by Richard Felton Outcault, starred a Lower East Side tenement guttersnipe child of visually indeterminate ethnicity (later it was clarified his background is Irish) who got his nickname from his dingy yellow nightshirt. He would inspire the term "yellow journalism." Comic-book superheroes are also tied to cities: Superman to Metropolis, Batman to Gotham City, Spider-Man to New York City. The first two can be understood as fictionalized versions of New York: comics writer Frank Miller says that Metropolis is New York in the day, and Gotham is New York at night. The very first book to advertise itself as

a "graphic novel," Will Eisner's 1978 *A Contract with God*, is specifically about city life, tracing tales of woe among four separate residents of a Bronx tenement.

Comics are linked to the suburbs in their expression of teenage and midlife middle-class angst—and they also are inspired by and reflect the energy, diversity, and populism of cities. Many of today's most significant and innovative comics pivot on the space of the city, from Ben Katchor's graphic novel *The Jew of New York*, set in the 1830s, to Peter Kuper and Seth Tobocman's politically radical comics anthology *World War 3 Illustrated*, which has covered protests and gentrification in New York and elsewhere, to cartoonist Guy Delisle's travelogue *Pyongyang*, detailing his time in the North Korean capital, to the cartoonist Seth's whimsical, aesthetically rich comics stories that prominently feature the fictional Canadian city of Dominion (and for which he has constructed an intricate three-dimensional cardboard model, itself now the subject of a documentary).

Chris Ware's Illinois-based *Building Stories*, like Harvey Pekar's Ohio-based *American Splendor*, uses the rhythms of comics, its ability to capture and frame small moments, to chronicle everyday life in the Midwest—the experiences of a regular person in a regular town (and, before she moves to the suburbs, a regular city—Chicago). But while Ware's work is about individual interiority as it develops in connection with the spaces people inhabit, Pekar's work is largely about exteriority, tracking a democracy of voices in a city's public spaces. And while *Building Stories*, however satirically, advertises on its back cover its sympathy with the afflictions of "the middle- and upper-class literary public," Pekar's *American Splendor* comes at midwestern ordinariness from the opposite angle, an explicitly working-class point of view. Each issue carries the subtitle *From Off the Streets of Cleveland*.

Pekar, who died in 2010 at age seventy, is one of the best-known contemporary cartoonists—a public figure people who don't pay attention to comics might have come across on television or in the

movie theater, or have read about in the many profiles of his cantan-
kerous, outsize personality. Daniel Clowes once remarked that being
a famous cartoonist is like being a famous badminton player (which is
to say, not very famous at all). But over decades of paradigm-shifting
work, which slowly became more and more recognized and then
eventually quite mainstream, Pekar, a Cleveland file clerk with a self-
published autobiographical comic book, became as close to a celebrity
in the broader popular culture as any cartoonist this book covers. In a
2016 episode of the *New Yorker Radio Hour*, Henry Finder, an editor
at the *New Yorker*, noting the history of "comic books that weren't the
kind of standard issue," first names Pekar, followed by Crumb and
Spiegelman.

The "comics bard from Cleveland" became a semicelebrity as a
professional populist curmudgeon appearing frequently on *David
Letterman* in the 1980s and '90s, and his life story was made into an
award-winning 2003 film, also named *American Splendor*, starring
Paul Giamatti as Pekar, and Pekar himself (credited as "Real Har-
vey"). The film won the Grand Jury Prize at the Sundance Film Fes-
tival and was nominated for an Academy Award. In Cleveland there is
a desk and bronze statue commemorating Pekar at his favorite public
library, where he went almost every day, and a Pekar Park in Coven-
try Village, in the Cleveland Heights neighborhood, where he lived
for decades. As Robert Crumb, his frequent collaborator, explained,
"He's the soul of Cleveland. . . . He's passionate and articulate. He's
grim. He's Jewish. I appreciate the way he embraces all that darkness."

Unlike most of the literary world, comics is not New York City–
centric. Cleveland looms big in the history of comics, and in its fu-
ture. Bill Watterson of the adored *Calvin and Hobbes* grew up and
lives near Cleveland (he joked to the *Washington Post* in a 2016 ar-
ticle titled "Wait—Just How Did Ohio Become the Cradle of Great
Cartoonists?" that it helps "to grow up with sober midwestern values
and to live someplace without a lot of exciting diversions"). Cleveland

boasts one of today's most acclaimed young comics writers, Brian K. Vaughan (of *Y: The Last Man*, *Ex Machina*, *Saga*, and *Paper Girls* fame). Like fellow Clevelanders and comic-book icons Jerry Siegel and Joe Shuster, who introduced their creation Superman to the world in 1938, Pekar, born the following year, came from a family of Eastern European Jewish immigrants. Pekar grew up with Yiddish as his first language; his parents, Saul and Dora Pekar, hailed from Białystok, Poland, and called him by his Yiddish name, Herschel. Saul Pekar was a Talmudic scholar who in his American life owned a grocery store on Cleveland's East Side, on Kinsman Avenue; the family lived above the store. In the agonizing comics story "Out of the Past," Pekar details how his father, catering to the neighborhood's population of "Jews, Italians, blacks, and some Slavs," worked a ninety-hour, seven-day workweek and how it "tore" Harvey apart as a child to see his father have to forsake an intellectual life to get by in America. (Speaking of Polish Jewish émigré fathers: Pekar heavily criticized Art Spiegelman for not treating Vladek Spiegelman well enough in the pages of *Maus*, a beef that seems more personal than actually evaluative.) Pekar worked in his father's grocery from the age of ten; he grew up, when not at school and working, out on the streets of his ethnically mixed neighborhood, where he was often bullied as unassimilated and learned how to fight. After high school, Pekar briefly joined the Navy, and spent one year at Case Western before dropping out. He became a committed autodidact, reading constantly (hence the library statue).

Pekar met Crumb, who had moved from Philadelphia to Cleveland to work for the American Greetings card company, in 1962; the two were neighbors. Pekar introduced Crumb to Cleveland's full range of ethnic neighborhoods ("Well whaddya know—a white slum," Crumb remarks in amazement as the two walk down the street in one *American Splendor* story). They also bonded over their love of jazz, about which Harvey sometimes wrote as a freelance critic. "Harvey was the

first person I ever met who I thot [*sic*] was a genuine 'hipster,'" Crumb recalled, referring to the historical definition of the term à la Norman Mailer's *The White Negro: Superficial Reflections on the Hipster*, the 1957 essay that examines self-consciously nonconformist young white people who adopt black music and culture as their own. "I was very impressed. He was heavily into modern jazz, had big crazy abstract paintings on the walls of his pad, talked bop lingo, had shelves and shelves of books and records, and never cleaned his apartment . . . and he was seething intense, burning up, always moving, pacing, jumping around . . . just like a character out of Kerouac." When he later drew him, Crumb portrayed Pekar as a wild-eyed, manic creature in a hole-bitten T-shirt. After some odd jobs, including one as a mail carrier, in 1965 Pekar began working at the Cleveland Veterans Administration hospital as a file clerk, a job he would keep for the next thirty-seven years, until his retirement.

His friendship with Crumb, besides stoking his record-collecting habit, got Pekar interested in turning his sharply focused observations of quotidian life into comics—despite the fact that he couldn't draw easily or well. With Crumb's encouragement during a visit to Cleveland in 1972—during which he offered to illustrate Pekar's stories—Pekar started scripting comics stories to be drawn by others. In Pekar's way of working, he would author all of the text and sketch crude stick figures into frames to guide his collaborators as to how he envisioned the stories breaking down. The words and the compositions belonged to him; the actual marks belonged to artists with a range of different styles (he even collaborated with Alison Bechdel, whose solo work he strongly supported, and Joe Sacco). Whether one feels connected to a Pekar story or not often depends on the vagaries of taste and who is illustrating. Pekar's first comics story, "Brilliant American Maniacs Series No. 1: Crazy Ed," a one-pager illustrated by Crumb about a chance conversation with a stranger about the name Harvey, was published in 1972, in the underground comic book *People's Comics*.

(A fascination with names, as seen later in "The Harvey Pekar Name Story," is a running theme of Pekar's work.)

After publishing a few scattered comics stories in underground comic books over the next few years and getting a good response, Pekar decided to make a go of it in 1976 with very his own title. The Crumb-illustrated story "How I Quit Collecting Records and Put Out a Comic Book with the Money I Saved," published in 1979, details Harvey's plunge into the world of self-publishing comics, after he realizes that his record-collecting habit eats up every available cent in his already modest lifestyle and is detrimental emotionally and practically ("I was spending all of my money on records I just filed away. . . . I had to think twice about buying a hamburger or going to a movie"). When he decided to quit obsessive collecting cold turkey, Pekar, gainfully employed as a file clerk, realized he had the money to independently print and circulate his comics. In the mid-1970s, Pekar also realized that the variety and openness of underground comics publications, after the end of the Vietnam War and the dilution of the counterculture, were on the wane. Practical-minded and taking matters into his own hands, "I found out," Pekar discloses to readers about comic books, facing us directly, rendered in Crumb's quivering, shaded lines, "I could save up enough bread in a year to publish one."

American Splendor #1, fifty-two pages of original stories, which sold for $1, appeared in 1976 with a bold, primary-colors cover by Cleveland artist Gary Dumm, and billed itself as "Adults Only." (The stories themselves usually appeared in black and white, as with most inexpensively produced undergrounds.) Although somewhat satirically also billed as the "Big Bi-Centennial Issue," the first issue of *American Splendor* celebrates something it claims as quintessentially American, and urban, and splendid: the street-level, public-sphere conversation. On the cover, three men, identified as Sid, Freddy, and Harvey, sit on the steps of a closed store on a city street and talk—specifically about ethnic politics: Sid tells a story about Gavrilo Princip, the Yugoslav

nationalist who assassinated Franz Ferdinand, sparking World War I. From the very beginning, Pekar's comics sought to capture the cadences of conversation in public space that characterize the ethos and energy of city life—particularly diverse, working-class city life. The three men, discussing Eastern Europe, sit under a store sign featured prominently in the composition that advertises Italian and Lebanese specialties.

American Splendor appeared once a year, and for its first fifteen issues, until 1991, Pekar self-published the comic—even after mainstream publisher Doubleday issued two *American Splendor* book collections in 1986 and 1987, the first of which won an American Book Award (later on, when Pekar fell ill, comic-book publishers Tundra, and then Dark Horse, assumed publishing responsibilities). Pekar innovated comics autobiography, widening its scope to include the working-class quotidian, and showing how comics could make the rhythms of daily life, especially in public spaces, evocative and communicable. "I want to write literature that pushes people into their lives, rather than helping them escape," Pekar once explained to an interviewer. His topics are the daily encounters of everyday life, or existential musings about seemingly simple facts of life like one's name—but always in relation to a public body, to the city. The celebrated forty-eight-panel "The Harvey Pekar Name Story," illustrated by Crumb, features Pekar in every same-size frame addressing the audience face-on, musing on the other Harvey Pekars in the Cleveland phone book. (You wouldn't think this would be very adaptable for the drama of cinema, but it's replicated with Paul Giamatti and limited animation in the *American Splendor* film.)

American Splendor developed self-consciously humorous—but true!—descriptive taglines on its covers: "Stories About Record Collecting and Working"; "Stories About Sickness and Old People." One of Pekar's funniest slice-of-life stories is "Standing Behind Old Jewish Ladies in Supermarket Lines": when an old Jewish lady surprises him

by asking if he wants to cut her in line, Pekar, who is Jewish himself, thinks earnestly, "I was really amazed by her courtesy. That's the first time a Jewish lady was nice to me in a supermarket! . . . She's taller than most old Jewish women. . . . Maybe she's a *mutant*!" Pekar's settings are largely public spaces: workplaces (including, prominently, the VA hospital), businesses (the tailor shop, the bakery, the fruit stand, the diner), the city street (as each and every issue announces), and civic spaces like the public library.

Pekar's one-page "Overheard in the Cleveland Public Library: March 21, 1977," with art by Gary Dumm, displays one of Pekar's signature talents: listening. He sought above all to be accurate in his comics' transcription of everyday encounters and interactions—even ones from which Harvey himself is directly absent, but to which he can be a witness (he sometimes goes by the moniker "our man"). The eight-panel "Overheard" features Harvey only silently in its top title frame—although readers merely see his back, his posture indicates he is observing the conversation in front of him. The story is about everydayness: about something that happened at the library on some routine day, a Monday, when Pekar went there. It also links class politics and aesthetics, all while also addressing itself to the kinds of meaningful, if awkward, interactions between strangers that can happen in public spaces like a library.

The story begins midconversation as a bespectacled librarian speaks to a man in a patched coat who has approached her. We soon learn that the man, clutching sheets of his poems, had asked that the librarian evaluate his poetry. She directs him to the Cleveland Area Arts Council, which prompts him to complain that nobody likes his poetry: "I show it to everyone an' nobody likes it . . . But I read this

Harvey Pekar and Gary Dumm, cover of *American Splendor* #1, 1976.

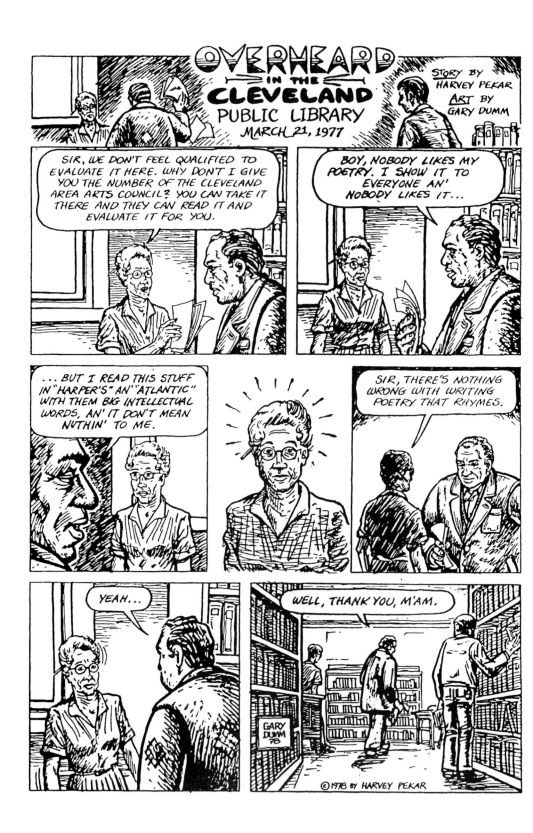

stuff in 'Harper's' an 'Atlantic' with them big intellectual words, an' it don't mean nuthin' to me." In the center of the page, Pekar and Dumm drop the panel borders to emphasize the librarian's shock, and add the spiky lines, a staple of comics language that cartoonist Mort Walker named "emanata," which indicate surprise. They also drop any speech or thought balloons—the panel is silent. Pekar, so attuned to rhythm, to jazz, often uses his sensitivity to music and to sound in general to dramatic effect by removing it in his comics. Many of his stories, which are often divided in regularized panels, emphasize silent beats in a conversation, as "Overheard" does.

"Sir," says the librarian, "There's nothing wrong with writing poetry that rhymes." Pekar presents the encouraging librarian—and by extension, the library itself—as a space for aesthetic inclusion (if not aesthetic evaluation) that results from its structure as a public, and therefore, in some profound way, populist space that accommodates both poetry that codes as "high" (the difficult words of published poets) and that codes as "low" (the rhyming poetry of amateurs). In 1979, Pekar authored a second version of this same story, which he called "Library Story: Take Two," with the artist Michael T. Gilbert—the subject clearly made a big impact on him, as he himself, in a different medium, created a different kind of amateur "poetry" (he is often referred to as the poet laureate of Cleveland).

Comparing the different comics renditions of the same event makes clear how important visual style is to the effect of the final Pekar story. The city Pekar presents is about voices, about conversation—something his own comics stage in the very fact of their collaborative fabric, their ongoing conversation between writer and artist. In other words, in its procedure his work stages the very dialogue that his com-

Harvey Pekar and Gary Dumm, "Overheard in the Cleveland Public Library, March 21, 1977," *American Splendor* #3, 1978.

Used by permission of Joyce Brabner (Harvey.Pekar.Estate@gmail.com).

ics are so intent on capturing in the Cleveland in which he lives and moves. His city is a space of dialogue, and so are his comics, in the basic aspect of their creation. As we see even in the very first *American Splendor* cover, dialogue is fundamental to Pekar's art. Sometimes a story pivots on a funny exchange Pekar had with a co-worker, or even just the everyday witticisms or quirks of certain co-workers, which *American Splendor* largely lovingly profiles. In "Lunch with Carmella," Harvey recalls the title character, a strange but admirable longtime employee of his office building. In one of my favorite Carmella moments recounted by Pekar, her co-worker Ruth Rizzo says to her, "Carmella! Shame on you! Your dress is dirty!" to which the haggard-looking Carmella replies, deadpan, "Yeah, but it's only dirty on the outside."

Pekar's comics, in capturing a democracy of voices—which includes, of course, his own—seek to present the idiosyncrasies of speech that constantly buzzes around the city. Pekar carefully catches the way people around him actually speak—their cadences of speech, the modulations and inflections, and also their idiomatic differences. Frequently, Pekar throws in ethnically specific phrases or bits of language without explanation; he sees his comics, then, as for the community, widely speaking, of people who are pictured within the pages of *American Splendor*—or for someone engaged enough with the story to look things up on her own. I had to look up three Yiddish words in the two-page "The Maggies," a brilliant story in which Harvey—ever the fan of the spontaneous street-level encounter—runs into a tiny, wizened old man on the street, whips out his pad and pencil, and grills him about a group of low-level 1930s Cleveland Jewish gangsters, while being berated by the man. "Do you want to hear this or do you want to exhibit your idiotic sense of humor?!" the man rails when Pekar (as usual) jokes about a name. In addition to his musician's ear, the fact that he grew up speaking Yiddish and later learned English, switching between the two, must have also forced attention to sound,

context, and speech. One short conversation, then, is often the subject of a Pekar story, as in the story "A Compliment."

This six-panel vignette, created with Crumb, takes place in the hallway of the VA hospital. It includes one panel of simple silence. Pekar narrates a chance encounter with his co-worker Mr. Boats, a recurring and philosophical character in *American Splendor*, who here defends Harvey from good-natured ribbing about his head-to-toe outfit of secondhand clothes ("That's all right! This boy knows what t'*do* with *his* money!!"). The representation of speech in *American Splendor*, as in many comics, doesn't adhere to correct spelling but rather seeks to express rhythm in its visual emphasis (the bold letters) and the aural capture of speech over grammar and spelling convention (Harvey's own speech is usually represented by many dropped vowels; "enuff" not "enough"; "yer" not "your"; "lissen" not "listen"). *American Splendor* is full of accented speech—including Pekar's own—as part of his comics portrait of the city, one which marks and celebrates differences as opposed to eliding them. The old Austrian doctor at the hospital says, "Here's a choke zat you can poot in your book"; the courteous old Jewish lady in the supermarket asks him, "You vant go ahead of me?" Comics is how Pekar collects these voices and interactions, recording events so mundane, as Crumb put it, that they seem exotic.

Pekar was not the first cartoonist to produce man-on-the-street comics. A few years earlier, in 1974, New York City cartoonist Stan Mack started publishing *Stan Mack's Real-Life Funnies*, observational comic strips that were "guaranteed overheard," in alternative weekly paper *The Village Voice*, which had also launched Jules Feiffer's celebrated *Sick, Sick, Sick*. It ran for twenty years. In an interview, Mack charmingly said that he "learned to take notes on my shirt cuffs and walk backward in crowds. But most of all I learned to listen to what ordinary people have to say." Whether New York City or Cleveland, the space of the city is about a cacophony of voices (Mack recently

complained when he listens these days it's mostly all people on cell phones). But while Pekar wasn't the first cartoonist to evoke the energy and diversity of the city in comics this way, he was the first to do so with ambitions to make his comics, inlaid with autobiography, literary, and longform in scope. Mack's strips were revealing but short, part of a newspaper comic strip tradition; Pekar's, created for comic books, were longer and moodier, able to be expansive because of their self-published format. Pekar was only answerable only to his own sense of judgment, and the willingness of his collaborators; his stories were able to meander along with his subjects or his own philosophizing. And many of his stories are long.

Some of Pekar's lengthiest stories detail his eight appearances on David Letterman's shows *Late Night with David Letterman* and *Late Show with David Letterman* between 1986 and 1994. A big part of Pekar's legacy as an artist, and a midwestern populist, comes from his role as a repeat guest on Letterman's show. And this legacy is not only within the comics field—Pekar is central to television history. When Letterman retired in May 2015, numerous think pieces about his role in American culture appeared—and many of them brought up Pekar, whose off-script, on-air fights with Letterman were awkward and electrifying. On the night of Letterman's last show, the *Washington Post* ran an article, "How Harvey Pekar Became One of David Letterman's Greatest Recurring Guests," which claims that Pekar "remains one of his most memorable recurring guests ever—even through the rearview mirror of Dave's 33-year late-night run." Television host and comedian Jimmy Kimmel wrote in *Time*, "The best guests were the worst guests, those who either didn't get it or didn't like it: Bryant Gumbel, Nastassja Kinski, Cher, Harvey Pekar" (what a great list!).

Part of the charm of Pekar as a guest on late-night national tele-

Harvey Pekar and Robert Crumb, "A Compliment," *American Splendor* #7, 1982.
Used by permission of Joyce Brabner (Harvey.Pekar.Estate@gmail.com).

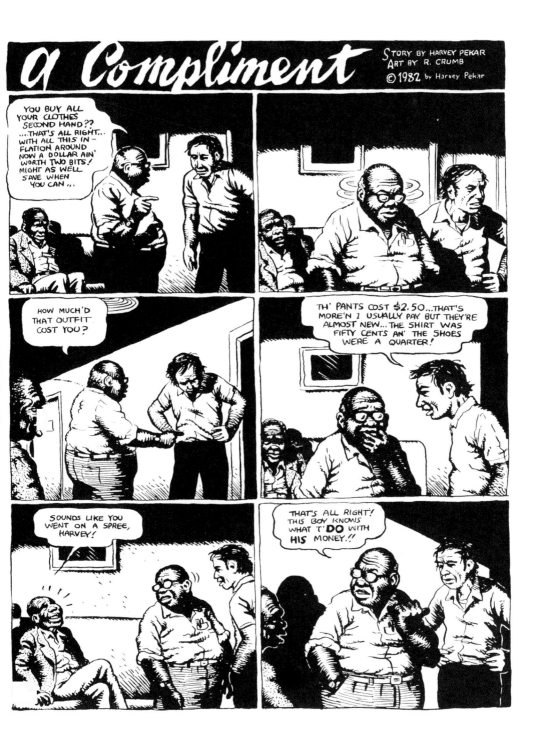

vision, in the beginning, was what must have seemed like the weirdness of his fame: a successful autobiographical indie comic book. The first Doubleday anthology had just been released, and received a rave review from Michiko Kakutani in the *New York Times*. When Letterman's producers called Pekar to book the show, he had never seen it before (he watched it twice to prepare for his own appearance). Letterman, in 1986, didn't seem to care much about the comics. Decades later the Cleveland *Plain Dealer* quoted Harvey's wife, Joyce Brabner, explaining she thought that Dave "confused Harvey being a comic-book writer with Harvey being a comic, which he wasn't." But Pekar mined his television appearances for his own comics stories, in this way creating a dialogue about those events: first, Letterman's edited version of events, televised (and filtered through a network team); followed by Pekar's edited version of events, drawn in comic-book frames (with an illustrator).

In the first appearance, Letterman goes light on the comics and heavy on the jokes aimed at Pekar himself as a Clevelander in New York City. The not-so-hidden subtext from Letterman, a former weatherman from Indianapolis, was "look at this midwesterner in the big city." In Pekar's version, though, titled simply "Late Night with David Letterman," he shows readers just how prepared he was for this. In several spare, elegant spreads, readers see Harvey, deeply suspicious of the corporate entertainment industry, thinking hard, anticipating the show: "I musta rapped with dozens a' faster guys in delicatessens," Harvey reflects. He decides his appearance will be adversarial in tone, and he explicitly makes it a class issue. "He's middle class, polite, he don't talk fast," Pekar thinks. "He ain't useta guys like me. . . . I got a lot of experience, but not on TV. It worked onna street corner, but will it work on TV?" What comes through profoundly in Pekar's account of the show, though, is how linked his identity as an artist really became with the city of Cleveland itself. A page of the story quickly shifts from discussing the *American Splendor* anthology to Dave's

question, "Now, how are things in Cleveland going?" The cartoonist known for listening to voices in the actual space of the city is now in a bigger city, in a studio, having a completely contrived—which is to say, staged—conversation. In a sense, the Letterman show, while also about conversation, is the opposite of *American Splendor*, which pivots on the encounter itself as spontaneous and organic—the unexpected exchange, the surprise meet-up. As novelist Ed Park describes *American Splendor* in the *Village Voice*, "In Pekar's world . . . a walk around the block could turn into a chamber piece of chance encounters and oddball conversations." The television talk show format, on the other hand, literally stages talk artificially—it's based on the contrivance of talk, whatever interesting thing may happen. It's not from the street, it's from the studio. So Pekar may have been in a much bigger city than Cleveland, but he's less impressed with the results. As Pekar said in his first appearance, "I ain't no show biz phony."

It got rougher, though, between Pekar and Letterman, although audiences enjoyed their antagonism. In 1987 Pekar appeared on the show wearing a T-shirt that proclaimed, "On strike against NBC." His comics story about this episode is called—a long and literal title—"My Struggle with Corporate Corruption and Network Philistinism." Pekar accused Letterman of scabbing a worker's strike, and he wanted to talk about how NBC's parent company, General Electric, manufactured arms and produced nuclear reactors. The two traded many insults, with Letterman accusing Pekar, in a class-inflected put-down, of having "bad manners." The following year, though, got even worse, with the conversation disintegrating into a flurry of heated insults during which Pekar told Letterman he looked like a "shill" for General Electric. Letterman lost his temper, told him he would never be invited back, denigrated the comics—he spitefully named *American Splendor* a "little Mickey Mouse magazine"—and called Pekar, unkindly, a "dork." The segment ended with the two of them yelling "you're full of shit" at each other, which was bleeped

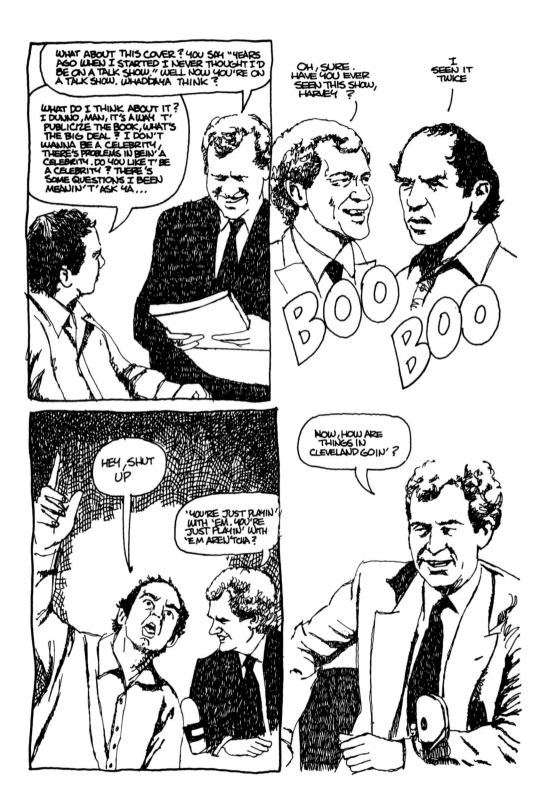

out, before Letterman said, "Cleveland, you have my deepest, most heartfelt apologies," and NBC cut to a commercial. On television, Pekar was gone after the break. In the comics story, though, we see him lingering in the set chair, alone, looking victorious. Pekar had actually touched a nerve. After Pekar's death, Letterman copped to his excessive reaction: "I loved Harvey. He was a wonderful guest. The kind you don't see anymore. The only real problem with Harvey was my immaturity."

There's something impressive about Pekar's ability to elicit spontaneous reactions from his interlocutors, even if, as in Letterman's case, those reactions stem from anger. The reason that he's a successful, if difficult, guest is that he brings the spontaneity of his comics—the rapping with guys in delis they document—to Letterman, despite the artificiality of the interview show format. Pekar was offered his own talk show in 1987 by the Fox network, which he declined along with other lucrative television deals: the contrivances of the studio felt like torture to him. With its capacity to record regular voices and create visual dimension for their speakers, comics was his medium, and his secure working-class job was his anchor. Pekar's accomplishment was to connect the two, within the economically depressed but still vibrant Cleveland, through *American Splendor*. Movingly, after Letterman, cruelly, calls him a dork on national television, Pekar says—and the two are speaking over each other here—"I was a file clerk before I knew you, and I'll be a file clerk after." Pekar stayed in his job at the VA hospital even after he got famous. He refused promotions and retired in 2001. "My lifestyle has not changed at all. I'm still the same schlep I used to be," Pekar said in an interview in 2006 posted on the website of Random

Harvey Pekar and Gerry Shamray, "Late Night with David Letterman," *American Splendor* #12, 1987.

Used by permission of Joyce Brabner (Harvey.Pekar.Estate@gmail.com).

House, one of his last publishers. As his character in the movie says, "Ordinary life is complex stuff."

Ordinary life (with some mystical elements thrown in) is complex, too, in the comics series *Love and Rockets*, the brainchild of three brothers from Los Angeles: Gilbert, Jaime, and Mario Hernandez. *American Splendor* and *Love and Rockets*, both early to emerge and long-running, appeared within five years of each other. Together, they set the tone for independent comic books of the 1980s and beyond: Pekar and the Hernandezes (known collectively as "Los Bros") brought the comics field in new directions. These artists reveal how comics, in its porous, democratic openness, is a mirror of the ongoing vitality of city spaces—their energy, hybridity, range of voices. Comics, as a spatial form, can evoke place powerfully, and also graphically detail it. But it can further in its form—its mix of styles and influences—reflect the multiplicity of those who inhabit cityspaces.

Like Harvey Pekar's Cleveland, Jaime Hernandez's Huerta, part of greater Los Angeles, comes to life in *Love and Rockets* as its own character—a fully-fleshed-out home for both its residents and readers to return to. *Love and Rockets*, which includes separately authored storylines by Jaime and his brother Gilbert—and sometimes their older brother Mario—has been running since the 1980s. Huerta, though, is a fictional city—although it is based on Jamie Hernandez's hometown of Oxnard, California. Pekar depicts marginalized working-class urban populations, and so does Hernandez—but *Love and Rockets* specifically focuses on Mexican American life in Southern California. Jaime's mother, Aurora, hailed from a poor part of El Paso, Texas; his father, Santos, came to California from Mexico and worked on a GM assembly line. The two met in Oxnard's fields and packinghouses.

And while *American Splendor* is about perhaps eccentric working-class people from distinct backgrounds making a go at getting by through working straight jobs (Pekar, after all, worked for the government), *Love and Rockets* is steeped in punk culture, self-consciously

positioning itself as outside the mainstream. *Love and Rockets*, as Hernandez has noted, focuses on outsider culture both by depicting Mexican American experience, and by depicting the anti-conformist culture of punk music, whose in-your-face, do-it-yourself attitudes inspired the Hernandez brothers to self-publish their comic book in the first place. The intersection fueled by the space of the Southern California city—Mexican American and punk—had never been represented in comics, let alone with female lead characters. Hernandez's effervescent Maggie Chascarillo and Hopey Glass, best friends and sometimes lovers, became iconic (they grace the cover of this book).

Nothing remotely like *Love and Rockets* existed before its first issue in 1981; it created its own context and went on to become the flagship publication of world-renowned independent comics publisher Fantagraphics. *Love and Rockets* deliberately sought to present something that was missing. "Even if we failed at it, at least we tried," Gilbert Hernandez said, explaining the brothers' thinking. "'Hey, look, here's this comic about punk rock and Hispanics. This is new and different.'" Unlike Pekar's fragmented dispatches in *American Splendor*, the Hernandez brothers aimed to tell stories about interpersonal interaction in greater Los Angeles and its barrios through complex characters and inventive, dramatic storytelling. Huerta—and specifically the barrio, or neighborhood, Hoppers 13—became a pulsing fictional world, textured so finely in its realism, its concrete details and dialogue, that anybody from any background could connect to its residents and their ordinary and extraordinary experiences. The cartoonist Adrian Tomine, creator of dozens of iconic *New Yorker* covers and 2015's acclaimed short story collection *Killing and Dying*, which has elicited comparisons to Raymond Carver, told me that when he first discovered *Love and Rockets*, "I really felt that I had more of a personal connection and investment in the lives of these fictional characters than in the real people in my life." The Hernandezes have also been a major influence on novelist Junot Díaz, who claims,

"American fiction is [still] catching up to *Love and Rockets*." (Jamie Hernandez drew the slipcase and chapter headers for the deluxe edition of Díaz's book *This Is How You Lose Her*.) Neil Gaiman, the novelist and comics writer, told the *Guardian*, "I don't really understand why the material of *Love and Rockets* isn't widely regarded as one of the finest pieces of fiction of the last thirty-five years. Because it is." *Love and Rockets* was recently voted the best nonsuperhero comics of all time by *Rolling Stone*.

Jaime, who was born in 1959, grew up as one of six siblings in southside, inland Oxnard (known as Scalon), a coastal city roughly thirty miles outside LA whose spaces included agricultural areas and suburban sprawl. Mario Hernandez called their upbringing "Dickensian"—the family was poor—but the siblings felt lucky to be encouraged in their comics reading and writing. In an effort to keep the children quiet in the small house, their father allowed comics, to which they were totally attentive, and encouraged them to draw their own comics in turn, with crayons on torn-up paper bags. Aurora Hernandez was not only tolerant, but was an actual dyed-in-the-wool comics fan of the Golden Age of the 1940s and '50s. She read the comics her kids brought home, and according to Mario, as long as they weren't getting Fs, she let the comics remain in the house. The brothers collected and hoarded them starting at a young age, clearing shelf space in their closet. The brothers never stopped reading, collecting, and drawing comics, even after their father died when Jaime was eight—they simply broadened their tastes and their skills. As his younger brothers edged toward adulthood, Mario noticed—as if suddenly looking one day at their comics with fresh eyes—that Jaime

Jaime Hernandez, page from "Wigwam Bam," *Love and Rockets #33*, 1990, featuring his central protagonists, Maggie and Hopey, attending a punk show that is monitored by helicopters and policemen. Characters in the central panel have tattoos or T-shirts that refer to LA bands Black Flag, the Germs, and X.

Used by permission of Jaime Hernandez.

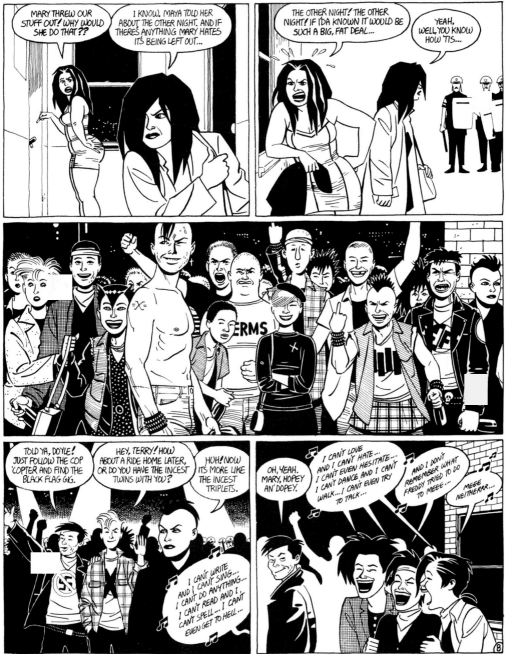

"I CAN'T DO ANYTHING" BY X-RAY SPEX

and Gilbert, who was two years older, were actually doing surprisingly professional work, just for their own amusement.

When Jaime attended junior college in 1978—which he claims was only due to a Social Security deal related to his father's death that paid out if he had college credits—art classes changed his life. He had already produced quality comics for years, many of which had sci-fi and adventure elements, just for his family's eyes (and a few fanzines), but as Mario saw it, when Jaime took life-drawing classes his style "just blossomed into what it is now"—as if his natural ability to draw so cleanly, to "make that one line fill volumes," had been unleashed. At this time punk was hitting LA, too, with bands like the Bags, Avengers, and the Zeroes emerging (alongside those noted in the previous caption). Along with life drawing, which unlocked his style, punk's vitality changed Jaime's life. "I was dead since sixth grade," he once told an interviewer—a feeling perhaps related to the death of his father a few years earlier—and then "I came back to life."

With its focus on regular people making their own culture with whatever means available, punk helped Jaime focus his comics on experiences in the barrio for people like him and his friends. This eventually became a bigger focus than the sci-fi storylines that took up a lot of space in early Hernandez brothers comics. "The rocketships got in the way, you know?" he explained in an interview. "And I thought, I'm more interested in this street-life thing that I'm doing. You know, and before punk, I was into the low-rider stuff. And so punk kind of made sense—it was gritty street stuff. And I go, that's where I come from! [*Laughs.*] And you add music to it—hey great!" Jaime and his brothers were in punk bands (Dr. Know); Jaime created flyers and handbills for local punk shows. Punk culture inspired him to create comics as a public platform, and it also, as a lifelong practice, became a subject of his comics, which depict that street life, and make many references to bands, gigs, and song lyrics. Jaime's punk flyers and comics influenced each other. Take the similarities between

his flyer for an Oxnard punk show, with its cholo man announcing a performance of the band Circle Jerks in a speech balloon filled with Mexican American slang (and humorous gang intimations), and the cover, years later, to the important *Love and Rockets* collection *The Death of Speedy*—which features a cholo man, the gangbanger Speedy Ortiz, in the same posture, palms beatifically turned outward, figured as Jesus.

Mario was so knocked out by Jaime's postcollege drawing that he proposed printing a Hernandez comic book. He borrowed money from their youngest brother Ismael to pay the printer, and arranged the self-publication of Jaime and Gilbert's all-black-and-white *Love and Rockets* #1, the pages of which the three of them then stapled and collated in Mario's living room. And so *Love and Rockets* was born as a family enterprise, inspired by do-it-yourself punk values, with Jaime and Gilbert each creating half the content for each installment. When, soon after, the brothers sent their work to Gary Groth, the publisher of Fantagraphics, they expected rejection—but instead were immediately snapped up. By issue #10, Jaime and Gilbert could live off of the proceeds from *Love and Rockets* (during the release of the first few issues, they still lived with their mother). In 1985, a band from England—best known for the eighties hit "So Alive"—named themselves Love and Rockets, after the comics.

Seth, the cartoonist behind *It's a Good Life If You Don't Weaken*, among other strikingly evocative graphic novels, has suggested that in comics "the combination of writing and drawing your world seems to set it apart from other kinds of world building." *Love and Rockets*

Jaime Hernandez, punk flyer, 1982, and cover for *The Death of Speedy: A Love and Rockets Collection* (Seattle: Fantagraphics), 1989. The inside brim of the cap worn in the flyer spells SCXCH—for Scalon x Chiques, the slang term for Oxnard (it means "Little Chicago," a reference to the underground West Coast marijuana trade that went as far as the Midwest).

Used by permission of Jaime Hernandez.

is about creating a world, which is to say, it is about articulating the unstable, always shifting intersection of location and culture, through both words and images. Both brothers' storylines are powerfully about place—and how and with whom those places get populated. Jaime's stories are centered in Hoppers 13, and most often star his signature protagonists Maggie and Hopey—the on-off couple whose exploits have come to be known as the "Locas" stories. Gilbert's take place both in Los Angeles (Junot Díaz once wrote me that Gilbert's collection *Love and Rockets X* was "LA as fuck"), and in the fictional Mexican village of Palomar. (This storyline has elicited many comparisons to Gabriel García Márquez.) A decades-long ongoing serial, *Love and Rockets* is less about plot per se than about richly conceived characters, and atmosphere, conjuring verbally and visually the space in which people live and move. And since its characters age with the comic, readers get the sense of following intimately drawn lives in what often feels like something approaching real time, producing investment in their affairs, jobs, roommates, grudges. As Alison Bechdel writes about Hernandez's comics, "Rereading the early Locas stories, I find that although my recall of some of the plots is hazy, all of the drawings remain vividly incised in my memory. . . . What remains is less a stylized world than a world distilled to its fantastic, magical, quotidian essence. . . . manifestly legible."

And what does Hernandez make legible in his urban tapestry? Lesbian lives, bisexual lives, immigrant lives, working-class lives, children's lives, women's lives, gangbangers' lives, ex-gangbangers' lives, punk musician's lives, second-generation lives—lives that hadn't flourished on the comics page before with such richness and such traversing of boxes and boundaries. The space of the city, home to so

Jaime Hernandez, page from "Locas at the Beach," *Love and Rockets #15*, 1985, featuring Maggie, an auto mechanic, and Hopey, a bass player.

Used by permission of Jaime Hernandez.

many distinct populations, generates the interweaving identities that Hernandez creates on the page. It means one thing when Ware draws a bedroom scene of a white couple in the suburbs; it means another thing when Jaime draws a bedroom scene of two Latina lesbians in a tiny, crowded apartment: comics as a way to put marginalized bodies and psyches on the page.

In a page from *Love and Rockets* that sweetly exhibits the rapport of lovers Maggie, an auto mechanic, and Hopey, a bass player in various punk bands, the two, at bedtime (and while a roommate curses at them to "shut the fuck up"), discuss the thorny intersection of gender, work, and immigration. Maggie describes her difficulty as a female mechanic servicing men who are embarrassed by her ability to help them. Hopey reminds her of their "old country" attitudes while Maggie in turn reminds her of the importance of present attitudes. Hernandez's comics, with their attention to "old" and new customs, traditions, and generations—and how they intermix—are influenced by a wide range of sources that speak to the diversity of LA as a fount of creativity and energy (Hernandez still lives in the Los Angeles metropolitan area). What many would consider fringe communities find full display in *Love and Rockets*, and Hernandez's openness parallels the city's openness, not only in the kinds of bodies that show up in his work, but also in the aesthetics of his comics.

The mash-up represented by city space, where so many practices and attitudes coexist, is an inspiration, and it is reflected in the aesthetic diversity that Hernandez's comics display. They are dense with references, and as inspired by the look of kids' comics *Archie* and *Dennis the Menace*, in which Hernandez recognizes an appealing warmth, as by confrontational LA punk bands and the weird genius of junk culture and lowbrow entertainment genres. The kitschy yet athletic world of female pro wrestling, for instance, shows up throughout *Love and Rockets*—Hernandez is a serious fan—entering the storyline most often through Maggie's aunt Vicki Glori, a wrestling champion and

entrepreneur. A long list of "some important art" compiled by Hernandez names all sorts of different high and low genres and forms and people, including "Edward G. Robinson, wax museums, Harry Lucey [of *Archie*], Fred Blassie [a professional wrestling villain], X, John Stanley, true ghost stories, R. Crumb." Speaking of ghost stories (and true ones at that): *Love and Rockets* copiously and elegantly mixes genres, so we see a gritty, on-the-ground realism combine with slapstick combine with touches of the supernatural. Isabel Ortiz, Speedy's sister, for instance (meditatively closing her eyes on the cover of this book), grows to enormous, magical proportions (a former gang member and author, she is known by some locals as the "Witch Lady"). *Love and Rockets* creates its meaning, and its emotion, out of a vibrant, and surprisingly unencumbered, blend of different genres that leaves open joy and mystery, levity and tragedy in its compelling creation of a multivalent, and multilingual, community.

Hernandez's comics, along with his distinctive characters themselves, wear this hybridity easily. *Love and Rockets* in its comics frames reflects the multiplicity of the space it enlarges for readers—in the characters' wide range of references, from underground to mainstream culture; in its visual attention to the tiniest details of space and sartorial style; in its attention to the interactions of "new" and the "old" worlds (as we also see in Pekar); in the aesthetic inspirations shaping Jaime's stark yet sumptuous line; and its constant, rich sense of possibility. Asked once if his comics, putting underrepresented lives on the page, were angry, Hernandez said, "It didn't matter if I was a Mexican anymore. I had the comic book, and I was going to show the world. . . . It was not so much angry art, the anger just helped me put it out. . . . I found ways of being angry and portraying beauty at the same time, you know?. . . . Gilbert has said this before, it's my love letter to the world."

WHY PUNK?

It was about advocating kids not to wait to be told what to do, but make life up for themselves, it was about trying to get people to use their imaginations again, it was about not being perfect, it was about saying it was okay to be amateurish and funny, that real creativity came out of making a mess, it was about working with what you got in front of you and turning everything embarrassing, awful, and stupid in your life to your advantage.

—Legs McNeil on punk, *Please Kill Me*, 1996

Just about anyone who has paid any attention to pop culture in the past thirty years can picture Bart Simpson. He has popping saucer eyes, a red T-shirt, and what looks like a crown of jagged hair. First appearing on television in 1987, Bart is the perpetually-ten-year-old Simpson family son who quickly became a globally famous figure for pugnacity and rebellious disrespect ("Don't have a cow, man!"). What few people know, though, is that Bart's iconic hairline is lovingly lifted from cartoonist Gary Panter's punk

everyman character Jimbo and his spiky hair—meaning that one of America's most beloved pop culture characters actually springs from a key figure in its groundbreaking punk scene.

In the late 1970s, *The Simpsons* creator Matt Groening and Gary Panter were both living in Los Angeles, in what Groening describes as "a couple of the sadder neighborhoods in Hollywood." Groening, who graduated from the Evergreen State College in Washington, had grown up in Portland, Oregon, while Panter hailed from Sulphur Springs, Texas; both moved to LA after college. Panter was scrounging illustration jobs. Groening was working, among other places, at a copy shop.

At the shop, Groening self-published—that is to say, photocopied—his darkly funny *Life in Hell*, which he would staple together and send to his friends in the Pacific Northwest, including cartoonist Lynda Barry. He also sold copies for a few dollars in the "punk" section of a local record store on Sunset, where he was an employee, called Licorice Pizza. The title was a reaction to living in LA. It featured anthropomorphic rabbits; its tone was existential and its star was the downcast Binky the bunny, also an everyman observer like Panter's Jimbo. Binky, who has big ears, wide eyes, and a pronounced overbite, is joined in the strip by Sheba, his on-off girlfriend; Bongo, a one-eared rabbit even more alienated than Binky; and Akbar and Jeff, fez-wearing humans who are maybe brothers, maybe lovers. "*Life in Hell* actually sold copies," Groening says. "Sometimes the punks would tear up copies, but sometimes I sold them."

Panter, whose own self-published comics Groening had read and admired, wrote him a fan letter in 1978. (Leonard Koren, who published an avant-garde lifestyle magazine called *Wet*, first showed Panter *Life in Hell*.) Groening describes being actually "frightened" by Panter's handwriting—today still known, which is to say admired, for its scratchiness and intensity—but he wrote back. The two met and became fast friends, plotting how to make art people would pay

attention to. Groening recalls how they would "scrape coins out of the carpet of our crummy little apartments and split burgers and then scheme about how to invade pop culture."

The two young cartoonists scraping to split some Astro Burgers between them would manage to succeed in that scheme. *The Simpsons*, Groening's wildly successful animated television creation, is the longest-running scripted American prime-time television show in history, and its insights and mottos have earned the status of cultural truth. "D'oh!," clueless patriarch Homer Simpson's exclamation, was added, in 2001, to the *Oxford English Dictionary*. Groening says he owes his success to Panter, who went on from their early, scheming days to win—among many other accomplishments—three Emmys as the set designer of the popular *Pee-wee's Playhouse*, the children's show and creative phenomenon that ran on CBS from 1986 to 1990. Remember the talking chair, Chairry, with her Betty Boop eyelashes and a mouth between the cushions? "Gary brought that psychedelic crazed Gary Panter style to Saturday morning, and he completely warped a generation of kids," Groening says. "Gary went first, and he was my role model."

Video still of Matt Groening comparing images of Bart Simpson and Gary Panter's Jimbo character (on the cover of *Jimbo: Adventures in Paradise*, Raw/Pantheon, 1988). Jesse Stagg and Alex Czetwertynski, directors. Produced by For Your Art.

Used by permission.

The punk scene that launched cartoonists Panter and Groening was part of a larger punk movement that hit America, and the UK, in the mid-to-late 1970s. Both political and aesthetic, the punk movement, which often registered as a visceral or even violent response to mainstream pop culture, encouraged people to create their own culture across many different forms of production. This includes, most famously, the music that came to be known as punk rock (the phrase *punk rock*, then, is sometimes used synonymously with *punk*). Punk culture often consolidated around bands, particularly their live performances, and the independent labels that developed to put out their music, along with the art and graphic design that went into their promotion—as well as the fanzines that articulated their ideas and goals. The "do-it-yourself," or DIY, ethic is the defining feature of punk culture and production. As Jaime Hernandez explained, he never realized he could be a cartoonist until he got involved with punk. "Then I thought, 'Oh, this is kind of the same thing,'" Hernandez told comics writer Neil Gaiman. "They were all the same to me, so if you could do that with punk, you could do that with comics."

"Punk" was a term for disrepute and outsiderness, resignified in the 1970s as an expressive, antiestablishment rejection of the "expert" and the corporate. The word "punk" had been used in the music magazine *Creem* to describe 1960s garage bands, and had appeared in gangster movies, in prison slang, and in Shakespeare's plays (usually as a synonym for "whore," as in "your French crown for your taffety punk" in 1605's *All's Well That Ends Well*). It makes an appearance in William S. Burroughs's 1953 *Junky*, in which the character Roy says, about two men harassing him, "Fucking punks think it's a joke." (Burroughs, in the oral history *Please Kill Me*, simply notes, "I always thought a punk was someone who took it up the ass.") In mid-1970s New York, bands like the Ramones, Television, and Blondie—the latter name a reference to the eponymous comic strip that began in 1930—were generating zealous attention, playing at venues like the

East Village's CBGB. But it was only after the fanzine *Punk* began publication in January 1976 in New York that "punk" began to become a movement one could identify. Before *Punk*, as Guy Lawley points out, people called the sound of these New York bands "street music." "It wasn't an original concept," founding editor John Holmstrom, a cartoonist, explains, "but it wasn't very well-defined, so starting a magazine called *Punk* took some nerve." Soon after, more bands and fanzines that understood themselves as explicitly punk cropped up (and later Legs McNeil, another *Punk* contributor, complained that the world incorrectly understood punk as English). The Sex Pistols, a band from London whose one studio album, 1977's *Never Mind the Bollocks, Here's the Sex Pistols*, initiated a widespread UK punk movement characterized by short, sped-up rock songs and anticonformism, gained transatlantic notoriety, especially when bassist Sid Vicious was arrested in New York for murdering his girlfriend in October 1978, four months before he died of an overdose. In Los Angeles, where plenty of bands were sprouting up, the highly influential punk fanzine *Slash*—which also birthed an important record label of the same name—launched in 1977, the year Panter and Groening both moved to the city.

Fanzines link punk and comics directly. Zines, as today they are commonly known, are independently published periodicals on a range of topics. They play a crucial role in the history of comics—an art form conventionally designed for print circulation—and in punk, a historical movement and ongoing system of values that prizes independence at the level of creation. The roots of zines and comics run deep together: teenage writer-artist team Jerry Siegel and Joe Shuster published the earliest incarnation of Superman in 1933 in their very own mimeographed fanzine *Science Fiction: The Advance Guard of Future Civilization*. And zines, with their DIY ethic, are a cornerstone of punk philosophy and its music specifically: they represent independence from the corporate, the building of community through the

circulation and exchange of knowledge, and a forum for promoting bands. One sees in punk zines—as one does with iconic punk album covers like the Clash's 1979 *London Calling*, a dark homage to Elvis Presley's self-titled debut album combining pink and green stylized letters with black-and-white photography—just how key the frisson between words and images that motors comics is to the punk aesthetic.

Groening and Panter's career trajectories demonstrate punk's role in contemporary comics—and also how the graphic novel today trades on so many of its values, including an emphasis on immediacy and the handmade, for what is now a mainstream audience. Alternative newspaper *The LA Reader*, founded in 1978, picked up *Life in Hell* as a weekly comic strip in 1980. Panter, who had also self-published, began publishing *Jimbo*, named after his signature character, once a month in *Slash* in 1978; he also created covers and design for the famed publication. Jimbo is an ageless navigator of a confusing world. Panter has said of Jimbo, who he has been drawing since 1974, "Jimbo is an observer. He is not very willful. His drives are simple. He is not stupid, but he is no genius. I use him to observe the places I put him in, which are satirical social, technological, and control situations."

Once Panter and Groening became friends, the two budding cartoonists drew comics together in a wild, apparently untrained style for punk zines such as *Flipside* and *Chemical Imbalance* under the monikers the Fuk Boys or the Shit Generation. Their longest collaboration, "Ocurence at Oki Dog," is an almost unreadably scribbled and dense two pages. It is also hard to find—before now it has never been reprinted outside of a fanzine. One dopey-looking character is rendered in a simple yet exaggerated style recognizable to any *Simpsons* fan and wears a T-shirt of LA punk band the Germs (Panter's first wife Nicole

Gary Panter, cover of *Slash* featuring Jimbo, Vol. 2.7, 1979.

Used by permission of Gary Panter.

Panter had been the band's manager until they disbanded in 1980). The speech balloons are full of the cross-outs that characterize punk's deliberately rough aesthetics. In the story, two friends set out in a car to hot-dog restaurant Oki-Dog, run over a pet cat, pick up a hitch-hiker with a hook for a hand, and fight that hitchhiker before the car crashes and he dies on the street. While today one thinks of Groening as the creative force behind one of the biggest, most recognizable entertainment properties in history, Art Spiegelman first knew Groening as "Gary's punk rock friend."

Born in Durant, Oklahoma, Panter is part Native American; his paternal grandmother was a Choctaw Indian. She lived with Panter's grandfather, who suffered from a liquor-induced paralysis known colloquially as jake leg, in the small Choctaw town of Talihina (Choctaw for "iron road"), Oklahoma, where Panter would visit as a child. Panter was raised a fundamentalist Christian in the Church of Christ in Texas: first in Brownsville, across the border from Mexico, and then in the small town of Sulphur Springs. His father ran a five-and-dime and painted traditional Western paintings on the side. Panter,

Panel from "Ocurence at Oki Dog," by Gary Panter and Matt Groening, as the Fuk Boys, in *Flipside* #33, 1982.

Used by permission.

by his own account, saw modern art in a magazine at age ten and became obsessed. In 1969, he went to Belfast as a missionary, but his interest in art soon overtook his dedication to religion. In 1971, he started keeping drawing sketchbooks, and shortly after he started producing his own pamphlets and zines. Panter earned his BFA in painting at East Texas State University in 1974.

Panter explains that he was "kind of waiting for punk rock. I was waiting for someplace I could plug in." He worked as a janitor in Texas before moving to LA, just around the time that punk rock was becoming a full-fledged movement. *Slash*, one of its signal publications, covered LA bands like the Germs, X, and the Screamers, in addition to groups like England's the Sex Pistols. In LA he found he could plug in.

Panter recounts to *Vice* that after moving to LA, one night he was walking down Gower Gulch—the nickname for the intersection of Sunset and Gower in Hollywood—and saw a copy of the first issue of *Slash* laying on a newsstand. He found its sensibility similar to his— "big crude graphic stuff that's probably out of fine art type of stuff, like [Robert] Rauschenberg and [Kurt] Schwitters." Panter explains, "I'd seen something in the paper about punks, and I thought, these are like creepy little neo-Nazis, you know—what a bunch of jerks. But mostly it was people out of art school who wanted to make something happen." In 1977, Panter created a poster that remains one of the most recognizable emblems of the punk movement: the stark, black-and-white graphic rendition of shrieking vocalist Tomata du Plenty of the Screamers, complete with a vertical signature reminiscent of Japanese painter and printmaker Katsushika Hokusai. This dramatic image became the Screamers official logo and one of the most nationally and internationally famous images to emerge from punk rock. It alone adorns the cover of the art book *Punk: An Aesthetic*. Panter's graphic sensibility came to substantially define the visual culture of punk, from band flyers, record sleeves, and cover art, to T-shirts and posters, comics, books, and fanzines.

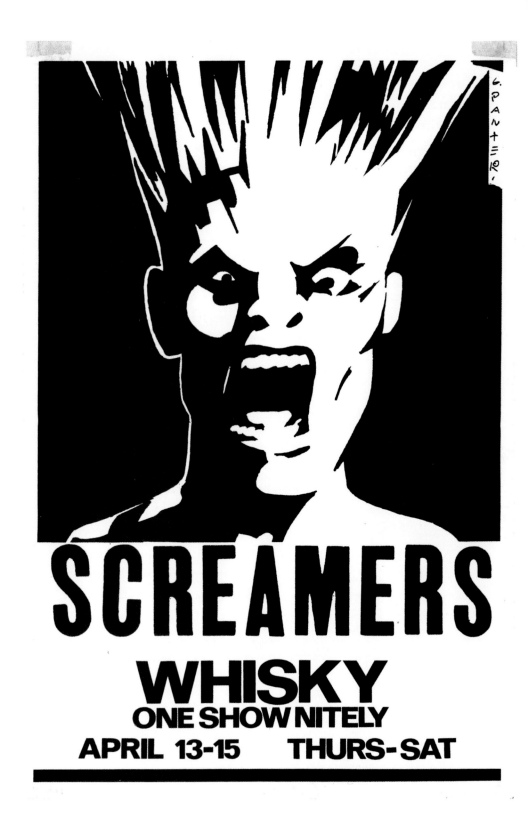

Graphic work like the Screamers flyer, with its forceful, clean lines, displays one aspect of Panter's artistic practice, but as he has pointed out, "I can draw in many, many, styles and invent styles to serve ideas." Today widely considered one of the finest drawers, or draftsmen, of his generation, Panter innovated contemporary art and punk by making a significant movement out of purposeful bad drawing. "That was the cool thing about punk rock," Panter explained at a conference I organized in Chicago. "It was just, get up there and do something. Start. And I like cruddy stuff. I always liked bad drawing." For Panter, "bad drawing" is when the shakiness of the hand is intentionally evident. Its unevenness or looseness, as opposed to being concealed and corrected, becomes part of the surface of the page. Panter's development of a dense, chaotic, messy style in drawing is perhaps his greatest contribution to punk specifically—and to post–World War II aesthetics generally, in comics and also in art and design circles. The resolute imperfection of his drawing style, which became known as the "ratty line" aesthetic, challenged audiences to confront drawing as expressive and material as opposed to merely illustrative and transparent.

Panter began making scratchy drawings in 1972, supposedly when his Rapidograph pen, a technical, even-weight pen and a cartoonist's staple, jammed up. Panter also notes the influence of growing up on the border of Mexico, where he encountered print shops that printed appealingly off-register. His textured, messy, febrile, forceful hand eventually became his trademark, and the ratty line became a defining feature of punk across the board. "Panter's scratchy, seemingly untrained line became as much a symbol of the era as fuzzy three chord loud songs," John Carlin writes in an essay on Panter's book *Cola Madnes* (yes, with one "s"). In Panter's comics, the deliberate

Screamers poster, art and design by Gary Panter, 1977.

Used by permission of Gary Panter.

"mistakes" often register in words, too: with misspellings, cross-outs, and visible redactions.

Panter is the innovator of punk comics; people sometimes call him the king or the godfather of punk comics. Lynda Barry (Matt Groening's best friend) recalled Panter to me this way: "Gary was beyond ahead of the pack. I mean, you didn't even know that you were in a race or on a racetrack or that you were a horse." Charles Burns created a 2-inch-high autobiographical booklet about the 1970s, in which he describes seeing Panter's work for the first time in the pages of *Slash*: "Somehow, with only a few pages of comics," Burns writes, "he managed to define a new whole aesthetic for me: punk comics. From that moment on I wanted to be a punk cartoonist too." Burns would succeed: in addition to his acclaimed graphic novel *Black Hole*, he recently released the punk-themed trilogy *X'ed Out*, and he regularly publishes a zine, which he gives out for free, titled, appropriately, *Free Shit*.

An amusing *Jimbo* strip from a 1979 *Slash* crystallizes Panter's expressive, mash-up aesthetic. Here, Jimbo, drawn in line art with freckles and a torn T-shirt, encounters two classic American franchises: Burger King and *Nancy*, the classic comic strip that stars an eight-year-old girl. (Buying cheap burgers, alone or together, is a recurring theme for both Panter and Groening; here perhaps it underscores the turning of Jimbo's luck.) Above the big letters of the title—drawn to look pixelated (or "raster"), like early 8-bit video games—is a heavily redacted, inked-up block of handwritten text in uneven capital letters. It's an idiom one also sees in the speech balloon above in "Ocurence at Oki Dog." Panter calls attention to the visual surface of the page, to the line or mark itself, as the unit of currency, as opposed to narrative coherence. The words readers can piece together make an absurd whole ("Jimbo never eat. Jimbo eat. He eat receipt," etc.). This strip also incorporates collage: an actual receipt from Burger King, peppered with realistically drawn flies.

The character Nancy, recognizable by her bubble of black hair and her bow—but rendered by Panter in an intentionally crude style—speaks in long articulate sentences. She confronts Jimbo about his dismissal of her strip, defending its style (its "machine-like precision"), absurdism, and humor. "It functions as a nostalgic buffer against future shock for a tired & technology-torn species," she explains to him. This installment of *Jimbo* is itself the conspicuous opposite of "machine-like" in its look. Yet it ends with Nancy accusing Jimbo—and therefore punk culture itself—of being contemptuous and superior and then further one-upping him by scolding him in the last panel for actually not being "punk" enough. "By the way, what's a guy in a so-called punk magazine doing walking around without a guitar?" she says, producing one as a gift. The strip concludes with Sluggo, Nancy's ill-behaved friend, violently demanding to join the hypothetical band. It is a self-reflexive strip about aesthetics that manages to also be light and funny. Its ragged lines, play of different styles, and black-and-white patterning produce what artist Mike Kelley called Panter's "elegantly brutal" work.

Panter shifted attention from graphic perfection to sheer graphic exuberance. In his marks on paper, one can feel the body on the page, etched into the surface. The embrace of the mistake, the scribble, and the rough-hewn created an unparalleled liveliness and energy in his drawings—it called attention to the grain of the line and became an aesthetic philosophy. Panter dedicated a 1979 *Jimbo* comic strip "To the Guardians of the Ratty Line." In an interview, he said, "I tried to embrace all the smudges and mistakes. That's analogous to punk." Chris Ware puts it well when he writes that Panter's comics "were the first to show how the hand of the cartoonist, usually sublimated in a considered, codified calligraphy, can tear into the surface of the page, and the reader's mind, if the artist wants it to."

While the ratty line became the hallmark of punk aesthetics, Panter's—and Groening's—career also demonstrates how comics ex-

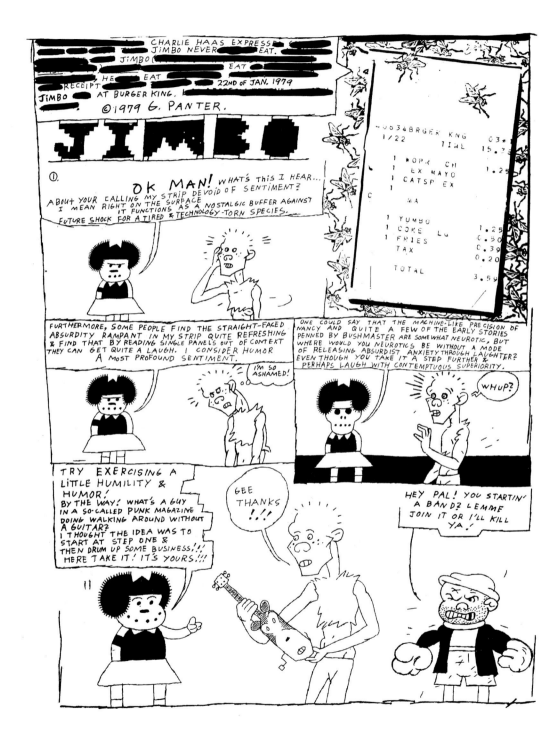

tended punk culture into the mainstream, exemplifying its values. The DIY ethic is the defining feature of punk; and it motivated comics culture for decades before "punk" even became a term to describe art. Fanzines first emerged in the 1930s, largely in science fiction readerships; in the 1960s, humor and comics fanzines also became popular. If self-published fanzines consolidated the punk movement, unifying and articulating its interests and goals, the DIY practice had been a crucial feature of comics for some time, from postwar satire fanzines to underground comics and beyond. Significantly, many of those who would become big figures in underground comics in the late 1960s and early '70s started in high school, with their own mimeographed magazines. A list of amateur titles by now-acclaimed cartoonists includes Art Spiegelman's *Blasé*, Justin Green's *Step-Up*, Jay Lynch's *The Vulgarmental*, Robert and Charles Crumb's *Foo*, Skip Williamson's *Squire*, and Denis Kitchen's *Klepto*. There is a generational shift from the "hippie" culture of Crumb to the punk culture of Groening and Panter, but the ethos is the same—comics is the realm of the democratic *and* the experimental.

Fanzines have a close relationship to the birth of independent comics. (In an ironic twist, Dr. Fredric Wertham, who wrote *Seduction of the Innocent* in 1954, which was responsible for crushing the mainstream comics industry, went on to publish, in 1973, the loving study *The World of Fanzines: A Special Form of Communication*.) Roger Sabin and Teal Triggs, the editors of *Below Critical Radar: Fanzines and Alternative Comics from 1976 to Now*, write that the overlapping zine and alternative comics scene is about "people making their own culture rather than consuming that which is made for them; [it is] about replacing institutionalized information with individual energy and expression; it is about [people] saying what they feel instead

Gary Panter, *Jimbo* comic strip in *Slash*, Vol. 2.4, 1979.

Used by permission of Gary Panter.

of corporations selling them a life." Their title, *Below Critical Radar*, comes from Spiegelman, commenting on the BBC about one of the benefits of working in a form where conventional cultural constraints do not apply in the same way they do for more mainstream forms. Both comics and the punk movement are often a cultural refuge for outsiders.

In the mid-to-late sixties in America, teenage fans of satire comics like *Mad* found one another through the mail and created their own teenage "elsewhere": a network based on an ethic of sharing information about comics form and method. As cartoonist Jay Lynch describes, "We all started drawing cartoons for [the fanzine] *Wild* and eventually we all started corresponding with each other, just asking questions about how each one had gotten various shading techniques." The proliferation of networking members in this youth community proved that the comics art produced in the fanzines served more than an aesthetic or satirical function, also serving a social function. As I note in the introduction, Crumb inaugurated the comics underground when he sold *Zap* in 1968 directly out of a baby carriage on San Francisco's Haight Street. A punk move before punk became a movement, Crumb's rejection of mainstream channels shows how self-published DIY comics offers a through-line across antiauthoritarian cultural movements in the second half of the twentieth century.

Underground comics, like the punk fanzines that appeared less than ten years later, rejected all mainstream channels of publication or distribution. The comics originated entirely with the artist, were self-published or published by loose collectives, and were distributed nontraditionally (hence the baby carriage). On the first page of *Zap* is the 1967 comic strip "Mr. Sketchum is at it Again!," a statement of purpose that we can understand applies to the whole fanzine and comics scene. One of the strip's last frames shows a kid waving at an artist from a faraway building. The artist in the strip, pencil behind his ear, exclaims, "It's a kid! And he's waving to us from all the

way over there! Must be miles! Isn't that amazing? See what I mean? Things like that are happening all the time in these comic strips." In this manner, Crumb explicitly figures his reasons for cartooning as opening lines of communication. Punk, too, was and is about an ethics of exchange, encouraging people to make their own art and media.

The connection between comics and punk was on display not only in LA. New York City's *Punk* magazine was started by three friends who had grown up in Cheshire, Connecticut: Ged Dunn, Eddie "Legs" McNeil, and the cartoonist John Holmstrom, its instigator and its editor. McNeil came up with the title, after rejecting Holmstrom's suggestion *Teenage News* (though none of them were teenagers), and the group plastered mysterious flyers all over New York City announcing, "WATCH OUT! PUNK IS COMING!"

Punk was a founding document of the movement, and from the very start it was a hybrid of comics and music coverage. Legs McNeil sees its creative genesis as a combination of the two: "The whole idea for *Punk* magazine came from two inspirations: John Holmstrom's teacher at the School of Visual Arts, Harvey Kurtzman, who was the cartoonist who had started *Mad* magazine, and the Dictators's [1975 album] *Go Girl Crazy!*" The enduring legacy of *Punk*'s intertwining of comics and punk rock can be seen in a recent box set by the echt-punk band the Ramones. This collection, *Weird Tales of the Ramones*, with a lush, faux EC Comics box cover, comprises almost a hundred songs *and* a gorgeously produced, full-color, fifty-two-page bound comics anthology featuring comics about the Ramones by twenty-five cartoonists including Holmstrom, Sergio Aragonés, Bill Griffith, Mary Fleener, Steve Vance—and Jaime Hernandez. The Ramones, so closely tied with *Punk*, have often made their love of comics known—for instance, by collaborating with Daniel Clowes for their video for "I Don't Wanna Grow Up."

Holmstrom's primary identity was as a cartoonist. As McNeil notes, he had attended the School of Visual Arts in New York, where

he obsessed over Marvel titles by Steve Ditko and Jack Kirby, followed underground comics, and had studied with the legendary Kurtzman. Holmstrom even worked as an office assistant for comics titan Will Eisner, who also taught at SVA, just a few years before Eisner's *Contract with God*. He performed his own "Cartoon Concerts," which mixed photography, comics, and sound in live performance. At SVA, Holmstrom thought "a marriage between these two unique art forms, rock 'n' roll and comic strips, was a historical inevitability." In a collected edition of *Punk*, he explains, "I wanted to use cartoons to break down barriers and change the world."

Punk offered a mix of comics and music reviews throughout its tenure (it ceased publication in 1979). Every issue had comics and cartoons, by Holmstrom and others, along with photographs and writing, and all of *Punk*'s reporting and commentary, in a style evocative of comic books, was hand-lettered, so that a feature credit might read, as in 1976's issue #5: "Bowie Falls to Earth! Review by Mary Harron—lettered by Holmstrom." (Harron went on to direct successful movies, including *American Psycho*.) *Punk*'s first issue featured an interview with Lou Reed, the hilarious "Rock'n'Roll Vegetable" (the title is a play on his album *Rock n Roll Animal*), which appeared partially in hand-lettered text, partially as a comic with references to *Zap* and EC Comics, and partially in photos. The cover, as in almost every issue thereafter, featured a cartoon of a performer. Holmstrom created a bug-eyed Reed for the inaugural issue. For an issue featuring Blondie, *National Lampoon* cartoonist Bobby London drew lead singer Debbie Harry in the spotlight, bleaching Harry's iconic hair and the moniker PUNK with the same electric yellow. (You can spot London's character Dirty Duck among the punks in the crowd.) A typical feature of the magazine was "punk fumetti"—a photo comic. In roundups of recommended new work, a frequent feature of fanzines, reviews of comics often interspersed with reviews of bands and records.

Robert Crumb even contributed to *Punk*. When issue #5 ran a parody of his *Mr. Natural* comic strip—"Mr. Neutral by R. Crumbun," which implied the title character was running out of steam—Crumb wrote in to the magazine. In a two-page letter *Punk* printed later that year, Crumb admits to being wounded by the parody, but comes around to stating his admiration for *Punk*. The last line of his letter, forging a link with comics, reads, approvingly: "And keep the hand-printing . . . don't listen to anybody who wants you to go suck . . . stay loose!" He followed with a P.S.—"I really am going to quit the Mr. Natural strip. . . . I was thinking about it anyway, but getting the issue of *Punk* #5 today in the mail was the convincer"—and several additional postscripts, including one in which he states, "I like you kids, don't get me wrong. . . ." He gives his permission for the magazine to reprint his work for free—the cultures of exchange model valued by both underground comics and punk (his drawings in fact do show up in later issues). Crumb's influence, and the ethos of edgy and yet democratic comics culture, can be felt throughout the run of *Punk*. The explicit links between comics and punk rock were not limited to the United States, either. In England, cartoonists like Savage Pencil—the nom de plume of artist and music journalist Edwin Pouncey—published comic strips in music magazines such as *Sounds*. Savage Pencil, who began his *Rock 'n' Roll Zoo* comic strip there in 1977, is one of the dedicatees in Panter's list of the "guardians of the ratty line."

On the pages of *Punk* and *Slash* and *Flipside* and *Search and Destroy* and many others, fanzines solidified, and advanced, the connection between comics and punk. Comics and punk revealed a shared aesthetic on the pages of fanzines: collage, word and image experimentation, immediacy in the line, celebrating imperfection. The fanzines gave a platform to musicians and to graphic artists and all sorts of people in between to understand themselves as part of a shared, oppositional culture that valorized direct self-expression, however

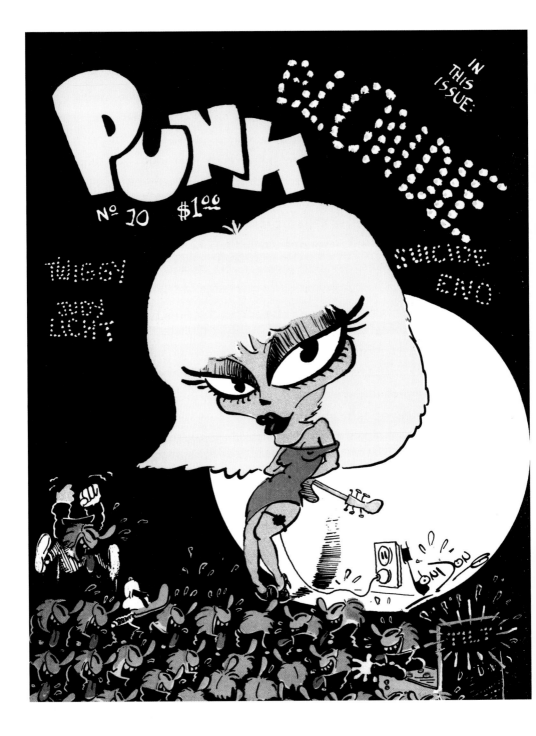

messy, "cruddy," or "ratty." And, perhaps most significantly, fanzines provided a model that unified punk music with the kind of production comics culture had been developing for years: DIY production and self-publishing. Fanzines were *about* that, and they *were* that too, assembled and distributed independently.

The whirlwind of energy in the 1970s around taking over the means of production for oneself gave rise to musicians and cartoonists and even fine artists. The common denominator was the idea of communicating directly and with immediacy, with no sacrifice of style—even if one's style was deliberately ratty. The artist Raymond Pettibon (born Raymond Ginn in 1957) bridges the worlds of comics and punk rock. Pettibon grew up one of five siblings raised Christian Scientist in the surfing town of Hermosa Beach, California. When he was twenty, his older brother Greg Ginn started the band Black Flag, one of the most famous hardcore punk bands in the world (Jaime Hernandez's Mohawked man holding a bottle in one hand and giving the finger on the other wears a Black Flag T-shirt in the punk show page from *Love and Rockets* reproduced in the previous chapter). Pettibon graduated with a degree in economics from UCLA, where he created editorial cartoons for the college daily paper. He briefly had a career as a public-school substitute math teacher, but he always wanted to be an artist; drawing was his primary medium. He designed the famous logo of four black bars, one of the most important logos in history, for his brother's band. The simple bars evoke the shape of a black flag flying, which represents anarchy, in distinction to a white flag of surrender.

"The symbol: it means as much to people as the music ever did," Henry Rollins, the band's singer, said in a documentary. The *Guard-*

Bobby London drawing of Debbie Harry for the cover of *Punk #10*, 1977.

ian reported the Black Flag logo is the most popular tattoo symbol of all time (actress Kristen Stewart caused a minor stir recently when she joined the large group of Black Flag tattooees). In addition to the logo, Pettibon created numerous band flyers and posters, building a powerful visual culture around Black Flag, attracting audiences and evoking rebellion and unrest. Hernandez described encountering a Pettibon flyer on the street for the first time and thinking, "Wow, comics and punk rock—I knew there was a connection!" Pettibon also self-published his first single-authored zine, *Captive Chains*, a noirish crime story featuring bondage and street gangs, in comics form. He published it in 1978 in an edition of five hundred—one of many such titles that combine word and image. Pettibon still makes zines as part of his art practice although he is now collected by museums worldwide. "I want to be as much as I can the democratic, no the soup kitchen artist," he said in an interview in 2008, adding that he would happily give away his zines for free.

Pettibon's drawing, springing out of LA's punk scene, is now understood both in the framework of fine art and comics. His iconic album cover for Sonic Youth's *Goo* (1990) is a drawing—with a catchy, comics-style word-and-image twist—of a 1966 photograph of the sister of the English murderer Myra Hindley and her husband. It is an instantly recognizable example of the interpenetration of comics and punk. *Goo*—the title refers to the blue, shapeshifting mermaid from the *Gumby* clay animation franchise—is one of the most famous rock album covers of all time. (The cover, inspiring more DIY practice, has spawned countless parodies including Chronic Youth, Sith Youth, Simpsonic Youth, Islamic Youth, Colic Youth, and, of course, Sonic Kitty; there is even a Tumblr called goomashups). Coming up

Raymond Pettibon, cover of *Goo*, 1990 (Geffen). The image first appeared in *Pettibon with Strings*, from 1988, of which about 60 copies were printed.

Used by permission of Raymond Pettibon.

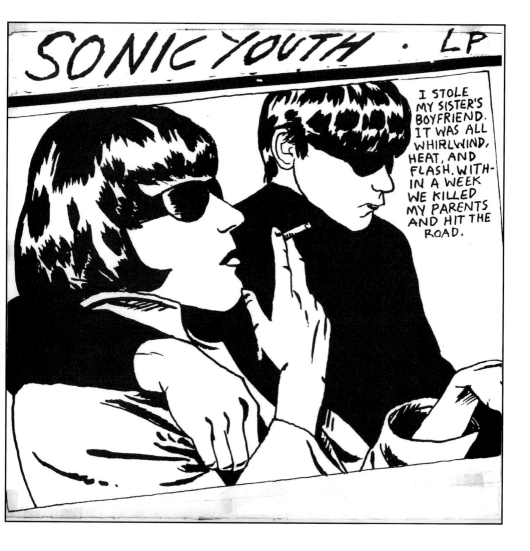

from the world of zines, Pettibon's style of drawing "is largely a comic style," as he sees it. Pettibon's drawings almost always combine images with captions he writes. "Where the image stops and the words begin is not that clear cut," he recently described his work to an interviewer. "It's more a give and take, a back and forth, dialectic almost in between the two." The "Comic Relief" issue of punk zine *Flipside* from 1982 that features Groening and Panter, writing as the Fuk Boys, also includes Pettibon, even more prominently. As with Panter—whose work now hangs in gallery and museum exhibits—Pettibon's artistic development was formed by the energies of DIY and print circulation.

By 1980, though, many of the famous punk zines had folded—they were important, but not always profitable, and after the initial burst of energy around punk many of them were hard to keep going as independent publications. Panter and Groening were undeterred. They had always schemed about how to infiltrate pop culture; they didn't want to stay at the margins, but rather to make art that would have an impact on wider culture. Panter published the Rozz-Tox Manifesto, a nineteen-item list, in 1980—it first appeared in chunks in the classified section of the *LA Reader* because it was free to print it there. The made-up term *Rozz-Tox* had appeared previously in Panter's *Jimbo* comics. The Rozz-Tox Manifesto was widely influential, and it is, essentially—and presciently—the story of comics. It urges artists and creators to "reckon with" society instead of rejecting its mainstream contours. So the Rozz-Tox advises, "Law: If you want better media, go and make it" (Item 15). "By necessity we must infiltrate popular mediums," Panter writes. "We are building a business-based art movement. This is not new. Admitting it is."

In the Rozz-Tox, which had a galvanizing effect on underground culture, Panter urges what he calls *recombination*, a mode of borrowing from all aspects of culture, high and low, old and new. Panter has also described his highly influential visual style as recombinant art. In the Rozz-Tox, he suggests—describing his own work and that of

so many cartoonists—that artists "extensively mine our recent and ancient past for icons worth remembering and permutating: recombo archaeology." What else is a hybrid word-and-image art form like comics, steeped as it is in popular iconography, if not recombinant? We see this aesthetic very specifically in Panter's work, for instance in his Dante-Jimbo mash-ups, the oversize hardcover books *Jimbo in Purgatory* (2004) and *Jimbo's Inferno* (2006), and in his book collection *Dal Tokyo*, in which he imagines a future Mars that is settled by Texan and Japanese workers. "Dal" in the title is short for Dallas— Dallas-Tokyo. Manifesting the idea of recombination, the *Dal Tokyo* strip was first published by the *LA Reader* in 1983, and later by a Japanese reggae magazine called *Riddim*.

Groening and Panter invaded popular culture, as the Rozz-Tox advised. Groening turned the smart irreverence of the Fuk Boys and his sardonic *Life in Hell* into one of the most popular television shows in the world. In 1984, Groening and his then-girlfriend (and future wife) Deborah Caplan, the *LA Reader*'s ad sales representative, self-published a collection of *Life in Hell* strips as a book, *Love Is Hell*. Groening says he made it to be square, deliberately, like a record album (the original edition is 12 by 12 inches), because he liked records and thought it could be sold in record shops. A few months later, Caplan and Groening had sold twenty thousand copies on their own. This success led to a deal with the publisher Pantheon, which reissued the book in 1986 (retaining the square shape at 9 by 9 inches). Caplan, who founded a company with Groening, organized wide syndication of the strip. The *Village Voice* called *Life in Hell* "the funniest, most sneakily radical strip in the country."

After he self-published the first *Life in Hell* collection, Groening's readership grew with *Work Is Hell* (1986), *School Is Hell* (1987), and *Childhood Is Hell* (1988), among others. His deceptively simple comics mix humor and darkness, as well as presenting ingenious layouts, like the fake magazine cover, and checklists. For example, "Your

Childhood Trauma Checklist" is a grim and also moving strip with rows and rows of boxes to mark, such as "punished for telling the truth," "being hit by parent," and "first realization that death is permanent." Groening often uses repetition of the frame, with labels, for comic effect, as in "The 22 Stages of Heartbreak," in which each stage is one fixed-perspective panel displaying Binky's expression as he navigates "slow sinking sensation," "deep despair," "sudden rage," and "heart of stone," among others, before the final stage: "ready for further punishment."

In 1985, when the television and movie producer James L. Brooks was putting together *The Tracey Ullman Show,* a variety show for Fox, his team came up with the idea to incorporate Groening's *Life in Hell* as short animated segments, called "bumpers," to separate out the sketches. A *Life in Hell* original drawing, of the harsh, clever strip "The Los Angeles Way of Death," had been given to Brooks a couple of years before as a gift. (The nine same-size frames present these ways to die: GUN; CAR; DRUG; SEA; AIR; COP; WAR; FAILURE; SUCCESS.) Groening, when approached, rejected giving up the rights to *Life in Hell,* so he sketched a different set of characters for Brooks—the Simpsons, based loosely on his own family. Fox, which vastly underestimated how big *The Simpsons* would become, struck a deal with Groening. (Among his many lousy jobs in LA was being a chauffeur, washing dishes at a nursing home, and landscaping at a sewage treatment plant; Groening is now hugely financially successful.) The bumpers were so popular that *The Simpsons,* as we know, became its own prime-time TV show in 1989.

The Simpsons decisively changed the idiom of contemporary television. It proved those wary of putting an animated series on prime

Matt Groening, "The 22 Stages of Heartbreak," © 1984 by Matt Groening. *Love Is Hell* (Pantheon Books, New York).

Image courtesy Bongo Comics Group.

THE HELL WITH YOU

RIP

CHAPTER XII:
THE 22 STAGES OF HEARTBREAK

LOVESTUFFER'S TEXTBOOK

○ DO NOT WRITE AND PUBLISH ANY BOOKS WHILE IN THE MIDST OF COMPLETE AND UTTER HEART-BREAK.

HERE'S VOL. 1 — THEY'RE ALL SONS OF BITCHES

SLAM!

THE FINAL SLAM! AND THERE YOU STAND! ALONE! IN SOLITUDE! ALL BY YOURSELF! SPOOKY, ISN'T IT? AND THIS IS ONLY THE BEGINNING....

THE FIRST FLINCH

AMAZEMENT

DISBELIEF

SHOCK

SLOW SINKING SENSATION

PAIN

EXTREME PAIN

PAIN PAIN PAIN

PAIN + WEEPING

DRUNKEN STUPOR

PAIN + WEEPING + HANGOVER

DEEP DESPAIR

SUDDEN RAGE

DEEPER DESPAIR

SELF-PITY

SELF-LOATHING

SEETHING HATRED

GLOOM

HEART OF STONE

WOUNDED BUT ALIVE

OCCASIONAL PERKINESS

READY FOR FURTHER PUNISHMENT

time wrong, and paved the way for many new shows in an era when television animation for adults was not an obvious choice. "Matt responds on a broadly populist front," Panter has said, "and reminds the populace they aren't as backward-thinking as they think they are." Even while working on *The Simpsons*, Groening continued to produce *Life in Hell*, which ran for thirty-five years, ceasing only in 2012.

Panter worked for CBS, creating enduring cultural icons for *Pee-wee's Playhouse* that were deeply weird in addition to actually being famous. Paul Reubens, who played Pee-wee, had studied performance art at California Institute of the Arts, and approached Panter in 1979 to create a poster for his stage show. Panter continued to design the posters, sets, and puppets for Reubens as his fame grew, eventually becoming the head designer for *Pee-wee's Playhouse*. The unique Panter-fueled aesthetic of his television show, wacky and yet intelligent, referencing older American popular culture yet tinged with the futuristic, made it a cultural benchmark (as major profiles around a 2016 *Pee-wee* movie affirmed, decades after the show became a smash). The show featured a veritable who's who, including a young Laurence Fishburne along with Phil Hartman, S. Epatha Merkerson, and many others; Mark Mothersbaugh from the band Devo wrote its theme song. "It was a show made by artists," Panter said. Panter won three Emmys, and was nominated for five more. (He sent his award statues to his mother back in Texas.) An essay published in the *Daily Beast* on the enduring significance of *Pee-wee*'s design suggests, "Instead of recreating the heart of the twentieth century as a nightmare, it turned the best parts of those decades into a funky paradise."

Panter and Groening both worked for major television networks in the late 1980s, and created new aesthetics for the mainstream. Eventually, so too did Pettibon. While he produced literally hundreds of zines from 1981 to 1992, he became an actual art world star in the 1990s. (Many of these zines are currently owned by MoMA, which also has exhibited objects from *Pee-wee's Playhouse*.) In 2013,

Christie's sold an untitled acrylic, ink, and pastel image on paper—an image of a surfer amid dense waves, with Pettibon's signature associative caption—for $1,575,000. Pettibon, along with artist William Kentridge, brought new attention in the contemporary art world to *drawing* as a practice and as a fine art object.

Punk thus turned a corner and became something else, something wider. The new era was marked, perhaps, by Panter's appearance in *Raw* magazine, founded and edited by Spiegelman and Françoise Mouly. In 1980, the same year that *Slash* folded, Spiegelman and Mouly self-published *Raw*, a high-end oversize magazine, before it was picked up by Penguin, which opened a new era for comics and wider readerships. Panter's first *Raw* cover, in 1981, won industry awards. It is a close-up image of a grimacing punk named X, in color, adapted from Panter's black-and-white *Okupant X*, the experimental 1977 book that collapses television, science fiction, comics, and performance art references and styles. This issue of *Raw* carried an appropriate tagline: "The Graphix Magazine That Lost Its Faith in Nihilism."

In 1989, for its inaugural issue with Penguin, *Raw* published Panter's cover image of Nancy mashed up with Popeye mashed up with Picasso's Cubist art—to name just one striking example of "recombinant art." Panter's artwork had by that point become closely associated with *Raw*, the game-changing magazine that made larger audiences than ever before take stock of comics.

Raw #2.1, the issue with Panter's mash-up adorning its cover, also presented a roster of cartoonists so evidently fresh and talented that they came to define the contemporary graphic novel field. These include Charles Burns (his story "Teen Plague," the prototype for *Black Hole*), Richard McGuire (his story "Here," which developed into the dazzling experimental graphic novel *Here*), and Art Spiegelman (his self-reflexive "Time Flies" chapter, the most important and most cited section of *Maus*).

The cover of *Raw* #2.1 is a typically brilliant Panter image. The

soft mess of red lines under the right eye looks forceful and delicate at the same time—it could indicate a bruise or a blush, something violent or something elegant. In 2000, in an irony not lost on Panter's fans who know his devotion to car culture exhibited in *Dal Tokyo*, Panter won a prestigious Chrysler Design Award, given to individuals in architecture and design who have "significantly influenced modern American culture." The range of Panter's artistic practice is huge, and it continually leaps over commercial, fine art, and grassroots boundaries. Panter moves in the world of design, as well as in the world of fine art as a painter (he graced the cover of *Modern Painters* magazine in 2015), and he is a drawer in many different iterations, including self-publishing cheaply made and inexpensive Jimbo comic books, which in today's parlance are called *minicomics*—a term for self-produced work. In 1993 Panter went back to Texas—Texans and religious fanatics are a comfort zone, he explained to me—to report in words and images for the *New Yorker* on the David Koresh–Branch Davidian compound standoff, in the full-color, five-page "Waiting for Waco." Panter's handwriting, which had frightened Groening in 1978, isn't tamed for *New Yorker* audiences—it's up-front in the piece, shaky, uneven, and ratty—and it extends that magazine's aesthetic range.

Punk profoundly influenced comics, and comics profoundly influenced punk. Today, punk rock's historical era is over, but comics is an art in which we can recognize its values—the weirdness and the alterity along with the accessibility—while comics also extends its reach into the mainstream, abandoning none of punk's energy while also creating new models for art. Cartoonists in the 1970s and '80s did want better media—and they did go and make it.

The desire to make experimental work for a wide audience defines

Gary Panter, cover of *Raw* #2.1, 1989.

Used by permission of Gary Panter.

RAW

CHARLES BURNS
TEEN PLAGUE
FROM
OUTER SPACE

KIM DEITCH
TOM DEHAVEN
50'S COMMIE
NOSTALGIA

JACQUES LOUSTAL
EATING DISORDERS
IN CENTRAL
FRANCE

BEN KATCHOR
THE PURPOSE
OF LANGUAGE

ART SPIEGELMAN

MAUS

NEW CHAPTER

OPEN WOUNDS FROM THE CUTTING EDGE OF COMMIX

how we can think of the best comics today. And Panter, along with other cartoonist punks, created a culture of immediacy and expressivity that has become key to how we understand and articulate ourselves today. The DIY ethic, and the value placed on the accessibility of low production values for high impact work, rhymes with the significant focus on the handmade evident, for instance, in the phenomenon of Etsy, the hugely successful online retailer that that has offered new models of self-distribution and is "the place to buy and sell all things handmade." Creators from diverse backgrounds and contexts are producing more printed zines and minicomics than ever (at Quimby's Bookstore in Chicago, for instance, there are fabulous zines made by eight-year-olds). At the same time, if in printed comics one recognizes core features of punk, such as its no holds-barred content, devotion to reproducibility (which is to say, communication through circulation), attachment to self-publishing models, and pressure on traditional modes of gaining expertise, one also sees this now online. In the contemporary proliferation of blogs, which encourage uncensored, direct communication, and webcomics, in which an artist can circulate her work easily and immediately, the energies of punk have found a new platform.

ACTUAL SIZE
OF THE
BIOPSIED
WORMY
BASTARDS

ARISA

WHY ILLNESS & DISABILITY?

With *Binky Brown*, comics went practically overnight from being an art form that saw from the outside in to one that sees from the inside out.

—Chris Ware on Justin Green, 2009

It was simple and that's really what I'm like on the inside, I feel like. That picture is *me*, more me than I am.

—Allie Brosh on *WTF with Marc Maron*, 2014

One of the signal features of comics is its immediacy, as its role in developing the visceral and action-oriented punk movement makes clear. To invoke cartoonist Gary Panter again on punk philosophy: "It was just, get up there and do something. Start." Two different artists working in the "get up and start" mode, almost forty years apart, created new idioms for expressing illness. They went out on a limb when similar work didn't yet exist, and in so doing, revealed just how richly comics can present the consciousness of a person suffering from a mental disorder. Justin Green's

pathbreaking underground comic book *Binky Brown Meets the Holy Virgin Mary*—the very first autobiographical work in comics—about a young man with debilitating obsessive-compulsive disorder, and Allie Brosh's deeply personal, massively popular webcomics collection *Hyperbole and a Half*, about a young woman with depression, are crucial works in the comics canon. Green was an innovator of underground comics; Brosh of webcomics. Underground comics, as an unrestricted, below-the-radar cultural and publishing movement, finds an analogue in today's webcomics, a platform that similarly aims for direct, uncensored, immediate communication.

Stories about illness and disability use the show-and-tell aspect of comics so basic to its hybrid form to reveal hard-to-convey truths about sickness or ability, and profoundly shaped the comics and graphic-novel field today. It is no coincidence that the risky founding work of comics autobiography is about a young man with debilitating obsessive-compulsive disorder. *Binky Brown*, the ambitious forty-four-page underground comic book from 1972, serious and personal, set the terms for the "graphic novel" field to come. It is also no coincidence that Brosh's *Hyperbole and a Half*, a breakout webcomic of the same title that drew as many as five million unique readers a month to her blog before becoming one of the twenty-first century's best-selling graphic novels in 2013, is about depression.

Even when graphic novels had much, much less cache than they do now, formative works in the field were generated out of illness and disability. We see this with Green's inaugural comics autobiography, *Binky*, and later with early graphic novel titles such as English cartoonist Al Davison's 1990 *The Spiral Cage*, about his spina bifida, and Harvey Pekar, Joyce Brabner, and Frank Stack's 1994 *Our Cancer Year*. While Pekar's *American Splendor* is about recording the ordinary, this book, coauthored with his wife, Brabner, and drawn by Stack, actually centers around an extraordinary event: Pekar's diagnosis with lymphoma. (He ultimately died, in 2010, not of cancer but

rather of an accidental overdose of prescription medication.) David Wojnarowicz's AIDS-focused *Seven Miles a Second*, a collaboration with cartoonists James Romberger and Marguerite Van Cook, was released posthumously in 1996 after the art star's death from AIDS at age thirty-seven. First published by Vertigo, DC's darker adult imprint, it has become a cult classic. Chock-full of beautifully colored surrealistic images, *Seven Miles a Second* presents Wojnarowicz's anger, frustration, and sadness about his disease and its effect on his community. Other important early titles addressed the AIDS crisis, too, even in very different contexts, such as MTV's *Real World: San Francisco* star Judd Winick's graphic novel *Pedro and Me*, about costar Pedro Zamora, the Cuban American AIDS activist who died of the disease at age twenty-two while the show was airing.

Comics about illness, and disability—both mental and physical—have multiplied hugely over the past twenty years as people have recognized the form's immediacy and its diagrammatic ability to display otherwise hard-to-express realities and sensations. The capacity of comics to be diagrammatic—representing objects in space and in time, showing and telling—serves the authors of many different kinds of stories, from those that shed light on institutional spaces like hospitals to those that present details like the measurements of a core biopsy needle—drawn in Marisa Acocella Marchetto's *Cancer Vixen* at actual size. Also appearing at full size is a drawing of her biopsied tissue. Comics's diagrammatic quality allows Marchetto and others to easily diagram medical equipment and procedures, providing specific, visual information about treatment and process. Comics can lend itself to didactic diagrams, in addition to storytelling ones, that don't feel disruptive in the flow of a page. Brian Fies's *Mom's Cancer*, for instance, within the unfolding story, effectively explains, describes, and reproduces X-rays of his mother's cancer before and after chemotherapy.

Comics can make visible both external features of a condition,

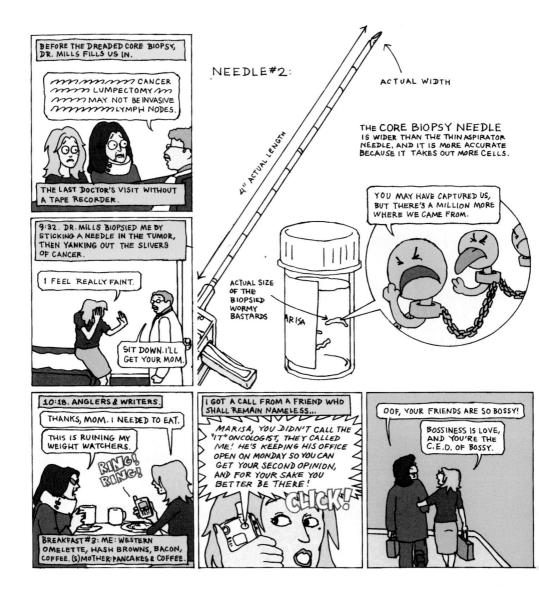

Marisa Acocella Marchetto, page from *Cancer Vixen* (New York: Knopf), 2006: Marisa undergoes a core biopsy accompanied by her mother.

and internal, cognitive and emotional features that are otherwise hard to communicate accurately. There is a large body of work depicting individual experiences that are hard to imagine existing in either words or pictures alone. Cancer, one of the leading causes of mortality worldwide, is a common theme of seasoned comics professionals and field newcomers alike. A short list of graphic novels about cancer, after Pekar, includes Stan Mack's *Janet & Me*; Miriam Engelberg's *Cancer Made Me a Shallower Person*; Marchetto's *Cancer Vixen*, Fies's *Mom's Cancer* (which initially was a popular webcomic before it was picked up by Abrams); David Small's *Stitches*; and Jennifer Hayden's boldly titled *The Story of My Tits*. There is profound autobiographical work about epilepsy (David B.'s *Epileptic*, an international sensation translated from the French); chronic pain (John Porcellino's *The Hospital Suite*); herpes (Ken Dahl's *Monsters*); lupus (Julia Wertz's *The Infinite Wait*); Alzheimer's disease (Sarah Leavitt's *Tangles*); and anorexia (Katie Green's *Lighter Than My Shadow*), as well as titles like Cece Bell's award-winning young-adult-oriented *El Deafo*, based on her own childhood growing up deaf. Today we see trenchant, path-setting books about mental illness by Green and Brosh, and also by many others who have distinct points of view in thinking about illness. While we have Ellen Forney's *Marbles: Mania, Depression, Michelangelo, and Me*, a graphic memoir about the author's own bipolar illness, we also have Darryl Cunningham's sobering *Psychiatric Tales: Eleven Graphic Stories About Mental Illness*, based on his work as a health-care assistant in a psychiatric ward in the UK.

The number of these kinds of stories are growing, so much so that the recent international "graphic medicine" movement can claim a large body of work related to its central concern. The authors of the *Graphic Medicine Manifesto* define their movement as focusing on the overlap of comics and the "discourse of healthcare," broadly conceived. The *Graphic Medicine Manifesto* was published in 2015 by six authors—a mix of practicing doctors, nurses, and professors—and

received a rave review in the *New York Times*. The relationship of text and image is a crucial medical and diagnostic issue. Late twentieth-century medicine, as critic Jared Gardner points out, saw a drive "to replace patient narratives with data derived from ever more sophisticated diagnostic technologies," including imaging technologies understood to be "objective" and accordingly weighted more heavily than patients' own subjective descriptions. Comics's mix of words and images can convey key information that is otherwise hard to share or communicate. Graphic medicine is interested in comics that seek to find a way to depict complicated experience accurately—in both words and pictures alike, and in the spaces of meaning between them.

This includes the experiences of doctors and nurses as well as patients. Welsh physician Ian Williams, one of the manifesto's authors who maintains www.graphicmedicine.org, depicts the trials and tribulations of giving medical care in his own graphic novel *The Bad Doctor*. Comics both by and for doctors and nurses about administering care and medical education now join comics about the experience of illness created by patients themselves. A few years ago a psychiatrist in the West Bank wrote me about using comics to help people with trauma. And a doctor at the University of Chicago Medical Center contacted me recently about advice on developing a comic for patients about how procedures and care happen in the often-confusing physical space of the hospital.

Illness and disability have also entered into graphic fiction in powerful ways: as we've seen, Charles Burns's *Black Hole* centers on a made-up infectious disease whose symptoms and emotional effects Burns portrays in vivid visual detail. Notable recent comics hits across the genre spectrum feature amputee protagonists, as in Chris Ware's *Building Stories*, whose unnamed heroine has a below-knee amputation and several prostheses, and Marjorie Liu and Sana Takeda's *Monstress*, whose heroine Maika is amputated at her left elbow. While the former is a fine-grained realist epic, and the latter is a popular femi-

nist fantasy, both works confront the reader with large, unadorned, powerful visual images of bodies deemed "imperfect" or lesser than.

Illness and disability are also part of the DNA, so to speak, of superheroes—which often relates to their traumatic origin stories. Often for superheroes a condition of disability is countered by an amplification of another part of the body, creating their extraordinary abilities, as Marvel's Silver Age comics make particularly clear. Daredevil (Matt Murdock) is blind from a radiation accident, but has enhanced senses and reflexes known as "radar sense." The X-Men's Professor X (Charles Xavier) is wheelchair-bound, but has such powerful mental abilities he can transcend his physical body. Iron Man (Tony Stark) has a chest injury—shrapnel near his heart—that is countered by his invention of a mighty electromagnet that also powers his special armored suit. Hawkeye (Clint Barton), for part of his history, is apparently deaf—he has worn hearing aids in various comics—but has incredible visual acuity (hence he's a master marksman). And the body of the DC superhero Cyborg (Victor Stone) is crushed in an accident, so his scientist father—who had experimented with enhancing his son's intelligence—upgrades him to a cybernetic body to match his intellect.

And perhaps most famously, there is Barbara Gordon, a character in the Batman universe first introduced in 1967 as the daughter of Gotham City police commissioner Gordon, and the most iconic version of the superhero Batgirl. In Alan Moore's controversial *Batman: The Killing Joke* in 1988, Gordon was paralyzed in a gun attack by

Marjorie Liu and Sana Takeda, full page image from *Monstress* (Portland: Image Comics), 2015, of Maika, a war survivor, who opens the series at a slave auction in which disabled bodies—hers and others—are judged and marketed; Chris Ware, full page image from *Building Stories*, 2012: the protagonist thinks about her body in its barest form.

Used by permission of Image Comics and Chris Ware. *Building Stories* image courtesy Chris Ware.

the Joker. Confined to a wheelchair, Gordon then became the superhero hacker and information broker Oracle, with superior intellectual prowess and computer skills—just in time for the explosion of the Internet. Oracle went on to cofound an all-female superhero team called Birds of Prey, which generated an over-twenty-year-long series beloved by fans. The Oracle character was retired by DC in 2011 when the company did a full reboot of their entire universe of characters, to the anger of many, especially when Barbara Gordon was resurrected as an able-bodied Batgirl who had been cured by an operation.

But while DC earned flak for retiring a character with a physical disability (and an iconic spunky female hacker at that!), Marvel has, to its credit, fascinatingly experimented with the comic-book format in order to address itself specifically to visually impaired fans of its blind superhero Daredevil, allowing the representation of a disabled superhero to actually innovate the way the company thinks about audience. In 2011 Marvel released an audio edition of their new *Daredevil* #1 for free on their website, in conjunction with the comic book (it can still be found online at Marvel.com). The blind-friendly audio version runs about twenty-six minutes long, and is read by Marvel editors voicing and acting different characters, like a radio drama. In a brief introduction to the audio version, a Marvel senior editor claims they got the idea because the company got so many letters from visually impaired fans who noted their friends had to read Daredevil comics out loud to them. While there isn't yet a braille version in the works, braille is often closely and accurately represented (as are various assistive technologies) in the comic book itself, and fan sites have speculated it might be a possibility. The popular *Daredevil* television show on Netflix, following suit, has added optional audio descriptions in addition to spoken dialogue, and inspired think pieces about its representation of disability.

But it is Justin Green's *Binky Brown Meets the Holy Virgin Mary*, the very first work of autobiographical storytelling to appear in comics,

that is the ur-text of comics illness and disability narratives. Green's devotion to his own highly private, painful obsessive-compulsive disorder as the central plot point of a comics story was unprecedented and threw the field wide open. Further, *Binky Brown* is a fully designed, stand-alone comic book with a single story front to back, calling attention to the fact that the subject matter deserves the integrity of its own space, covers, and binding. As Art Spiegelman writes in the introduction to the deluxe edition of *Binky Brown* published by McSweeney's in 2009, "Today a forty-four page work might seem like only a throat clearing exercise . . . but back in The Day"—the day of underground comics production in the 1970s—"forty-four pages was an epic." To return to a point from the introduction, while many designate Will Eisner's *A Contract with God*, a series of four linked vignettes, the first "graphic novel" because it used the phrase on its cover in 1978, this honor could just as easily be awarded to Green.

The ambition and seriousness of purpose *Binky Brown* demonstrates—to take on something hard, and private, in comics—directly inspired Spiegelman to create his three-page "Maus" story about his parents the same year, and inspired Aline Kominsky-Crumb and Robert Crumb, along with countless others, to create comics with the stuff of their own lives. Green not only influenced Spiegelman as a cartoonist, but also as an editor. His encouraging, taping-speed-to-a-nudge-letter move refused to let Spiegelman off the hook for creating "Maus" for *Funny Aminals*. "One point of my pentagon-shaped Pulitzer Prize belongs to him," Spiegelman writes, noting, "Before Justin Green, cartoonists were actually expected to keep a lid on their psyches and personal histories, or at least disguise them into diverting entertainments." And Green's founding work of comics autobiography is about communicating the experience of illness. Today we see on social media how powerful the inclination is to document and to share images, in photos and videos, from one's own life. But certain interior states—especially ones produced by illness, and mental

illness specifically—are not as easily photographable through a lens. With *Binky Brown*, we see how drawing ("making a picture") can document realities that cameras ("taking a picture") cannot capture.

Green grew up Catholic in Winnetka, Illinois, in a family with five kids. His mother was Irish Catholic. His father, who was Jewish, was a hardworking man who became a highly successful industrial real-estate agent (he was making more than his own father, a kosher butcher, by the time he was ten, employed as a batboy for the Chicago White Sox). Green loved comics from the time he was tiny. In a touching anecdote in the afterword to *Binky Brown*'s newest edition, he describes walking by himself at only age four to a "distant variety store" with a couple of dimes "burning a hole in my pocket" and his home address safety-pinned to his shirt. As a child in Catholic school, Green read *Treasure Chest*, a Catholic comic book that was distributed every month for free; later he became obsessed, like almost every cartoonist in this book, with the sophisticated satire of *Mad*. In the aforementioned afterword he also describes setting out on his bike—he would have been ten—during an actual blizzard to get a copy of *Mad* #26. Recurring theme: as a child Green happily risked his physical safety to procure comic books. In high school Green took weekend life-drawing classes at the Art Institute of Chicago, and later enrolled in the prestigious art school Rhode Island School of Design (RISD) for a BFA in painting. While Green loved comics, he aspired to be a fine artist.

In college, as a foreign exchange student studying in Rome in 1967, Green had a revelation when he saw "a little cartoon by Robert Crumb in a tattered European underground paper." (Crumb, often without his knowledge, was fairly widely disseminated in Europe from early on in his career.) Green was disenchanted by the airless-

Justin Green, cover of *Binky Brown Meets the Holy Virgin Mary*, Last Gasp, 1972.

Used by permission of Justin Green.

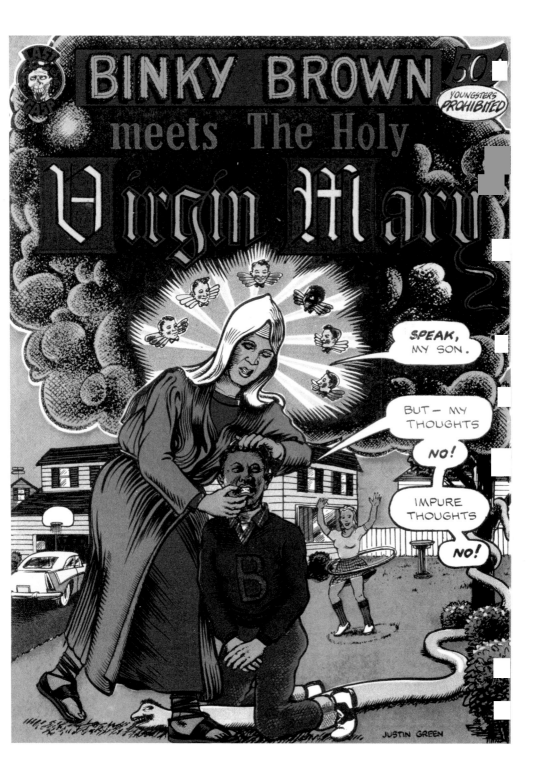

ness of art school, which felt pretentious. Abstract Expressionism was the dominant idiom, and Green's own oil painting was abstract, although he longed for the chance to create (unfashionable) realistic imagery. Hoping in Rome to learn from Renaissance masterpieces, Green found the city's landmarks were so filled with tourists they felt hard to enjoy or contemplate. At a conference I organized, Green explained that the unexpected encounter in Rome with Crumb's drawn line, from his strip "Itzy and Bitzy in 'Cause and Effect,'" felt like "a call to action." Crumb's marks on paper seemed full of a vitality and energy that had been missing in Green's own artistic practice, and Crumb felt more electric to Green than the classical art in Rome. He describes how Crumb's characters "had a sculptural quality, as if they were made out of Silly Putty"; he admired the playfulness and joy the drawing exuded in addition to the evident craftsmanship. Green went on to earn his degree from RISD in 1968, and very briefly enrolled in graduate school at Syracuse before quitting painting altogether and deciding to move to San Francisco to join the burgeoning ranks of underground cartoonists.

In 1971—the same year his first cousin William Friedkin would win an Academy Award for directing *The French Connection*—Green began *Binky Brown*. In his black-and-white comics, befitting his background, Green exhibited what underground cartoonist Spain Rodriguez deemed a "Catholic Style": clarity of line, academic realism, and observance of perspective. In 1995, its original publisher, Last Gasp, reprinted *Binky Brown* in a book collection of Green's comics. *Binky's* enduring significance over generations was sealed in 2009 when the acclaimed literary publisher McSweeney's, known for its high production values and experiments with print, reissued it as a deluxe, 10-by-14-inch clothbound edition, presenting facsimiles of the original artwork at full size.

Green embarked on *Binky Brown*, after publishing some shorter underground pieces, "out of an internal necessity to define the psy-

chic components of a specific condition"—obsessive-compulsive disorder (OCD), an anxiety disorder. The National Institute of Mental Health defines OCD, which afflicts approximately five million people in America, as a condition in which a person has "reoccurring thoughts (*obsessions*) and behaviors (*compulsions*) that he or she feels the urge to repeat over and over." Green describes his OCD, in an interview, as a "spatial and temporal relationship with Roman Catholic icons, architecture, and doctrine that has been resounding in my life for almost forty years." Green's OCD—like many people's—is fundamentally about controlling one's relationship to space, and arranging objects and oneself in space. And comics is a form that is structured at the most basic level by the arrangement of objects in space. We see this both within a panel (like Spiegelman's comparison of drawing panels and packing a suitcase in chapter one) and with the meaningful arrangement of panels themselves on the page or screen. *Binky Brown* is not only the first comics autobiography, but it is also the first literary work, whether fiction or nonfiction, about OCD, anticipating, in Green's own words, "the groundswell in literature about obsessive compulsive disorder by almost two decades."

Comics is a form, then, that rhymes with, and perhaps can even replicate, compulsive spatial focus and arranging. Alison Bechdel's *Fun Home* details her childhood OCD, which is in part about the location of her body in space: in the book, before the child can cross any threshold, she needs to tabulate the number of edges and subdivisions in front of her. Soon she realizes that in all threshold spaces, and indeed between all solid objects, hangs an invisible substance that she needs to clear away. In an interview with Bechdel about her ritualized and complicated practice of producing comics, she added, "I do like to describe my drawing process as a barely harnessed obsessive-compulsive disorder." Green, in an essay on OCD, referred to his disorder as "codifying every square inch of space"—another formulation that also describes creating comics. Noting the differences between

writing a novel and writing a graphic novel, Bechdel once noted that today one could write a book and never physically touch one's own prose at all, whereas when she wrote *Fun Home*, "I had to touch every millimeter of all of the pages." Green pointed out at the conference that a cartoonist needs to be very exacting about space, explaining: "The slightest little flick of the hand like a thirty-second of an inch makes all the difference in an attitude or a gesture."

Cartoonists of autobiographical comics often encounter the claim that their work is "cathartic," and yet that notion has always seemed to be exactly the opposite of the labor-intensive, and often obsessive, process of composing comics. Once asked if making *Maus* was cathartic, Spiegelman responded that it would be like the catharsis of making "a 100-faceted wooden jewel box." In other words, not cathartic at all. Putting one's experience into little boxes in space doesn't lend itself to the purging implied by catharsis. It's like building a visual, material, counter-edifice to express a mental edifice, a mental structure. Green describes comics the following way: "The true craft requires the precision of a jeweler along with the fortitude of a cobbler, and neither discipline comes easily." *Jeweler, cobbler*: it's the connection of intricate parts to one another—one mark to another mark, panels to other panels, words to images—that makes up the stuff of comics.

So what made Green turn to comics specifically for this story of mental illness? He made the work, as he explained, to define the psychic components of an illness—not only for himself, but also for an audience of readers, which he could do through the revealing form of comics. At the outset of the book, Green's character Binky Brown is a thirteen-year-old boy growing up rigorously Catholic in Winnetka in the late 1950s. (The choice to call himself "Binky Brown" is unrelated to Matt Groening's rabbit Binky from *Life in Hell*, and presumably a play on Green's last name and the abjection the protagonist feels: a hopeful, verdant green turned to depressing, stain-like brown.) In some respects Binky lives what might seem to an outsider like a nor-

mal young life: he goes to school, rides his bike, climbs trees with friends, squabbles with his siblings, reads comic books. As his body develops, however, he can't help but to see the Virgin Mary, who is represented all around him, including in his home, as a potentially naked woman, which causes him terrible, crippling anxiety. His connection with religion is both punitive for him and potentially arousing. One early panel juxtaposes the hairs escaping a nun's habit with the imagined pubic hairs of a girl on the beach.

Binky is so distressed about his involuntary sexualization of Mary that he comes to believe "penis rays" emanate from his penis and

Panel from Justin Green, *Binky Brown Meets the Holy Virgin Mary*, showing the title character understanding his hands and feet, in addition to his penis, as phallic objects that can emit harmful "rays."

AS OUR SPECIMEN PASSES THROUGH PUBERTY TO YOUNG MANHOOD, THE WIERD RAYS CONTINUE TO BEAM FROM HIS PECKER, HANDS, FEET, AND THE LONGITUDINAL LENGTH OF WHATEVER OBJECT COMMANDS HIS JERKY ATTENTION SPAN. WHETHER HE IS STANDING, WALKING, SITTING, SPITTING, EATING, SHITTING, TALKING, LIS-TENING, FUCKING, LAUGHING OR CRYING, HE HAS ONE EYE ON THE NEAREST STATUE, PAINTING, OR "SECONDARY ELABORATION" (ROSARY, EVEN BOOK THAT MAKES REFERENCE TO MARY). BUT BINKY LIVES WITH THE DILEMMA BY WARDING OFF MADONNA THOUGHTS WITH REPEATED INCANTATIONS ("NOVATIN", "NO", "ME NOT SIN",ETC.) AND BY CONSTANTLY RE-POSITIONING OBJECTS AND HIS BODY.

1959

1971

can potentially harm Mary should the ray interact with a statue of her or with other religious icons and symbols. A famous panel from *Binky Brown* shows him masturbating miserably, with the ray evident, thinking, "How can this little thing cause so much trouble?! Why was I ever born? Wish I coulda been a girl!" Binky becomes obsessed with policing his sexuality. As Green explains in a later essay, "Even glancing at a woman's fully clothed breast was counted as a venial sin. The hourly sin count became so great that it was impossible to function normally." Eventually any object longer than wide, including his own hands and feet, figures as a penis to Binky, with damaging rays he must prevent from crossing, and, in his mind, physically interacting, with any pictures and statues depicting Mary and any religious objects or edifices in general. Some painful images from *Binky Brown* show him running outside, for instance, on two feet that he feels are—and draws to be—two erect penises. Like Burns's precisely detailed panels of molting and rotting skin in *Black Hole*, these images force an uncomfortable looking for the reader, an encounter with physical and emotional states made confrontationally concrete.

Eventually, after a long and sincere losing battle to try to control his uncontrollable thoughts, and the rays, and a crystallizing event in which he fantasizes about Mary while praying in church, Binky, still a teenager, officially leaves Catholicism, figuring that he's sure that he is already damned for eternity. But his OCD does not abate even after he is no longer a practicing Catholic. The rays still emanate from all phallic objects, including his penis, hands, and feet. A powerful tier-wide timeline, which begins in 1959 and ends in 1971, presents five successive Binkys, each one a little taller and differently styled than the last. The rays emanate, crisscrossing, from all parts of his body,

Justin Green, panel from *Binky Brown Meets the Holy Virgin Mary* (San Francisco: McSweeney's), 2009, facsimile of original art, 1972.

Used by permission of Justin Green.

hands and feet included, as Binky grows up and navigates the world. Even though he rejected the church, "our lady looms over him as a supernatural reality." He is still desperately tethered to his OCD even in 1971, using stopgap measures we see him develop as a child, such as incantations (the made-up "noyatin," which stands for "no sin") and "constantly re-positioning objects and his own body," whether he is "standing, walking, sitting, spitting, eating, shitting, talking, listening, fucking, laughing or crying." Finally Binky decides to literally smash his idol in his own cleansing ritual in his San Francisco apartment; he buys a dozen small Madonna statutes that he destroys with a hammer.

What was and remains so striking about *Binky Brown* is how Green visualizes his obsessive-compulsive imaginings—the way he depicts his visual imagination as concrete on the page. Penis rays, in his drawings, actually make physical contact with other objects. Green the artist draws the rays as existing in space, as his character experiences them. Here we see how drawing can offer a picture of a consciousness—a mental state or a psychic landscape—that is internal to an individual. Green translates his "mind's eye" into a visual form on the page that readers can encounter and understand.

Readers, then, can witness what Binky experiences when he exits his home "imperfectly": the stairs literally fly out and grab him by the shoulders. Aligned with Binky's consciousness (if not his actual optical viewpoint), we see this actually happening in the panel; readers confront Binky's interior reality, however surreal. Chris Ware points out that Green's work inaugurated comics as a form that "sees from the inside out"—and hence could address itself to complex internal realities. Later on the page depicting the aggressive anthropomorphized stairs, Green writes in a box of text that Binky was "susceptible to bizarre, compulsive commands." In the image below, Green draws a small male angel, shaped like an adult man but perhaps a quarter the size of a human, hovering above Binky's head and touching his finger to Binky's nose as he barks

out orders. Comics can render metaphors concrete on the page in order to make an experience vivid—as when Brian Fies draws his mother in *Mom's Cancer* actually swimming in a sea of fine print. And, perhaps most significantly, through its word-and-image form, comics can depict a range of hard-to-picture effects of the individual experience of illness—especially mental illness, in which one person's reality may not be easily shared by others. The stairs rebuking Binky are not metaphorical, but represent an actual interaction in his own mental landscape.

Further, comics can bring together different versions of a self on a given page, which helps to convey the experience of a mental illness like OCD. Within the frame readers see a younger version of the author—the adolescent Binky, say, running down the street—and they also read that character's spoken words or private thoughts in speech balloons or thought balloons within the frame. And readers also read retrospective narration, which usually appears outside of the action of the story, above or below the frames. This represents yet another version of self (perhaps older and wiser). The retrospective narrative voice in *Binky* appearing above or below the frame creates a tension with the protagonist's voice from within the frame.

This is key to communicating what Green calls the double vision of OCD: both the recognition that an obsession or a compulsion isn't rational, and the profound need to execute its mandates anyway. Green identifies the *double-trackedness* of comics form—its pairing of commentary in text boxes with action unfolding in frames—as something that itself mirrors the OCD "double vision." Both *Binky* in particular and comics in general, Green has observed, carry the double vision that characterizes the condition of the disorder. This double vision of comics allowed Green to portray the most private and intimate moments from his life—say, masturbation and religious visions—and also to portray himself as what he calls "a specimen." In *Binky*, the narration even refers to the protagonist as "our specimen," instead of "our hero," as we see in the timeline panel. Green created

a new form of comics self-expression that deliberately presents the autobiographical self as both a looking self (a subject) *and* a looked-at self (an object).

Green went on from creating comics to make a living as a master sign painter—a trade, like comics, all about spatial precision, handcraft, and stylized letterforms. (One of his several post-*Binky* book titles is *Justin Green's Sign Game*—comics about sign painting!) He married the cartoonist Carol Tyler, a *Wimmen's Comix* contributor who is the author of a trilogy about her father's experience in World War II, *You'll Never Know*. (They first met while he was driving a city bus in Chicago.) Unlike many of the most important underground cartoonists, he is not prolific. Green and Tyler now live in Cincinnati, where Green is back to creating comics more regularly after a fall from a ladder during a job in 1990. He has a major retrospective show at the historic Carnegie Galleries in Kentucky in 2018.

Binky Brown Meets the Holy Virgin Mary, the 1972 comic book that was printed on cheap newsprint, sold around forty thousand copies, a robust figure for an underground title. "I'll never forget seeing the unpublished pages," Spiegelman recounted of visiting Green's home, "hanging from a clothesline stretched around the drawing table and all through his living room . . . and knowing I was seeing something New get born." Green set an example for cartoonists, and he also earned admiring and bewildered responses from cultural heroes including writer Kurt Vonnegut and film director Federico Fellini (speaking of film, his cousin Friedkin had a smash hit the following year with *The Exorcist*, which actually does not feel that removed in some ways from the tortures of *Binky*). Spiegelman has described how *Binky*, although it was out of print for over twenty years, never faded

Justin Green, page from *Binky Brown Meets the Holy Virgin Mary*, 1972.

Used by permission of Justin Green.

away: it was an instant classic, and photocopies eagerly exchanged hands for years; it was "long a secret of the cognoscenti," Spiegelman writes.

Even within the already independent-minded underground, Green was, in the early 1970s, a recognized originator of DIY publishing: he created a series of self-published comics titles in a series called *Off the Cuff*—single sheets of letter-size paper, xeroxed on both sides, and then folded and stapled to become an eight-page booklet—and sold them for 7 cents. While these booklets are a far cry from the gold-embossed hardcover that would house *Binky Brown* thirty-seven years later, they suggest, along with the personal and financial risk Green took to produce *Binky Brown* in the first place, how the urgency to create a direct, uncensored account of the experience of illness led to the creation of new formats and genres.

The same is true of the cartoonist and writer Allie Brosh, born in 1985, whose *Hyperbole and a Half* comics grew out of her desire to chronicle her life—and specifically, to communicate her experience of severe depression. Brosh, a biology major and a track athlete at the University of Montana, began drawing and writing about her life using Paintbrush, a free Mac computer program for basic graphics, and posting her comics and observations to her personal blog (also free). *Hyperbole and a Half* is one of the most fascinating and moving success stories in comics of the past decade—and it suggests that today's webcomics, a democratic playground, are the new underground comics: a self-publishing platform in which the artist has total, unrestricted freedom to communicate directly with audiences and to create, unfettered, whatever she wants. In Brosh's case, that is a funny, profanity-laced, sad, weird world of adventure and feeling that probes Brosh's depression by investigating the nature of causality—especially in family incidents from childhood—and the nature of empathy, between humans and also between humans and animals.

Brosh hilariously anatomizes her dogs' inexplicable behaviors, and

her own past behavior—like the time she broke into a room of her grandparents' house from an outdoor window in order to devour an entire birthday cake, or the time she convinced her mother to take her to a birthday party while Brosh was under heavy sedation. These stories frame those in which she turns to her circumstance of depression in the present. In Brosh's meditation on causality in *Hyperbole and a Half*, her childhood self comes into vivid focus. How did certain patterns or inclinations get set? How does Brosh understand her childhood behavior to produce insight about her adult problems? One of the funniest *Hyperbole and a Half* stories is "Warning Signs." Like all of Brosh's stories, it combines comics made with Paintbrush—hand-drawn words and images in frames—with typeset text.

Brosh recounts how when she was ten she buried a crayoned letter in her backyard addressed to her future self at age twenty-five. The letter, when she remembers it and amazingly finds it in the ground seventeen years later, makes her feel profoundly "weird about myself." Of the six questions she asks her future self in the letter, four are about dogs; she also introduces herself to her future self by name, as if the older Allie wouldn't know; and, perhaps most devastatingly to the older Brosh, the letter's last line is "Please Write Back": her child self thought her adult self might actually write back from the future. In response, Brosh brilliantly composes the rest of the story as a series of letters to her younger self at troubled ages (four, five, six, seven, ten, thirteen). The final letter is addressed to "Dear other iterations of my past self," and compliments them "for not being so goddamn weird that I felt I had to address you personally in a letter for the future." As with Green, Brosh's comics picture different versions of self interacting on the page.

What started out in 2009 as one young woman's personal blog—one she confessed to starting in order to procrastinate for a physics final—quickly became a phenomenon. Particularly popular were Brosh's posts delving deeply into the experience of depression.

Brosh's post "Depression Part Two," from 2012, got an astounding 1.5 million hits in a single day. Brosh is prodigiously talented, as her unique humor and aesthetic make evident—and she without question touched a nerve, and galvanized a community, by so directly addressing depression through comics. In 2013, her webcomic was published as a colorful, nonchronological, eighteen-episode book collection by Simon & Schuster, titled *Hyperbole and a Half: Unfortunate Situations, Flawed Coping Mechanisms, Mayhem, and Other Things That Happened*: it became a #1 *New York Times* best seller. The *Times* book critic Dwight Garner wrote that it "foreground[s] offbeat feeling and real intellect" and reported that his wife "wept with pleasure" while reading it. *Advertising Age* named Brosh one of the fifty most influential creative figures in the world. Psychologists praised Brosh's account of depression, and she was profiled in *Psychology Today*. Even Bill Gates wrote a long, rave review on his blog *GatesNotes* asserting, "*Hyperbole and a Half* gave me a new appreciation for what a depressed person is feeling and *not* feeling. . . . [She has] the observational skills of a scientist, the creativity of an artist, and the wit of a comedian." Scott McCloud, who included Brosh in the volume *Best American Comics 2014*, called her "one of the most widely read cartoonists on the planet."

Brosh was born in Auburn, California, and moved to Sandpoint, Idaho, with her parents and little sister when she was eight. She struggled with ADD as a child, and her battles with her parents around her hyperactivity and willfulness show up in *Hyperbole and a Half* (as do her mother's initial struggles with their very rural location: in one episode, her mother takes her daughters for a walk in the forest abutting

Allie Brosh, page from "Warning Signs." From *Hyperbole and a Half: Unfortunate Situations, Flawed Coping Mechanisms, Mayhem, and Other Things That Happened* by Allie Brosh.

Time travel is a complex subject that I don't expect a ten-year-old to fully understand, but this is more than just a basic misunderstanding of time travel.

their house and the trio becomes desperately lost for hours). Brosh's profound lifelong love of animals, particularly dogs, helped shape her childhood, as her comics make clear. She graduated from the local Sandpoint High, where she was a state champion cross-country runner, and was successfully recruited by the University of Montana for a running scholarship. She married longtime boyfriend Duncan Hendrick, a runner and a fellow science major at the University of Montana, in 2012; the two eventually moved to Bend, Oregon. Brosh, to her great surprise, began to be able to support herself through the sale of the *Hyperbole and a Half* website's merchandise in 2010.

Brosh was a creative child, with no access to what she calls "passive entertainment," and often wrote and drew her own stories to amuse herself. (She has explained that her rural upbringing, with the forest at her disposal, allowed her to be a "weirder" kid than she might otherwise have been.) When her parents first got a computer, she told the magazine *True/Slant*, she liked to use it to draw in Microsoft Paint, a program (much like the later Paintbrush for Macs) that is included free in all versions of Windows. She even drew in this program when, as she puts it, "I was bored in my dorm room in college," as she puts it. But it wasn't until Brosh, still in college, saw the "rage comics" meme circulating on the Internet that she became inspired to draw for her own blog.

"Rage comics" first appeared on a simple, open-to-anyone image-based online message board called 4chan (4chan.org). The original rage comic, posted to 4chan in 2008, is a four-panel strip that begins with a crude drawing of a person defecating and then getting splashed by toilet bowl water, ending with a close-up of a loosely scrawled, angry screaming face, surrounded by lots of capital F and U letters. This face launched the meme. In the democratic culture of the Internet, it became a widely shared and used template: the comic was reposted many times, and online audiences edited the comic to adapt the face to tell different stories. Eventually other simply drawn faces—and not

all of them angry, but all of them adaptable—joined the rage comics movement. It was an accessible way for people, especially young people online, to use humor and create stories to express themselves. This was very appealing to Brosh. "When I first discovered rage guy," she recounted of the face that started it all, "I laughed for ten minutes straight at just the one picture. I literally could not get myself under control. I don't know what it is about it, but it triggered something in me that made me want to start drawing again." Brosh began adding comics and drawings to her written blog. (And several of her own pictures, such as one with the words "CLEAN <u>ALL</u> THE THINGS!" above an image of herself holding a broom in one hand, and raising a fist of determination in the other, have now become Internet memes.)

As a stand-up comedy fan, Brosh found that comics brought the "physicality" of what she admired in stand-up to her storytelling: "facial expressions, body posture, tone of voice." Around the time *Hyperbole and a Half* took off in 2010 (then hitting two million monthly visitors), she told an interviewer that she had decided to start making pictures the previous year because "I've always had this frustration surrounding trying to tell a story properly—it never seems to come out like it felt." The combination of words and drawn images remedied that frustration. In Brosh's hands we see how adept comics can be at sharing the complicated internal processes of depression. As she once remarked, in a Talks at Google appearance, with nonverbal cues "you can say 1,000 things at once."

Part of the appeal of the rage comics faces is how expressive they are in their simplicity; they capture something for people in their reduction. Brosh's comics, created in Paintbrush, which offers only rudimentary brush tools and fill tools, look simple, basic, even childlike: they are minimalist, largely devoid of shading or detail. McCloud suggests that Brosh's work could be "jarring to traditional sensibilities, with its sloppy, scribbly style"—but then notes, "*Hyperbole and a Half* connects with readers strongly enough to rewire a million ideas

of what 'good' comics look like." Brosh taps into cartooning's signature power: distilling and condensing essence through line, something a reader most often recognizes in how she draws faces, which are a focal point of *Hyperbole and a Half* in both form and content. Brosh's images are carefully crafted for maximum expressivity, if not for maximum realism. "I know it looks crude," she told a newspaper interviewer. "But it's a very purposeful crudeness. Sometimes I'll redraw something 10 times."

Brosh's depiction of herself is *Hyperbole and a Half*'s most salient, and most compelling visual feature. She draws herself, at all ages, in all situations, in the same way: as a stick-figure creature with a monochromatic pink dress that goes up to her neck, and solitary black lines for arms and legs. Her large white face has big round eyes and a mouth (no nose). And, prominently, her character has what I thought of for years as a little yellow horn, like a conical party hat, that seems to sit atop her head, emphasizing her (adorable and maniacal) creature-like quality. As I finally learned from reading the FAQ section of *Hyperbole and a Half* online, it's actually supposed to be a ponytail—but conventional visual realism isn't really the point of the comic, as Brosh knows, since she jokingly suggests, "you may also think of it as a shark fin if you wish."

The power of drawing is that it can capture a concept otherwise too abstract to articulate. Brosh's drawing of herself reflects her internal reality; it merges that internal reality with an external one, lending features to a self-portrait that indicate that self's innermost feelings about herself. Brosh has said that her self-portrait in *Hyperbole and*

Allie Brosh, from "Depression Part Two," originally part of Brosh's webcomic of the same title. This story got 1.5 million hits in a single day, and five thousand comments. From *Hyperbole and a Half: Unfortunate Situations, Flawed Coping Mechanisms, Mayhem, and Other Things That Happened* by Allie Brosh.

a Half represents herself more accurately than the three-dimensional person with whom one could interact. She told the comedian and podcaster Marc Maron that the drawing is "really what I'm like on the inside, I feel like. That picture is *me*, more me than I am." Brosh has repeatedly explained this, telling the *New York Times*, "That is me deep down. This ridiculous, sort of crudely drawn, absurd thing. That is a more accurate representation of me than me in the person." In her Talks at Google appearance, she even took pains to clarify that it's not just about public interfacing: she herself relates more to her drawn character than to her flesh and blood self. In *Binky Brown*, comics represent a troubling mental landscape concretely, seeing "from the inside out," as Ware puts it, of Green's brain—and in *Hyperbole and a Half*, too, Brosh's self-figuration represents a profound set of personal feelings that express an internal reality.

Hyperbole and a Half, in its storylines, attends often to the notion of different realities: to the divide between public and private realities for a depressed person, and also to the divide between those who are suffering from depression and those who aren't. In "Depression Part Two," in which she reveals her suicidal feelings, Brosh recounts how her severe depression made it so that "I could no longer rely on genuine emotion to generate facial expressions . . . when you have to spend every social interaction consciously manipulating your face into shapes that are only approximately the right ones, alienating people is inevitable." In the panels here that show people with two different realities trying to interact with each other, readers gain access into Allie's efforts, and her feelings, to which her friend doesn't have the same access; Brosh stages this encounter, and many others, to try to communicate a state of mind that may not be easily apprehended from the outside.

Another feature Brosh uses to picture her depression in comics is her figuring her own interior dialogue as an interaction between two separate selves. This represents more attention to the theme

of different realities—but it addresses the different realities of dis-connected multiple private versions of self. The story "Motivation" begins with Brosh's statement, "One of the most terrifying things that has ever happened to me was watching myself decide over and over again—thirty-five days in a row—not to return a movie I had rented." The story details, through this one example, the effects of depression, including a constant back and forth with oneself about motivation. There are hints of this in Brosh's opening sentence: "me watching myself decide" implies the coexistence of active and passive selves battling it out. In a six-page segment of the story, readers see Brosh's selves as separate characters, one standing up, one sitting on the couch, engaging one another. On the last page of the conver-sation, Brosh writes, in typeface below the comics panels, "I'm al-ways surprised when I lose." Which is the real "I"? They both are, in Brosh's psychic landscape; this story movingly reveals, through the visualization of separate selves, the difficulties of decision making that doesn't immediately appear rational. Brosh revisits the late movie in the story "Depression Part One," in which she draws the selves duking it out again, with the comment, "Trying to use willpower to overcome the apathetic sort of sadness that accompanies depression is like a person with no arms trying to punch themselves until their hands grow back."

Brosh has struggled openly with her depression in her comics, proving how immediate and resonant the form can be for express-ing a disorder that is famously hard to describe. She now has a large community of fans following her moves in real time; when she has disappeared for stretches on social media, or on her blog, strangers who feel connected to her through reading her comics have publicly worried about her. In 2013, the year *Hyperbole and a Half* became a best-selling book, Brosh had a cancer scare, and her little sister Kaiti Brosh, twenty-five, also an athlete and a devoted animal lover, com-mitted suicide in Idaho. In one of very few interviews Brosh has done

I'm always surprised when I lose.

Allie Brosh, page from "Motivation," originally from her webcomic of the same name. From *Hyperbole and a Half: Unfortunate Situations, Flawed Coping Mechanisms, Mayhem, and Other Things That Happened* by Allie Brosh.

since 2013, she told Marc Maron that after her sister's death, "My dad gripped me by my shoulders and looked me in the face, just crying and saying, 'You can't kill yourself, you can't do this, you're all we have left!' . . . My immediate thought was: Well, fuck!" While hopefully this will change, Brosh's Twitter account stopped updating in 2014, as did her personal Facebook page. Her blog has not been updated since her book came out in 2013. A second book collection, *Solutions and Other Problems*, whose cover is on publisher Simon & Schuster's website and on Amazon, was originally scheduled for 2015, then pushed back to the fall of 2016, and then delayed indefinitely. Brosh gives a voice, and an image, to depression that manages, through the language of comics, to be both abstract and precise. After she disappeared online, one fan addressed her on Reddit: "Your writing and art changed my perspective and opened a dialogue with the world about this nightmare." The success of *Hyperbole and a Half* points to the vital, open creativity of webcomics—an easy-to-circulate platform that gives artists and biology majors alike a space to produce stories that address illness and disability, among so many other topics, and to share them meaningfully. I hope Brosh returns to the arena soon.

WHY GIRLS?

n the graphic novel world, girls are the new superheroes. They are the action stars, the focal point, the figures whose backstories, ideas, inclinations, struggles, and triumphs are presented with detailed attention in autobiography and fiction alike. In independent comics, pairs of girls—clever, winning teenagers—have become some of its most recognizable stars from early on: the effervescent Hopey Glass and Maggie Chascarillo from Jaime Hernandez's *Love and Rockets*; the smart, sulky, and funny Enid Coleslaw and Rebecca Doppelmeyer from Daniel Clowes's *Ghost World*. (The latter two were portrayed, as noted, by Thora Birch and Scarlett Johansson in the Oscar-nominated 2001 movie.) *Ghost World* is an early example, in 1997, of a full-bodied "graphic novel." It's also one, significantly, that realistically portrays the humor and intelligence of girls' friendships. It became a cultural phenomenon, with many critics and fans weighing in on Enid and Becky as though they were real people. There is even a Little Enid action figure, as if to underscore the substitution of girls as comics heroes. Some of the very biggest graphic novel hits of the twenty-first century are about girls, from Allie

Brosh's *Hyperbole and a Half* to Lynda Barry's *One Hundred Demons* (about growing up on the interracial streets of Seattle), Marjane Satrapi's *Persepolis* (about growing up in wartime Tehran), and Alison Bechdel's *Fun Home* (about growing up gay with a closeted father in rural Pennsylvania).

Many famous comics, of course, feature girls—including some of the most widely circulated comic strips of the past century. There's *Nancy*, starring a spunky eight-year-old girl (the one with dark hair drawn as spiky halo). There's also *Little Lulu*, whose titular heroine (the one with dark hair drawn as three ropes of curls) is always outsmarting the boys. Sidekicks: Sluggo and Tubby, respectively. Both strips began in the 1930s and have become classics. Then there is the

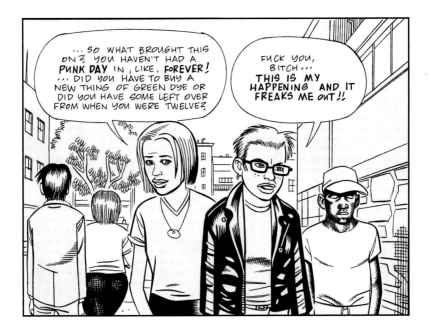

Daniel Clowes, panel from *Ghost World* (Seattle: Fantagraphics), 1997: best friends Becky (left) and Enid (right) take a stroll.

Used by permission of Daniel Clowes.

eponymous heroine of *Little Orphan Annie*, a comics strip so popular that Annie is a kind of twentieth-century cultural truth, spawning a musical and many movies (as well as references in contemporary anthems like Jay-Z's "Hard Knock Life"). *Little Lulu*'s creator, Marjorie Henderson Buell, explained her choice of protagonist in a description applicable to all the famous girl characters of the humorous gag comics strips: "I wanted a girl," Buell said, "because a girl could get away with more fresh stunts that in a small boy would seem boorish."

Little Lulu is one of the most iconic comic strips of all time, as well as an acknowledged influence on Gary Panter, R. Crumb, and many others. And *Nancy*, an installment of which, as Art Spiegelman likes to point out, is actually reproduced in miniature in his 1973

Little Enid Action Doll, Presspop. A "punk" version comes with green hair.

© Daniel Clowes. Photograph used by permission of Yasutaka Minegishi, owner of Presspop, Inc.

American Heritage Dictionary next to "comics," is a favorite strip to celebrate. Nancy's likeness has been redrawn by Panter, as we saw, as well as by Charles Burns, Ivan Brunetti, and many, many others, including cartoonist Mark Newgarden in his avant-garde tribute called "Love's Savage Fury" and visual artist and poet Joe Brainard, in the experimental collection *The Nancy Book*. But despite these enduring girl characters from the family-friendly arena of newspaper comic strips, whose beginnings predate the meteoric rise of comic books, the world of comics has generally come to be seen—largely because of the predominantly male comic-book superheroes—as one dominated by boys and men (and boy-like men).

Comics began in the United States as a form of entertainment for *any* potential reader of a newspaper. Hearst and Pulitzer, building New York City's sensational press to be as profitable as possible, certainly hoped to gain adult readers when they developed daily comic strips and full-color Sunday supplements, which became widely popular. Yet comics, as we know, were called "the funnies," and the medium came to be, broadly speaking, associated with humor and children. When superhero comic books hit in the late 1930s, and became a hugely popular consumer product (recall Justin Green venturing out alone at age four with dimes in his pocket, burning with desire to buy a comic book) the association of comics with youth culture became more specifically the association of comics with boys. As a general matter this remained true despite the rise of other genres, such as romance comics aimed at girls, which began in the late 1940s. There were very few female superheroes, barring Wonder Woman, for decades; many, if they appeared, appeared as token women in a group of men, or as secondary characters. Superheroes were, in essence, about celebrating masculinity, even if what that meant was up for grabs. And even international comics hits outside of the realm of the superhero, like *Tintin* or *Astérix*, both from the Franco-Belgian tradition, largely featured boys and men. Marjane Satrapi, growing

up in Iran in the 1970s, read very few comics but had access to *Tintin*. "My cousins were reading *Tintin* . . . but in *Tintin* you don't have any female persons so I couldn't identify with any of it," Satrapi has explained.

There are historical reasons, then, that comics gets associated with boys and adolescents, but there are also plenty of reasons one need not make that association now. The field has shifted dramatically. We see this in the world of independent graphic novels like *Ghost World*, and also in mainstream superhero comics. Marvel's *Ms. Marvel*, one of the company's top sellers since its debut in 2014, stars Kamala Khan, a sixteen-year-old from Jersey City, New Jersey (student by day, shape-shifting superhero by night). Perhaps based on the success of Khan with readers, Marvel presented a new Iron Man character as a girl, too: fifteen-year-old Riri Williams, an African-American certified genius who fashions her own suit from discarded tech she finds on the MIT campus. She is called "Ironheart." On a more lighthearted note, there are also Marvel offerings like the widely praised *Unbeatable Squirrel Girl*, which began as an ongoing series in 2015 and stars fourteen-year-old Doreen Green, bestowed with squirrel-like abilities including that of communicating with squirrels (which apparently helps to defeat enemies). Both Marvel and DC are investing more, in every medium, in young women superheroes, as we see in the current success of television shows based on comic-book superheroes like *Jessica Jones* and *Supergirl*. The number of female creators, of graphic novels and of mainstream comic books alike, is on the rise. Female readership, always hard to measure, seems to be on the rise too: 51 percent of people who identify themselves as comics fans on Facebook are women, according to an MTV News article (up from a recent 43 percent). And even kids' comics are getting in on it: smart comics *for* girls, not only about them, is a newly thriving area of the field (the Internet abounds, too, with cute and informative lists like GeekDad's "12 Comics for a 7-Year-Old Girl").

While there is now a wealth of charming and also sophisticated comics for kids, and girls specifically, by a wide range of creators on a wide range of topics, graphic novels for adults with girls at their center have captured the public imagination forcefully. Particularly in graphic memoirs like Barry's *One Hundred Demons* and Satrapi's *Persepolis*, as well as in Bechdel's *Fun Home* and Phoebe Gloeckner's *A Child's Life* and *The Diary of a Teenage Girl*, we see how comics can evoke childhood, and particularly girlhood, so powerfully. As we see in Barry and Satrapi's monuments to girlhood, narratives of growth, of hybrid identities and developing selves, make sense— and flourish—in comics. This is because of the form's diary-like intimacy—its handwrittenness—and its ability to layer moments of time, to take both granular and synthetic views at once. And while both Barry and Satrapi's works let the troubles the authors experienced in their childhoods come to the forefront, both are also edged with generous humor. This stems from the tension between how Barry and Satrapi depict their naïve younger selves within the comics frame, and how as adult narrators they recollect those younger selves in overarching prose.

Barry has spent a career focusing on children in her comics. The author of eighteen books, she is one of the world's most famous literary cartoonists and the foremost chronicler in any printed medium, perhaps, of American adolescence. The novelist and critic Nick Hornby, reviewing *One Hundred Demons*, proclaimed that Barry "seems to me to almost single-handedly justify the form; she's one of America's very best contemporary writers." In the late 1970s, *Two Sisters*, her first published book—which she self-published by xeroxing her comics and sending them in hand-decorated manila envelopes to purchasers—starred nine-year-old oddball twin girls who were misunderstood by their mother and the world at large. Barry also grew up feeling misunderstood by her mother, who had grown up in the Philippines and immigrated to the United States, where she worked

as a hospital housekeeper. In a contributor's note to *The Best American Comics 2006*, Barry writes that she was born "to a woman who came from the Philippines on a military transport plane and a navy man who drank and bowled," adding, "They didn't like each other and they didn't like their kids." Her parents divorced when she was a child. Her father, who left the family altogether, is a meat-cutter of Irish and Norwegian descent. Alongside a photograph of her that is part of a traveling art exhibit titled *kip fulbeck: part asian, 100% hapa*, Barry—who has pale skin and long red hair—notes, "People can't believe I'm Filipina but then I tell them I'm also Norwegian, and Norwegian blood can suck the color out of anything."

Barry, who has two brothers, was born in 1956 in Richland Center, Wisconsin, where her mother, she told me, was the "odd person with a heavy Filipino accent." The family moved to Seattle when she was four, into a house that had a large and varying number of Filipino families—a community where "my dad was the only one speaking English . . . my dad was the only white guy . . . and everybody was speaking Tagalog." The family next moved within Seattle to a mixed black, Chinese, and Japanese neighborhood that Barry describes as "the poorest part of town."

Barry's comics are distinguished by their ability—one Barry has always had—to capture the way children actually speak: their slang and syntax, and particularly their spoken intonation and inflection. It's a big part of what makes her comics feel so vital and authentic. Barry grew up in a bilingual family, an English-speaking child among adults who spoke Tagalog, a language they did not teach to her. The resulting special attention to language and listening seems a likely source of her ongoing interest in how people speak, and her incredible ear for it. She managed to understand certain Tagalog words as a kid although they were never explained to her.

As she makes clear in *One Hundred Demons*, Barry grew up in what she describes as "a really violent, difficult house." She hasn't spoken to

her mother in over twenty years, and she explained at a conference in Chicago, "I know people are like, *Oh, that's so sad.* . . . If you met her you would know I'm free!" The family, which included Barry's Filipina grandmother, a sympathetic figure whom she adored, was what she calls "Catholic. Catholic with vampires." (She depicts this in the chapter "The Aswang," about Filipino folklore's flying vampire dog-woman.) Barry had very few books in her childhood home: the final chapter, "Lost and Found," poignantly explains how as a girl with limited resources she loved reading the classified ads in the newspaper as a kind of literature—one for which she could imaginatively fill in the blanks. Her love of drawing was not valued, either—her mother often accused her of wasting paper when she drew—but Barry copied R. Crumb's *Zap* #0 in junior high and later drew for her high school paper. Barry transferred out of her local high school, where there was a high level of violence, to Seattle's Roosevelt High School, a calmer environment where cartoonist Charles Burns was also, at the same time, a student. At sixteen, she held a seven-nights-a-week job as a janitor on top of high school.

Barry enrolled in 1974 at the Evergreen State College in Olympia, Washington—an experimental, progressive college in which students study one subject intensively across disciplines, and earn written evaluations instead of letter grades. At Evergreen, where she studied the history of science and history of the Renaissance, Barry began modeling for life-drawing classes as a fluke when a professor, after a last-minute cancellation, approached her in the lunchroom, mistaking her for someone who had done it before. Barry hadn't, but she said yes anyway because she was broke, and found she loved being around students making images. Eventually, modeling in the class of art professor Marilyn Frasca, Barry "just started crying," she told me, "because I realized I didn't want to be on the table. I wanted to be in her class." She went on to study intensively with Frasca for two years. Evergreen is also the alma mater of several important creative contemporary cul-

tural figures—including lead members of the feminist riot grrrl bands Bikini Kill and Sleater-Kinney and peace activist Rachel Corrie.

Barry met Matt Groening while both, along with Burns, were students at Evergreen—and where her reputation preceded her. Groening had heard that there was a girl in a nearby dorm who had written to Joseph Heller, the author of *Catch-22*, and had received a reply. Impressed and intrigued, Groening tracked Barry down. The two became best friends. They also dated for a period; at one point Groening even asked Barry to marry him. He was the editor of the college newspaper, and once he got to know her, he pestered Barry into contributing. Groening printed her comics for the first time, and his encouragement, as an editor and a fellow cartoonist, inspired her to keep drawing: "I would just send crazy little comics that didn't make any sense. . . . I would just drop them off in the mailbox to Matt," she recalled to me. In turn, Barry's exuberant sensibility, with her scruffy drawing style, was a huge influence on him. Barry's black line art is always energetic, favors expressivity over realism, and can often be exaggerated. Both deploy an ostensibly simple, fluid black line and have an elastic take on drawing bodies.

"Lynda Barry is the funniest person I have ever met," Groening told the fanzine *Chemical Imbalance*. "Lynda was great [in college] because she really opened things up for me as far as inspiration and doing whatever you want in a comic strip." As a general rule, and to this day, the two acknowledge each other in their books: "LYNDA BARRY IS FUNK QUEEN OF THE GALAXY," reads a *Life in Hell* note on the copyright page. "P.S.MattGisstillFunkLordofUSA," proclaims the acknowledgments of *One Hundred Demons*. On *Life in Hell* calendars—a popular novelty item for decades—Groening typically lists Barry's birthday. In a recent public event in New York, the affectionate pair, whose lifestyles and career paths have diverged sharply, taking Groening to Los Angeles and Barry back home to Wisconsin, admitted they disapprove of each other "very much."

"You think LA is hell," Groening reminded Barry, "this awful place of corruption and anti-creativity. And when I look at Wisconsin—" "It's its own kind of hell," she finished for him. "When I look at your place in Malibu, and you can see the ocean, I just think, 'I'd rather die than live here.'" Both were inducted this past summer into the Comic-Con's Hall of Fame. Groening, ascending the stage to accept his honor, quipped, "My influence is Lynda Barry."

After college, Barry moved back home to Seattle, where alternative weekly newspapers—along with those in LA (where Groening had moved), Chicago, New York, and elsewhere—were starting to pick up steam as a popular format. Barry had a comic strip series called *Spinal Comics*, which she had started in college—it was "basically women talking to men in the bar, but the men were giant cactuses." When Barry submitted her comics to the *Seattle Sun*, the editor called her back shortly after, asked her to come in to the office, and rejected the work, lecturing her that her comics were racist. Barry was utterly bewildered ("Something about . . . Mexicans and white women. . . . The comics had nothing to do with Mexicans, or white women"), but as she was leaving, the man who managed the back page, and hated the editor, ran down the stairs after her and without even reading the comics offered to print them. Her work appeared weekly in the *Seattle Sun*.

Barry's readership started to grow within the alternative newspaper world—as did Groening's with *Life in Hell*. Whenever either Groening or Barry was approached by a paper interested in printing their comics, that one would pitch the other to the paper too. In 1980, Groening wrote a long, famous article about culture and aesthetics in the *LA Reader*, where he worked, called "Hipness & Stupidity," which Barry describes as "about how lame stuff is actually cool." Groening gave her a shout-out in the piece, "like I was a cartoonist of some standing," she told me, "which was just bullshit" (Groening wrote with an artificial distance about Barry, naming her a "Seattle art-

ist" with a "brilliantly stupid and hip comic strip"). The editor of the *Chicago Reader*—where Chris Ware would later serialize *Jimmy Corrigan*—saw the piece and called Barry, asking to run her comics. They paid $80 a month; Barry was able to quit her job selling popcorn at a movie theater to become a self-sufficient artist.

Barry's weekly syndicated comic strip came to be called, eventually, *Ernie Pook's Comeek* ("pook" rhymes with "book"—the title was an in-joke with her brother, who as a small child loved the made-up phrase). After her strips would get printed in the newspapers, Barry would xerox them to create small collections that were sold at Printed Matter, the esteemed artists' bookstore and gallery in New York City. At Printed Matter, Barry described, she had a sense that somebody was actually "getting" her work. Barry almost single-handedly reinvented the content of newspaper comic strips, and the gag strip in general, by focusing in the late 1970s on what she calls "darkness."

"There weren't that many comic strips that had a lot of trouble, that weren't funny, you know?" she told me. "The setup for a comic strip is four panels and that last thing should be a punch line, so when people didn't get that punch line they became very upset and would write furious letters to the editor about how there's nothing funny about child abuse." Barry explained that she realized a comic strip "could contain something sad, like a song. A song could be happy or sad, and I thought a comic strip should be the same." And for her this meant a focus on children, especially girls.

Barry's first book collection, *Girls and Boys*, was issued in 1981. *Girls and Boys* had some strips about romantic relationships, and many about the chaotic, difficult lives of kids. In one strip two boys beat each other until a stranger on the street intervenes. In another a brother and sister speculate their mother is never coming home because she's going to "get drunk and marry a bum." In yet another a mother passes out from drinking and her daughter protects her from her angry father. It was a comic strip that depicted the kinds of grim,

everyday events that might happen in real life. Chris Ware has said Barry taught him how to create believable fiction in comics. "She moved the medium closer to real literature," the cartoonist Ivan Brunetti declared.

Barry's new comic strip idiom—edgy, dark, sometimes grim, sometimes funny—caught on, bringing the full tonal range of the interior lives of children in teeming households, streets, and classrooms to the forefront of comics. Barry earned devoted readers, especially with her beloved character Marlys Mullen, a nerdy, chubby, freckled eight-year-old girl with glasses, always surrounded by a large cast of family members, including her troubled brother Freddy, teenage sister Maybonne, and cousins Edna and Arnold. Marlys had optimism, and oddball charm; her perspective often threw the adult world into relief. In "Marlys' Guide to Queers," Barry creates the four-panel strip as an open letter to the world from eight-year-old Marlys, complete with the child's own comics (dotted with spelling mistakes) that picture of scenes of discrimination from a child's point of view. It ends with a remark—"If you see my Uncle John and Bill please say I miss them"—that suddenly injects personal poignancy to the young girl's "guide" structure, demonstrating Barry's powers telling stories with the elliptical economy of comics.

At its peak, *Ernie Pook's Comeek* was syndicated in over sixty newspapers. Barry became a nationally known figure across different media. In the 1980s and early 1990s, the charismatic Barry was a frequent guest on *David Letterman*—like Pekar, although Barry's spots are fizzier, friendlier, and much, much funnier (she's a natural in front of an audience). Barry exhibited paintings and mixed-media work in galleries, though she elected to cut the fine art world out of her practice in the late 1980s: "Rich people," Barry told me, "need [art] to be this sort of deep *experience*, and they're sort of buying the talisman of the experience." She published two brilliant prose novels about teenage girls: *The Good Times Are Killing Me*, about a black-white inter-

racial junior high friendship, and *Cruddy,* a macabre, hilarious, and moving novel about the daughter of an ex-Navy-man butcher who is kidnapped by her father for a road trip. *The Good Times Are Killing Me* was adapted, by Barry, to be an award-winning off-Broadway play in 1993. That year she released a spoken-word recording, *The Lynda Barry Experience.* It is telling that Barry is currently a tenured

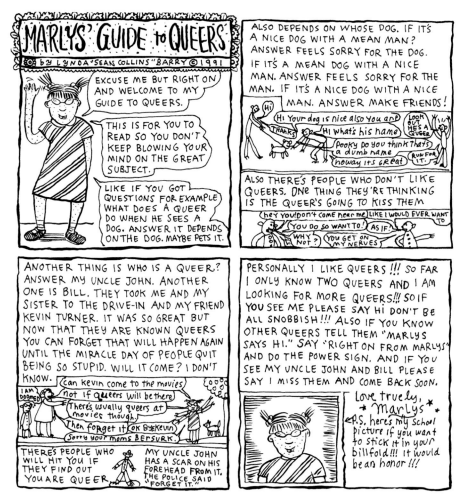

Lynda Barry, "Marlys' Guide to Queers," 1991, reprinted in *The Greatest of Marlys* (Montreal: Drawn & Quarterly), 2016.

professor, at the University of Wisconsin, Madison, of what is called Interdisciplinary Creativity (the best job title perhaps ever!).

But it is in *One Hundred Demons*, Barry's first explicitly autobiographical work, that she gives fullest expression to the lives of girls, including, of course, herself. Structured into nineteen discrete comic strips each named for a "demon," *One Hundred Demons*—as Barry explains in the introduction—is based on a painting exercise called "One Hundred Demons" that she first read about in the library, guided by the example of a hand-scroll painted by a sixteenth-century Japanese zen monk.

The demons run the gamut from topics such as "Dancing," "My First Job," "Dogs," and, of course, "Girlness" (hint: Barry, the tomboy daughter of an ultrafeminine mother, didn't think she had any) to

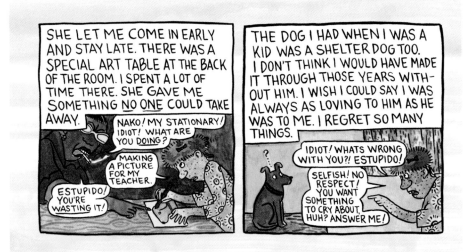

Lynda Barry, page from "Dogs," *One Hundred Demons*, first published in 2002, and reprinted (Montreal: Drawn & Quarterly) in 2016. The "she" referred to in the text box is Barry's second-grade teacher, whose kindness turned her life around. The woman pictured is Barry's mother.

concepts such as "Magic" and "Hate." Many of the stories, which are not chronological, are about class and ethnicity—"Common Scents" details how classmates, and their parents, perceive Barry's Filipino household as smelling a certain way; "The Visitor" is about a wealthy white boy who romanticizes ethnic neighborhoods, including Barry's own. Many are about the creeping self-consciousness of adolescence, along with what could only be described as trauma. "When I was little, bad things had gone on, things too awful to remember but impossible to forget," the narrator states in the darkest chapter, "Resilience" (which is not a feel-good story: "I cringe when adults talk about the resilience of children," Barry writes). "*One Hundred Demons* is heavy," Barry told me, expressing concern about when parents buy it for children: "'Well, just to let you know, there's incest and suicide, and drug-taking. There's, like, everything's in there.'" One of the fascinating features of *One Hundred Demons*, as with *Hyperbole and a Half*, is that it may not appear at first glance, perhaps, like an emotionally "heavy" book. It appears in gorgeous full color: each chapter presents a distinct background color, and each chapter is preceded by a digital reproduction, a scan, of a two-page multimedia collage, which preserves its bumpiness and craftedness. The rich visual volume and density of the collages offset the economy of the comics narratives they precede, which vary from only fourteen to twenty frames, and typically offer only two frames per page. From her evidently hand-painted words to her dense, accumulative collages, Barry's work is enormously tactile and appealing.

One Hundred Demons, aside from its collages, is entirely painted, as per the exercise, with an inkstick, inkstone, and an Asian-style brush. Barry's comics are distinguished by their sensitivity to voice, including the "voice" created by the shape of the lines on the page. Different drawing implements produce different voices, in Barry's view—and in many cartoonists'. (She's not alone: Spiegelman makes readers aware of this by drawing each character of his underground

comics story "Ace Hole: Midget Detective" with a separate kind of drawing tool.) While cartoonists typically pencil scripted words before inking them on the page, Barry doesn't use a script and never pencils her work, a practice that demands spontaneity—an alertness in the moment to what her character might say—that most cartoonists find insane. Barry switched to a brush from a pen around 1985, and even handwrites—or rather, paints—her prose novels: she wrote *Cruddy* in watercolor on construction paper and blew the pages dry with a hairdryer before it was transcribed for print.

One Hundred Demons opens with a double demon: "Head Lice and My Worst Boyfriend," which immediately sets up major themes of Barry's childhood in an only-eighteen-panel story: her mixed ethnicity and culture, her struggle to maintain self-confidence in the face of an "unpredictable and quite violent" mother, and the way that people repeat the traumas of their filial relationships in their romantic ones. Set against a brushed-peach background, "Head Lice and

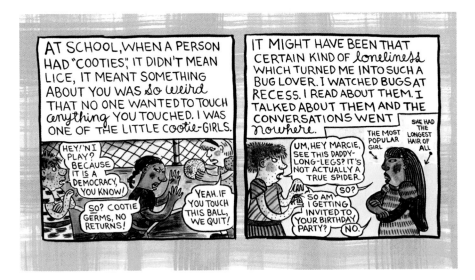

Lynda Barry, page from "Head Lice and My Worst Boyfriend," *One Hundred Demons*.
Used by permission of Lynda Barry/Drawn & Quarterly. Image courtesy Drawn & Quarterly.

My Worst Boyfriend" connects different versions of Barry's younger self, flipping back and forth in time. It links Barry's awkward, fifth-grade self—specifically her experience growing up Filipina American, and making friends during the summer when she traveled to the Philippines—with her young adult self suffering through a long-term relationship, set against the background of her ongoing, difficult relationship with her mother.

The strip opens with two selves in one panel: in text boxes above the frames that depict her childhood, Barry the adult narrator wonders why head lice never hit her neighborhood (her speculation: between the chain-smoking and the asbestos in their homes, the kids were too toxic for lice). Speaking of infestation: other students told her she had "cooties" and refused to play with her, as she shows us—and the resulting loneliness, the adult narrator writes, "turned me into such a bug lover." In several panels we see Lynda trying to make friends in school, including sweetly reporting to its most popular girl, "Hey Marcie, see this daddy long-legs? It's not actually a true spider." In the Philippines visiting family during summer break she has better luck, befriending two curious kids, one of whom she calls the Professor, who love bugs and are fascinated by her red hair, and wonder if her lice—or *"kuto"*—would match her light coloring. Lonely back at home after the visit, her mother confirms, "You talk, talk, talk, talk all the time. No one wants to listen to an idiot." In its last four pages, the story shifts to picture an older Lynda, who has left home, now volunteers as a fifth-grade teacher, and is dating a boyfriend with a "pretty name" and a "freaky ponytail" who reads the *Lonely Genius Gazette.*

Barry draws this boyfriend—white with a brown ponytail, tie, and round glasses—but doesn't name him in the book. As several articles have revealed, it is Ira Glass, of *This American Life* (Glass, now so associated with Chicago and its radio station WBEZ, actually moved to Chicago in 1989 to be with Barry, who lived there). His behavior in

the strip is self-centered and condescending, especially when it comes to class and race difference. Barry narrates her "worst boyfriend" in one panel in the following way: "He was raised in a nice suburb and had always been something of a gifted child. He seemed interested in my background and nicknamed me 'little ghetto girl.' I'm sure he meant it in the nicest way." As if this is so outlandish it needs verification, a little arrow with a note that reads "actual dialog" points to their conversation below. (For the record, Glass told the *Chicago Reader*, "I was an idiot. I was in the wrong. . . . About so many things with her. Anything bad she says about me I can confirm.")

Eventually Barry gets lice from her fifth-graders, and the story circles back to the ghost of her former, fifth-grade self who opens the story. (Incidentally, one of this story's many compelling features is its hilarious and painful look at the shame of adults contracting lice; when I got lice not too long ago from my boyfriend's small daughter the first person I contacted for advice was Barry. She signed her email

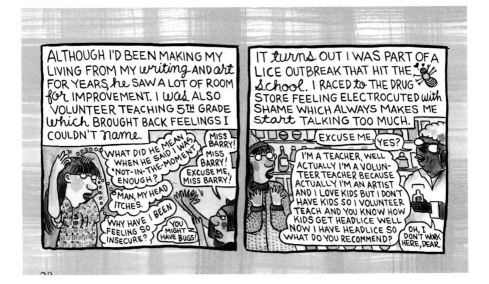

Lynda Barry, page from "Head Lice and My Worst Boyfriend," *One Hundred Demons*.
Used by permission of Lynda Barry/Drawn & Quarterly. Image courtesy Drawn & Quarterly.

"Your Sister in Lice Infestation.") Barry shamefully gives lice to her worst boyfriend. As they stand together washing their hair with the toxic lice-killing shampoo, it dawns on her: she finally has lice, and her boyfriend reminds her of the Professor, the Filipino boy who was the first love of her life. After she tells him this, half-laughing, half-crying, the subsequent panel shows the boyfriend morph into shades of Lynda's mother: "You talk talk talk about asinine memories like they *mean* something! You're shallow! You're poison! Do you really think I'm interested?" to which Barry replies, with a bolt of recognition, "MOM?!" "Why are we compelled to repeat the past?" Barry asks in the final panel in her signature mix of cursive and capital letters, both girlish and bold at once.

"Head Lice and My Worst Boyfriend," as with each chapter of *One Hundred Demons,* represents girlhood so effectively because it is able to display—and even to put together, in one frame, as we see with Barry narrating her childhood in prose and also drawing her own child body in space on the page—different versions of a growing self, with different abilities, kinds of knowledge, and kinds of voices. Barry moves back and forth between childhood, adulthood, and interim stages in the space of the book. And no one of these selves is any more real than the other. Comics can bring forward the hybrid self, the developing self, the split self (as we saw with Brosh). As a temporal and spatial form motored by images, comics can also powerfully evoke what memory feels like, how memory works, and can bring forward the importance of girlhood recollections. "Head Lice and My Worst Boyfriend," which explores the mix-up of the past and present in the protagonist's mind, also performs that in its form, which shuttles back and forth between time periods. The entire book enacts this movement: a life is not a chronological set of events, but rather a collection of nonchronological moments. "We think that we are going into the future, but actually what we're doing is going into the past," Barry claims about how images—memories—present themselves. "There's

this feeling that there's a chronological order to things because there's an order to the years, and there is an order to our cell division from the time we're a little embryo until we're dust again. But I think the past has no order whatsoever." Her books are about presenting the everyday lived details of girlhood, but also about remembering—and they mimic, with their profusion of images "which move every which way," as she puts it, the process of how one remembers.

Even in its physical design, *One Hundred Demons* evokes girlhood. Barry is an outspoken fan of handwriting, and her comics have a very distinct—and to me quite beautiful—evident handwrittenness about them. The mix of lowercase and uppercase brush-painted letters, which we see in sentences and even sometimes within the physical, material space of one word, has no narrative function, but it does have a visual function. It is decorative, and in its unpredictability and ornamental quality, it asks a reader to be aware of the body whose hand creates the comics; it ruffles the surface of the page. "I'll read anything that had handwriting, and it's really hard for me to be bored or unhappy when I'm reading comics," she told me. "I even love stuff that . . . you might think, this isn't really working, or this isn't really exciting. I never think of that. I think drawing, writing, handwriting, drawing." *One Hundred Demons*'s handwriting feels intimate and personal, like a reader is encountering a diary or a manuscript; the book also frequently depicts the character Lynda in the act of composing, hand on paper, as we see in the page from "Dogs," among many, many others. *One Hundred Demons*, with its lush prefatory collages, also evokes scrapbooking—a form that has often been associated with girls recording their lives. In the collages, there is a piling on of commonly found, disposable, everyday objects. As Barry described her

Lynda Barry, the two facing collage pages for the chapter "Resilience," *One Hundred Demons*.

Used by permission of Lynda Barry/Drawn & Quarterly. Image courtesy Drawn & Quarterly.

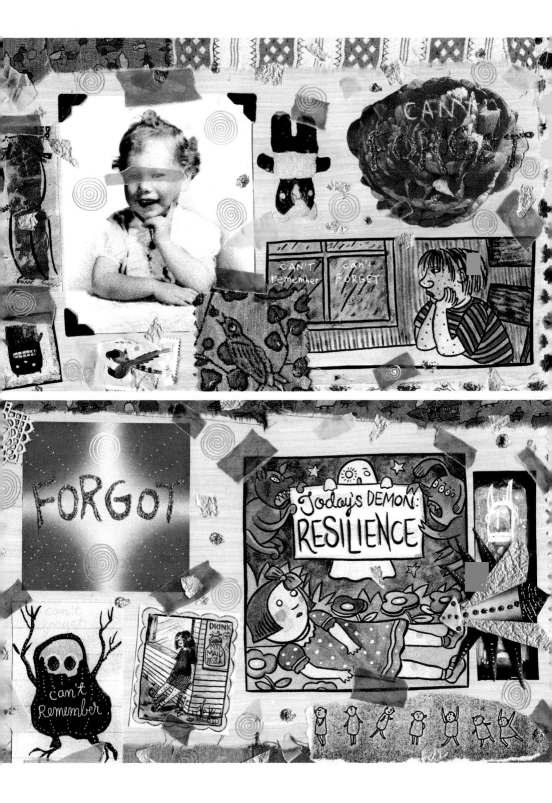

studio: "I have tons of trash laying all over the floor and everywhere in bowls."

Barry's autobiographical work about her girlhood calls attention to itself as multilayered composition—and to the self as collage—in its open layers of painting, words, and bits and pieces of ostensible debris. One of the book's central themes is what counts as "waste"—from a child herself, and from childhood memories. The collages, which announce the title of the chapter on their right-hand side, offer snippets of the subsequent strip, repeated handwritten words and phrases, original painted illustrations, and an accumulation of sundry materials, including strips of brightly colored fabrics; cardboard; magazine pictures; tissue paper; the scalloped edge of a paper bag; photographs of Barry herself; the printed insides of bank envelopes; interior candy bar and gum wrapping; dried flowers; bits of doilies; glitter globs; the sewing trim rickrack; Chinese postage stamps; origami creatures; a stuffed animal; and pieces of old pajamas. Through an accessible popular medium, comics, that has long been viewed as disposable, *One Hundred Demons* salvages the detritus of girlhood as productive collage. On the book's last page, which is composed on yellow legal paper (which looks great), Barry notes, "I like to paint on legal paper or on the classified section of the newspaper or even pages from old books! I will try any kind of paper, typing paper, wrapping paper even paper bags!" Using cheap, common, or utilitarian paper—the kinds of materials associated with her girlhood, and the kinds of materials to which kids have access—is an important part of Barry's goal to make what others would deem "waste" something valuable.

While in Barry's story she encounters the most trouble from within her own family, Satrapi's *Persepolis* features a supportive family protecting their daughter from extremism and war. But both of these graphic memoirs show, through words and images together, how the everyday lives of girls can include joy and humor alongside the com-

plexities of violence. (Neither are meant for children, although I often learn, as with *Maus*, of teachers assigning *Persepolis*, which is a quite violent book, to young students.) Barry and Satrapi—one working in the United States, the other in France—both published their memoirs in the early years of the twenty-first century. They focused the world's attention on girls as a powerful subject for adult comics and on the lived reality of girlhood as historically and politically—and artistically—significant.

But while Barry's graphic memoir is colorful, dense, and accretive, Satrapi's is black and white, minimalist, and expressionistic. Both are structured by short, titled episodes, but while Barry's skips around in time, mimicking the procedure of memory, Satrapi's is linear and chronological: the story opens when she is ten, and ends when she is twenty-four. Both are about how class position shapes a girl's self-concept: in Barry's case, growing up poor, from an immigrant family; in Satrapi's case, growing up privileged, to elite parents (she introduces this early, when the child Marji, short for Marjane, explains that she wanted to grow up to be a prophet because she's sad her maid does not eat with the family, and she's embarrassed to ride in her father's Cadillac). Alongside these loving, intellectual parents, who provide her a constant safe space, she suffers, as a growing girl, the oppression of both the Islamic Revolution and the Iran-Iraq War (in one episode a missile hits her street and kills her neighbors). Satrapi's account of her childhood growing up in Tehran has earned the most international attention of any graphic narrative in the past fifteen years.

An only child, Satrapi was born in Rasht, Iran, to an engineer father and dress-designer mother; her maternal grandfather (whom she never knew) was an Iranian prince who later became prime minister and a communist, spending most of his later years as a political prisoner. As the book details, Satrapi attended French schools in Tehran, and watched with curiosity and bewilderment the political shifts to which her parents were so attuned, particularly the shift in govern-

ance from the reign of the deposed shah to the takeover of the Islamic regime. The Islamic Revolution began when she was ten; that year, her beloved uncle Anoosh, her father's brother, also a communist, was executed as a so-called Russian spy. Allowed one visitor before his execution, he chose his young niece, a scene very movingly portrayed in *Persepolis*.

At fourteen, Satrapi disputed politics with one teacher and actually struck her school principal. Her outspokenness and hotheadedness led her parents, fearful for her safety, to send her out of the country to Vienna, where she attended a French school for four years. Despite the fact that she felt alienated in Vienna as a foreigner from a war-torn country, Satrapi excelled in school. She earned the top possible grade on her French baccalaureate degree—the same year she rebelliously became her school's so-called "official" drug dealer. Satrapi returned to Iran at eighteen before leaving the country, again, for France at age twenty-four (where *Persepolis* leaves her). Always hoping for the best opportunities for their daughter, her parents encouraged her to leave Iran, where basic freedoms were being denied: "I forbid you to come back," her mother says to her daughter at the airport on her way to Paris at the end of the memoir.

Satrapi is a trained artist: she earned a college degree in graphic arts from the School of Fine Arts in Tehran and a graduate degree from the École Supérieure des Arts Décoratifs in Strasbourg after her move to France. After Strasbourg, aiming for a career creating children's books, Satrapi joined the Parisian studio group Atelier des Vosges, whose members included several cartoonists. It was there, after her book projects for children had been met with rejection—and after a friend gave her *Maus* as a birthday gift—that Satrapi started *Persepolis*, in 1999, with encouragement from her studio mates such as the cartoonist David B., creator of *Epileptic*.

Satrapi credits *Maus* as her most important influence. In a lecture I attended she called it "the biggest revelation of my life." While there

is a very rich visual culture in Iran, a comics culture in particular doesn't exist very widely. In *Persepolis* Marji is seen, charmingly, as a young girl reading a comic book called *Dialectic Materialism*, but it is a Soviet-published comic book. There were no homegrown Iranian comics when Satrapi lived there. Satrapi, who has two fine arts degrees, hadn't specifically planned on becoming a cartoonist. She called *Maus* "a bomb in my head," explaining, simply, "When I read *Maus* . . . I saw that it was possible to talk about war in the comic format." *Persepolis* blends a focus on the details of one girl's life—the games she played with her friends, her conversations with God, her aspirations—with a focus on the tumult and brutality of war.

Persepolis was first published in France, where Satrapi still lives and works, in four separate books (or, as they are known there, *tomes*). She wrote *Persepolis* in French, her second of six languages, and the first tome, published by the independent comics collective L'Association, appeared in 2000. Attention to the book grew by word of mouth; without any PR or marketing, it sold a record three hundred thousand copies in France, a surprise best seller. In the United States, before it was collected in one edition, *Persepolis* appeared in two volumes, the first in 2003 (which focuses on Marji's childhood in Tehran) and the second in 2004 (which focuses on her adolescence in Vienna as well as in Tehran). The first volume appeared as *Persepolis: The Story of a Childhood*. Its de-particularized subtitle, as with Gloeckner's *The Diary of a Teenage Girl*, suggests that while some may view the events of her life as unusual, for many girls the mix of joy and fear, play and violence, is in fact ordinary.

There are over a million copies of *Persepolis* in print, and it appears on over 250 syllabi in the United States alone. Satrapi has contributed op-ed—or "op-art"—pieces in comics format for the *New York Times*, and has weighed in on issues like the banning of the veil, also known as the hijab, in French schools for venues such as the *Guardian* ("I know what it has felt like to be pushed into being religious, so I know

what it feels like to be pushed into being secular. It is the same violence"). *Persepolis*, centered on a girl from a country the US president deemed part of the "axis of evil" the year before it appeared in English, was recently the required freshman reading for cadets at West Point, which is still a predominantly male institution. Satrapi was invited to speak there in 2005, and later created an op-art essay about her positive experience in the *New York Times*. And in 2006, the film version of the same title—a black-and-white animated feature codirected by Satrapi and the French underground cartoonist Vincent Paronnaud— won the Jury Prize at the Cannes Film Festival. It became France's first animated film to be nominated in the Best Foreign Picture category at the Academy Awards. And while the book has already been translated into over twenty-five languages, it has yet, for political reasons, to be translated into Farsi or published in Iran—although Satrapi has mentioned that there is a Persian version, which she has not seen or authorized, circulating on the black market there. While Satrapi's parents, who are featured heavily in the book, still live in Tehran, she has explained, "I no longer go to Iran, because the rule of law does not exist there." The name on her passport is different from the name under which she publishes her work, in part to protect her family.

In *Persepolis*, the personal is always political: girlhood reminiscences overlap with chronicles of war, and are articulated through momentous historical events. *Persepolis*, which begins with the issue of veiling, opens with a row of only two frames. The first panel sets the stage: a girl sits in the center of the frame, her chest-length veil framing her glum expression, her arms crossed in front of her. "This is me when I was 10 years old," Satrapi writes above the unsmiling girl.

Marjane Satrapi, first page of *Persepolis* (New York: Pantheon), 2003.

THE VEIL

THIS IS ME WHEN I WAS 10 YEARS OLD. THIS WAS IN 1980.

AND THIS IS A CLASS PHOTO. I'M SITTING ON THE FAR LEFT SO YOU DON'T SEE ME. FROM LEFT TO RIGHT: GOLNAZ, MAHSHID, NARINE, MINNA.

IN 1979 A REVOLUTION TOOK PLACE. IT WAS LATER CALLED "THE ISLAMIC REVOLUTION".

THEN CAME 1980: THE YEAR IT BECAME OBLIGATORY TO WEAR THE VEIL AT SCHOOL.

WEAR THIS!

WE DIDN'T REALLY LIKE TO WEAR THE VEIL, ESPECIALLY SINCE WE DIDN'T UNDERSTAND WHY WE HAD TO.

IT'S TOO HOT OUT!

EXECUTION IN THE NAME OF FREEDOM.

GIVE ME MY VEIL BACK!

YOU'LL HAVE TO LICK MY FEET!

OOH! I'M THE MONSTER OF DARKNESS.

GIDDYAP!

"This was in 1980." In the following panel, on the other side of the gutter, we see a row of four similarly composed girls, unsmiling with crossed arms, and only a sliver of a fifth on the reader's left: we are only able to infer a hand, a bent elbow, and a chest-length veil. "And this is a class photo," the narrator continues. "I'm sitting on the far left so you don't see me. From left to right: Golnaz, Mahshid, Narine, Minna."

On the very first page, Satrapi demonstrates the subtle tricks and erasures that frames can play. They can situate and dignify a character—or sever her in two. In the opening pair of panels, Satrapi suggests the differences between seeing whole and seeing only partially, incompletely, in disembodied fragments—the psychological conditions suggested by the chapter's title, "The Veil." An icon of a single eye, directly engaging the reader, hangs over the book's very first gutter. From the start, Satrapi indicates, readers of *Persepolis* are aligned with her own probing vision as a witness to events in Iran. Not that things are always what they look like. After introducing herself— "This is me"—Satrapi immediately conceals her body in the next, crowded frame: "You don't see me." Here and throughout *Persepolis*, however, word and image are in tension. We see the protagonist, at least partially, even as she insists we don't; we pore over the details of an image that is clearly a drawing, which she declares a "class photo." Carefully reading *Persepolis*, like Satrapi's own witnessing, requires weighing what we see against what's veiled from view, what we're shown against what we're told. Comics calls attention to what we as readers "see" and don't see of the girl at the book's center.

Each chapter of *Persepolis* opens with a stripped-down, elegant black bar at the top of the page that presents, in large white block letters, a simple title—"The Bicycle," "The Letter," "The Cigarette"— preceded by a corresponding visual icon. Satrapi's style in some ways looks very simple. It is monochromatic: all flat black and white, no intermediate grays and evidently no shading. There's a starkness,

and a spareness, to her images. She also often rejects "correct" perspective.

The apparent simplicity of Satrapi's visual technique rests on historical and ethical complexity. *Persepolis*'s drawing style references ancient Persian miniatures, murals, and friezes, and joins a continuum of Persian art: as Satrapi explained in an interview, in Persian miniatures, as in her own book, "the drawing itself is very simple," and the perspective is often deliberately flat. That simplicity, she continues, is "the Iranian side" of her style, and she notes that it "will always be with me." And yet Satrapi deviates from Persian art's colorful palette and limits herself to black and white. Her minimalist play of black and white is part of an avant-garde tradition, stemming from her stated mission to depict historical events on a plane of unnervingly abstracted horror. Satrapi was particularly inspired by the black-and-white shadow play of early German Expressionist film, particularly F. W. Murnau's vampire film *Nosferatu* (1922), and by the high-contrast woodcut style of French artist Félix Vallotton, who etched a 1916 woodcut album of images, *C'est La Guerre!* ("That's War!"). "Violence today has become something so normal, so banal—that is to say everybody thinks it's normal," Satrapi explained in an interview. "But it's not normal. To draw it and put it in color—the color of flesh and the red of the blood, and so forth—reduces it by making it realistic." As a work of witness and testimony, *Persepolis* is invested in truth and accuracy, and yet it is always deeply stylized, never visually "realistic." Satrapi's visual style, with its pared-down lines and flattened perspective, as in visual modernism, is hardly a sign of artistic deficiency (as some critics have claimed), but rather a sophisticated, and historically aware means of doing the work of seeing.

And that visual style forcefully conveys the viewpoint of a child. *Persepolis* is, after all, the "story of a childhood," as the subtitle of the first volume declares: one seen through a child's eyes and her

crumbling innocence. Satrapi's drawings—minimalist, scaled-back, gorgeous to look at—never square comfortably with the unspeakably traumatic events of her world: imprisonment and torture, harassment and execution, bombings and mass murder. *Persepolis* at its core is about the violence one witnesses and the unseen violence one is left to imagine. Real and imagined violence, in specific bodies both wounded and dead, are depicted frequently, appearing in nearly every chapter. A signature feature of *Persepolis* is its frequent arrangement of dead or dying bodies—from protests, massacres, and battlefields—in stylized, almost architectural formations, in pyramids, rows, or symmetrical groups, as a child might picture mass death.

A striking example of the book's child's-eye rendition of trauma comes in the chapter called "The Heroes." (Marji and all the kids in her neighborhood are obsessed with "heroes," and make up stories about their heroic fathers.) Two friends of the family, imprisoned for

Marjane Satrapi, panel from *Persepolis*.

their political views and released after the shah's upheaval, visit Satrapi's family and describe the torture they underwent. "My parents were so shocked," Satrapi remembers, "that they forgot to spare me this experience." Several panels across this episode show Marji looking increasingly bewildered as the men describe their nails being pulled out, being whipped with electric cables, and having cigarettes put out on their bodies. The conversation moves on to a friend, Ahmadi, who did not survive his time in prison. Ahmadi, in the words of one of the friends, "suffered the worst torture." In a large, borderless panel in the middle of a crucial page, Satrapi draws the flood of horrific images that these stories produce in Marji's mind, as she tries to visualize a man urinated on, tied down and beaten with a whip, and burned with an iron. While we are supposed to understand these depictions as the child Marji's envisionings, they are plausible visualizations. These images are unsettling enough, but Marji's imagining of Ahmadi's final torture is among the book's most alarming, unforgettable images. "In the end," the narration reveals, "he was cut to pieces." The page-wide panel that follows marks the limit of young Marji's imagination—what she *cannot* yet realistically envision.

What can Marji imagine? A white body, floating on a stark black background, disarticulated into seven neatly separated parts—head, torso, pelvis, four limbs, all apparently hollow. In Marji's mind the man is cleanly pieced apart and arranged like a dismembered doll on the floor, or an operating table. This panel demonstrates how certain modes of representation—even in a self-consciously artificial form like comics—convey trauma differently, and perhaps even more potently, than realism. The image and impression of a man "cut to pieces" in its full, traumatizing inhumanity cannot be illustrated by words alone, or even by detailed pictures, from the perspective of children or adults. This moment in *Persepolis*, then, reveals the defamiliarizing at which comics excels. It channels a child's imagining

of another's fatal torture, displaying a way of seeing and showing that is intentionally estranging. Satrapi impresses on readers a child's bafflement and confrontation with the terrifying actuality of her world. What is ostensibly "simple" here offers a complex emotional landscape—one impossible to present with words alone. "I cannot take the idea of a man cut into pieces and just write it," Satrapi told an interviewer. "It would not be anything but cynical. That's why I drew it."

One Hundred Demons and *Persepolis* both focus on the question of when a girl grows up. Barry writes, above a drawing of herself sick at age thirteen, "When did I become a teenager? Was it when I started shop-lifting? Dropped acid laid on me by hippies in the park?" In *Persepolis*, Marji descends into her family basement, meditates on getting busted by her mother for cutting class, and on executions of political prisoners . . . and smokes her first cigarette, breaking the frame to address readers and let us know, at age twelve, cigarette in hand, "I kissed childhood goodbye." These books investigate the notion of

Marjane Satrapi, panel from *Persepolis*.

girlhood—where it is, how long it lasts, if it ever leaves—through formats and styles that place a reader back in time, and with the shifting perspectives and imaginations of the girls they feature. As a form all about the representation of time, and one that is accessible and stylized both, comics can reveal the complexity of growing up, especially during dark periods like wartime.

WHY WAR?

arjane Satrapi's *Persepolis* bridges two of contemporary comics's most urgent themes: girlhood and war. The comics form has evolved as an instrument to circulate powerful images, together with words, of wartime experience and history. Sometimes these images are almost unbearably violent—in fact, that is part of their force. Joe Sacco granted me permission to use one of his comics panels of the July 1995 Srebrenica massacre of more than eight thousand Bosnian Muslim men and boys, from his *Safe Area Goražde: The War in Eastern Bosnia 1992–1995*, for the cover of one of my previous books. Although my publisher was on board with the cover—a strikingly detailed black-and-white drawing of men being shot en masse above a ditch littered with bodies—I hesitated. Was it actually exploitative, I wondered, to make this painful image of physical suffering a book cover? I asked Sacco what he thought. "Well," he replied, "it happened." This brief exchange about the representation of genocide hit home for me, profoundly and instantly, how comics seek, in a world arena, to deliver such images in order to inform, to reveal. They produce and share details of war—especially

from an on-the-ground, civilian perspective—in order to further understanding, to join the historical record.

War has long been a compelling subject for comics, and other forms of visual art. As far back as one chooses to look, sequences of images have conveyed stories of war: in cave paintings; in Attic black-and-red-figure vases from the Archaic and Classical period that portray scenes from the *Iliad*. And for many, many centuries, combinations of images and text in print have sought to represent the circumstances of war. Robertus Valturius's military guide *De Re Militari* (*Art of War*), for instance, illustrated with informational woodcuts, appeared in 1472 (the Metropolitan Museum of Art Bulletin calls it "the first illustrated book about the science of war"). Especially before the age of the camera, drawing was a standard form of witnessing and reporting, as in the French printmaker Jacques Callot's *Miseries of War*, a series of etchings about the Thirty Years' War, from 1633; Spanish painter and printmaker Francisco de Goya's *Disasters of War*, a series of etchings about the Spanish War of Independence, created in the 1810s; and in the images made by artist-reporters such as Winslow Homer during the US Civil

278 The Wheel. The poem reads: "The ever-watchful eye of divine Astraea [Justice] completely banishes mourning from a region when, holding the sword and scales in her hands, she judges and punishes the inhuman thief who awaits passersby in ambush, wounds them and toys with them, then becomes himself the plaything of a wheel."

War, when bulky cameras were inconvenient on the battlefield and periodicals were still unable to reproduce the tonal qualities of photography.

Fascinatingly, during the Golden Age of the comic book, starting in the late 1930s, fictional comics about real-life wars were a booming genre. Superhero, science fiction, and other fantasy genres have also, of course, long proffered global (and intergalactic) wars as central to their storylines, and continue to do so. (The Marvel comic-book storyline *Civil War*, for instance, which fueled *Captain America: Civil War*, the world's highest-grossing film in 2016, is not about the US Civil War, but rather about the world's superheroes in a "civil war" with each other.) But superheroes entered real wars too: the cover of the March 1941 issue of *Captain America Comics*, by Jack Kirby, shows the hero raiding Nazi headquarters and punching Hitler in the jaw—before the United States had even entered the war. Comic books helped to develop a patriotic wartime culture among civilians (some superheroes even formally, if briefly, enlisted), and they became a key part of GI culture. One quarter of all books shipped abroad to soldiers during World War II were comic books. As historian Bradford Wright points out about wartime comic books, despite some ugly racial stereotyping, World War II "marked a rare convergence of interests between publishers, creators, readers, and government policy." A superheroic take on World War II history lasted for decades. The popular comic book *Sgt. Fury and His Howling Commandos*, whose storyline is about an elite World War II unit, began in the early 1960s and lasted through the early 1980s.

An important new kind of war comics was also invented at mid-

Jacques Callot, *The Miseries of War*, plate titled "The Wheel," 1633.

Image courtesy of Dover Publications, from *Callot's Etchings: 338 Prints*, ed. Howard Daniel, 1974.

century with Harvey Kurtzman's *Two-Fisted Tales*. (Kurtzman, who had served in World War II, as did many cartoonists including Will Eisner, also founded the tremendously influential *Mad* in 1952.) *Two-Fisted Tales*, a bimonthly war comic published by EC Comics, began in 1950 and, with the beginning of the Korean War only a few months later, devoted itself to delivering a detailed look at war, along with *Frontline Combat*, also published by EC. While many other war comics of the period romanticized the experiences of American soldiers and their cause, and criticized the inhumanity of enemy forces, *Two-Fisted Tales*, which was heavily researched, sought a more realistic take on the circumstances, brutality, and futility of war. "Corpse on the Imjin!" a favorite story of Art Spiegelman's, shows the pain and shame of one man killing another in one-on-one combat on the River Imjin in Korea. "Atom Bomb!," which Kurtzman created with Wally Wood, was highly unusual for 1953 in taking a sympathetic view to a Japanese family in Nagasaki, who are the comic's surprising protagonists.

By the height of the underground comics movement of the late 1960s and early 1970s—which was fueled by the anti–Vietnam War counterculture—far fewer mainstream war comics were in publication. Comics, though, was a form in which antiwar sentiments could be expressed, both underground and aboveground. Perhaps most notably, Garry Trudeau's brilliantly titled *But This War Had Such Promise*, a *Doonesbury* comic strip collection from 1973, featured a satirical but sharp-edged take on the war in Vietnam: the character B.D. enlists, and the strip follows him to Vietnam, where he befriends a Viet Cong soldier named Phred. Trudeau, whose long-running, syndicated *Doonesbury* has also offered Iraq War plotlines, was censored by newspapers for his Vietnam content; he was later honored by the

Dick Ayers, cover of *Sgt. Fury and His Howling Commandos* #52, 1968.

Vietnam Veterans of America. Cartoonists such as Jules Feiffer, Greg Irons, Ron Cobb, and others produced comics, some quite cutting, that were critical of the war.

But it was not until Keiji Nakazawa in Japan and Art Spiegelman in the United States, both of whom were inspired by antiwar counterculture in their respective countries, that comics became a form for bearing witness to war. Nakazawa, as the first chapter details, was a primary witness to the atomic bomb blast of Hiroshima, while Spiegelman, whose parents survived Auschwitz, is a secondary witness. Works like Spiegelman's *Maus: A Survivor's Tale* and Nakazawa's *Barefoot Gen: A Cartoon Story of Hiroshima*, both based on formative shorter works published in 1972, meaningfully capitalize on the intimacy of comics to probe the line between the public and the private—where history and individual experience meet—through stories of their families in World War II. The comics reporting of cartoonist and journalist Joe Sacco, on the other hand, documents wars with no connection to his family or background, and is inspired by trying to understand the nature of war itself. Sacco is the contemporary inheritor of the long tradition of "drawing to tell" that we recognize in Callot and Goya and the artist reporters of the nineteenth and early twentieth centuries. And he offers a prime example of what comics today can do: he has reinvented a genre, comics journalism, that is now flourishing across the globe.

Best known for his war reporting from the Middle East and the Balkans, Sacco has singlehandedly made serious comics reporting about war and global conflict a contemporary phenomenon, and he has influenced countless other artists across media, from Egypt's Magdy El Shafee (*Metro: A Story of Cairo*) to Israel's Ari Folman, who claimed the biggest influence on his acclaimed, animated film *Waltz with Bashir* was Sacco's comics series *Palestine*. Sacco's major works in the past two decades include *Palestine*, about the Israeli-Palestinian conflict during the First Intifada; *Safe Area Goražde*, about the so-

called UN-designated "safe" municipality Goražde in Bosnia during the Yugoslav Wars; *The Fixer: A Story from Sarajevo*, which also focuses on the Yugoslav Wars, from the perspective of a Sarajevan soldier and "fixer" (an in-the-know local hired by foreign journalists); and *Footnotes in Gaza*, which investigates two 1956 massacres of Palestinians by Israeli soldiers (the largest killings to have taken place on Palestinian soil) by extensively interviewing survivors. Sacco's most recent book of reportage, *The Great War*, is a twenty-four-foot foldout book that is a panorama of the first day of the battle of the Somme. This work was recently blown up to over five hundred feet as an installation in the Paris subway.

Sacco was born to a Catholic family in 1960 in the southern European island country of Malta, in a town of eight hundred people called Kirkop. Although *Footnotes in Gaza* conspicuously depicts him using his Maltese passport while traveling to the Middle East—he is a character in all his reporting—he now has dual citizenship with the United States. Sacco's Maltese nationality and Catholic upbringing have helped him navigate Jewish-Muslim conflict zones, such as Israel and Palestine, for which his background does not supply an obvious affiliation or context. For Sacco growing up, war was a fact of life. His parents had survived terrifying German and Italian air raids during World War II on British-controlled Malta. For one of Sacco's first major comics stories, "More Women, More Children, More Quickly: Malta 1935–43 as Recounted by Carmen M. Sacco," he interviewed his mother about her girlhood experiences during the war. The title refers to an infamous 1932 statement by British politician Stanley Baldwin: "The only defence is offence, which means that you have got to kill more women and children more quickly than the enemy if you want to save yourselves."

Sacco moved around a lot as a young person. When he was just one, the family left Malta for Melbourne, Australia, where Leonard Sacco worked as an engineer, and Carmen Sacco as a high school

teacher. As a child Sacco was a fan of British war comics, and noticed that his friends were all of mixed nationalities, and many from European families displaced by the war. American involvement in Vietnam increased during Sacco's childhood and became an obsessive focus in the global news media. When he was twelve, the family moved to Los Angeles, where his father pursued aircraft technology and maintenance, and then shortly after landed near Portland, Oregon, in a suburb called Beaverton, where Sacco started high school and ignited his passion for journalism as a writer (and sometimes cartoonist) for the school paper. Highly driven, Sacco attended the University of Oregon, majored in journalism, and graduated in three years. He read voraciously, and was particularly fascinated and moved by the journalists coming out of the Vietnam era like Michael Herr and Hunter S. Thompson, figures who had reinvented journalism to be a more self-aware, openly subjective, and writerly enterprise under the banner of what was called New Journalism.

Sacco created his first complete comic book around age seven. It wasn't until he moved back to Malta in his early twenties, however, that he finally got to publish his own comic books—even if they were formulaic romance comics. Sacco had been approached by a publisher about creating Malta's first comic-book series. He put out six issues of *Imhabba Vera* (*True Love*) in Maltese. As Sacco told me, because Malta had no history of comics, comics wasn't considered automatically, as in other cultures, a medium meant for kids. In one story, Sacco even had his protagonist traveling to Holland for an abortion, a procedure outlawed in Catholic Malta.

As much as he loved writing comics on deadline in Malta, Sacco—who had been working privately for years on his own long comics story about Vietnam—returned to the United States. After attempting to get a new monthly publication in Portland off the ground, he landed a job as a staff writer at *The Comics Journal*, the sophisticated trade magazine published by the independent press Fantagraph-

ics Books, which helped to create the field of literary comics in the 1980s. For Sacco, more and more, it seemed possible to create comics that engaged his skills as a journalist. Fantagraphics began publishing Sacco's first stand-alone comic-book series, *Yahoo*, in 1988. A consistent focus of the series is war; one issue about his obsession with the Gulf War is even titled "How I Loved the War." Another is called "War Junkie." Eventually, Sacco's interest in the Middle East led him to an entirely new kind of comics—comics for which he would report, as a journalist, on the realities of war.

Sacco traveled to Palestine in the winter of 1991, and spent several months in Israel and Palestine interviewing about a hundred people on both sides of the conflict for his groundbreaking comic-book series titled *Palestine*. He wasn't there to interview Israelis and Palestinians *for* anybody—representing a news organization, for example—other than himself. His independence, and his lack of institutional (or personal!) money helped him to gain trust on the ground. The ability to be independent can be part of the power of the direct, auteurist comics medium as a form for reporting.

As the simple, almost confrontational title *Palestine* indicates, Sacco's goal was to reveal Palestinian perspectives on the conflict. He became fascinated by Middle Eastern wars and conflicts in part because of how lopsided American news coverage of the Middle East in the 1970s and '80s felt to him. *Palestine*, then, is an effort to address the elision Sacco saw in the United States of a Palestinian point of view. But while he is open about his goal, Sacco does not sacrifice his journalistic practices or ethics; *Palestine* is resolutely a work of journalism and not one of propaganda. Sacco maintains that his professional standards "are every bit as good as those of other journalists." He explained to me, "I want to show the Palestinian side of things because just on a very basic, basic level, I feel like their side's being misrepresented, or hasn't been shown enough in the West, especially in the United States. . . . But if the Palestinians are portray-

ing themselves poorly in my eyes, that's not going to stop me from showing that." *Palestine* offers a chapter called "Getting the Story," in which Sacco presents an unseemly conversation with a group of Palestinian men, one of whom says, "Kill the Jews, and that makes us happy." Sacco also reports the opinions and beliefs of Israelis in chapters such as "Eye of the Beholder," "Through Their Eyes" and "Tel Aviv," titles that, like the book's simple place-name title, emphasize point of view.

It is hard to overestimate the importance of Sacco's *Palestine* to the comics world and to contemporary political and popular culture in general. Sacco established the terms for the field of comics journalism—and for contemporary war comics—in the early 1990s with *Palestine*'s nine issues (1993–1995). Published as discrete twenty-four- and thirty-two-page comic books with full-color covers, *Palestine* cost $2.50 (the first three), and then $2.95 each. Nothing quite like *Palestine* had appeared before—something that addressed gravely serious and complicated subject matter from the ground, and also worked within comics conventions. The covers depict grave sites, protests, torture, shootings, and arrests—underneath large, cheerful hand-drawn block letters, in outline with shading, that colorfully spell out PALESTINE across the top of each issue.

The image underneath the baby-blue letters of issue #7, for instance, shows a man with a bleeding stomach wound being dragged by his legs out of the frame as he grimaces deeply, his blood streaking behind him across the rocky soil like tire tracks. The dramatic composition of the image suggests a "first-person" point of view, as if the reader looks out from the perspective of the man whose hands we see grasping the injured man's leg. A tiny floating box of text, "by Joe Sacco," matches the shade of the title—which matches the trim on

Joe Sacco, cover of *Palestine* #7, 1994.
Used by permission of Joe Sacco.

the sneakers in the foreground. The striking covers of *Palestine* make legible how Sacco owns comic-book conventions for a new context: he combines the energy and immediacy of inexpensive, accessible, serial comic books with the gravity and rigor demanded by a journalistic investigation into world-historical conflict and its effects on the ground. The back cover reads, in type: "IN THIS ISSUE: A downpour in Jabalia . . . overflowing sewers and abandoned homes . . . a walk with veterans of the intifada's first day . . . thrown from a hospital bed . . . marriage prospects for a disfigured girl . . . bone-snapping on video . . . breaking a curfew."

Palestine eventually won an American Book Award, was glowingly reviewed in outlets like *Publishers Weekly* and the *New York Review of Books*, and was issued as a single volume in 2001 with an introduction by the celebrated literary critic Edward Said. *Palestine* was a crossover success, both with a wide range of comics fans—those who were likely to stumble across an issue for $2.95 at the local comic-book shop—and those who sought out the work because of its reputation as one of the most nuanced Western perspectives on the lived lives of contemporary Palestinians. Said wrote, "With the exception of one or two novelists and poets, no one has ever rendered this terrible state of affairs better than Joe Sacco." He praised the density of Sacco's comics, noting their unhurried pace, wealth of information, and their "power to detain" readers on the page. An episodic work, *Palestine* is structured, as is all of Sacco's work, into titled sections that vary in length. Like all of his comics, *Palestine* combines a synthetic, big-picture view of a conflict—how that conflict, or war, is played out on a collective stage—with detailed attention to the everyday details of people's lives, both in what Sacco himself observes and re-creates, and in drawings that illustrate the oral testimonies of individuals who have experienced torture, for example.

Sacco is just as influenced by artists like Pieter Bruegel the Elder, the sixteenth-century Dutch painter, as he is by twentieth-century

prose journalists like Hunter S. Thompson. Bruegel, known as one of the greatest landscape painters, holds such massive appeal for Sacco not only because Bruegel is an incredibly acute social critic, but also because his large, detailed paintings are invested in recording customs and practices of everyday life. Sacco often features large, panoramic landscapes in his comics, which appear as double-spreads, with one image overtaking two facing pages. In these remarkable comics landscapes, one also recognizes the influence of some of Bruegel's most famous compositions—wide views, full of swarming detail, in which there is no central subject or action. When Sacco traveled to war-torn Goražde, Bosnia, for his book *Safe Area Goražde*, he said he felt that "I'd stepped into a painting by Bruegel." One of *Safe Area Goražde*'s most striking double-spreads pays homage to the composition of Bruegel's famous 1562 painting *The Triumph of Death*, from the hills right down to the dog in the center left foreground (a reproduction of the painting sits in Sacco's studio).

As with Bruegel's landscapes, Sacco's comics offer rich, detailed views of place that allow a reader to imagine how people live in extreme times and situations. In drawing and painting, media that can assemble moments into one dense image, the artist has the ability to record detailed information in a revealing wide or bird's-eye viewpoint. "That's the great thing about being a cartoonist," Sacco told the media theorist W. J. T. Mitchell. "If you know something about drafting or perspective, you can pull yourself up." This elevated view of a swarming landscape—one in which many narratives and stories are happening at once in an information-rich scene—is typical of Bruegel and, as critic Jeff Adams has pointed out, rhymes in particular with his 1559 *Kermesse at Hoboken*, which pictures a church

Joe Sacco, double-spread drawing of Jabalia refugee camp, *Palestine* (Seattle: Fantagraphics), 2001.

Used by permission of Joe Sacco.

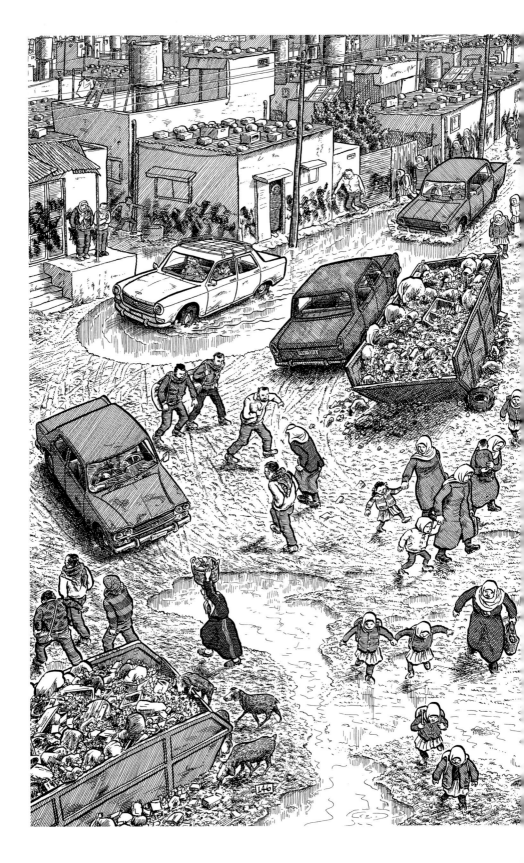

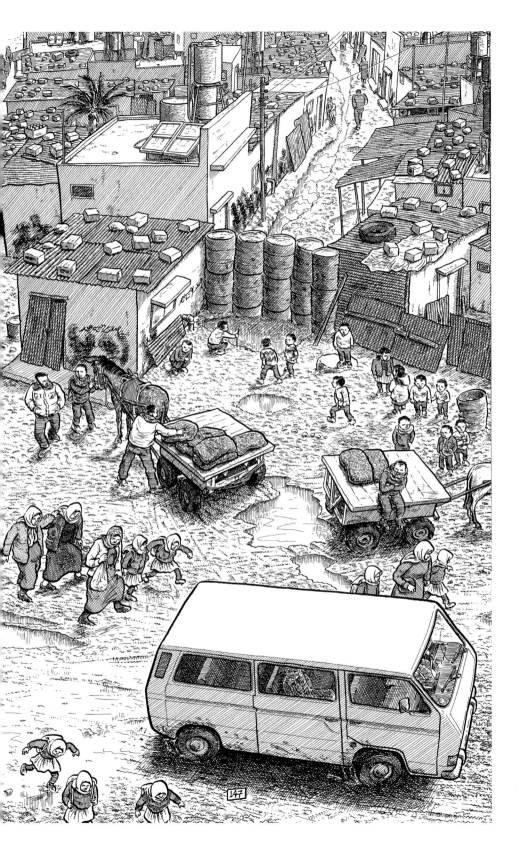

147

festival in a Flemish village in a composition similarly overrun with people, animals, and horse-drawn carts.

A panorama of the Jabalia refugee camp, which is in the Gaza Strip, conveys a sense of the overcrowding, poor conditions, and disrepair, and also of everyday life persisting—schoolchildren walking home, mothers holding the hands of children, women helping each other through the mud, a shirt and pair of pants hanging to dry despite the wet weather, cars inching forward through the packed space. Sacco has described how landscape is a character in his comics—just as much as any person. "If you are depicting something graphically and it has a pretense to journalism, the idea is to get the reader there somehow," he explained. "I want the reader to open up the book and just immediately be there." While Sacco argues that traditional American journalism has "this tendency for uselessness as far as giving people a feel for what it's really like," he contends that comics, on the other hand, "is a very engaging journalistic medium" because "it allows a sense of time and place to seep in through images."

The double-spread of the Jabalia refugee camp in *Palestine* is also a "bleed": the images run off the margins of the page, swarming every inch of space. We see mud everywhere; children and adults slog through it and leap over puddles of water in the foreground, while in the background cars slowly wind their way through deep pockets of water toward large dumpsters of trash. Specific graffiti is visible on walls; elsewhere one notices graffiti that has been painted over. Sheep eating trash and donkeys pulling carts populate the landscape. Cinder blocks and tires hold down roofs from blowing off of rickety residences; the background is thick with roofs, water towers, and cinder blocks. I can count seventy-five people in the image, and many mininarratives playing out in its corners and edges as people move through space. As with many of Bruegel's famous landscapes, no one action takes center stage, and every inch offers information for a reader

to take in. And readers get hard information about conditions—for example what materials the residences are made of, what counts as trash disposal—as well as a feeling of what moving through that space might have felt like. The heart of *Palestine* takes place in the Jabalia refugee camp, where Sacco stayed with a resident and translator named Sameh. Jabalia, which has a reputation for tough, harsh conditions, is where the First Intifada (or "uprising") began in 1987, triggered by a disputed traffic accident in which four Palestinians were killed nearby: it's a fitting center for *Palestine*.

Palestine is an incredibly prescient book, portraying the stone-throwing and other protest activities of the First Intifada, which ended in 1993 (shortly after Sacco's trip concluded). The book ends with a gesture toward what would later become the signature act of the Second Intifada—suicide bombing—in a chapter that focuses on a lost Israeli bus: it stands in nicely as a metaphor for how a country guides a people, transporting them to a future, and also suggests how public transportation became the site of suicide bombing and other attacks.

Sacco's war tour de force, however, is his *Safe Area Goražde*. In this case, the community ravaged by violent conflict is the so-called "safe area" municipality of Goražde, Bosnia, where Sacco traveled in late 1995 and 1996. Goražde's Muslim residents had fallen victim to or endured brutal attacks from Serb nationalists, including from people who were once their friends and neighbors before the war, and continued to be under siege. Goražde was one of six Bosnian enclaves that the UN declared "safe" during the Yugoslav War—another was Srebrenica, where the biggest massacre on European soil since World War II took place in July 1995, a genocidal action in which upward of eight thousand men and boys were killed and dumped into mass graves. Sacco writes in the book that Goražde, which had received very little press coverage compared to other "safe" territories like Sarajevo, "had become a symbol of the meaninglessness of the safe area

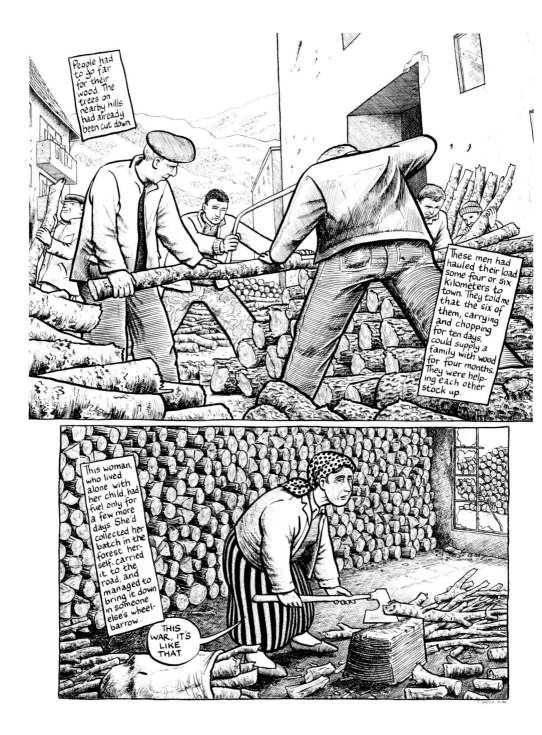

concept specifically and the impotence of the international community generally."

Safe Area Goražde shows how powerfully comics journalism can reveal the experience of living through war—for soliders, civilians, and refugees. It details location in the way that *Palestine* does, allowing a person to access the smallest details of place. It also reveals a facet of war that does not often get covered by news outlets, whether on television, online, or in the newspaper. *Goražde*, for which Sacco interviewed soldiers and civilians alike, gives readers many well-researched and repeated images of battle frontlines, which are heartbreaking. But it also focuses on a distinct level of information—the details that aren't usually sexy enough to make the shorter or quicker news stories—about how people in wartime conduct their everyday lives. "I talk to a lot of journalists and sometimes I'll read something they write and they are so focused on the main issue that they don't allow for those humanizing moments that actually reveal the people they are talking to as human," Sacco explained in an interview.

Both visually and verbally, Sacco carefully documents what gets dropped out in the broad strokes of political and war reportage, such as how people in Goražde cut and stacked wood, or precisely how they put together paddle-wheel generators jerry-rigged from refrigerators and cars. "I recognize this isn't the type of thing that's going to make it in the newspaper," Sacco said in an interview, noting that these details would be "lost" to history otherwise. Offering elaborate visual backgrounds in addition to textual information, comics journalism can include details that amplify the atmosphere Sacco seeks to convey, while also transmitting relevant hard information. This is an important feature of how *Goražde* communicates the effect of war on regular, ordinary people.

Joe Sacco, page from *Safe Area Goražde* (Seattle: Fantagraphics), 2000.
Used by permission of Joe Sacco.

Images of stacks of wood—drawn so precisely that one can read the grain of each piece—recur throughout *Safe Area Goražde*. Sacco highlights the documentary aspect of his comics in his meticulous style, in which he precisely reproduces texture, from soil to wood to fabrics. Each page here, as in all of Sacco's comics, is separately dated with "J. Sacco" followed by the month and year Sacco completed it, emphasizing its quality as a document. Sacco establishes early on how residents of the city, who couldn't leave the area and who were besieged on all sides, went to efforts to find and stack wood to heat their homes with wood stoves (the trees in the nearby hills had been depleted). In an early page of the book, after remarking how cold Goražde is in a chapter called "The Deep Dark," Sacco draws a group of men cutting wood—stockpiling it—in a large panel that bleeds off the page and takes up an entire tier. A slightly smaller panel below, which is bounded with margins on all sides, as if to suggest the feeling of being trapped, shows a woman—a single mother—bent over, ax in hand, chopping wood. Sacco notes in a text box that at the time the two of them met, she only had enough wood for a few more days. "This war, it's like that," she declares with resignation, in a stark speech balloon whose words appear in capital letters that hover over her small satchel of wood. How do everyday lives unfold? Sacco asks readers to confront the difficulties of daily life in wartime, to understand how the dwindling of resources in a specific war-torn area comes about and is confronted—if it can be.

One of the most gripping and horrifying sequences in *Safe Area Goražde* occurs in a subsequent chapter, "The First Attack," which exemplifies one of the signature features of Sacco's war comics: his meticulous visualizations, in the medium of comics, of the oral testimonies of people he interviews. In Sacco's war comics, the focus is constantly shifting between showing in detail the ordinary rhythms of life for people trying to survive in a conflict zone (to procure heat, electricity, shelter, food) and showing extreme and often fa-

tal violence—another feature, of course, of war. What would it be like if your neighbors, including people you thought were your friends—or your children's friends—suddenly turned on you and started killing you? "The First Attack" refers to a terrifying, grim day, May 22, 1992, in which Serbian nationalists, including some from Goražde, attacked Bosnian Muslim inhabitants of the town. In the account supplied to Sacco by several residents, inhabitants of the Kokino Selo neighborhood are suddenly besieged, as the nationalists fire upon them with automatic weapons from the surrounding hills and shell the neighborhood. The women and children start running to the local Drina River, hoping to escape. The chapter follows multiple people, and their unfolding stories, chronologically from the beginning of the attack. Here, as in other testimonies that take readers back into the past, Sacco replaces white backgrounds with ominous black backgrounds.

One particularly moving page opens with the voice of a man, Izet, in the first square panel. Sacco draws his name in capital letters, and quotes him directly. Below, he draws what Izet's experience looked like, based on testimony and research. Families are crawling, on their stomachs, over a field to the Drina River to avoid gunfire. Izet's thirteen-year-old daughter, whom readers see in a panel that pictures the two of them from behind, as if our viewpoint is propelling them forward, is crying. In her fear she protests to her father, in that touchingly stubborn childlike way, that she'll get her clothes muddy, as if she doesn't realize she could be killed any minute. The next panel pulls back to a wider view, an eerie image revealing the field is full of bodies, some already dead, as far as the eye can see. In the middle of the page, as the perspective swings around to face Izet and his daughter, they pass a man whose stomach is ripped open,

Joe Sacco, page from *Safe Area Goražde*: Izet and Rumsa's testimony.
Used by permission of Joe Sacco.

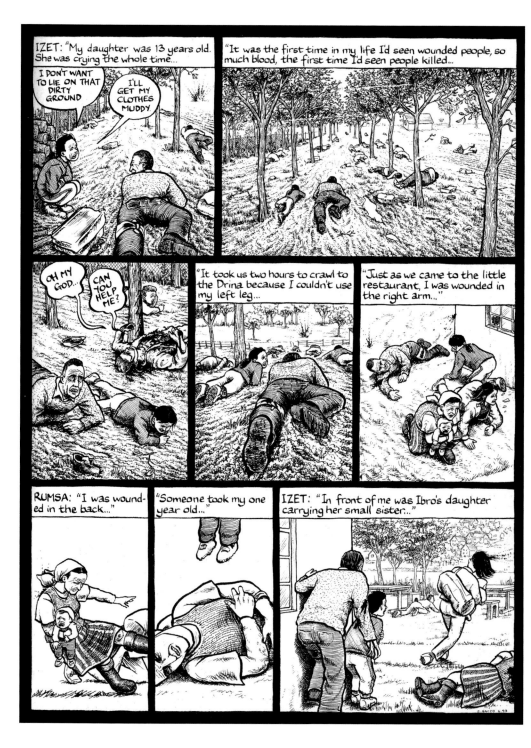

lying on his back, dying. Izet has already been shot once, and is dragging his left leg.

As they edge to the side of a neighborhood restaurant, where others also escaping from the village are paused, crouching, Izet is shot again. The narrative then switches, in the last tier of the page, to Rumsa, a woman who in panic is running to the river alongside her eldest daughter, age twenty, with her youngest daughter, age one, in her arms. We see Rumsa crouching at the side of the restaurant when Izet gets shot in the arm. When Sacco switches over to her voice, we see her get shot too. The text reads, as a direct quotation, "RUMSA: I was wounded in the back . . ." above an image of her, in a head kerchief and skirt, midfall. "Someone took my one year old . . ." are the words at the top of the next frame, a moving and terrifying image in which all readers see are the child's feet as her tiny body is lifted away in a split second from her shot, felled mother. The gap of space between the baby's feet and the mother's supine body is at the center of the panel. Rumsa is on the ground; the baby is being snatched to safety in a hail of gunfire—by someone Rumsa can't see, as we can't either.

The page's last panel switches back to Izet. Its last words are as follows: "In front of me," Izet says, "was Ibro's daughter carrying her small sister. . . ." In the accompanying image, readers see that it was the baby's older sister who grabbed her the moment their mother was shot, and kept running. She stopped to try to save her sister's life, while barely slowing her pace, once her mother went down. The angle the image takes is from behind the assembled group; we see an image of the twenty-year-old running, baby in her arms, midgait. If we look closely we see streams of blood spurting out the right side of her head; she is shot in the forehead. Her head inclines to the right as the blood, almost blending in with her black hair in Sacco's drawing, sprays out. The older sister is killed trying to save the youngest member of her family. Sacco endeavors to communicate the experience

of war through comics by both directly citing the actual testimony of survivors, and by picturing their experiences—and making them immediate—for readers. Sacco sets up readers to witness the unfolding event of the young woman's death in what approximates real time, aligned with the gaze of other horrified onlookers.

Other media seeking to convey extreme human experience include both words and images—most notably film. But work like Sacco's is a markedly different form because it is hand-drawn by a single person. As Sacco pointed out in an interview, "You might need $50 million to put together a film of similar scope to [my] book on Goražde." Comics can be powerfully direct. "A cartoonist needs only pen and paper," Sacco has said. As he suggested, the medium of comics "can be used with humility to its advantage." Humility was Sacco's aspiration in the often-violent *Safe Area Goražde*, in which witnesses and survivors recount, and Sacco himself observes, deeply traumatic events. The direct connection of cartoonist to witness—in which the cartoonist endeavors both to present a witness's voice and to visually re-create his or her experience on the page—offers an immediacy and a straightforwardness that feels appropriate to the easily sensationalized subject of war. In comics, the reader controls his or her own pace of consumption, unlike in a time-based medium such as film or video, in which a violent image might flit by, or occupy the screen for what feels like too long. In Sacco's comics, the reader can choose to linger on a violent image, to study and decode it, or to skip it: to put the book down, to quickly turn the page. When war— with its violence—is the subject, pacing becomes an ethical issue. In comics the reader, unforced, may pace herself, look as little or as long as she wants. Film, on the other hand, as Sacco has contended, "washes over you."

Joe Sacco, page from *Safe Area Goražde*.

Used by permission of Joe Sacco.

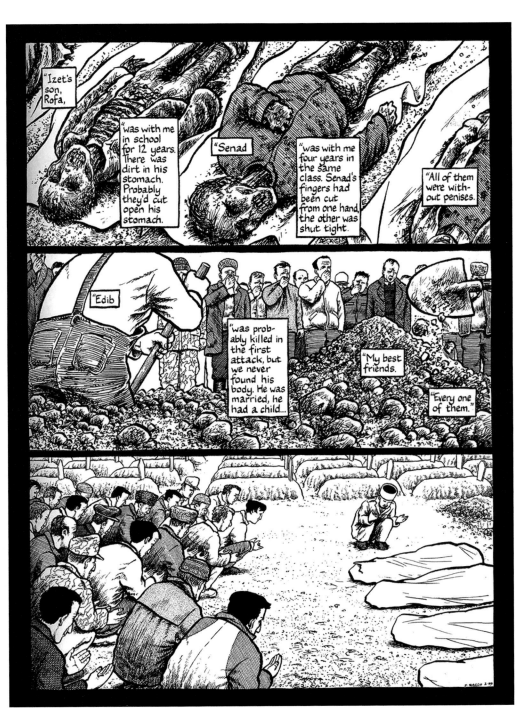

However, working for print, Sacco does deploy the language of comics, and a striking, precise drawing style, to suggest a slow and careful engagement with the subject of war. He evens calls his work "slow journalism"—it functions with a slowness that is a deliberate rejection of today's deadline culture and hyperactive news media. Later on in "The First Attack," for instance, readers encounter a display of these compositional and stylistic elements together in an episode about uncovering mass graves. Here the narrative shifts to focus on Edin, a young man who is a lifelong resident of Goražde, in Kokino Selo, and is Sacco's translator and fixer (Sacco concentrates on the role of fixers to journalists in his following book). Edin recounts to Sacco how in March 1993 people in Goražde found seven bodies, massacred, dead for months, in a grave with a dog buried on top of them. Two of the bodies found were his best friends.

In one particularly disturbing page, which represents the testimony of Edin, Sacco draws four of the seven bodies in its opening panel. Here, noticeably, Sacco also uses fragmented text boxes—one of his signature techniques—to lead the reader's eye across the difficult-to-look-at corpses. In his comics, Sacco often breaks a sentence up into different text boxes that float, unconventionally, all over a panel or page. The effect is elliptical, asking readers to pause and look, and to follow the movement of the text over and across the image (in this technique, Sacco has said an influence is the stylized use of ellipses by French avant-garde novelist and World War I veteran Louis-Ferdinand Céline, author of *Journey to the End of the Night*). Sacco spatializes the prose in an almost diagonal line across the ruined bodies, giving the words material weight on the page. The panel begins, in Edin's voice, with a small box hovering between two bodies, one of which anchors the left corner: "Izet's son, Rofa,"—no full stop. (Izet is the same man who we encounter earlier shepherding his daughter to the river.) As the eye follows the unfurling words, it stumbles over additional bodies, laid out on the ground, large and badly

decomposed, eyeless, sunken, mouths eaten away to reveal teeth in the perpetual grimace of skulls.

The first sentence continues, in a box laid over one side of the panel's first full-length corpse (a body with what appears to be a pile of stones in its center): "was with me in school for 12 years. There was dirt in his stomach. Probably they'd cut open his stomach." The next sentence starts in a box placed on the body of a third man, over his left shoulder: "Senad," the sentence begins in its own box—and one must move over his rotted corpse in order to stop at another box over his right shoulder, "was with me four years in the same class. Senad's fingers had been cut from one hand, the other was shut tight." The last of the five boxes is a single sentence unto itself, superimposed over the chest and completely decomposed arm of the fourth body: "All of them were without penises."

The fragmentation of this text out, over, and onto the emasculated bodies of murdered men has a dramatic effect that slows regular reading down. The eye instantly—upon reaching the far side of the panel—jumps back to the mutilated bodies, and if one did not linger long enough on them the first time, one now notices (and confirms) that there are black gulfs between their stiff legs, violent thatches of absence. The panel's composition of words and images also delivers a paradoxical, unsettling effect: the words appear at once to float between the bodies and to stamp themselves onto the bodies. "Senad" appears in its own box up near the left shoulder of a corpse, like a name tag. And the page's final panel, in which Edin and other men from Goražde pray during the proper burial they finally give the murdered men, demonstrates the poignancy of silence, removing words from a form that is structured by the constant back-and-forth rhythm between reading and looking.

In order to be able to draw these disinterred bodies accurately, Sacco consulted forensics experts. Their decomposed faces, torsos, and limbs, partially clothed with rotting garments, are drawn with

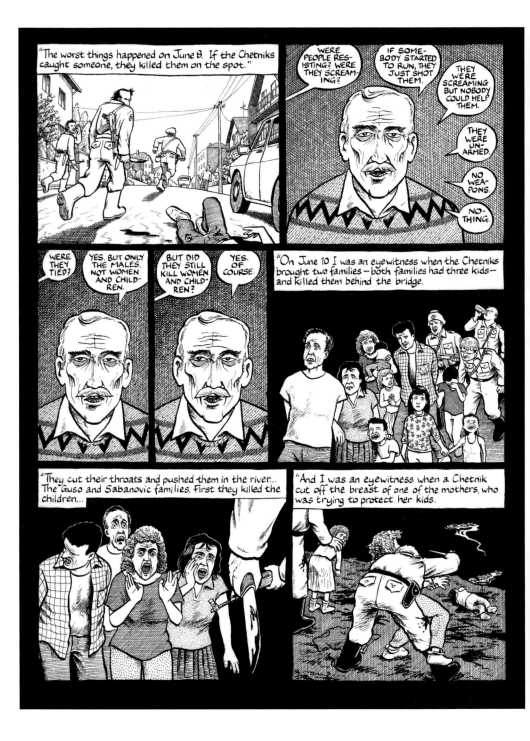

striking exactitude. Sacco sometimes draws with the exaggerated, curvy lines of underground cartoonists like R. Crumb (the "bigfoot" style crops up whenever he draws himself, for example), but when he wants to, he can draw with a very, very high level of realistic detail—one that is distinct in comics and comparable perhaps only to Phoebe Gloeckner's. His approach, then, to drawing war is very different from the monochromatic simplicity of Marjane Satrapi's child's-eye view. Art Spiegelman also draws mass graves, in *Maus*. But while Spiegelman's style of loose black lines, and de-particularized faces, signals his abdication of aesthetic mastery as appropriate to a story about the Holocaust, Sacco's style is dense, virtuosic, and often photorealistic. It is an ethical attempt to represent people whom he believes have been ignored in the world arena with as much particularity as he can deliver.

Sacco's desire to represent particularized individuals (whether dead or alive, as above) is clear in his attention to faces—specifically the faces of those people whose testimonies he draws. Sacco wants readers to encounter a specified individual—not just a faceless victim. He also wants to pull back the curtain, and show how journalism actually works—to show the context that allows his interviews and conversations to happen, to show the seams of the enterprise and not just the seemingly transparent final product. By detailing the faces of his subjects both in the present-tense situation of testimony and in the past events that they narrate, Sacco asks readers to exchange gazes with these war-battered subjects. He wants readers to confront these people face-on, suggesting a mutual, equalizing exchange, rather than looking down, up, or sideways at them.

We see this in *Safe Area Goražde* with Rasim, an older Bosnian Muslim man who was an eyewitness to literally hundreds of kill-

Joe Sacco, page from *Safe Area Goražde*: Rasim's testimony.

Used by permission of Joe Sacco.

ings of Muslims by Serb nationalists (who are here widely called "Chetniks," a derogatory term) on a bridge over the Drina. Rasim barely escaped with his own life after being dumped on a truck on its way to an execution site after he was twice helped by Serbs who recognized him and chose to save him—one a neighbor, one a friend of his daughter's. Throughout "Around Goražde Part 1," the chapter that details Rasim's story, Sacco consistently draws the heavy-eyed, mustached Rasim—framed face-on in a panel, looking out directly at readers in a patterned sweater, collared shirt, and existentially weary expression. In this way, too, Sacco shuttles back and forth from the present to the past, reminding readers of the scene of testimony in addition to what it reveals of the past. His own voice, "offstage," even enters several panels. This page elaborates the killing of children. "But did they still kill women and children?" Sacco's voice asks from off to the side, even as Rasim stares out at readers. "Yes. Of course," Rasim replies. Sacco's investment in visual realism stems from his belief in the ethical efficacy of showing, as much as possible, what an event was like. Sacco said in an interview, "[The Serbian nationalists] were killing kids. . . . I decided to make this a realistic comic, and once I made that decision I just thought . . . 'I'm not going to try to make it abstract. I mean, killing a kid is killing a kid.'"

The issue of drawing faces comes up again in Sacco's *Footnotes in Gaza*, a 418-page investigation—through interviews, on-the-ground research in the Middle East, and archival research in Israel and at the United Nations headquarters—into what transpired during two massacres of Palestinians by Israeli soldiers in 1956 in the wake of the Suez Canal crisis. In the first, in the town of Khan Younis, a

Joe Sacco, *Footnotes in Gaza* (New York: Metropolitan), 2009: the schoolyard gate in Rafah.

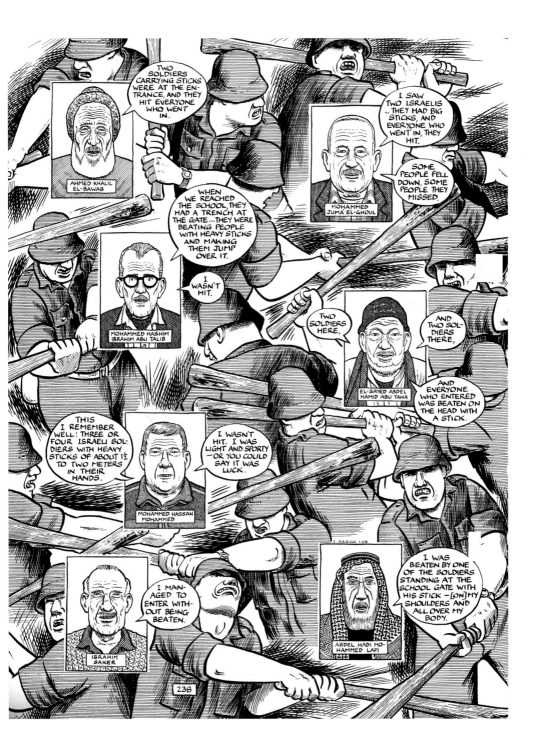

presumed 275 unarmed men were lined up against a wall and shot. In the second, less than two weeks later, in the neighboring town of Rafah, a presumed 111 unarmed men were shot and beaten to death during a daylong screening operation in which people were forced out of their homes and into a schoolyard. *Footnotes in Gaza* is the most relentlessly violent of all of Sacco's books, in terms of the sheer numbers of corpses that populate its pages. I asked Sacco in an interview if it was hard to draw *Footnotes*, which he worked on for seven years— three for research, four drawing. Sacco has joked about "Joe Sacco Trauma Syndrome." "I did not want to go to the drawing table," he told me. "When you're in the middle of it, you don't like doing it, but it's your job. You know you have to get through this, you have to show this. You made that decision to show it."

Sacco pays special attention in *Footnotes* to faces, even more so than in his other works, in which the individuated face is always on display. *Footnotes* aims to archive, in comics, the oral testimonies of the massacres by every single survivor Sacco could track down. In his effort to amass these voices in order to understand the events, Sacco carefully draws and fully identifies each witness by first and last name. One feature of the Rafah massacre that Sacco focuses on closely is how prisoners were herded into the schoolyard. Israeli soldiers with heavy sticks stood at either side of the gate to the school, and beat people on the head as they were forced to pass through. Sacco's own narration explains that while the group of survivors had some differing accounts, and forgot various details of the traumatic day so many decades back, this part of the day "remains burned into even the most age-dulled minds." In one dense, virtuosic page in this episode, Sacco drops the page borders and even panels and fills the page entirely with assembled moments of time. The present-tense faces of survivors, each of which is framed in a small box with a full-name identification, are overlaid on images of soldiers athletically swinging sticks, so that the page produces a jumble of accumulated actions, with each witness's

face and short account, in speech balloons, of entering the gate. This dense page palimpsests past and present, and juxtaposes Israeli and Palestinian bodies in the swirls of action, suggesting the chaos and confusion felt by the prisoners.

The juxtaposition of the faces of the Israeli soldiers (there are two of them, whom Sacco draws repeatedly) and the Palestinian survivors also emphasizes just how differently Sacco draws the soldiers and the civilians. In the swirl of the page, the Israeli faces are mostly obscured—readers do not have much access to their eyes, for example—while the Palestinian faces are particularized, a feature highlighted by how they are framed, in same-size panels that evoke passport or school photos. Sacco told me that he realized, creating *Footnotes*, that he had hit a sort of wall in his quest to understanding war. "You have to put yourself in everyone's shoes who you draw, whether it's a soldier or a civilian. You have to think about what it's like: What are they thinking? What are they feeling? The truth be told, that's part of the reason I don't [always] show Israeli soldiers' faces. I couldn't understand it. . . . I couldn't always put myself in their psychology properly, so in a lot of cases, I refrained from drawing their faces."

Footnotes is a masterpiece of reporting and research. Reviewing the book in the *New York Times Book Review*, the seasoned Middle East expert Patrick Cockburn declared that *Footnotes*, which he calls "investigative reporting of the highest quality," stands out as "one of the few contemporary works on the Israeli-Palestinian crisis likely to outlive the era in which they were written." And yet for Sacco, in some ways *Footnotes* represents a dead end—the limit of his understanding of war, as we see with his inability to understand certain actions. Sacco told me, "I don't know where to go from here, except to delve into human psychology. . . . What am I going to do after this, keep detailing massacres?" Indeed, a current project, which will be years in the making, goes all the way back, in his efforts to understand war,

to the early civilization of Mesopotamia, seeking out the answer to the question, How does the state get a person to kill another person?

Sacco's comics are thoroughly international. In addition to his two books each located in the Middle East, and in the Balkans, and his *The Great War*, which takes place in France, Sacco has done multiple, important comics stories on refugees, including long pieces on displaced Chechens ("Chechen War, Chechen Women"), and on refugees to Malta ("The Unwanted"). He has traveled to India for "Kushinagar," about the effect of the caste system on Dalit villagers in northern India, and he has also explored poverty in America in his collaborative book with prose reporter Chris Hedges, *Days of Destruction, Days of Revolt*. During the Iraq War, he was embed-

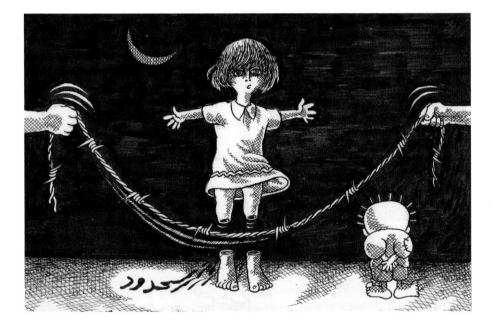

Naji al-Ali, cartoon featuring child-witness Hanthala staring along with readers at the scene, circa 1983–1985. Translation: "The borders."

Published with permission of the Naji al-Ali family. Image courtesy Khalid El-Ali.

ded with US troops and produced several comics reports, including "Down! Up! You're in the Iraqi Army Now," which examines American training of Iraqi troops and was published in *Harper's* (as were many influential reports from artist-reporters during the Civil War). When Sacco first took himself to the Middle East, for *Palestine*, he wasn't sure how people would receive the news that he was there as a journalist and cartoonist both. But in Palestine, he came to realize, there was an extant culture of respect for cartooning because of Palestinian cartoonist Naji al-Ali. Naji al-Ali, who had grown up in part in the Ain al-Helweh refugee camp in southern Lebanon, was assassinated in London in 1987. His cartoons spoke truth to power—Israel, the United States, factions within Palestine—and featured a character, starting in 1969, who remains an icon across the Middle East: Hanthala, a ten-year-old child. Hanthala, always barefoot, and almost always with his back to viewers, is a figure for witness: we see him seeing the scene that al-Ali draws, and his presence functions like a conscience. Sacco wrote the introduction to *A Child in Palestine*, the first collection in English of Naji al-Ali's work, which was published in 2009.

Sacco established conflict zones around the world as an urgent subject for contemporary comics. He is also, it is worth recalling, the first Maltese cartoonist, and worked to develop Malta's comics culture in the 1980s. Globally, the biggest and perhaps most obvious comics markets and comics cultures are the Japanese manga tradition; the Franco-Belgian comics tradition, which gave the world *Tintin*; and the American comics tradition (Canada also has a thriving independent comics scene). However, there are other significant traditions from around the world that are emerging and becoming vital. India is now the world's fourth-largest producer of comic books and graphic novels—even though the book considered the country's first official graphic novel, Orijit Sen's *River of Stories*, did not appear until 1994. Sen's *River of Stories*, a work in the social

justice mode of comics journalism, focuses on the effect of the construction of dams on the Narmada River. In the global arena, *River of Stories* is an early and important example of comics journalism, a continuously growing genre in India, and one can understand why many cartoonists there have engaged with Joe Sacco's work (especially after his 2011 "Kushinagar"). Cartoonists including Sarnath Banerjee, the author of four graphic novels, most famously *Corridor* (about a secondhand bookstall in Delhi) and Vishwajyoti Ghosh, who recently edited an anthology of graphic narratives from India, Pakistan, and Bangladesh titled *This Side That Side? Restorying Partition*, have become big names both inside and outside India. The first Comic Con India was held in Delhi in 2011. Indian cartoonists have showcased work in this annual convention alongside visitors to the country including Robert Crumb and Aline Kominsky-Crumb, and Brazilian artist-brother team Fábio Moon and Gabriel Bá. New Cons have cropped up across the country; the cofounder of New York City's important anti-war social justice comics anthology *World War 3 Illustrated*, Peter Kuper, was a featured guest at the Bangalore Comic Con in 2014. Comics in Western and Eastern Europe, in places like Italy and Poland, have been steadily on the rise. In 2006 the Studio Museum in Harlem staged a show called *Africa Comics*, featuring comics from every African country. In Singapore, China (despite censorship issues), Malaysia, and Korea, in addition to the enormous comics culture in Japan, comics making is on the rise.

In short, comics cultures are sprouting from places all over the globe, even from locations that don't have long historical comics tra-

Riad Sattouf, *The Arab of the Future 2: A Childhood in the Middle East* (New York: Metropolitan), translated from the French, 2016. Riad and his parents, living in Syria, watch Syrian Special Forces on television.

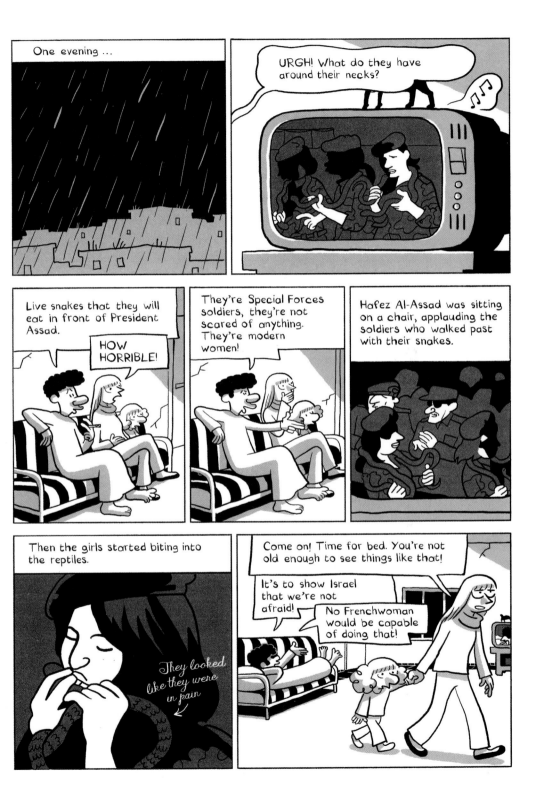

ditions. One enormous regional growth area for comics is the Middle East. In Israel, which hasn't traditionally had a rich comics culture, cartoonists like Rutu Modan (whose illustration is the cover of my book *Graphic Women*) and Asaf Hanuka have been translated and gained international fame. There was a whole spate of sophisticated comics done during and after the Arab Spring, and places like Cairo (with its comics magazine *Tok Tok*) and Beirut (with its comics magazine *Samandal*) have thriving comics cultures. A recent book on contemporary Beirut even opens by referring to webcomics by the cartoonist Mazen Kerbaj.

But the most famous comics work in recent years to come out of a Middle Eastern context is Riad Sattouf's international best seller *The Arab of the Future: A Graphic Memoir*, which was first published in France and is now appearing as several translated volumes in the United States. Unlike Sacco's finely grained black-and-white pages, *The Arab of the Future*, a childhood memoir rather than a work of journalism, uses clean, simplified lines and cheery pastel colors— many pages are solely pink and black—with schematic, rounded shapes, like the loose spirals that indicate Riad's "flowing blond hair like a Hollywood actress." The first volume has already been translated into sixteen languages. Sattouf, who has a French mother and a Syrian father, and grew up in Libya, Syria, and France, is notable for being the only cartoonist of Arab descent to have been on staff at *Charlie Hebdo*. It was *Charlie Hebdo*'s offices in which terrorist gunmen massacred twelve people, including the magazine's editor, likely because the French satirical comics publication had published mocking images of Mohammed.

Sattouf drew a regular strip for *Charlie*, called *The Secret Life of Youth*, a man-on-the-street-style real-life strip, for ten years until just a few months before the attacks. (He revived the strip for the first issue of *Charlie* that was published after the attacks.) *The Arab of the Future* adopts the point of view of the child at its center; its title refers

to what Sattouf's father, a Sunni Muslim hailing from a village near Homs, explained to Riad he wanted him to become. In terms of identity and futurity, Sattouf, after a difficult childhood, seems to have chosen a more flexible, and deeply felt, identity. As Sattouf himself told an interviewer in 2016, "[I'm] not French, I'm not Syrian . . . I'm a cartoonist."

WHY QUEER?

The fastest-growing area in comics right now may be, broadly speaking, queer comics—comics that feature in some way the lives, whether real or imagined, of LGBTQ (lesbian, gay, bisexual, transgender, and/or queer) characters. Queer comics are one of the most vibrant areas of contemporary comics, fueled in large part by the runaway success of Alison Bechdel's 2006 graphic memoir *Fun Home: A Family Tragicomic*—the story of a gay girl and her closeted, ultimately suicidal gay father that was adapted to be a Broadway musical of the same title, and went on to win the Tony Award for Best Musical in 2015. Gayness used to be a public accusation leveled at comics to discredit the medium: in the 1950s Batman and Robin, and Wonder Woman, were suspected to be gay, and therefore a negative influence. Dr. Fredric Wertham wrote in his influential book on comics that the former represent "a wish dream of two homosexuals living together," and for the latter, "the homosexual connotation of the Wonder Woman type of story is psychologically unmistakable. . . . For girls she is a morbid ideal." The infamous 1954 Comics Code, inspired by Wertham's study, banned "sex perversion

or any inference to same"—a clear reference to homosexuality. But today gay comics are an ever-expanding feature of the field, marking a new era of self-expression. Comics used to be read paranoically as gay code; in contemporary comics queer identity is openly announced.

The excitement around queer comics, from readers and creators both, is rising steadily. Justin Hall's compendium *No Straight Lines: Four Decades of Queer Comics*, an edited collection, sold out its first print run in 2012. Two cult classic graphic novels from the nineties, artist and activist David Wojnarowicz's *Seven Miles a Second* and literary critic and writer Samuel Delany's *Bread & Wine: An Erotic Tale of New York* (both collaborations with illustrators), were reissued in deluxe editions in 2013 for new readerships. And 2015 marked the creation of the first annual comics convention to focus on queer culture: Flame Con. New York City's Flame Con describes itself as "a two-day comics, arts, and entertainment expo showcasing creators and celebrities from all corners of LGBTQ geek fandom," and specifies "geeks of all types are invited to attend and celebrate the diversity and creativity of queer geekdom and LGBTQ contributions to pop culture." Most significantly, however, the range and volume of queer comics appearing right now demonstrates how forcefully the realities and details of gay life can get expressed and visualized in comics. Diverse comics about all sorts of aspects of queer experience flourish online, in the direct and censorship-free zone of webcomics. And in the world of print, we see an outpouring of distinct genres of comics that explore and address queerness. Among the artists creating this work, Bechdel has shown most powerfully how comics can be a space for sophisticated storytelling about the complexities and joy of queer life.

Bechdel was influential long before *Fun Home*, which was published when she was forty-five. Bechdel's hugely important and popular syndicated comic strip *Dykes to Watch Out For*, which chronicles the everyday lives of a diverse group of mostly gay friends and lovers, began in 1983 and ran for twenty-six years; it changed comics cul-

ture and broader queer culture definitively. The guide *Dyke Strippers: Lesbian Cartoonists from A to Z* is even dedicated to Bechdel. Film director Lana Wachowski, of the *Matrix* franchise (and a trans gay woman), wrote recently that although she was a fan of mainstream comics as a kid, and later the work of Robert Crumb, "It wasn't until I discovered Alison Bechdel's *Dykes to Watch Out For* that I really understood what I was looking for, a queer world with stories and characters that I could recognize, that I could laugh with and care about."

The history of gay comics, however, doesn't start with Bechdel. It has roots that go back at least to the underground comix movement of the 1960s and '70s—and even earlier, too, if one considers classic comic strip characters like George Herriman's Krazy Kat, one of the most celebrated characters in the history of comics. *Krazy Kat* (1913–1944) which debuted in William Randolph Hearst's *New York Journal*, featured a famous love triangle: the mouse, Ignatz, hates the cat, Krazy. Krazy, however, passionately loves Ignatz; even though the mouse throws bricks at Krazy's head, they are received affectionately. Offissa Pupp, a dog, adores Krazy and hates Ignatz as a result. Krazy is androgynous, a "kat" with a fluid gender that seems to shift and is never actually meant to be conclusively verified (sometimes the narration refers to Krazy as a "he"; largely, however, Krazy has been interpreted as female, including by superfan e. e. cummings). In an exchange from a 1915 *Krazy Kat* daily strip, Krazy complains, "I don't know if I should take a husband or a wife," to which the indifferent Ignatz responds, "Take care," and hurls a brick. That a syndicated strip published in a mainstream Hearst paper—Hearst adored the strip's artistic merit and gave Herriman a lifetime contract—had such a conspicuously "genderqueer" star at its center indicates that queer comics, even if not hailed as such, have been lurking in plain sight for over a hundred years, at least. We might even consider queerness part of the DNA of comics.

Other newspaper strips have featured openly gay characters, some

Akbar and Jeff, characters since the late 1970s.

controversially. Garry Trudeau's topical and political *Doonesbury* also introduced an openly gay character in 1976—early for mainstream comics. Readers first meet the character Andy Lippincott in a law library as the object of a female crush. In the *Doonesbury* storyline, after a yearlong battle, he dies of AIDS in 1990, an event that helped bring discussions about the disease into a wide number of homes. Andy is the only fictional character to be included on the real-life AIDS Quilt. (He later appears to longtime character Mark Slackmeyer in a dream to tell Mark that Mark is in fact gay, causing him to come out of the closet.) And Matt Groening's *Life in Hell*, which ran for thirty-five years starting in the late 1970s, featured the always-together characters Akbar and Jeff. Akbar and Jeff—also early and prominent gay characters who eventually became well-known in popular culture—are identical-looking men in fezzes and Charlie Brown–style shirts who initially were introduced by Groening as "brothers, or lovers, or both" but were soon acknowledged as gay.

Asked by a fanzine in 1987 if his characters had ever elicited a homophobic reaction, Groening replied yes. "The main reaction was when I first acknowledged that either of these characters could possibly be gay, some people who had been following the strip for years and had feelings about gays were very, very upset, which made me very, very happy." (When Groening ended *Life in Hell*, a tribute poster was assembled; Alison Bechdel's contribution was a fitting Akbar and Jeff tribute strip about the multivalent word "gay.") The newspaper strip *For Better or For Worse*, by Lynn Johnston, about a suburban family with three kids who age in real time, introduced one of its characters, Lawrence—a friend of the family's son—as gay. In 1993, when Lawrence came out, *For Better or For Worse* was syndicated in hundreds of newspapers. The backlash was so intense that today Johnston devotes a portion of her website to explaining it under the heading "Lawrence's Story." It may be hard to remember or imagine just how unusual sensitive gay content was for the "funny pages" of mainstream newspapers

even twenty-five years ago, but within a week, nineteen papers had canceled *For Better or For Worse* outright, many more had suspended the strip, and Johnston went on to receive over 2,500 personal letters (in the days before email, no less), including death threats. "I learned that the comics page is a powerful communicator," Johnston writes on her website. "I learned that our work is taken seriously."

These widely popular strips, which each came at gayness from a different angle, provided important early examples of gay representation in comic strips. But the gay or queer characters they featured were secondary characters. It wasn't until the underground comics movement, starting in the early 1970s, that gay comics as a self-conscious genre took root. In the underground, comics was reinvented as a medium for self-expression. It follows that the underground was also where political, identity-based comics were first developed, bolstered by the energy of the left-wing counterculture's attention to disenfranchised voices—and also by women cartoonists' reactions to what they perceived as the overly straight, overly male first wave of underground cartoonists. The comic book *Wimmen's Comix*, run by a collective of female cartoonists, developed as a platform specifically for women in 1972. And their debut issue (which is also where Aline Kominsky-Crumb's comics first saw print) featured a three-page story about lesbianism, "Sandy Comes Out," by Trina Robbins, a guiding force in the Wimmen's Comix Collective. The story, about a young woman coming out and joining a "gay/hippie commune," was framed as a "true life" comic about a friend of the artist (unidentified as such in the story, that friend was Sandra Crumb, Robert Crumb's sister.)

While *Wimmen's Comix*, and other feminist comics titles, acted as a corrective to the male-dominated underground comics scene, they were thin on gay content and gay authors. The perceived heterosexism of feminist underground comics inspired Mary Wings, then twenty-four, to self-publish the first full-length lesbian comic book, *Come Out Comix*, in 1973—a groundbreaking, stand-alone title that

paved the way for queer comics of all different kinds to claim a place in the field. The underground inspired that kind of creative practice: if you perceived a gap, you could fill it yourself. Soon thereafter, *Wimmen's Comix* published its first lesbian contribution by an actual lesbian, Roberta Gregory's "Modern Romance"—also, like Wings's comic book, a coming-out story (Gregory would later go on to publish the hilarious comic book *Naughty Bits* during the 1990s, starring the character Bitchy Bitch, and a spin-off collection, *Bitchy Butch: The World's Angriest Dyke*). Wings followed up in 1976 with another comic book, *Dyke Shorts*. The work coming out of the underground was substantial, and personal, claiming space for nuanced stories that previously hadn't found expression in comics—or in most other media. When Bechdel started drawing her comic strip *Dykes to Watch Out For* in 1983, "there was already such a thing as a lesbian cartoonist," she notes. "I didn't have to invent it, or fight for it, or suffer over it. I just did it."

Comics about gay men were slower to form, although the artist known as Tom of Finland, and his drawings of well-endowed muscle men, were significant to gay culture starting in the 1950s, along with plenty of other homoerotic fetish drawings and pornography. There were some gay-themed single-panel gag cartoons in the burgeoning gay press, like Joe Johnson's campy "Miss Thing" and "Big Dick," which appeared in *The Advocate* starting in the late 1960s. The country's oldest LGBT-interest magazine, founded in 1967, *The Advocate* has always featured cartoons and comics as a form reflecting, however humorously, on gay life. And Rupert Kinnard's *Cathartic Comics*, an early version of which first appeared in his college paper in 1977 before later migrating to multiple alternative weeklies, notably featured the first continuing African-American gay characters in comic strips—the Brown Bomber, a man, and Diva Touché Flambé, a woman. But the central figure in gay comics is surely Howard Cruse, a respected cartoonist raised in Alabama who

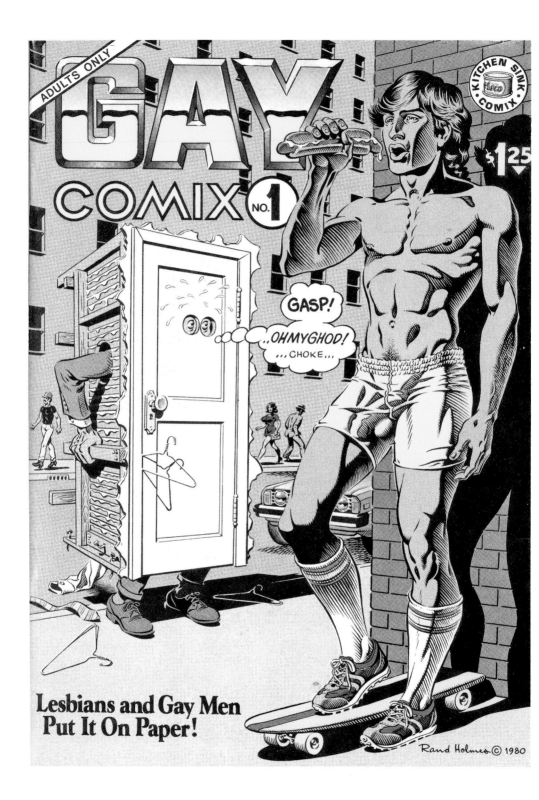

began an underground comic strip, *Barefootz* (the titular character was always barefoot), in 1971. Five years into its publication, the strip's character Headrack came out as gay. Cruse knew this choice would mark his own public coming out, and though he struggled with the decision to draw gay content, he was encouraged ultimately by Mary Wings to take the leap into that subject matter. "Gravy on Gay," in which Headrack comes out, is a story whose central plot point Cruse described as "an explosion of long-repressed liberationist fury."

Cruse became the founding editor of the field-defining comic book *Gay Comix*, published by the underground press Kitchen Sink starting in 1980. It may have taken longer than other underground titles to coalesce, but its significance has been enormous. (And it lasted eighteen years, longer than most underground publications, excluding *Wimmen's Comix*, which lasted twenty years.) *Gay Comix* aimed for inclusivity and to consolidate queer underground comics. It came with the tagline "Lesbians and Gay Men Put It On Paper!" Its first cover, by Rand Holmes, hilariously features a man walking down the street, stuck in a literal closet, ogling another man in shorts eating a hot dog. In *Gay Comix*, Cruse crucially frames comics as an uncensored art form in which stereotypes and expectations can be overthrown in favor of particularity and range. "In this comic book you'll find work by lesbians, gay men, and bisexual human beings. The subject is Being Gay," he wrote in the editor's note. "Each artist speaks for himself or herself. No one speaks for any mythical 'average' homosexual. No one is required to be 'politically correct.'" For Alison Bechdel, discovering the first issue of *Gay Comix* was the single biggest event that sealed her fate as a cartoonist. "I'd been out as a lesbian for a couple of years, [but] the notion of cartoons about being gay had

Gay Comix #1, ed. Howard Cruse, cover by Rand Holmes, 1980.
Used by permission of Martha Holmes.

never crossed my mind. It was like, 'Oh, man! You can do cartoons about your own real life being a gay person.'"

Bechdel grew up the eldest of three siblings in the small rural town of Beech Creek, Pennsylvania, in a Victorian Gothic Revival house whose restoration was her father's "monomaniacal" obsession. As her graphic memoirs *Fun Home* and *Are You My Mother? A Comic Drama*—centering on her father and mother, respectively—reveal, both of her ambitious, intellectual parents longed to be artists but ultimately fashioned their lives along more conventional lines. Bechdel's father, Bruce, who was passionate about high modernist literature created by William Faulkner, F. Scott Fitzgerald, James Joyce, and Marcel Proust, among others, was a local high school English teacher and part-time funeral home director—at the Bechdel Funeral Home, a family-run business. *Fun Home* is short for "funeral home," and refers to the nickname for the family business. (The job was part-time by necessity because Beech Creek is so small.) Bechdel's mother, Helen, worked as a substitute English teacher, was devoted to piano, and performed in regional theater productions. Both were judgmental and exacting. As a child Bechdel was encouraged—if not overencouraged, or rather overshadowed—in her creative pursuits. When Bruce presented the young Alison with a diary, he himself then decided to write its first sentence, about himself: "Dad is reading." One episode in *Fun Home* depicts how Bruce, unbidden, creates a second stanza for a short poem spontaneously written by the seven-year-old Alison; she dutifully adds it to her typescript and never writes another poem (ever). Soon after, Bruce chides her for coloring her *Wind the Willows Coloring Book* in a way he deems incorrect; he sits down and takes

Drawn copies of Alison Bechdel's *The Bugle*, 1970–1972, photographed in Bechdel's present-day studio. Note the Father's Day and Mother's Day editions. She would go on to write separate memoirs about each of her parents.

Photo courtesy Alison Bechdel.

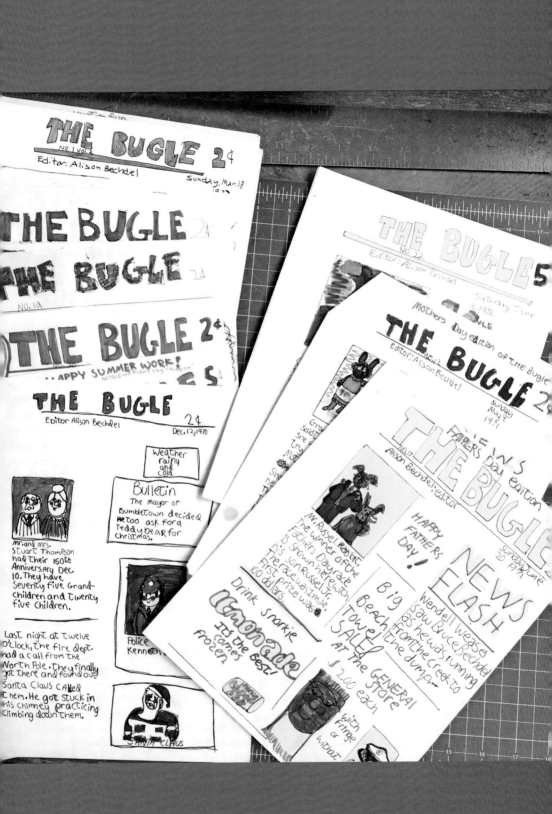

over the coloring as she walks away, dampened ("Look. By adding thin layers of goldenrod and yellow-orange, I get a richer color"). Bechdel told me, only partially joking, "I became a cartoonist because it was a black-and-white world where I didn't ever have to think about color." But as a child she constantly drew her own colorful images, and even created her own magazines and comics. Her charming words-and-pictures bulletin *The Bugle*, created when she was eleven, priced at 2 and then 5 cents, is one such example. Bechdel, always drawing inventively, even cared about reproduction and circulation as a child—her methodical practice was to individually hand-draw multiple versions of the same issue to sell to her family members. Bechdel, too, became an avid reader of *Mad*. When she was little, Bechdel told me, "I wanted to become a cartoonist but that got drilled out of me."

Bechdel began college at Simon's Rock, a school for younger motivated students, when she was sixteen, and eventually attended the progressive Oberlin College in Ohio. At Oberlin—also my alma mater, and that of Julie Taymor, Mark Boal, Josh Neufeld, A.K. Summers, Cory Arcangel, Karen O, Lena Dunham, and a whole host of creative people—Bechdel majored in studio art and art history. One day in the campus bookstore during her junior year, she realized that she was a lesbian while she browsed (appropriately, given her family's obsession with reading) through a book documenting gay experiences called *Word Is Out: Stories of Some of Our Lives*. In college, despite her sense she could never actually become a cartoonist, Bechdel drew avidly in her sketchbooks. And her interest in comics—her attention to letterforms and handwriting, to creating sequences of images, and to the relation of word and image—threaded through her art projects. A piece called *Self-Portrait* she created for a drawing class fascinatingly offers a sequence of large bordered panels, each of which has words and pictures inside it. Besides being "proto-comics," as Bechdel put it to me, the piece also shows how "I've clearly for a long time been preoccupied with how my parents are operating through me

creatively"—the central theme, perhaps, of both of her memoirs. One portion of *Self-Portrait* offers small photographs of her parents, along with samples of their handwriting, like an equation: added together, they equal a photograph of Bechdel and her handwriting. Bechdel made this piece in the spring of 1980, between coming out as a lesbian to her parents and her father's death. It was created right after a visit home, in which she and her father connected, fleetingly, for the first and only time about their shared homosexuality. In *Self-Portrait*, underneath the designation "genetic," Bechdel inks a comment that is a strikingly relevant description of cartoonists' dedication to handwriting: "Handwriting (like drawing) = externalization of internal

Alison Bechdel, excerpt from *Self-Portrait*, 1980: close-up of panel on handwriting.
Photo courtesy Alison Bechdel.

images." A few months later, the closeted Bruce Bechdel, shortly after his daughter had come out as gay, and a few weeks after his wife asked for a divorce, committed suicide at age forty-four.

After graduation, Bechdel moved to New York City and worked a series of temp jobs. She had been rejected from all the graduate art schools to which she had applied—including Yale, RISD (the alma mater of Justin Green), and the School of the Art Institute of Chicago (the alma mater of Chris Ware, and where Bechdel and I once gave a standing-room-only talk). "I attended the MFA Program of the *streets*," Bechdel jokes in one of her comics—and clearly it gave her the right experience. She wandered into the Oscar Wilde Memorial Bookshop on Christopher Street in the West Village (now shuttered), found the first issue of *Gay Comix*, and realized that she could combine two important features of her life: her love for comics, and her dedication to being an out lesbian. "That was quite momentous for me," Bechdel recalled of discovering a model in Cruse and the existence of comics devoted to queer life. "Howard was hugely formative in that sense. And also I loved that he was *so good*—he was so technically good at what he did, but he still did queer stuff. That he would bring that talent into the subculture was very moving to me." Bechdel began pursuing her own drawings with renewed energy—and practiced drawing women. From childhood straight on through college and after, Bechdel almost exclusively drew men in her sketchbooks, a kind of drawing she has described as "almost involuntary." Bechdel struggled with drawing women with anywhere near the same fluidity and grace with which she had been drawing men since she was a child. And, she found that if she thought of the women she drew specifically as lesbians, it was easier to draw them.

As a young lesbian just out of college in the early 1980s, Bechdel yearned to see reflections of her community, even if she had to create them herself. "I was very hungry to see visual images of people like

Dykes to Watch Out For, plate Nº 19

Twyla is appalled to learn that Irene is a morning person.

Alison Bechdel, first published installment of *Dykes to Watch Out For*, in *Womanews*, 1983.

Used by permission of Alison Bechdel.

me," she told *The Comics Journal*. One day, in the margins of a letter to a friend, Bechdel doodled a drawing of a naked woman in mid-stride clutching a coffeepot, labeled it "Marianne, dissatisfied with the breakfast brew"—and then wrote, "Dykes to Watch Out For, plate no. 27." Unlike in her methodical, sequentially numbered childhood bulletin *The Bugle*, there were no other plates yet, but the concept of a series or catalog of dykes compelled her. Bechdel set about sketching other dykes for her series, and eventually submitted her captioned cartoons to *Womanews*, the feminist monthly where she volunteered. Her first work saw print in 1983: "Dykes to Watch Out For, plate no. 19: Twyla is appalled to learn that Irene is a morning person." It proved popular, and Bechdel began publishing *Dykes to Watch Out For* in every issue of *Womanews*. Soon she switched to a multipanel strip format, and eventually *Dykes to Watch Out For*, whose stories got

longer and longer, earned a national audience in the alternative press as a biweekly feature.

Dykes to Watch Out For was a sensation. (It is *almost* America's first ongoing queer comic strip; Cruse's *Wendel*, about an irrepressible gay man and his lover, began appearing in *The Advocate* just a few months earlier.) In 1986—the same year that Bechdel published her first autobiographical story, in *Gay Comix*—Firebrand Books published a book collection of *Dykes to Watch Out For* to acclaim. This collection contains the now-classic story "The Rule," reproduced here in the introduction, which became the basis for the globally known "Bechdel Test," a standard for gender equality in film that has served to reinforce Bechdel's stature in popular culture. (It's amazing how many films, including serious and acclaimed ones like *The Social Network*, or the first *Star Wars* trilogy, fail this test, since the bar seems pitifully low: the movie has to have: 1) two women in it; who 2) talk to each other about 3) something besides a man.) In addition to national syndication in the alternative and gay press, eleven subsequent book anthologies of *Dykes* appeared, with amusing titles like *Hot, Throbbing Dykes to Watch Out For* (1997) and *Dykes and Sundry Other Carbon-Based Life Forms to Watch Out For* (2003). Bechdel has been making a living as a cartoonist since 1990, when she was able to quit her day job. In 1993, *Gay Comix*, which inspired her before she even knew she would become a cartoonist, published a special all-Bechdel issue.

The first ongoing lesbian comic strip, *Dykes* began presenting a recurring cast of characters in 1987—a large group of lesbian (and some bisexual and straight) friends and sometimes lovers living in an unspecified, midsize American city. Throughout its twenty-eight-year run it focused intently, always with warmth and humor, but with

Sydney and Mo in Bechdel's *Dykes to Watch Out For* story "Sense and Sensuality," collected in *Hot, Throbbing Dykes to Watch Out For* (Ithaca: Firebrand), 1997.

Used by permission of Alison Bechdel.

precision, on contemporary politics as much as on the continuing, soap-opera style drama of its characters. "The interplay between the personal and the political is an enduring fixation of mine," Bechdel has said. "I look back now at the genesis of *Dykes* and I see it very much as a reaction to what happened with my father. I felt that to a certain extent he killed himself because he couldn't come out, so I was determined to be utterly and completely out in my own life." *Dykes* captures the texture of its characters' lived lives with such an attentiveness that it feels like it is presenting the lives of real people—friends, neighbors, co-workers, family—as they unfold. Although *Dykes* is fictional, Bechdel explains it has a "journalistic" quality: it translates the everyday realities of a certain slice of queer life to the page. Its central protagonist is Mo, a funny, perpetually worried white, middle-class dyke who is a stand-in for Bechdel (and who for years dates Sydney, a supercilious women's studies professor). Other characters include Clarice, an attorney; Toni, her accountant wife and fellow mother; Jezanna, a bookstore owner; Lois, a genderqueer sex-positive bookstore employee; Sparrow, a bisexual director of a women's shelter, and her partner, Stuart; and Ginger, an English professor. There are plenty of professors in the cast and plenty of professor fans who love Bechdel's send-up of academic discourse (I can speak from authority). "Will you do me the honor of paradoxically reinscribing *and* destabilizing hegemonic discourse with me?" Sydney asks Mo when she proposes.

An ongoing, serialized comic strip like *Dykes*, which took place in the present tense and was invested in reflecting the world, appearing every two weeks, opened up the door for participation and interactivity, bringing in a population of involved readers. Creating the strip, Bechdel was aware of how it produced a community eager, as she had been, to see certain kinds of underrepresented lives reflected back at them. The last chapter of Bechdel's compilation book *The Indelible Alison Bechdel* is even called "Audience Participation," something the

form of an ongoing comic strip engenders. Bechdel deadpans, "I have the dubious privilege of receiving constant feedback about the progress of the narrative." The investment of readers indicates how profoundly people attended to sophisticated queer representation—something that was made even more legible when Bechdel began posting *Dykes* installments on her website www.dykestowatchoutfor.com, her website where many of the strips are archived, and are richly commented upon. "Alison: Is the intensity of our attachment to and obsessions about your characters freaking you out just a tiny bit?" one person reasonably mused in the middle of a thick, intelligent batch of comments in 2006.

Other significant queer comics joined *Dykes* and other works in the 1990s. With humor and savvy, several of these tapped into a wellspring of anger around social relations including sexual harassment and rape culture (and don't feel dated today). One of my personal favorites is Diane DiMassa's laugh-out-loud *Hothead Paisan: Homicidal Lesbian Terrorist*, which began as a self-published comic book/zine in

Diane DiMassa, panels from *Hothead Paisan*, 1993, reprinted in *The Complete Hothead Paisan* (San Francisco: Cleis Press), 1999.

Used by permission of Diane DiMassa.

1991. DiMassa and fellow cartoonists such as Jennifer Camper (*Sub-Gurlz*; *Rude Girls and Dangerous Women*) tapped into social rage in their comics, with jokes about castration and feminist-lesbian anger abounding. (Camper, a Lebanese American lesbian attentive to Middle Eastern politics, wrote the best review of *Persepolis* I've read—and in comics form, too.) Their comics were a release. With guns, axes, and grenades, Hothead unapologetically kills men who "manspread" on the subway, who catcall her, who show disregard for her space on the sidewalk. DiMassa's description on her website is apt: "Hothead and her beloved cat, Chicken, have been providing rage therapy for exhausted devotees since 1991. Hothead is fully in touch with your Inner Societal Rage and gleefully carries out the fantasies you would never act on. Would you. Reading Hothead comics is guaranteed to give you a fleeting sense of empowerment while you laugh until you realize it's not funny and start crying."

The nineties also saw a turn toward the intimacy of autobiography in addition to generalized social rage. Ariel Schrag's true-life comics charted her coming out while a student at Berkeley High. The enterprising Schrag, A-student and baby dyke, produced a different comic-book series for each year of high school: *Awkward*, *Definition*, *Potential*, and *Likewise* (Schrag went on to write for *The L Word*). The result is compellingly personal work that feels like it unfolds in close to real time and is rich with fascinating details of adolescence. It's like a very impressive blog, before blogs existed, and with sweet, earnest drawings of masturbation, sex, and chemistry exams. And Cruse published his graphic novel *Stuck Rubber Baby*, based loosely on his real-life experiences as a closeted gay man in the South working in the civil rights movement, in 1995.

But no other comics work that touches on queer lives prior to *Fun Home*—and few other graphic narratives at all, from any time—presents the intimacy, depth of feeling, length, and storytelling rigor that *Fun Home* does. The first graphic narrative published by

Houghton Mifflin, *Fun Home* won an immediate "crossover" audience, both an audience outside of the comics world and the niche or "cult" (read: gay) audience that was the most fervently devoted fan base of *Dykes to Watch Out For*. Famed book designer Chip Kidd, also the editor of Pantheon's Graphic Novels imprint, offered a striking endorsement, calling *Fun Home* "a rare, primal example of why graphic novels have taken over the conversation about American literature." *New York Times* reviewer Sean Wilsey raved, "If the theoretical value of a picture is still holding steady at a thousand words, then Alison Bechdel's slim yet Proustian graphic memoir, 'Fun Home,' must be *the* most ingeniously compact, hyper-verbose example of autobiography to have been produced." (And: perhaps slim compared to Proust, but not slim by graphic novel standards at 232 pages.) Modest to a fault, Bechdel confessed to a London newspaper, "It still strikes me as very unlikely that an odd, cerebral story about a lesbian and her closeted gay suicidal mortician father would have struck a chord with anyone but me"—but it did, instantly winning acclaim and hitting the best-seller list, making a splash in a way very few graphic novels since *Maus*—also a book investigating filial relationships and parental suicide—have done. *Fun Home* was voted *Time* magazine's #1 book of the year—in any category. *Fun Home* showed definitively how comics could be a captivating form for presenting the interior and exterior lives of gay characters over time.

Bechdel spent almost two decades working as a cartoonist before she started a memoir about her father's death; it was a story she had been carefully considering for a long time. "I finally sat down to write the book when I was almost forty, right at that weird midpoint in my life where my father had been dead for the same number of years he'd been alive," Bechdel explained in an interview. She then spent seven years working on the intricately crafted book, which has seven chapters each loosely tied in title and thematics to an author—or in some case, several authors—her father loved, notably

James Joyce. *Fun Home* focuses on a gay daughter's investigation into the life of her closeted gay father, presenting both childhood recollections and adult research into letters, diaries, records, and photographs. Told in a nonlinear fashion, *Fun Home* gracefully weaves in and out of different times across all of its chapters; its elegant but promiscuous view of time is one of its most striking and moving features (for instance, in the book's suggestion that Bruce Bechdel was, in essence, ceaselessly committing suicide, even as a child, as when he wanders off alone in fields of mud as a toddler and sinks in them, to be rescued by a passerby). *Fun Home* is what Bechdel names "labyrinthine" instead of having a chronological structure; it repeatedly circles in to central themes and questions. Chief among these is the question of causality: Bechdel sets out to explore what she can about her father's life in order to figure out if her own coming out had anything to do with his suicide. The story is not plot-driven: both of the evidently dramatic events in *Fun Home*—Alison's coming out and her father's suicide—are revealed early on in the book. *Fun Home* is rather a drama of archival discovery and interpretation, as Bechdel searches for and discovers evidence about her father's life as a gay man.

The seed for the book was the discovery, shortly after her father died, of a photograph that Bechdel reproduces as a drawing in *Fun Home*. After college, organizing her belongings in the family house, Bechdel found a photograph of her former babysitter, Roy, lying on a hotel bed in only his underwear. The photo was taken the summer Bechdel was eight, during a trip Roy, Bruce, and the three Bechdel kids took to the Jersey shore. The photo, which she found at once aesthetically beautiful and shocking, Bechdel told me, "was a stunning glimpse into my father's hidden life, this life that was apparently running parallel to our regular everyday existence." In the hotel where Roy posed on the bed, Alison and her brothers had slept in the adjoining room. The negative strip that includes the picture of Roy, who

was then seventeen, is preceded by three of Bruce's snaps of his kids on the beach.

Curiously unconcealed evidence of her father's secret life—it was sitting in an envelope marked "Family"—the photograph of Roy lingered in Bechdel's mind. Finding the photograph, she identified with her father as gay person—she told me, "I felt this posthumous bond with him"—at the same time that she realized the betrayal it represented: to the underage babysitter, and to her mother, in addition to Bruce's unsuspecting kids. Bechdel's drawing of the photo is her book's one and only double-spread, and the space it takes up underlines its key role in shaping the premise of *Fun Home*.

Bechdel draws the photograph bisected by the seam of the page, with her left hand holding it out in front of her. She places readers in the position of her optical point of view, but she draws her hands much larger than life-size, calling conspicuous attention to the scene of looking and to the photograph as a handled artifact—not a simply transparent window into reality. In *Fun Home*, Bechdel uses two different visual representational styles: one that is heavily crosshatched, which is used for drawing the tone of photographs, and codes as realistic, and one that has crisper black line art and simpler shading, which anchors the world of the book. *Fun Home* also employs color: there is a gray-green ink wash throughout that Bechdel has described as "elegiac." The drawing of the Roy photograph, which arrives roughly halfway through the book, is "literally the core of the book," Bechdel told me, its own "centerfold."

On the previous page, an adolescent Alison and her father, in a rare moment of alignment, together admire a fashion centerfold in

Alison Bechdel, the only double-spread in *Fun Home: A Family Tragicomic* (New York: Houghton Mifflin), 2006: Alison looking at a photograph of Roy taken by her father.

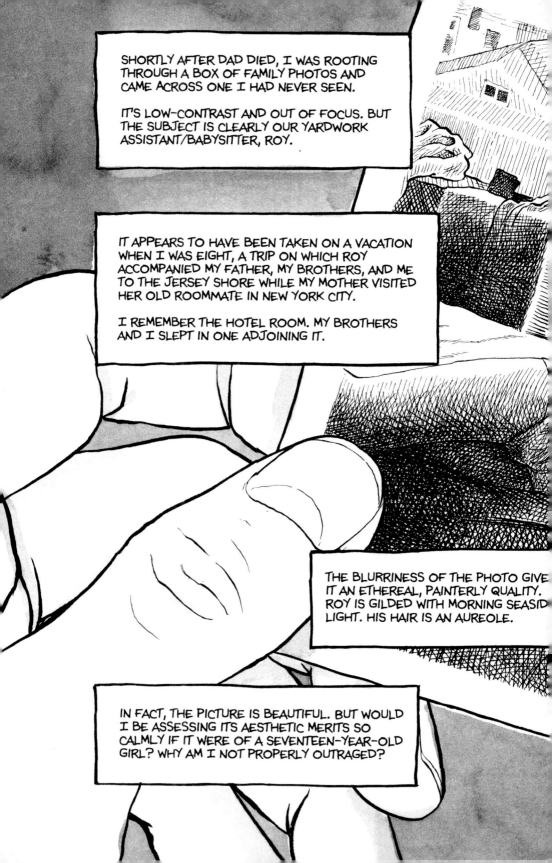

SHORTLY AFTER DAD DIED, I WAS ROOTING THROUGH A BOX OF FAMILY PHOTOS AND CAME ACROSS ONE I HAD NEVER SEEN.

IT'S LOW-CONTRAST AND OUT OF FOCUS. BUT THE SUBJECT IS CLEARLY OUR YARDWORK ASSISTANT/BABYSITTER, ROY.

IT APPEARS TO HAVE BEEN TAKEN ON A VACATION WHEN I WAS EIGHT, A TRIP ON WHICH ROY ACCOMPANIED MY FATHER, MY BROTHERS, AND ME TO THE JERSEY SHORE WHILE MY MOTHER VISITED HER OLD ROOMMATE IN NEW YORK CITY.

I REMEMBER THE HOTEL ROOM. MY BROTHERS AND I SLEPT IN ONE ADJOINING IT.

THE BLURRINESS OF THE PHOTO GIVE IT AN ETHEREAL, PAINTERLY QUALITY. ROY IS GILDED WITH MORNING SEASID LIGHT. HIS HAIR IS AN AUREOLE.

IN FACT, THE PICTURE IS BEAUTIFUL. BUT WOULD I BE ASSESSING ITS AESTHETIC MERITS SO CALMLY IF IT WERE OF A SEVENTEEN-YEAR-OLD GIRL? WHY AM I NOT PROPERLY OUTRAGED?

PERHAPS I IDENTIFY TOO WELL WITH MY FATHER'S ILLICIT AWE. A TRACE OF THIS SEEMS CAUGHT IN THE PHOTO, JUST AS A TRACE OF ROY HAS BEEN CAUGHT ON THE LIGHT-SENSITIVE PAPER.

THE PICTURE WAS IN AN ENVELOPE LABELED "FAMILY" IN DAD'S HAND-WRITING, ALONG WITH OTHER SHOTS FROM THE SAME TRIP.

THE BORDERS OF ALL THE PHOTOS ARE PRINTED "AUG 69," BUT ON THE ONE OF ROY, DAD HAS CAREFULLY BLOTTED OUT THE "69" AND TWO SMALL BULLETS ON EITHER SIDE WITH A BLUE MAGIC MARKER.

IT'S A CURIOUSLY INEFFECTUAL ATTEMPT AT CENSORSHIP. WHY CROSS OUT THE YEAR AND NOT THE MONTH? WHY, FOR THAT MATTER, LEAVE THE PHOTO IN THE ENVELOPE AT ALL?

IN AN ACT OF PRESTIDIGITATION TYPICAL OF THE WAY MY FATHER JUGGLED HIS PUBLIC APPEARANCE AND PRIVATE REALITY, THE EVIDENCE IS SIMULTANEOUSLY HIDDEN AND REVEALED.

Esquire; Bechdel narrates that their "shared reverence for masculine beauty" was a "slender demilitarized zone" that lay between them. But the page about Roy's photograph, crucially, is about the concomitant identification *and* disidentification Bechdel feels toward her father. The comics page in Bechdel's hands registers this paradox. While she meticulously reproduces the details of the once-hidden photograph, a kind of dutiful tribute to and inhabitation of her father's illicit desire, she also overlays eight distinct text boxes, full of her own words, over the photograph. The placement of the irregular boxes—each of these boxes is a different size—over the drawing of the standard-size photograph reflects both Bechdel's confusion and also her own medium's disruption, with the overlaid layers of meaning offered by comics, of her father's perfectly framed, wordless moment.

When they lived together in the family home, Bruce and Alison were what the narrator calls "inverts, and inversions" of one another, often butting heads over deeply felt, identity-driven aesthetic choices. One amusing page presents these contrasts, and clashes, in four emblematic scenes: Alison was "Spartan to my father's Athenian. Modern to his Victorian. Butch to his nelly. Utilitarian to his aesthete." As a child, and a teenager, Alison didn't consciously realize that her father might be gay, but as Bechdel confesses in *Fun Home*, above a drawing herself as a small child staring at her father getting ready for church by applying a "bronzing stick" to his face: "My father began to seem morally suspect to me long before I knew that he actually had a dark secret."

Alison knew her father was a "sissy" and felt that he represented "a chink in my family's armor, an undefended gap in the circle of our wagons"—which underscored her own attraction to the butch. Her

Alison Bechdel, page from *Fun Home*.

I WAS SPARTAN TO MY FATHER'S ATHENIAN. MODERN TO HIS VICTORIAN.

BUTCH TO HIS NELLY. UTILITARIAN TO HIS AESTHETE.

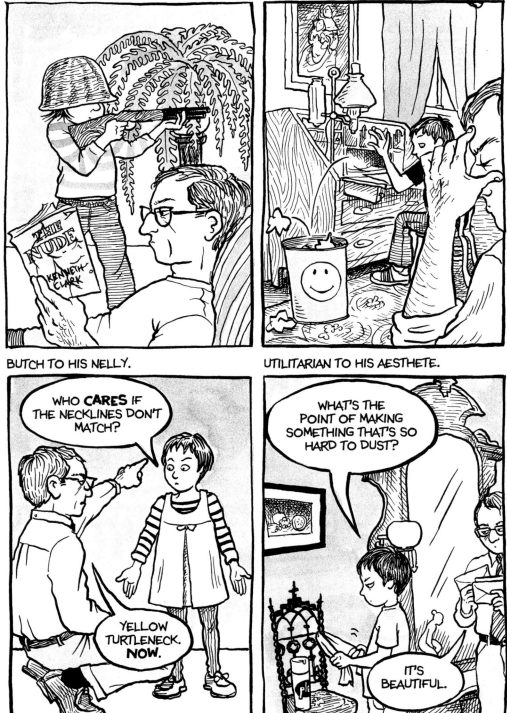

mother reveals the actual dark secret privately when Alison comes out; Bechdel draws her young self's shock and surprise, lying stupefied on the floor of her dorm room—"*Dad?* With other *men?*" But Alison did realize that her father had something to hide, and that it drove his obsession with perfect surfaces. She grew to loathe the embellishments and ornament of the family home as "lies." Above a drawing of Bruce Bechdel taking a carefully posed photograph of his wife and children on the porch ("Mass will be over," her mother pleads), Bechdel declares, "He used his skillful artifice not to make things, but to make things appear what they were not." Her father, she notes in the book, treated his children like furniture and his furniture like children. And he had a violent temper toward everyone in his family. "In my earliest memories," Bechdel writes in *Fun Home*, "Dad is a lowering, malevolent presence." Physical affection was scarce in the Bechdel household. Bechdel draws the two times she literally ever saw her parents express physical affection, which astonished her. Her mother abruptly stopped kissing her goodnight when she was seven. And she rarely, if ever, touched or was touched by her father with any loving intention. One heartbreaking scene in *Fun Home* shows her as a small child "unaccountably moved" to kiss her father goodnight, and awkwardly kissing his hand before fleeing his bedroom in embarrassment.

But Alison and her father—both "inverts" (an outdated nineteenth-century term for homosexuals) and inversions of each other, as she points out—are disidentified and identified with each other throughout *Fun Home*, giving the book its tricky edge. "I was trying to compensate for something unmanly in him," Bechdel writes above an image of them looking in the mirror together, while "he was attempting to express

Alison Bechdel, page from *Fun Home*.

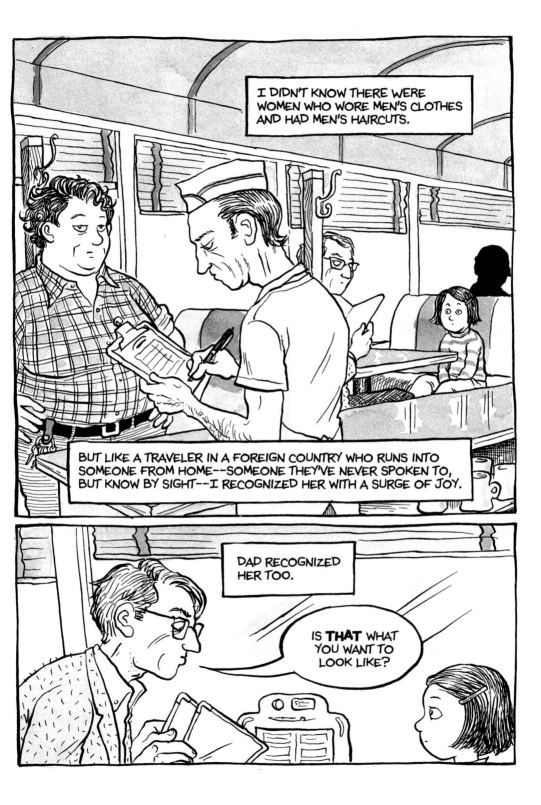

something feminine in me." At five, while at a diner with her father, Alison sees a brand new sight, one that sustains her for years: a "truck-driving bulldyke" in whom she recognizes a kindred spirit "with a surge of joy." In a scene that brilliantly exploits the silent narrative of changing facial expressions, her father turns to his small daughter, who hasn't spoken a word, and, knowing, says derisively, "Is *that* what you want to look like?" She knows she is supposed to say no, and he knows the answer is probably yes. In the coming years, Bruce and Alison share some fleeting moments of alignment and connection—almost entirely over literature and intellectual life. In their most affirmative exchange in the entire book, they spontaneously compliment each other in the car on the way home from school—for Alison has wound up in her father's high school English class, and actually likes it. "You're the only one in that class worth teaching," Bruce tells her as she drives home, in a panel that takes up the entire bottom tier of a page and frames the car perfectly within its borders. "It's the only class I have worth taking," Alison responds. They begin to see each other as intellectual companions, sharing books and ideas about them. In a move that feels momentous, because it seems to Alison like it could be an acknowledgment of her sexuality, Bruce gives her a copy of Colette's *Earthly Paradise.*

But it is harder to forge an explicit connection around being gay. On her first vacation home from college after she has come out to her family—and after her mother has confided in her about her father sleeping with men and boys—Alison tries desperately to connect with Bruce around their mutual queer sexuality. When the two of them venture out together for a screening of *Coal Miner's Daughter,* Alison forces herself to try to discuss it with him in the car. Before her trip

Alison Bechdel, page from *Fun Home.*

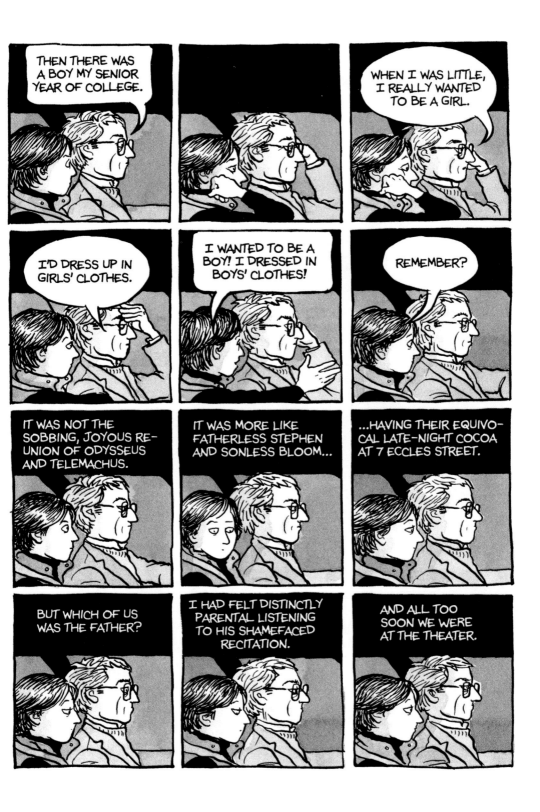

home, Bruce had written Alison letters full of tantalizing enigmatic statements reflecting on his choices ("There was not much in the Village then that I hadn't known in Beech Creek"). Bechdel, narrating, puts it this way, over her drawing of the letter: "He thought that I thought that he was a queer. Whereas he knew that I knew that he knew that I was too." The scene of shared but silent acknowledgment is emblematic of the whole book: it is not a triumphant confirmation of common experience, and offering of support. Instead, while Bruce haltingly acknowledges, "I guess there was some kind of . . . identification" when Alison asks if he chose Colette for her knowingly, Bruce resists the affirmation of common experience she's driving at.

The car exchange—the one time father and daughter ever discussed what Bechdel describes to readers as "our shared predilection"—is visually striking because it is the only set of pages, aside from the double-spread pages featuring the Roy photograph, that functions as a unit of two. But unlike the pages that present the Roy photograph to readers and are overlaid with Bechdel's irregular frames, these pages are the most strikingly regularized in the entire book: mirroring each other, each offers twelve same-size frames—what Ivan Brunetti has called a "democratic" grid, in which the panels are the same size and produce even beats of time. Bechdel divides this crucial conversation— the first time Bruce talks openly to Alison about his sexuality—into many separate frames, and moments, letting the weight of the silences sink in. Many panels offer a beat of silence—most notably the last six that close out the exchange, in which no dialogue happens at all, and Bruce leaves his daughter hanging. The dialogue ends with Alison, looking animated, trying to connect: "I dressed in boys' clothes . . . remember?"

Bruce never responds, and readers encounter the six beats of silence on the page. And while the perspective of each panel is the same, showing Alison and Bruce together in a small space, each panel yet underlines the stark division between father and daugh-

ter: graphically, they are each aligned with a separate car window, and a black bar of sorts lies between them. In this final chapter of the book, although Bruce admits "some kind of identification," the graphic features of the page help us to realize how tenuous and unfulfilling this conversation is for his young daughter so eager to confirm something she shares with her father. After the movie, their attempts at queer connection are again thwarted: they go to a local gay bar, where they are turned away because Alison is underage. The final panel of the episode, in which the pair drive home, is a mirror image of the panel in which father and daughter compliment each other after class, only this time, as Bechdel writes, "we drove home in mortified silence."

Despite or because of the gap between father and daughter, *Fun Home* is immersed in verbal and visual languages of touching. *Fun Home*'s comics form is central to what it suggests about the relationship between Alison and her father, and how the adult artist carries that relationship forward in her life. Bechdel often describes comics as a form of touch, explaining that drawing a person for her can be like touching that person. The paper is like skin, she has pointed out. "It's a figurative stroke, because obviously the only thing I'm really making contact with is the pen and paper, but that contact—of the nib and the ink on the paper—is very literal and sensual." In *Fun Home*—and in the later *Are You My Mother?*—touch is also an explicit theme of the book: if as a child Bechdel felt cut off from touch, and was further, irrevocably cut off from her father because of his early death, drawing images of her father is a way to touch him and reencounter him, to be close to him.

And comics is not only a way to intimately touch the subjects, even and especially the dead subjects, on whom Bechdel's work centers—to "lay hands" on them through drawing, as *Fun Home*'s own language suggests—but it is also a way to mark her *own* body onto the page. Bechdel's redrawing of family archives for her comics page—all the

maps, letters, diaries, records, and photographs that she carefully reproduces in her own hand, instead of scanning—is a way for Bechdel to place her body back into the past histories and narratives for which her role is unclear, to make herself present in her parents' lives. Bechdel also poses her own body in digital reference photographs that she uses to draw her comics. Regardless of who the character is, Bechdel poses as that person for the reference shot, creating both her own shadow archive of her family's past, and inhabiting her parents in a form of acting. The really interesting thing, she said once, explaining her process, "is when I have to act out my parents having a fight and I have to be both of them."

Fun Home strikes a note distinct from the celebration or the anger we see in many gay comics. It is about the process of reading and looking—at the past, including queer histories of earlier generations. It is about the question of how we feel we can know the things that we know. It is a portrait of a relationship that is rife with contradiction: Bechdel's father, as cruel and petty as he was, was both a disabling *and* an enabling force for his daughter, who became the artist—as *Fun Home*, the book about him, proves—he always wanted to be, because of him *and* in spite of him. Bechdel offers a complex portrait of her family in comics that is unlike her father's practice of photography, in which he composes a scene, captures what looks perfect, and freezes it in time. Rather, the cross-generational queer comics story, meditating on the different possibilities afforded father and daughter, shows readers two intertwined gay lives that are contradictory, ambiguous, and inconclusive, even in death. Comics represents the fullness of this complexity, even as it preserves the gaps and elisions in Bechdel's knowledge and in her relationship with her father. "If language was unreliable, and appearances were deceiving," Bechdel mused in a talk about comics, "then maybe by triangulating between them, you could manage to get a little closer to the truth."

In Bechdel's graphic memoir, we see the combination of techni-

cal expertise and rigor in the service of "queer stuff" that the cartoonist so admired in Howard Cruse's work. But instead of bringing her talent into the subculture, with *Fun Home* Bechdel brought her talent—and a compelling portrait of a queer life—into the mainstream, without sacrificing any of the richness that made her earlier work so beloved. It wasn't a case of Bechdel conforming to the mainstream; it was a case of Bechdel reinventing the mainstream, demonstrating how comics can map untraditional lives (her own and her father's) with unusual sophistication and sensitivity that inheres in the frames and gutterspaces of comics, along with the intimate, caressing touch of ink.

Fun Home further reinvented the mainstream when an adaptation of the graphic memoir became a Broadway musical in 2015 (it opened off-Broadway at New York City's Public Theater in 2013). *Fun Home* the musical seems a very unlikely project, for several reasons. From a Broadway standpoint, the topic, perhaps, seems grim (not only suicide, but suicide of a mortician) and unsexy (rural butch lesbian, as opposed to the urban gay men who have historically been the queer characters in Broadway shows). "Is America Ready for a Musical About a Butch Lesbian?" a *Slate* headline reasonably wondered. And then there's the question of translating comics to theater. Comics, as Art Spiegelman puts it, "[lets] you read in the quiet theater of your mind"—through its interplay of presence and absence, image and word on the page. How was a musical going to replicate the effects of comics—for instance, the intimacy of handwriting—that feel so key to grasping the paradoxes of the Bechdel household? Bechdel likes to joke in public that the reason she said yes to a musical is because she thought nobody would ever see it. I remember discussing adaptation with her when she first told me about her choice to allow the *Fun Home* musical to happen. Bechdel had also received offers from film producers and directors. Her choice to go with a musical instead, she told me, was because theater lacks the verisimilitude of film; musical

theater was just so weird that it might be able to translate a comics story, with all of its intricacies and abstractions, best.

Written by Lisa Kron with music by Jeanine Tesori, and directed by Sam Gold, the *Fun Home* musical does replicate many of comics's most interesting formal possibilities. (Bechdel was closely involved as an adviser but had no formal role in the production.) *Fun Home* deploys three separate actresses to play Alison during three different periods of her life—child, college student, and adult cartoonist—and at some key moments, it intertwines distinct time periods by having them walk into spaces of the past, or future, collapsing time in the way that comics does so noticeably. And the musical shows itself to be brilliantly attentive to the importance of the silent visual details

Alison Bechdel, center, onstage at the Tony Awards after *Fun Home* wins Best Musical, June 2015.

Photograph by Theo Wargo/Getty. Used by permission.

of the book. One of the high points of the musical is the song "Ring of Keys," performed by the child Alison, based on a tiny visual detail in the book's diner scene that goes verbally unremarked in the book itself: the ring of keys worn by the butch truck driver in the diner whom Alison stares at adoringly. *Fun Home* won five Tony Awards in 2015. Kron and Tesori became the first all-female writing team to win a Tony in the Best Score category; the production took home the Best Musical Tony and dragged Bechdel on stage. In a touching photo from the event, the shy Bechdel, wearing a formal suit and Bruce Bechdel's cufflinks, flanked by women in evening gowns, looks like she can't believe what just happened. (She will soon make a cameo on a forthcoming *Simpsons* episode in which Lisa and Marge write a collaborative graphic novel called "Sad Girl" that gets turned into a Broadway musical by an avant-garde director . . .)

The massive success of *Fun Home* first as a graphic novel, and then as the inspiration of a celebrated musical, has galvanized queer comics—if not directly, then simply in widening the sense of possibility for queer representation in all sorts of different spaces. There are now countless comics about queer life, in print and online. A very, very short list includes A.K. Summers's memoir *Pregnant Butch*, in which she draws herself as a pregnant Tintin; Diane Obomsawin's *On Loving Women*, vignettes about coming out drawn with elegantly simple animals; Elisha Lim's *100 Butches* (for which Bechdel wrote the introduction) and *100 Crushes*; Ed Luce's *Wuvable Oaf*, a love letter to the bear scene of San Francisco; Jaime Cortez's *Sexile*, about Adela Vázqez, an activist transgender Cuban immigrant; Nicole Georges's *Calling Dr. Laura*, also a filial mystery; Julie Maroh's *Blue Is the Warmest Color* (translated from the French and the inspiration for the 2013 film); Noelle Stevenson, Grace Ellis, Brooke Allen, and Shannon Watters's *Lumberjanes*, for kids and adults alike, described by afterellen.com as "for the little queer Girl Scout in your heart"; Kelly Sue DeConnick and Valentine de Landro's sci-fi prison comic

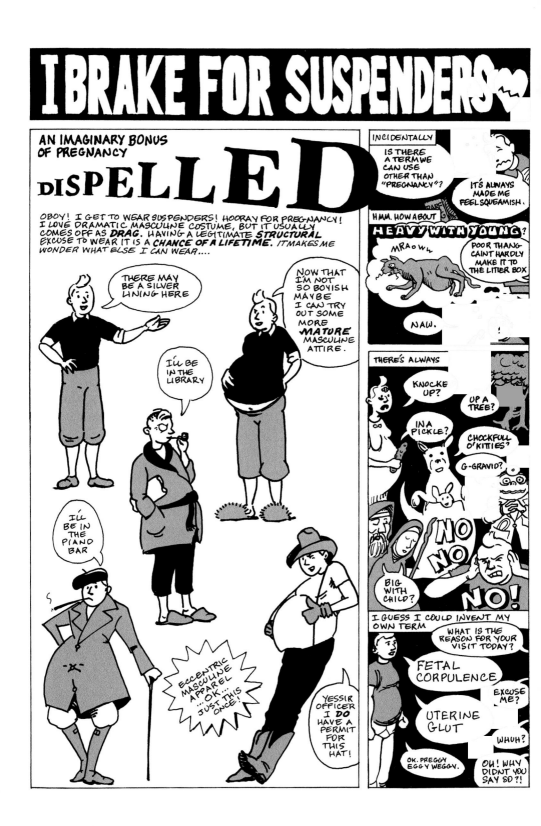

book *Bitch Planet*; Brian K. Vaughan and Fiona Staples's *Saga*, which features a queer ghost; Maggie Thrash's memoir *Honor Girl*, about falling for another girl at camp; Beldan Sezen's *Snapshots of a Girl*, about the queer daughter of Turkish immigrants; Emil Ferris's *My Favorite Thing Is Monsters*, which stars a gay ten-year-old girl in 1960s Chicago; Edie Fake's *Gaylord Phoenix* and *Memory Palaces*, an architectural look at Chicago's queer history; Kieron Gillen and Jamie McKelvie's *The Wicked + The Divine*, a popular fantasy comic book peopled with a large cast of queer characters, including a trans woman; and Dylan Edwards's *Transposes*, true stories about female-to-male queer-identified trans people. In a fascinating foreword to Edwards's book, Bechdel makes a compelling point: comics storytelling, which can be purely visual when it wants to be, can circumvent the problem of language—that is, what pronoun to use—when referring to a person's pretransition past. We see the female-bodied children in *Transposes* who become male-bodied adults without the burden that language can sometimes be felt to provide.

Queer characters and themes are happening now with new force in mainstream comics, too. In 2010 Archie Comics, for instance, a commercial staple that has been around since 1939, introduced its first gay character, Kevin Keller. In his first appearance in the ongoing storyline, Veronica wants to date him but he is uninterested. He eventually marries a man and becomes a senator. The first issue in which Kevin appeared was so popular it sold out, and the company reprinted an issue for the first time in their history. And transgender characters are notably starting to make it to mainstream comics too. In 2015, Marvel introduced the transgender character Sera in the superhero title *Angela: Asgard's Assassin*. Angela is Thor and Loki's long-lost sister—and Sera is her traveling companion. And there are

A.K. Summers, page from *Pregnant Butch* (Berkeley: Soft Skull Press), 2013.

Used by permission of A.K. Summers/Soft Skull. Image courtesy A. K. Summers.

many more transgender superheroes steadily appearing, alongside openly gay ones—the DC character Midnighter was recently even shown using Grindr. In 2016, after all these years—especially since Wertham put her sexuality on trial in the 1950s—Wonder Woman was revealed to be queer. The news was confirmed by *Wonder Woman* writer Greg Rucka and received with an outpouring of enthusiasm. The following month, the character—certainly a first—was named an honorary ambassador "for the empowerment of women and girls" by the United Nations. After the character assumed the role for several months, the UN rescinded her ambassadorship over objections she wasn't a suitable role model. Whatever one may think about the real-life diplomatic appointment of a fictional entity, the public debate around this comics character proves that her relevance—and her queer relevance—not only persists but has grown.

WHY FANS?

I attended the San Diego Comic-Con International, North America's largest fan convention, known simply as Comic-Con, for the first time in 2011 to deliver a talk on an experimental dance performance inspired by comics (!). It was attended by, among others, an unselfconscious man in full superhero regalia, including tights and a cape. He nodded energetically throughout, raised his hand to ask questions, and spoke to me afterward—a professor himself, I discovered. Not a word was exchanged about the fact that he was attired in full costume. Earlier that morning I had noticed another man in the café where I was working stand in line and order a latte through the grate of the helmet of his full-body, metal suit of armor. He clanked in and clanked out in the heavy plate armor, and the barista didn't bat an eyelash.

Today fans of comics are professors and poets and gallerists and curators and artists and students and nerds and cosplayers—and combinations of these, like the professor in cape and full costume. The practice of *cosplay*, a combination of "costume" and "play," was first popularized in Japan; increasingly widespread in the United

The author talking to another professor after a presentation, San Diego Comic-Con, 2011.

Used by permission of Amy Squires. Photograph courtesy Amy Squires.

States, it is used as a verb and a noun, like "Google." (Overheard sentences at Comic-Con, from the same mouth: "Don't cosplay in Baltimore"; "I try to fly with cosplay as infrequently as I can.") Highly recommended: cartoonist Dash Shaw's 2016 graphic novel *Cosplayers*, a sweet take on a friendship between two young filmmakers that develops out of cosplay admiration at a convention.

I taught the Harvard English Department's first dedicated course on comics and graphic novels in the spring of 2016. I lectured on the history of the graphic novel to fifty or so students who were majors in English, architecture, government, art history, anthropology, animation, sociology, math, biology, and chemistry, among others. That the university that is arguably the most famous in the world wanted

to run this course, along with the multiplicity of interests among the students involved, signals the expanding readerships for comics. In the summer of 2016, as a specialist in comics, I spoke at the Illinois Holocaust Museum on the occasion of an exhibit of a stitched cartoon booklet made by a young female prisoner in the Gurs concentration camp in southern France in 1941. Created as a sixty-fifth birthday gift for a barracks mate, it is titled *How It Is, But How It Should Be*, referring to life in and outside of the camp. I contextualized the booklet as part of a trajectory of artwork that includes graphic narratives of witness such as *Maus*. The next morning, I boarded a plane to San Diego for my second Comic-Con in that city, five years after my first, arrived at the teeming Convention Center, and was promptly handed a "Professional"'s badge emblazoned with a *Walking Dead* advertisement along with an enormous plastic backpack featuring the soaring (obviously) DC Comics character Supergirl. Comic-Con ran from Thursday, July 21, to Sunday, July 24; for three days, without even noticing what was printed on it, I wore a black lanyard splattered with red blotches that proclaimed, "FEAR THE WALKING DEAD."

I joked to people who asked me about this week of my summer that experiencing these two very different venues back-to-back produced a kind of cognitive dissonance. But this range represents something true about the very wide world of comics. The day after I returned from Comic-Con, and finished reporting on the convention for the international art bible *Artforum*, a calendar sent by a Holocaust survivor I met at the Illinois museum event arrived in the mail. Each month of this amazing document features a condensed, one-page comics version of a person's story—including his—of surviving the war, drawn by a different artist. All of this is to say: comics is today a form that appeals both to a solemn institution for commemoration and knowledge like the Illinois Holocaust Museum, and to a wide range of fans at the giddy celebration of popular culture that is Comic-Con. The institutions and the people fascinated by comics run the gamut, and

this group is now more diverse—and enthusiastic—than ever before. Even at a famous annual gathering dedicated to what we might think of as the field's most ardent and committed fans, this diversity is clear. I went to Comic-Con, one of the world's bastions for aficionados of comics (and one of the few places, I'm happy to report, that I get recognized by strangers), to take the temperature of the field.

It has become a cliché to say that Comic-Con isn't about comics anymore. One of the biggest fan conventions in the world, it started small, and it certainly started with comics: it was founded in 1970 as San Diego's Golden State Comic-Con by three San Diego comics professionals, Shel Dorf, Ken Krueger, and Richard Alf, for roughly three hundred attendees. Comics artist Jack Kirby and science fiction writer Ray Bradbury were among the featured guests at the first convention. Over the years, and especially after it moved from a local hotel to the enormous, airy San Diego Convention Center on the water, Comic-Con came to also feature, increasingly, a large swath of the entertainment industry: television, movies, and video games related to superheroes and to fantasy genres (this past year, for instance, anything and everything *Game of Thrones* had a *huge* presence in the convention hall). And also the stuff of popular culture: toys, costumes, and other novelty items. These days, people queue up outside the famous Hall H, the Convention Center's biggest space, which seats 6,500, to see premieres and teasers, along with A-list actors; the studios create buzz at Comic-Con for forthcoming movie releases and television seasons. The stylish young man I sat next to on the plane to San Diego, who was reading a comic-book adaptation of a George R. R. Martin *Game of Thrones* novel, explained to me that part of the draw of Comic-Con is viewing such "exclusives" at the convention ahead of the general population. He also noted that the huge popularity of superhero movies, especially in the past ten years—say, the *Avengers* or *Dark Knight* movies—has made comics even more acceptable in mainstream culture in general. (Marvel's *The*

Avengers, released in 2012 with a screenplay by Joss Whedon, is the highest-grossing superhero movie of all time, taking in well over $1.5 billion globally at the box office.) Economically, it seems to work to everybody's benefit: the big comics companies like Marvel and DC make tons of money off of superhero movies whose storylines are mined from the comics, and often popularize the source material; that money then supports the actual comic books and creation of content.

Despite the cliché, Comic-Con is absolutely still about the comics—it's just about a lot of other stuff too. Daniel Clowes, the cartoonist responsible for a dark take on superheroes (*The Death-Ray*) and superb observations on teenage girl friendship (*Ghost World*) told me during a break from signing his graphic novel *Patience* that "it's all just grown." Clowes, who first met the Hernandez brothers—who were also there signing books in 2016—at a Comic-Con decades ago, explained, "I feel like we have a much bigger audience than we used to but so do everybody else." Clowes continued, "It would literally be impossible to know about every comic coming out, even in a given two weeks." As I cut through the teeming crowd on my first day in an effort to locate Clowes signing at the publisher Fantagraphics's table on the convention floor, I encountered an enormous snaking line, which I later found out was for cartoonist Jim Davis, the creator of *Garfield*. It is, along with Charles Schulz's *Peanuts* (1950–2000), the world's most syndicated strip, with 230 million daily readers; it has been translated into 40 languages and appears in 111 countries. An impressively wide range of comics—from globally iconic strips like *Garfield* to the novelistic literary fare served up by Fantagraphics—shares space at Comic-Con.

The fan culture of Comic-Con has amplified across the board. Its inclusivity is inspiring, as is the sheer range of work and practices it encompasses, on vastly different scales, from the corporate to the individual. On the convention floor, toy giants like Mattel,

HAMLET

Kate Beaton's comic strip take on Hamlet, from *Hark! A Vagrant* (Montreal: Drawn & Quarterly), 2011. Her comic strip appears at www.harkavagrant.com.

Sanrio (Hello Kitty), and Hasbro stake out major space. Hasbro manufactures the My Little Pony universe of children's toys, and in 2011 one of the sights that awed me most was an enormous pink plastic pony, which seemed to practically reach the ceiling of the convention floor—it was many, many lengths taller than me. (Recently the adult male fans of My Little Pony, bronies, have garnered a great deal of fascinated attention, including two documentaries.) Yet on the first day I arrived at the 2016 Comic-Con, among all the corporate exhibits and larger-than-life promotion, I also encountered a woman selling beautiful, tiny, handmade felt gerbils and cats. Comic-Con is a platform for both mainstream culture and independent culture, all inclusively mixed in together. In that way, it represents the hard-to-pin-down world of comics perfectly—a universe of cultural production that is wildly variegated, yet invested in being accessible to readers, and celebrated by fans. Its profound nonjudgmental openness is its most salient feature, and the most salient feature of similar fan conventions. As Holly Rae Taylor, the painter and glass artist who is married to Alison Bechdel, described Comic-Con emphatically to me: "It's *permission*."

The Simpsons's Matt Groening, the cartoonist who vowed in the 1970s to invade pop culture, and succeeded wildly, perfectly represents the ethos of Comic-Con 2016. To my surprise (but I obviously shouldn't have been surprised), Groening participated on Friday morning in a bare-bones panel about obscure art comics called "*Kramer's Ergot* and the Art of the Comic Anthology," whose title refers to the series published by indie publisher Fantagraphics, before he sat in an enormous ballroom for four thousand people on Saturday for a panel simply titled *"The Simpsons."* The show has aired well over six hundred episodes. *"The Simpsons"* was held in Ballroom 20, which has its own Twitter account as "The second most demoralizing line at SDCC, rival of @HallHLine. Pucker up." The line to get into the panel was so long and loopy it snaked out the building, and just to find the end of it was literally an adventure (and one involving exer-

cise). Groening was joined by designers, writers, and producers, along with Nancy Cartwright, the voice of Bart Simpson (a chic blonde in a top with cut-out shoulders, she broke into Bart's voice often, and even told the crowd, referring to herself, "Bart's going to be a grandma!"). Groening sat at one end of a long table, which was projected on four enormous screens, dispensing prizes for every questioner, such as idiosyncratic *Simpsons* figurines of James Brown and skateboarder Tony Hawk. Groening's participation in these two profoundly different panels, in both size and focus, indicates the possibilities of a gathering like Comic-Con, where the scale of events ranges wildly from the little to the massive. Comic-Con presents a democracy of forms and types of media: it's an event in which one can revel in noncommercial, auteurist comics at the same time as in the vast popularity of enterprises like the *Simpsons* and the commercial comic-book giants like Marvel and DC.

Comic-Con's Eisner Awards—the Oscars of the comic industry, named after pioneering cartoonist Will Eisner (1917–2005)—strongly signaled in 2016 how the field of comics is currently opening itself up to honor both independent and commercial work, and work by creators who haven't always been well-represented in a field that historically has been white and male. Aside from—appropriately—inducting college buddies Matt Groening and Lynda Barry into the Hall of Fame, the Eisners in 2016 boasted a record number of nominations for women. In contrast, the global comics community's other most famous international comics convention, France's Angoulême International Comics Festival, whose attendees top two hundred thousand annually, nominated not a single woman the same year for its Grand Prix, for which thirty male cartoonists were shortlisted.

John Lewis, Andrew Aydin, and Nate Powell, page from *March: Book One* (Marietta, GA: Top Shelf Productions), 2013.

Charles Burns, Chris Ware, Riad Sattouf, and Daniel Clowes, among other nominees, withdrew their names from consideration (Clowes called it a "ridiculous, embarrassing debacle"). And, more important, many women were not only nominated but also actually won in San Diego, including Kate Beaton, who became the first woman ever to win in the Best Humor Publication category for her collection of strips, initially published online, called *Step Aside, Pops* (Beaton joked on stage, it must be, you know, that women just aren't funny!).

And perhaps the most surprising part of the Eisners: I never expected to meet civil rights icon and Georgia representative John Lewis, and to meet the former president and publisher of DC Comics, Paul Levitz, in the same evening. Yet there I was, shaking Lewis's hand in the wings off the awards stage after *March*: *Book Two*, the second installment of his autobiography in comics form—which he wrote with congressional aide Andrew Aydin and which is illustrated by Nate Powell—won the Eisner for Best Reality-Based Work, beating out Riad Sattouf's *The Arab of the Future*, among other highly acclaimed titles. Everyone in the audience seemed awed by Lewis's presence, and he seemed truly excited to be there (and to win!). Watching Lewis speak on television only a few days after the San Diego Comic-Con at the Democratic National Convention in Philadelphia, I marveled at the distinct spaces, and different kinds of creators and fans that comics is connected to in the twenty-first century: distinguished political leaders as well as "comic book heads" (to use a phrase of the rapper Murs, a participant on the panel "We Are All Heroes: A Conversation on the Changing Landscape of Geekdom and Fan Culture").

Comic-Con presents a vibrant, inclusive cultural mash-up, a democracy of forms and genres that openly mix under the wide umbrella of the comics universe. The Eisners, celebrating the industry's comics stars, underlined this. While generally people associate Comic-Con with the display of superhero products (and costumes), at the Eisners independent comics publishers conspicuously won the most awards.

Seattle's Fantagraphics and Montreal's Drawn & Quarterly, the two most famous comics publishers dedicated to the auteur model—in which one person both writes and draws the comics—cleaned up, with Fantagraphics publisher Gary Groth, and Drawn & Quarterly publisher Peggy Burns ascending the stage many times. Seeing Burns, a rare female publisher, on stage so many times was inspiring; Drawn & Quarterly, known as a feminist workplace, employs twenty women and three men. (At the ceremony, I sat at the Drawn & Quarterly table, along with Groening, Barry, Beaton, and others, as a participant in two of their convention panels.)

The other big winner of the night was Image Comics, the publisher best known right now, perhaps, for the *Walking Dead* comics, the source for the phenomenally popular television show, and for the hugely popular *Saga*, which is narrated by a woman looking back on the plight of her interracial-intergalactic parents during the time when she was an infant. (Cooper, my friend from the plane, summed up *Saga* aptly: "*Alice in Wonderland* meets *Star Wars* on acid.") Image as a company is not auteurist in the same way that both Fantagraphics and Drawn & Quarterly are, in which most of the work, like most of the comics covered here, is the result of the artistic vision of one person. Teams of people, even if sometimes just two, a writer and an artist, generally produce the work at Image. Yet the Portland, Oregon–based Image, created in 1992, was founded specifically as a company that would produce "creator-owned properties"—that is, comics for which the artists would not have to give up copyright to characters.

That copyright is even still an issue to be debated today shows how fractured the wide world of comics is—a fracture that an enormous umbrella event like Comic-Con, with the huge presence of commercial companies like Marvel and DC, can't help but underscore. Comics is a form that has always existed at the boundary of art and commerce. The history of the work-for-hire model in the mainstream

comics industry, in which artists are paid but not credited for their work on a story or series, or don't own the rights to the work they produce (for example, on a character owned by a company), is the exact opposite of the auteur model. At the Eisners, Elliot S! Maggin, who was the main writer for DC during the 1970s and '80s, received the Bill Finger Award for Excellence in Comics Writing, named after an "unsung" writer of the earliest *Batman* comics. Maggin—whose middle initial, in one of many great stories about comics culture, became linked to this piece of exclamatory punctuation when inkers for comics stories mistakenly turned the period after "S" into an exclamation point while inking the credits—delivered a rousing superhero-inflected speech that ended with the pronouncement: "The bad guy's name is work-for-hire." Mission: "Creator credits where appropriate."

Clearly lots of people agree. In Ballroom 20, at the *Simpsons* panel, someone asked Groening, "Why is your signature on all *Simpsons* merchandise?" After joking, "I had a really good lawyer," and noting "Charles Schulz has the same kind of deal," Groening simply said, credibly, that creator anonymity is "kind of mean." The presence of these issues at Comic-Con reminds one how recently comics has emerged as an artistic enterprise to be taken seriously, and demonstrates how wide the spectrum of comics production is. But independent comics, auteurist or collaborative, certainly were heavily celebrated in 2016. "We thank you for widening the comics canon beyond dudes and superheroes and North America," said Burns on stage, accepting the award for Finnish cartoonist Tove Jansson's induction into the Hall of Fame. Later on, accepting the Best Anthology award for *Drawn & Quarterly 25*, a book about the history of the company, Burns said, "We believe in David over Goliath." Image Comics artists in their own speeches afterward emphasized, explicitly, in turn, the *weirdness* that Image, another big winner of the night, encourages—they underlined that Drawn & Quarterly is not the only David. Clearly, independent comics of all sorts are on the rise

right now as the entire field opens itself up to a wider range of content, format, and genres (and genre mash-ups) than it has ever had before.

If all of this seems fractured, or the world of comics production seems almost incoherently diverse, the large range of practices—and the discussion about them—shows that comics as a form is blooming, across the board. Even at monstrously big events sponsored by Marvel or DC, the most mainstream corporate industry leaders, one sensed new directions. At the galvanizing "Women of Marvel" panel on Sunday (in another packed ballroom with a laughter-inducing long line), the audience, full of all genders and all ages, cheered enthusiastically throughout; the energy was palpable. Moderator Judy Stephens, the energetic Marvel producer whose half-shaved head was topped with a hot-pink Mohawk, shared a table with *Ms. Marvel* writer G. Willow Wilson, a convert to Islam who wore her usual headscarf. Stephens announced: "This is a power year for the women of Marvel." She reminded the audience that in 2016 Marvel had twenty female-led comic-book titles, including *Ms. Marvel* (which kick-started the trend), about a superpowered Pakistani-American girl in New Jersey, and *Moon Girl and Devil Dinosaur*, whose protagonist is the smartest person in the entire Marvel universe (whatever that means!). A mere six years ago Marvel had zero female-led titles. The crowd spontaneously applauded throughout. At the "Women of Marvel" panel it was also announced that professor and writer Roxane Gay, author of *Bad Feminist*, would be writing the *Black Panther* spinoff comic book *Black Panther: World of Wakanda*, with acclaimed poet Yona Harvey—both black women.

Over the convention weekend, race and gender emerged as central themes. If in 2015 *New York Times* critic A. O. Scott dubbed Comic-Con "The Year of the Woman," Comic-Con 2016 continued that trend—and with a focus, too, on girl nerds and, specifically, black girl nerds. I learned about websites like Black Girl Nerds (and got to hear founder Jamie Broadnax speak on the excellent "We Are All Heroes"

panel), Black Girls Code, Nerds of Color, and Black Gamers. On the all-female panel "Secret Origins of Good Readers," comics writer Anina Bennett told the audience, "You used to not even see women when you walked around at Comic-Con," deadpanning, "There was never a line for the women's room. Never." Yet, as fellow panelist Marjorie Liu, the writer behind the popular *Monstress* series, pointed out, when she became a hardcore fan of comics as a teenager and created her own fan website, "women were the driving force" in the comics fan community online—"women were writing most of the fan fiction."

Throughout the convention, there was lots of publicly stated love for "nerds" and "geeks" in general—an adorable, booming pride, like the entire enormous convention center that holds hundreds of thousands of people is today one big safe space for creativity under the banner of geekiness, coming from any person of any age. Murs, a panelist on "We Are All Heroes," in which the merits of certain black superheroes, and the concept of the superhero in general were debated, noted that he struggled as a kid—"As a black geek, you already have a lot of hate." The ultrawhite (although alien!) original superhero Superman, he explained, "has been pounded into the psyche of the entire world." At Comic-Con, one of the most popular T-shirts simply read, "Black Heroes Matter." (Another notable T-shirt included a popular baby tee: "My cape is in the wash.") One saw this in the programming—both *about* the nature of Comic-Con fandom (a true sign a field is becoming a field is self-reflective programming!), and programming that is indubitably (and adorably) geeky because it is so esoteric. Note the following description for a *Star Wars*–related panel: "The members of Haran'galaar (San Diego chapter) and Manda'galaar (Los Angeles chapter) discuss the process of building Mandalorian armor, the application process, what happens after you're approved, and why exactly they troop." Crucially, like so much else at

COSPLAY HAS NO BODY TYPE

#COSPOSITIVE

Graphic by Jason Wilkinson–TITAN Cosplay.
Used by permission. Image courtesy Jason Wilkinson.

Comic-Con, this panel is about building community—literally and figuratively—through sharing information about making.

The convention's passionate creativity and inclusivity is evident in cosplay, which is now one of its most famous features—the one thing someone who hasn't been might know about the convention. At first it's conspicuous, and one can't help noticing and cataloguing the characters, as I did at first: "Oh, there's Barbie, in the box"; "Oh, there's Jon Snow with his little white wolfpup"; "Oh, there's Hellboy eating a sandwich," "Oh, there's the lady monster from *Saga* with all the eyes" (the Stalk). But after a while it becomes normal; so many people are dressed up throughout the entire convention, doing everyday things, just in costume. Aside from certain superheroes, cosplay isn't directly related to any specific work in this book, but what it stands for, which is the craft and labor of making your own culture on your own terms,

is of a piece with the ethos of comics, for both creators and fans. The slogan "Cosplay Has No Body Type," along with hashtags like "#cospositive" and "#cospride," were on display at Comic-Con—as was, quite conspicuously, the practice of "cross-play," a specifically gender-bending form of cosplay in which a character is represented in costume but also reinterpreted as differently gendered. This could be something like men dressed as *Star Wars*'s Princess Leia as a slave—apparently a recognized cosplay—or an actual refiguring of the costume itself. A popular cosplay choice at the 2016 Comic-Con was a feminine Wookiee (that would be Chewbacca's species), with candy-colored fur and ladylike accoutrements. Sometimes I saw teams of them in different colors: mint green, hot pink, baby blue, with pearls.

At the panel "Cosplay: Let's Get Serious," the five participants—three of whom were wearing crowns (of felt, beads, and plastic, respectively)—agreed that the process of making is what cosplay is really about—or, as one panelist dressed as Princess Daisy from the Mario video games sweetly and geekily specified: "The cosplay process is 80 percent of what cosplay really is." The range of cosplay runs the gamut: some people buy costumes of existing characters, some people make costumes of existing characters, some people invent their own characters and build those costumes accordingly, and some people mash-up characters with great inventiveness, like a Spider-Man/Hello Kitty mash-up I admired in San Diego. It's a culture of expression that encourages active participation, not simply mimicry. Add dedication to wearing the costumes, which often debut at conventions. I was seated toward the back of the room at the above panel and was comfortably taking notes for a good thirty minutes before I noticed the couple next to me was dressed up—one as a full-body rotting-skin zombie, with peeling and mottled plastic all over her body, in the roasting San Diego July weather. I was touched to hear, because of the culture of support, that there are often cosplay repair stations at conventions, as Kathy Wiktor, from the company Cosplay

"Chewie's Angels," San Diego Comic-Con, 2016. Photograph by Keith Plocek.
Used by permission of Keith Plocek. Photo courtesy worldofwonder.net.

by McCall's, pointed out (she also noted she always brings duct tape to cons to help fix busted corsets).

"Cosplay: Let's Get Serious" was basically a deeply impressive sewing tutorial, where events like "sew-a-longs" were discussed, along with sewing machine tips, and general discussion of textile manipulation, like how to get piping and applique detailing to work with spandex, along with conversation about smocking techniques on corsets (my new hero: panelist Gillian Conahan, a beautiful self-described "sewing nerd" with a master's degree from MIT and a book for DIY cosplayers titled *The Hero's Closet*). Yes, this woman spent fifty hours embroidering one corset for a costume. When a fully attired-in-

something-I-couldn't-identify kid, maybe ten or eleven, stood up and raised his hand in the Q&A, and revealed "I'm just starting cosplay," the entire audience clapped. He asked for rules or tips. One panelist began by looking him over, kindly and seriously, from the stage, opening with, "I see you're wearing football pads. Football pads are a good base," before continuing her analysis. Comic-Con is a family friendly enterprise. Many, many kids come dressed up with their parents; the whole family is in cosplay.

The uninhibited inhabitation of costume—this owning of desire and self-expression—is on display in creative and moving ways at events like Comic-Con, where cosplay is encouraged and normalized by the community. And comics fans' deep commitment to creative self-expression is evident at many different comics conventions. It bleeds out from the convention center to the workaday world. As A. O. Scott pointed out in his recent article about attending Comic-Con, in which he pays tribute to fans' creativity, it is "also possible to marvel, so to speak, at how quickly and completely what once were subcultural pursuits have conquered the mainstream, and to appreciate the bottom-up, populist aspects of that conquest." Nerd culture, especially in the age of Silicon Valley dominance, is in. Fantasy culture, especially in an era of constant media attention to mass violence and wild politics on a global stage, is in (as so many *Game of Thrones* think pieces, as well as its permeation into contemporary political discourse, suggests). The figure of the superhero, whatever that means—and, crucially, who gets to be represented as one—is a freshly relevant corner of mainstream discourse, as we see in media attention to Ta-Nehisi Coates and Brian Stelfreeze's new series *Black Panther*, to new transgender superheroes (such as Chalice, from small publisher AfterShock), and to the superhero as a contemporary mode of description, as in "The Superhero Photographs of the Black Lives Matter Movement," a 2016 *New York Times Magazine* essay that focuses on the famous photograph of protester Ieshia Evans. Comic-

Ieshia Evans in Baton Rouge, Louisiana, July 9, 2016.

Photo by Jonathan Bachman/Reuters. Used by permission.

Con *is* popular culture, not something to the side of popular culture, and it is only getting more and more central.

The past few decades, as Scott suggests, have caught up with Comic-Con. And whether they are fans of commercial comics, which is generally associated with a now-chic and actually central geek culture, or of independent comics, which is now associated with a kind of literary cool, comics fans have a passion that is impressive: committed, energetic, participatory. In a beautiful, colorful double-spread at the end of Dash Shaw's *Cosplayers*, a book that offers loose lines and a collage aesthetic to capture the dynamism and aspiration of fan conventions, the two young women protagonists walk through a convention, as one, gripping a sword, says to the other, "We were into cosplay since before it was uncool." "Uncool" is the new "cool"—the nerdy, passionate attachment of fans.

In fandom, as in so many contexts, comics places pressure on what constitutes the "expert" and allows openings for the amateur. Fan sites and fan publications, for instance, in many cases provide the most detailed, interesting facts and insights about a work, creator, or movement; oftentimes much less is gleaned from a comparable scholarly article. (This has been a major lesson for me as a scholar of comics.) *Cosplayers* thematizes fans as makers of meaning. Shaw, a former student of Gary Panter's, offers cosplaying characters who are teenage filmmakers, using the stuff of life in front of them to make work they post online, which then attracts a surprising amount of attention. It's a graphic novel about the current age of creativity, in which people can make and circulate their own culture on their own terms. This is the central precept of the comics culture this book tracks. *Cosplayers* in a way is about the self as a medium—you show up to a convention and *you* are the medium. But it's a graphic novel for a reason—because the idea of people creating their own media and their own plotlines as opposed to being sold a life by someone else is what has always characterized so many comics of all different kinds. The effects of this independence of spirit are now seen, so to speak, everywhere.

The world of comics is massive right now, as an event representing so many of its constituent parts like Comic-Con makes clear. And the picture of the comics fan has changed, moving away from outmoded stereotypes. It no longer only represents those like the *Simpsons*'s Comic Book Guy character (although plenty of cranky white middle-age men who are sarcastic know-it-all collectors are of course comics fans), but also the young South Asian girl dressed as Kamala Khan, aka Ms. Marvel, in line with her father for the Comic-Con panel about *The Simpsons*. The entire enterprise, from literary graphic nar-

Dash Shaw, double-spread from *Cosplayers* (Seattle: Fantagraphics), 2016.
Used by permission of Dash Shaw. Images courtesy Dash Shaw.

ratives to the Marvel and DC universes and everything in between, is flourishing, in that new storylines, styles, genres, and audiences are becoming that to which comics addresses itself. There is now a line for the women's restrooms at Comic-Con (a good sign). Black heroes do matter. The field of comics is trending toward diversity and inclusion on all levels, and the cultures of creativity it stands for and engenders have positive effects in wider culture.

In the taxi on the way to the San Diego airport at sunset, after the convention ended, I chatted with my driver, a friendly older man with a Russian accent. Although invariably all the cabdrivers I met mentioned how crazy it was to have so many people flood their downtown area, he liked the Comic-Con crowd, he told me; they were generally friendly. One man, he said, got into his taxi "dressed like this"—he gestured energetically with his hands across his shoulders, as I imagined pointy, Star Trekky shoulder pads—"and like this," as he swept his hands in front of his face and I imagined some sort of face paint. Finally, he told me, he asked, "What's your costume?" The man answered simply, "This is me every day."

ACKNOWLEDGMENTS

Chris Spaide's resourcefulness, organization, dedication, good ideas, and good humor made writing this book possible—and, most important, fun. I couldn't have done it without him, on several different fronts. Mark Brokenshire provided support and his sage advice from the very beginning and I massively appreciate his involvement.

I owe a huge debt of gratitude to my agent, Zoë Pagnamenta, for her faith, knowledge, and guidance. I also owe a huge debt of gratitude to Eric Meyers at Harper, who happily for me "got" the project of this book right away. I'm very lucky to work with as savvy and inspiring an editor as Eric. Thanks, too, to Milan Bozic and the team at Harper who saw my book through to its final stages, and to Alison Lewis at the Zoë Pagnamenta Agency.

Gary Panter's comics preface and Jaime Hernandez's original cover make the work of writing a book feel worthwhile. I am beyond grateful to both of them for the art they created for *Why Comics?* The inimitable Seth honored me profoundly by drawing the author "photo."

During the time it took to drink a couple of beers, Noah Feldman had better thoughts about this book's structure than I did over months. Thank you, as ever, for invaluable advice. Eric Slauter, Michael Miller, Steve Biel, and Anna Henchman very generously helped me clarify my ideas early on. William Huntting Howell, Mark Brokenshire, Reed Gochberg, and Chris Spaide also kindly read chapters and offered key suggestions.

For encouraging conversations about aspects of this project I'd like to thank Ivan Brunetti, Chris Ware, Art Spiegelman, Alison Bechdel, A.K. Summers, Daniel Clowes, Joe Sacco, Adrian Tomine, Dan Nadel, Richard Dienst, Jaime Clarke, Marianne DeKoven, Tisse Takagi, Alison MacKeen, Peter Galison, Tom Mitchell, Janice Misurell-Mitchell, Ralph Rehbock at the Illinois Holocaust Museum, and Hamza Walker, among others already noted. The grad and undergrad students in my "Graphic Novel" courses at Harvard provided excellent insight about important features of comics (particularly Halie LeSavage, who wrote a senior thesis on *Building Stories*). Thank you, too, to Case Kerns for strong opinions, and to my students at the University of Chicago for ever-inspiring thoughts and conversations.

A fellowship at Wellesley College's Newhouse Center for the Humanities during the 2016–2017 academic year, along with the support of my deans and colleagues at Northeastern University, generously allowed me to complete this book. Special thanks to my fellow Newhouse Fellows Amit Sengupta and Jerry Pinto for talking with me about comics in India. I am also grateful for the invitations to give two recent keynote talks, at the annual Graphic Medicine conference in Seattle, and at the Documenting Trauma symposium at the University of Oxford, which helped me clarify ideas in this book with colleagues.

For their role in facilitating images, a big thank-you to Sruti Islam, Julia Pohl-Miranda, and Peggy Burns at Drawn & Quarterly; Jacq Cohen at Fantagraphics; Patrick Rosenkranz, Denis Kitchen, and Martha Holmes; Lauren Rogoff at the Wylie Agency; Lawrence Wong and Sherri Hinchey at Penguin Random House; Madeleine Hartley at Penguin Random House UK; Ron Hussey at Houghton Mifflin Harcourt; Carl M. Gropper at Will Eisner Studios; Joyce Brabner; Keith Plocek; Jason Wilkinson; Todd Hignite; Matthew Nolan; Marilyn Scott at the Billy Ireland Cartoon Library & Museum; Leigh Walton at Top Shelf; Monika Verma, at Levine Green-

berg Rostan, Yessenia Santos at Simon & Schuster, and Allie Brosh; Susan Grode, along with Janie Freedman, at KattenMuchinRosenman, and the Bongo Comics Group; Jesse Stagg and Alex Czetwertynski, along with Bettina Korek at For Your Art; Joan Ashe at Henry Holt; Allison Ingram at Condé Nast; Yasutaka Minegishi and Maki Hakui at Presspop, Inc.; Misayo Nakazawa, and Ayumu Kiryu at the Japan UNI Agency, Inc.; Marvel Comics; DC Comics; Kat Salazar at Image Comics; Reuters; Getty; and Linda Collins at Northeastern. A special thanks here to Khalid El-Ali, who was exceptionally generous in his correspondence and in granting permission for and supplying artwork by his father, legendary cartoonist Naji al-Ali.

Daniel Alarcón, Lynda Barry, Kate Beaton, Alison Bechdel, Charles Burns, Daniel Clowes, Robert Crumb, Diane DiMassa, Phoebe Gloeckner, Justin Green, Jaime Hernandez, Aline Kominsky-Crumb, Bobby London, Marisa Acocella Marchetto, Richard McGuire, Erika Moen, Josh Neufeld, Gary Panter, Raymond Pettibon, Joe Sacco, Marjane Satrapi, Dash Shaw, Art Spiegelman, A. K. Summers, Chris Ware: thank you for your help in enabling me to include your amazing images here.

For general support during the period I worked on this book, in addition to those previously named, I would also like to thank the late Dan Aaron, Ted Widmer, Elaine Scarry, Amy Squires, John Wiseman, Tamar Abramov, Lindsey and Ryan Bardsley, Richard Allison, Sophie Gee, Lev Grossman, and Richard and Patricia Chute.

BIBLIOGRAPHY

INTRODUCTION: COMICS FOR GROWN-UPS?

"An Evening With Neil Gaiman." *Meewella* (blog), October 3, 2007. Accessed April 24, 2017. http://www.meewella.com/fragments/an-evening-with-neil-gaiman.php.

Chute, Hillary. "Scott McCloud." *The Believer* 43 (April 2007): 80–86.

Comichron: A Resource for Comics Research. "Comic Book Sales by Year." Accessed April 24, 2017. http://www.comichron.com/yearlycomicssales.html.

"Comics Magazine Association of America Comics Code 1954." Reprinted in Amy Kiste Nyberg, *Seal of Approval: The History of the Comics Code*. Jackson: UP of Mississippi, 1998.

Emmert, Lynn. "The Alison Bechdel Interview." *The Comics Journal* 282 (2007): 34–52.

Feiffer, Jules. *The Great Comic Book Heroes*. Seattle: Fantagraphics Books, 2003.

Grasso, Brian. "I'm a Duke Freshman. Here's Why I Refused to Read *Fun Home*." *PostEverything* (blog), *Washington Post*, August 25, 2015. Accessed April 24, 2017. https://www.washingtonpost.com/posteverything/wp/2015/08/25/im-a -duke-freshman-heres-why-i-refused-to-read-fun-home/.

Groth, Gary. "Art Spiegelman Interview." *The Comics Journal* 180 (1995): 52–106.

Juno, Andrea. "Dan Clowes." In *Dangerous Drawings: Interviews with Comix and Graphix Artists*, edited by Andrea Juno, 98–113. New York: Juno Books, 1997.

"Lin-Manuel Miranda: By the Book." *New York Times*, April 5, 2016. Accessed April 24, 2017. https://www.nytimes.com/2016/04/10/books/review/lin-manuel-miranda -by-the-book.html.

MacDonald, Heidi. "Graphic Novel Sales Up 22% in Bookstores in 2015." *The Beat: The News Blog of Comics Culture*, January 22, 2016. Accessed April 24, 2017. http://www.comicsbeat.com/graphic-novel-sales-up-22-in-bookstores-in-2015/.

———. "How Graphic Novels Became the Hottest Section in the Library." *Pub-

lishers Weekly, May 3, 2013. Accessed April 24, 2017. http://www.publisher
sweekly.com/pw/by-topic/industry-news/libraries/article/57093-how-graphic
-novels-became-the-hottest-section-in-the-library.html.

MacGillivray, Clayton. "Art Spiegelman Talk at the University of Calgary." *Comic-
BookBin*, May 7, 2011. Accessed April 24, 2017. http://www.comicbookbin.com
/Art_Spiegelman_University_of_Calgary001.html.

Mankoff, Bob. *How About Never—Is Never Good For You?: My Life in Cartoons*. New
York: Henry Holt, 2014.

McCloud, Scott. *Understanding Comics: The Invisible Art*. New York: Harper, 1994.

———, and Hillary Chute. Public conversation. Harvard Book Store, Cambridge,
MA, February 5, 2015.

McLuhan, Marshall. *Understanding Media: Extensions of Man*. Cambridge, MA: MIT
Press, 1994 [1964].

Østergaard, Anders Høgsbro, dir. *Tintin et Moi*. Angel Films, 2003.

Said, Edward. "Homage to Joe Sacco." Introduction to *Palestine*, by Joe Sacco, i–v.
Seattle: Fantagraphics, 2001.

Segura, Jonathan. "Print Book Sales Rose Again in 2016." *Publishers Weekly*, January 6,
2017. Accessed May 25, 2017. https://www.publishersweekly.com/pw/by-topic
/industry-news/bookselling/article/72450-print-book-sales-rose-again-in-2016
.html.

Solomon, Deborah. "Revolutionary Spirit: Questions for Marjane Satrapi." *New York
Times Magazine*, October 21, 2007.

Spiegelman, Art. "1974 Artist's Statement." In *Co-Mix: A Retrospective of Comics,
Graphics, and Scraps*, n.p. Montreal: Drawn & Quarterly, 2013.

———. "Comics: Marching Into the Canon." Lecture. Columbia University, New
York, NY, April 9, 2007.

———. "Ephemera vs. the Apocalypse." *Indy Magazine*, Autumn 2005. http://
64.23.98.142/indy/autumn_2004/spiegelman_ephemera/index.html.

———. *MetaMaus*: *A Look Inside a Modern Classic*, Maus. New York: Pantheon, 2011.

Wertham, Fredric. *Seduction of the Innocent*. Laurel, NY: Main Road Books, 2004
[1954].

WHY DISASTER?

D'Arcy, David. "Profile: Art Spiegelman's Comic Book Journalism." Transcript. NPR
Weekend Edition, June 7, 2003.

Dreifus, Claudia. "A Comic-Book Response to 9/11 and Its Aftermath." *New York
Times*, August 7, 2004.

Faulkner, William. *Requiem for a Nun*. New York: Vintage, 2012 [1951].

Gleason, Alan. "The Keiji Nakazawa Interview." *The Comics Journal* 256 (2003): 38–52.

Gussow, Mel. "Dark Nights, Sharp Pens; Art Spiegelman Addresses Children and His Own Fears." *New York Times*, October 15, 2003: E1, E6.

Heer, Jeet. *In Love With Art: Françoise Mouly's Adventures in Comics with Art Spiegelman*. Toronto: Coach House Books, 2013.

Itō, Yu, and Tomoyuki Omote. "Barefoot Gen in Japan: An Attempt at Media History." In *Reading Manga: Local and Global Perceptions of Japanese Comics*, edited by Jaqueline Berndt and Steffi Richter, 21–38. Leipzig: Leipziger Universitätsverlag, 2006.

Nakazawa, Keiji. "A Note from the Author." In *Barefoot Gen, Vol. Two: The Day After*, translated by Project Gen. San Francisco: Last Gasp, 2004.

———. *Hiroshima: The Autobiography of Barefoot Gen*. Edited and translated by Richard H. Minear. New York: Rowman and Littlefield, 2010.

Panter, Gary. "Lines on Paper: Lynda Barry, Ivan Brunetti, R. Crumb, Gary Panter." Panel moderated by Hamza Walker at the Comics: Philosophy & Practice conference, Chicago, IL, May 18–20, 2012. Rpt. in *Critical Inquiry: Comics and Media*, edited by Hillary Chute and Patrick Jagoda (Spring 2014): 237–254.

Sacco, Joe, and Art Spiegelman. "Only Pictures?" *Nation*, March 6, 2006. Accessed April 25, 2017. https://www.thenation.com/article/only-pictures/.

Sontag, Susan. *On Photography*. New York: Picador, 2001 [1977].

Spiegelman, Art. "Ballbuster: Bernard Krigstein's Life Between the Panels." *New Yorker*, July 22, 2002.

———. *Breakdowns: Portrait of the Artist as a Young %@&*!*. New York: Pantheon, 2008.

———. "Drawing Blood: Outrageous Cartoons and the Art of Outrage." *Harper's*, June 2006, 43–52.

———. "Ephemera vs. the Apocalypse." *Indy Magazine*, Autumn 2005. http://64.23.98.142/indy/autumn_2004/spiegelman_ephemera/index.html.

———. "Four Maus Notebooks." *MetaMaus*. DVD. New York: Pantheon, 2011.

———. "Introduction: Putting Out the Garbage." In *Garbage Pail Kids*, by the Topps Company, Inc., 6–10. New York: Abrams ComicArts, 2012.

———. "Master Race: The Graphic Story as an Art Form." In *From Maus to Now to Maus to Now: Comics, Essays, Graphics, and Scraps*, by Art Spiegelman, 86–90. Palermo: La Centrale dell'Arte, 1998.

———. *MetaMaus: A Look Inside a Modern Classic*, Maus. New York: Pantheon, 2011.

———. "Obituary for Bernard Krigstein." In *From Maus to Now to* Maus *to Now: Comics, Essays, Graphics, and Scraps*, by Art Spiegelman, 90. Palermo: La Centrale dell'Arte, 1998.

———. "Pop Goes the Poppa—Or, the Vengeance of Dr. Speck" in *Real Pulp Comics* 1, 1971.

———. "Things Are More Like They Are Now . . . : SUNY Binghamton Commencement Address." In *From Maus to Now to* Maus *to Now: Comics, Essays, Graphics, and Scraps*, by Art Spiegelman, 22–24. Palermo: La Centrale dell'Arte, 1998.

Szasz, Ferenc Morton. *Atomic Comics: Cartoonists Confront the Nuclear World*. Reno: University of Nevada Press, 2012.

Temple, Kevin. "Gary Panter." *NOW*, May 19, 2005. Accessed May 1, 2017. https://nowtoronto.com/news/gary-panter/.

Tucker, Ken. "Cats, Mice, and History—The Avant-Garde of the Comic Strip." *New York Times Book Review*, May 26, 1985.

Van Biema, David H. "Art Spiegelman Battles the Holocaust's Demons—And His Own—in an Epic Cat and Mouse Comic Book." *People*, October 27, 1986. Accessed April 25, 2017. http://people.com/archive/art-spiegelman-battles-the-holocausts-demons-and-his-own-in-an-epic-cat-and-mouse-comic-book-vol-26-no-17/.

WHY SUPERHEROES?

Barthes, Roland. "The Third Meaning: Notes on Some Eisenstein Stills." In *Image-Music-Text*, translated by Stephen Heath, 52–68. New York: Hill and Wang, 1997.

Bongco, Mila. *Reading Comics: Language, Culture, and the Concept of the Superhero in Comic Books*. New York: Garland, 2000.

Brogan, Jacob. "Masked Fathers: *Jimmy Corrigan* and the Superheroic Legacy." In *The Comics of Chris Ware: Drawing Is a Way of Thinking*. Jackson: University Press of Mississippi, 2010.

Chute, Hillary L. "Art Spiegelman & Chris Ware." In *Outside the Box: Interviews with Contemporary Cartoonists*, 216–251. Chicago: University of Chicago Press, 2014.

———. "Daniel Clowes." In *Outside the Box: Interviews with Contemporary Cartoonists*, 98–117. Chicago: University of Chicago Press, 2014.

———. "Unkenny Valley." *Diary* (blog), *Artforum*, July 29, 2016. Accessed May 1, 2017. https://www.artforum.com/diary/id=62445.

Clowes, Daniel. Interview with Hillary Chute. San Diego, CA, July 24, 2017.

Coates, Ta-Nehisi. "The Return of the Black Panther." *Atlantic*, April 2016. Accessed

May 1, 2017. https://www.theatlantic.com/magazine/archive/2016/04/the
-return-of-the-black-panther/471516/.

Colton, David. "Superman's Story: Did a Fatal Robbery Forge the Man of Steel?" *USA Today*, August 25, 2008. Accessed May 1, 2017. http://usatoday30.usatoday
.com/life/books/news/2008–08–25-superman-creators_N.htm.

Edidin, Jay Rachel. "Pizza Dog and the Art of Comics: Deconstructing 'Hawkeye' #11." *Comics Alliance*, July 2, 2013. Accessed May 2, 2017. http://comicsalliance
.com/hawkeye-11-review-marvel-fraction-aja-pizza-dog-storytelling/.

Elsworth, Catherine. "The Tragic Real Story Behind Superman's Birth." *Telegraph*, August 27, 2008. Accessed May 1, 2017. http://www.telegraph.co.uk/news/celebrity
news/2628733/The-tragic-real-story-behind-Supermans-birth.html.

Glass, Ira, and Chris Ware. "Glass/Ware: New Media for Writing American Lives." Interview at the Thirteenth Annual Colloquium at the University of Minnesota, Minneapolis, MN, February 18, 2002. Accessed May 1, 2017. http://writing
.umn.edu/lrs/assets/pdf/speakerpubs/Glass_Ware.pdf.

———. "Superpowers: Prologue." Episode 178. *This American Life*, February 23, 2001.

Goldberg, Barbara. "Check That Bought Superman Rights for $130 Sells for $160,000." *Reuters*, April 16, 2012. Accessed May 1, 2017. http://www.reuters.com/article
/entertainment-us-usa-superman-idUSBRE83G02F20120417.

Ito, Robert. "Ta-Nehisi Coates Helps a New Panther Leave Its Print." *New York Times*, March 31, 2016. Accessed May 2, 2017. https://www.nytimes.com/2016/04/03
/movies/ta-nehisi-coates-helps-a-new-panther-leave-its-print.html.

Itzkoff, Dave. "Gene Luen Yang Thinks Superheroes Are for Everyone." *New York Times Magazine*, November 17, 2016, 66.

Kepner, Tyler. "Kobe Bryant Ends Career with Exclamation Point, Scoring 60 Points." *New York Times*, April 14, 2016. Accessed May 1, 2017. https://www.nytimes
.com/2016/04/15/sports/basketball/kobe-bryant-scores-60-for-los-angeles
-lakers-in-farewell-game.html.

Lamar, Cyriaque. "*Ghost World*'s Daniel Clowes Tells Us about The Death-Ray, His Chain-Smoking Teenage Superhero." *io9*, October 3, 2013. Accessed May 1, 2017. http://io9.gizmodo.com/5846141/ghost-worlds-daniel-clowes-tells-us-about
-the-death-ray-his-chain-smoking-teenage-superhero.

Lefèvre, Pascal. Comix Scholars listserv 2003, comix-scholars@clas.ufl.edu.

Leong, Tim. *Super Graphic: A Visual Guide to the Comic Book Universe*. San Francisco: Chronicle, 2013.

Massara, Kathleen. "Dan Clowes Talks About Nerdy Superheros, 9/11, and Spite

Wars." *Flavorwire*, September 28, 2011. Accessed May 1, 2017. http://flavorwire
.com/214131/dan-clowes-talks-about-nerdy-superheros-911-and-spite-wars.

Mietkiewicz, Henry. "Great Krypton! Superman was *The Star*'s Ace Reporter." *Toronto Star*, April 26, 1992, A10.

Morrison, Grant. *Supergods: What Masked Vigilantes, Miraculous Mutants, and a Sun God from Smallville Can Teach Us about Being Human.* New York: Spiegel & Grau, 2011.

Ricca, Brad. "The Amazing Adventures of Jerry Siegel and Joe Shuster." *PopMatters*, June 13, 2013. Accessed May 1, 2017. http://www.popmatters.com/feature/172288 -super-boys-the-amazing-adventures-of-jerry-siegel-and-joe-shuster/.

Schjeldahl, Peter. "Words and Pictures." *New Yorker*, October 17, 2005. Accessed May 1, 2017. http://www.newyorker.com/magazine/2005/10/17/words-and-pictures.

Seagle, Steven T. (story), and Duncan Rouleau and Aaron Sowd (art), "Unreal." In *9–11: The World's Finest Comic Book Writers & Artists Tell Stories to Remember*, vol. 2, 15–16. New York: DC Comics, 2002.

Willis, Simon. "Chris Ware, Everyday Genius." *1843 Magazine*, September/October 2013. Accessed May 1, 2017. https://www.1843magazine.com/content/features /simon-willis/chris-ware.

WHY SEX?

Adelman, Bob. *Tijuana Bibles: Art and Wit in America's Forbidden Funnies, 1930s–1950s.* New York: Simon & Schuster, 1997.

Arnold, Andrew D. "R. Crumb Speaks: Highlights of New York Public Library Conversation with Robert Hughes." *Time,* April 29, 2005. Accessed May 9, 2017. http://content.time.com/time/arts/article/0,8599,1055105,00.html.

Bagge, Peter. "Aline Kominsky-Crumb Interview." *The Comics Journal* 139 (1990): 50–73.

Beauchamp, Monte. *The Life and Times of R. Crumb: Comments from Contemporaries.* New York: St. Martin's Griffin, 1998.

Bright, Susie. "Introduction." In *Twisted Sisters 2: Drawing the Line*, edited by Diane Noomin, 7. Northampton: Kitchen Sink, 1995.

Chute, Hillary L. "Aline Kominsky-Crumb." In *Outside the Box: Interviews with Contemporary Cartoonists*, 81–97. Chicago: University of Chicago Press, 2014.

———. "Alison Bechdel." In *Outside the Box: Interviews with Contemporary Cartoonists*, 154–175. Chicago: University of Chicago Press, 2014.

———. "Art Spiegelman & Chris Ware." In *Outside the Box: Interviews with Contemporary Cartoonists*, 216–251. Chicago: University of Chicago Press, 2014.

———. "Lynda Barry." In *Outside the Box: Interviews with Contemporary Cartoonists*, 57–79. Chicago: University of Chicago Press, 2014.

Crumb, Charles V. *Training People Effectively: The Teaching Manual for Instructors and Supervisors in Business, Education, Industry, and the Professions*. Philadelphia: Lefax, 1970.

Crumb, Robert. "Introduction." In *A Child's Life and Other Stories*, by Phoebe Gloeckner, 4–5. Berkeley: Frog, 1998.

———. "R. Crumb's Universe of Art!" In *The R. Crumb Handbook*, 432. London: MQ Publications, 2005.

Heller, Marielle, dir. *The Diary of a Teenage Girl*. Sony Pictures Classics, 2015.

Juno, Andrea. "Art Spiegelman." In *Dangerous Drawings: Interviews with Comix and Graphix Artists*, 6–27. New York: Juno Books, 1997.

———. "Phoebe Gloeckner." In *Dangerous Drawings: Interviews with Comix and Graphix Artists*, 148–161. New York: Juno Books, 1997.

Kominsky-Crumb, Aline. *Need More Love: A Graphic Memoir*. London: MQ Publications, 2007.

McCloud, Scott. *Understanding Comics: The Invisible Art*. New York: Harper, 1994.

Orenstein, Peggy. "Phoebe Gloeckner is Creating Stories about the Dark Side of Growing Up Female." *New York Times Magazine*, August 5, 2001, 26–29.

Rosenkranz, Patrick. *Rebel Visions: The Underground Comix Revolution, 1963–1975*. Seattle: Fantagraphics, 2002.

Zwigoff, Terry, dir. *Crumb*. Superior Pictures, 1994.

WHY THE SUBURBS?

Amazon. "Questions for Charles Burns." 2005. Accessed May 9, 2017. https://www.amazon.com/Black-Hole-Pantheon-Graphic-Novels/dp/0375714723.

Ayroles, François. *Key Moments from the History of Comics*. Toronto: Beguiling Books, 2009.

Barry, Lynda. "Introduction." In *Best American Comics 2008*, edited by Lynda Barry, xi–xx. New York: Houghton Mifflin, 2008.

Burns, Charles. *Charles Burns*. Leuven: Beeld Beeld, 2011.

———. "A Project for *Artforum*, March 1991 [Untitled]." Rpt. in *Charles Burns*, 117. Leuven: Beeld Beeld, 2011.

"Charles Burns." Fantagraphics official website. Accessed May 9, 2017. http://www.fantagraphics.com/artists/charles-burns/.

Chute, Hillary L. "Charles Burns." In *Outside the Box: Interviews with Contemporary Cartoonists*, 32–55. Chicago: University of Chicago Press, 2014.

———. "Lynda Barry." In *Outside the Box: Interviews with Contemporary Cartoonists*, 57–79. Chicago: University of Chicago Press, 2014.

Gallo, Joe. "The Comic Strip Moves to the Suburbs: Settling for Less & Loving It!" *PopMatters*, March 3, 2000. Accessed May 9, 2017. http://www.popmatters .com/feature/000303-gallo/.

Heer, Jeet. "Updike: Portrait of the Artist as a Young Fan." *Paris Review Daily*, January 14, 2015. Accessed May 13, 2017. https://www.theparisreview.org/blog /2015/01/14/updike-portrait-of-the-artist-as-a-young-fan/.

Mann, Ron, dir. *Comic Book Confidential*. Sphinx Productions, 1989.

Spiegelman, Art. "Meet Art Spiegelman." *BookPage*, October 2008. Accessed May 13, 2017. https://bookpage.com/meet/12039-meet-art-spiegelman.

Sullivan, Darcy. "The Charles Burns Interview." *The Comics Journal* 148 (February 1992). Accessed May 9, 2017. http://www.tcj.com/the-charles-burns-interview -by-darcy-sullivan/.

Ware, Chris. "Graphic Novel Forms Today: Charles Burns, Daniel Clowes, Seth, and Chris Ware." Panel moderated by Hillary Chute at the Comics: Philosophy & Practice conference, Chicago, IL, May 18–20, 2012. Rpt. in *Critical Inquiry: Comics and Media*, edited by Hillary Chute and Patrick Jagoda (Spring 2014): 151–168.

WHY CITIES?

"An Interview with Harvey Pekar, Author of *Ego & Hubris*." Random House, 2006. Accessed May 14, 2017. http://www.randomhouse.com/rhpg/egoandhubris/pekar _interview.html.

Barnett, David. "'There's Nothing Like It In Comics' . . . How *Love and Rockets* Broke the Rules." *Guardian*, May 10, 2016. Accessed May 15, 2017. https://www.the guardian.com/books/2016/may/10/theres-nothing-like-it-in-comics-how-love -and-rockets-broke-the-rules.

Bechdel, Alison. "Introduction." In *The Art of Jaime Hernandez: The Secrets of Life and Death*, by Todd Hignite, 9. New York: Abrams, 2010.

Cavna, Michael. "How Harvey Pekar Became One of David Letterman's Greatest Recurring Guests." *Comics Riffs* (blog), *Washington Post* website, May 20, 2015. Accessed May 13, 2017. https://www.washingtonpost.com/news/comic -riffs/wp/2015/05/20/david-letterman-how-harvey-pekar-became-one-of-his -greatest-recurring-guests/.

———. "Wait—Just How Did Ohio Become the Cradle of Great Cartoonists?" *Comics Riffs* (blog),*Washington Post*, July 19, 2016. Accessed May 17, 2017. https://

www.washingtonpost.com/news/comic-riffs/wp/2016/07/19/wait-just-how
-did-ohio-become-the-cradle-of-great-cartoonists/.

Chute, Hillary L. "Adrian Tomine." In *Outside the Box: Interviews with Contemporary Cartoonists*, 194–215. Chicago: University of Chicago Press, 2014.

Connors, Joanna. "David Letterman Brought Harvey Pekar, His Cleveland Cool, and a Big Blow-Up to Late Night." *The Plain Dealer*, May 15, 2015. Accessed May 14, 2017. http://www.cleveland.com/entertainment/index.ssf/2015/05/david_letterman_brought_harvey.html.

———. "Harvey Pekar, Comic-Book Legend, Dies at Age 70." *The Plain Dealer*, July 13, 2010. Accessed May 14, 2017. http://blog.cleveland.com/metro/2010/07/cleveland_comic-book_legend_ha.html.

Crumb, R. "Introduction." In *American Splendor: The Life and Times of Harvey Pekar*, by Harvey Pekar et al., n.p. New York: Ballantine, 2003.

"Episode 43: Summer in the City [Marjorie Liu interview by Henry Finder]," narrated by David Remnick, *The New Yorker Radio Hour*, August 12, 2016. http://www.newyorker.com/podcast/the-new-yorker-radio-hour/episode-43-summer-in-the-city.

Hernandez, Gilbert. "Down Palomar Way [Interview by Chris Knowles]." *Comic Book Artist* 15 (November 2001): 44–55.

Hernandez, Jaime. "The Mechanic of Love [Interview by Chris Knowles]." *Comic Book Artist* 15 (November 2001): 56–64.

Hernandez, Mario. "A Love of Comics [Interview by John B. Cooke]." *Comic Book Artist* 15 (November 2001): 34–42.

Hignite, Todd. *The Art of Jaime Hernandez: The Secrets of Life and Death*. New York: Abrams, 2010.

Ito, Robert. "The Making of Daniel Clowes and a Golden Age for Comics." *The California Sunday Magazine*, February 4, 2016. Accessed May 13, 2017. https://story.californiasunday.com/daniel-clowes-patience.

Jacobs, Andrew. "The Voice to Stan Mack: 'It's Been Real, But'" *New York Times*, August 13, 1995. Accessed May 14, 2017. http://www.nytimes.com/1995/08/13/nyregion/neighborhood-report-greenwich-village-the-voice-to-stan-mack-it-s-been-real-but.html.

KCET. "LA Strips: Interview with Jaime Hernandez." *KCET Webstories*, Juan Decvis's YouTube page, uploaded on April 7, 2008. Accessed May 15, 2017. https://www.youtube.com/watch?v=vJOiJj8-D9s.

Kimmel, Jimmy. "Watching David Letterman 'Was More Important Than Sleep.'" *Time*, May 25, 2015. http://time.com/3858014/david-letterman-jimmy-kimmel-tribute/.

Moss, Jeremiah. "Stan Mack's Real-Life Funnies." *Jeremiah's Vanishing New York* (blog), July 18, 2013. Accessed May 14, 2017. http://vanishingnewyork.blog spot.com/2013/07/stan-macks-real-life-funnies.html.

Park, Ed. "Losing His Voice." *Village Voice*, July 29, 2003. Accessed May 15, 2017. http://www.villagevoice.com/news/losing-his-voice-6397248.

Seth. "Graphic Novel Forms Today: Charles Burns, Daniel Clowes, Seth, and Chris Ware." Panel moderated by Hillary Chute at the Comics: Philosophy & Practice conference, Chicago, IL, May 18–20, 2012. Rpt. in *Critical Inquiry: Comics and Media*, edited by Hillary Chute and Patrick Jagoda (Spring 2014): 151–168.

Silverblatt, Michael. "Jaime Hernandez and Junot Diaz: This Is How You Lose Her." *Bookworm*, KCRW. Los Angeles, CA: KCRW, February 13, 2014.

Walker, Mort. *The Lexicon of Comicana*. Lincoln, NE: iUniverse, 2000.

Witek, Joseph. *Comic Books as History: The Narrative Art of Jack Jackson, Art Spiegel-man, and Harvey Pekar*. Jackson: University Press of Mississippi, 1989.

WHY PUNK?

Berman, Shari Springer, and Robert Pulcini, dir. *American Splendor*. Good Machine and Dark Horse Entertainment, 2003.

Brisick, Jaime. "Raymond Pettibon." *MonsterChildren*, April 15, 2014. Accessed May 3, 2017. http://www.monsterchildren.com/8639/ten-years-of-mc-raymond -pettibon/.

Burns, Charles. *Cut Up: Random Fragments 1977–1979*. Series 2W, Box Y. Geneva: Bülb Comix, 2011.

Burroughs, William S. *Junky*. New York: Penguin, 2003 [1953].

Carlin, John. "Crossing the Line: The Profound and the Profane in Gary Panter's *Cola Madnes*." In *Cola Madnes*, by Gary Panter, 189–209. New York: Funny Garbage, 1989.

Chute, Hillary L. "Lynda Barry." In *Outside the Box: Interviews with Contemporary Cartoonists*, 57–79. Chicago: University of Chicago Press, 2014.

"Comic Relief." Special issue. *Flipside Fanzine* 33, 1982.

The Fuk Boys [Matt Groening and Gary Panter]. "Ocurence at Oki Dog." *Chemical Imbalance* 6, 1987 [1982].

———. "Ocurence at Oki Dog." *Flipside Fanzine* 33, "Comic Relief" issue, 1982.

Gaiman, Neil. "Jaime and Gilbert Hernandez Interview." *The Comics Journal* 178 (July 1995): 91–123.

Groening, Matt. "Gary Panter: Genius and Pal." In *Masters of American Comics*, edited by John Carlin, Paul Karasik, and Brain Walker, 300–307. Los Angeles and New

Haven: Hammer Museum and the Museum of Contemporary Art, and Yale University Press, 2005.

Groth, Gary. "Matt Groening Interview." *The Comics Journal* 141 (April 1991): 78–95.

Hignite, Todd. *In the Studio: Visits with Contemporary Cartoonists*. New Haven: Yale University Press, 2007.

Hoby, Hermione. "Raymond Pettibon: Punk with a Pencil." *Guardian*, December 14, 2013. Accessed May 2, 2017. https://www.theguardian.com/artanddesign /2013/dec/14/raymond-pettibon-sonic-youth-black-flag.

Holmstrom, John. "Prologue: 1972–1975: 'Systematic Destruction of Public Property.'" In *PUNK: The Best of* Punk *Magazine*, edited by John Holmstrom and Bridget Hurd, 1–5. New York: HarperCollins, 2012.

Kelley, Mike. "Gary Panter in Los Angeles." In *Gary Panter*, by Gary Panter and edited by Dan Nadel, 6–7. New York: PictureBox, Inc., 2008.

Kugelberg, Johan, and Jon Savage. *Punk: An Aesthetic*. New York: Rizzoli, 2012.

Lawley, Guy. "'I Like Hate and I Hate Everything Else': The Influence of Punk on Comics." In *Punk Rock: So What?: The Cultural Legacy of Punk*, edited by Roger Sabin, 100–119. New York: Routledge, 1999.

McNeil, Legs. *Please Kill Me: The Uncensored Oral History of Punk*. New York: Grove, 1996.

Nelson, Eric. "Interview with Raymond Pettibon." *Quick, Call the Waaaabulance!* (blog), 2008. Accessed May 2, 2017. http://ericrnelson.blogspot.com/p/ray -pettibon.html.

O'Connor, John. "Raymond Pettibon." *The Believer* 20 (December 2004–January 2005). Accessed May 3, 2017. http://www.believermag.com/issues/200412 /?read=interview_pettibon.

Ortved, John. *The Simpsons: An Uncensored, Unauthorized History*. New York: Faber and Faber, 2009.

Panter, Gary. "Gary Panter on Gary Panter." In *Gary Panter*, by Gary Panter and edited by Dan Nadel, 286–347. New York: PictureBox, Inc., 2008.

———. "Interview: Arranging Sights and Ideas." In *The Education of a Comics Artist: Visual Narrative in Cartoons, Graphic Novels, and Beyond*, edited by Michael Dooley and Steven Heller, 93–94. New York: Allworth Press, 2005.

———. "Lines on Paper: Lynda Barry, Ivan Brunetti, R. Crumb, Gary Panter." Panel moderated by Hamza Walker at the Comics: Philosophy & Practice conference, Chicago, IL, May 18–20, 2012. Rpt. in *Critical Inquiry: Comics and Media*, edited by Hillary Chute and Patrick Jagoda (Spring 2014): 237–254.

———. "The ROZZ-TOX Manifesto." 1980. Accessed May 4, 2017. http://www.altx
.com/manifestos/rozztox.html.

———. "Waiting for Waco." *New Yorker*, April 19, 1993, 85–89.

Pettibon, Raymond. *Raymond Pettibon: The Books, 1978–1998*, edited by Roberto
Ohrt. New York: D.A.P., 2000.

Phipps, Keith. "The Childish Genius of Pee-Wee's Playhouse." *Daily Beast*, Octo-
ber 23, 2014. Accessed May 4, 2017. http://www.thedailybeast.com/articles
/2014/10/23/the-childish-genius-of-pee-wee-s-playhouse.

Rosenkranz, Patrick. *Rebel Visions: The Underground Comix Revolution, 1963–1975*.
Seattle: Fantagraphics, 2002.

Sabin, Roger, and Teal Triggs, eds. *Below Critical Radar: Fanzines and Alternative Com-
ics from 1976 to Now*. Hove: Slab-o-Concrete, 2000.

Smith, Prichard. "Meet World-Renowned Illustrator Gary Panter." ArtTalk! *Vice* You-
Tube video, uploaded on April 16, 2013. Accessed May 2, 2017. https://www
.youtube.com/watch?v=1ir8t7PjuGw.

Stagg, Jesse, and Alex Czetwertynski, dir. "ForYourArt Interviews Matt Groening and
Mike Kelley About Gary Panter." ForYourArt YouTube video, uploaded on Febu-
rary 10, 2010. Accessed May 2, 2017. https://www.youtube.com/watch?v=KH
QDpp4WyXM.

Turcotte, Bryan Ray, and Bo Bushnell, dir. "The Art of Punk: Black Flag." *MOCAtv*.
MOCA YouTube video, uploaded on June 11, 2013. Accessed May 2, 2017.
https://www.youtube.com/watch?v=N0u04EqNVjo.

von Busack, Richard. "'Life' Before Homer: Matt Groening Interview." *Metroac-
tive*, 2000. Accessed May 2, 2017. http://www.metroactive.com/papers/metro
/11.02.00/groening-0044.html.

Ware, Chris. *Uninked: Paintings, Sculpture, and Graphic Works by Five Cartoonists*.
Phoenix: Phoenix Art Museum, 2007.

WHY ILLNESS & DISABILITY?

Bechdel, Alison. "A Conversation with Alison Bechdel." Writers at Rutgers Conversa-
tion Series. Rutgers University, New Brunswick, NJ, March 5, 2008.

———. "How." *Fun Home: A Family Tragicomic* press DVD. New York: Houghton
Mifflin, 2006.

Bookey, Mike. "Internet Famous! Allie Brosh Has Made Hyperbole and a Half
into One of the Web's Most Read and Hilarious Blogs." *Source Weekly*, No-
vember 17, 2010. Accessed May 16, 2017. http://www.bendsource.com/bend

/internet-famous-allie-brosh-has-made-hyperbole-and-a-half-into-one-of-the
-webandaposs-most-read-and-hilarious-blogs/Content?oid=2136577.

Brosh, Allie. "Hyperbole and a Half." Talks at Google. October 31, 2013. Accessed May
16, 2017. https://www.youtube.com/watch?v=s_LOCS2weNw.

Czerwiec, MK, and Ian Williams, Susan Merrill Squier, Michael J. Green, Kimberly R.
Myers, and Scott T. Smith. *Graphic Medicine Manifesto*. University Park, Pennsylvania: Pennsylvania State University Press, 2015.

Gardner, Jaredited by "Show Me Where It Hurts: Part 1." *Public Books*, November 15,
2015. Accessed May 15, 2017. http://www.publicbooks.org/show-me-where-it
-hurts-part-1/.

Garner, Dwight. "For The Precious Moments on the Porcelain Throne." *New York
Times*, November 9, 2013. Accessed May 16, 2017. http://www.nytimes.com
/projects/2013/holiday-gift-guide/#/?page=books&item=all

Gates, Bill. "A Funny, Brutally Honest Memoir." *GatesNotes* (blog). May 19, 2015.
Accessed May 16, 2017. https://www.gatesnotes.com/Books/Hyperbole-and-a
-Half

Green, Justin. "Afterword." In *Binky Brown Meets the Holy Virgin Mary*, 51–63. San
Francisco: McSweeney's, 2009.

———. "The Binky Brown Matter." In *Justin Green's Binky Brown Sampler*, 80–91.
San Francisco: Last Gasp, 1995.

———. "Comics and Autobiography: Phoebe Gloeckner, Justin Green, Aline
Kominsky-Crumb, Carol Tyler." Panel moderated by Deborah Nelson at the
Comics: Philosophy & Practice conference, Chicago, IL, May 18–20, 2012.
Rpt. in *Critical Inquiry: Comics and Media*, edited by Hillary Chute and Patrick
Jagoda (Spring 2014): 86–103.

Humphrey, Michael. "The Life and Lines of Allie Brosh: Hyperbole and a Half."
True/Slant, May 3, 2010. http://web.archive.org/web/20110905162044/http://
trueslant.com/michaelhumphrey/2010/05/03/the-life-and-lines-of-allie-brosh
-hyperbole-and-a-half/.

Johnson, Gabe. "Video: 'Hyperbole," Comedy, and Angst." *New York Times*, November 15, 2013. Accessed May 16, 2017. https://artsbeat.blogs.nytimes.com
/2013/11/15/video-hyperbole-comedy-and-angst/.

Juno, Andrea. "Art Spiegelman." In *Dangerous Drawings: Interviews with Comix and
Graphix Artists*, 6–27. New York: Juno Books, 1997.

Maron, Marc. "Episode 550: Allie Brosh." *WTF with Marc Maron*, podcast, November
13, 2014. http://www.wtfpod.com/podcast/episodes/episode_550_-_allie_brosh.

McCloud, Scott. "Oh Crap—Webcomics!" In *The Best American Comics 2014*, edited by Scott McCloud, 269–273. New York: Houghton Mifflin, 2014.

Mohammed, Zaineb. "Meet Allie Brosh, Reclusive Genius Behind the Blog (and Book) 'Hyperbole and a Half.'" *Mother Jones* (November/December 2013). Accessed May 16, 2017. http://www.motherjones.com/media/2013/10/allie-brosh-hyperbole-half-book-depression.

"Obsessive-Compulsive Disorder." National Institute of Mental Health. Accessed May 16, 2017. https://www.nimh.nih.gov/health/topics/obsessive-compulsive-disorder-ocd.

Randall, Jon. "The Goblin Meets Binky Brown Who Met the Holy Virgin Mary." *Goblin*. Accessed May 16, 2017. http://www.ugcomix.info/history/mirrors/Just.html.

Spiegelman, Art. "Introduction." In *Binky Brown Meets the Holy Virgin Mary*, by Justin Green, n.p. San Francisco: McSweeney's, 2009.

———. "Introduction: Symptoms of Disorder/Signs of Genius." In *Justin Green's Binky Brown Sampler*, by Justin Green, 4–6. San Francisco: Last Gasp, 1995.

WHY GIRLS?

Bahrampour, Tara. "Tempering Rage by Drawing Comics." *New York Times*, May 21, 2003. http://www.nytimes.com/2003/05/21/books/tempering-rage-drawing-comics-memoir-sketches-iranian-childhood-repression.html.

Barry, Lynda. "Contributor's Note." In *Best American Comics 2006*, edited by Harvey Pekar, 277. New York: Houghton Mifflin, 2006.

———. "Interview with Hillary Chute." New York City. June 7, 2008 and June 8, 2008.

———. "Lines on Paper: Lynda Barry, Ivan Brunetti, R. Crumb, Gary Panter." Panel moderated by Hamza Walker at the Comics: Philosophy & Practice conference, Chicago, IL, May 18–20, 2012. Rpt. in *Critical Inquiry: Comics and Media*, edited by Hillary Chute and Patrick Jagoda (Spring 2014): 237–254.

Borrelli, Christopher. "Being Lynda Barry." *Chicago Tribune*, March 8, 2001. Accessed May 16, 2017. http://articles.chicagotribune.com/2009–03–08/features/0903030596_1_lynda-barry-gas-leak-shy-child.

Chute, Hillary L. "Lynda Barry." In *Outside the Box: Interviews with Contemporary Cartoonists*, 57–79. Chicago: University of Chicago Press, 2014.

Fulbeck, Kip. *kip fulbeck: part asian, 100% hapa*. Exhibition. New York: New York University, March 10-May 30, 2008.

Groening, Matt. "Hipness & Stupidity." *Los Angeles Reader*, February 15, 1980: 1, 4–6, 23.

Hajdu, David. "Persian Miniatures." *Bookforum* (October/November 2004): 32–35.

Hornby, Nick. "Draw What You Know." *New York Times Book Review*, December 22, 2002: 10–11.

Jacob, Kathryn Allamong. "Little Lulu Lives Here." *The Radcliffe Quarterly*, July 1, 2006. Accessed May 16, 2017. https://www.radcliffe.harvard.edu/news/in -news/little-lulu-lives-here.

Kois, Dan. "Lynda Barry Will Make You Believe in Yourself." *New York Times Sunday Magazine*, October 27, 2011. Accessed May 16, 2017. http://www.nytimes .com/2011/10/30/magazine/cartoonist-lynda-barry-will-make-you-believe-in -yourself.html.

Larson, Sarah. "Groening and Barry Take New York." Blog post on the *New Yorker* website. March 13, 2015. Accessed May 16, 2017. http://www.newyorker.com /culture/sarah-larson/groening-and-barry-take-new-york.

McGonigal, Mike. "Matt Groening: Master of Rabbits." *Chemical Imbalance* 6 (1987): 26–33.

McNally, Victoria. "Why 2016 is the Year We Need to Stop Pretending That Women Aren't Geeks." December 22, 2015. Accessed May 16, 2017. http://www.mtv .com/news/2683640/geek-media-numbers-breakdown/.

Miner, Michael. "What Becomes of the Brokenhearted?" *Chicago Reader*, November 19, 1998. Accessed May 16, 2017. http://www.chicagoreader.com/chicago/what -becomes-of-the-brokenhearted/Content?oid=897809.

Satrapi, Marjane. "Address on *Persepolis*." New York City, September 8, 2004.

———. Jane E. Ruby Lecture. Wheaton College. Norton, MA, September 17, 2009.

———. "Veiled Threat." *Guardian*, December 12, 2003. Accessed May 16, 2017. https://www.theguardian.com/world/2003/dec/12/gender.uk.

———, and Vincent Paronnaud, dir. *Persepolis*. 2.4.7.Films, 2007.

———. "Press Conference: *Persepolis*." Cannes Film Festival, May 2005. Accessed May 16, 2017. http://www.festival-cannes.com/en/69-editions/retrospective/2007 /actualites/articles/press-conference-persepolis.

Weich, Dave. "Marjane Satrapi Returns." *Powells*, October 10, 2006. Accessed May 16, 2017. http://www.powells.com/post/interviews/marjane-satrapi-returns

Wood, Summer. "Scenes From the Axis of Evil: The Tragicomic Art of Marjane Satrapi." *Bitch* (Fall 2003): 55–58, 94–95.

Zwigoff, Terry, dir. *Ghost World*. United Artists, 2001.

WHY WAR?

Chute, Hillary L. "Joe Sacco." In *Outside the Box: Interviews with Contemporary Cartoonists*, 138–153. Chicago: University of Chicago Press, 2014.

———. "Stand Up Comics." *Village Voice*, July 19, 2005. Accessed May 17, 2017. http://www.villagevoice.com/2005/07/19/stand-up-comics/.

Cockburn, Patrick. "'They Planted Hatred in Our Hearts.'" *New York Times Book Review*, December 24, 2009. Accessed May 17, 2017. http://www.nytimes.com/2009/12/27/books/review/Cockburn-t.html.

Contino, Jennifer. "Pieces of War." *Sequential Tart* 10, vol. 4 (October 2001). Accessed May 17, 2017. http://www.sequentialtart.com/archive/oct01/sacco.shtml.

Cooke, Rachel. "Riad Sattouf: Not French, Not Syrian . . . I'm a Cartoonist." *Guardian* March 27, 2016. Accessed May 17, 2017. https://www.theguardian.com/books/2016/mar/27/riad-sattouf-arab-of-the-future-interview.

Groth, Gary. "Joe Sacco, Frontline Journalist: Why Sacco Went to Goražde: Interview with Joe Sacco." *The Comics Journal, Special Edition* vol. 1 (Winter 2002): 55–72.

Hayek, Ghenwa. *Beirut, Imagining the City: Space and Place in Lebanese Literature*. New York: I.B. Tauris, 2015.

Holman, Brett. *The Next War in the Air: Britain's Fear of the Bomber*. Farnham, Surrey: Ashgate, 2014.

Ivins, William M. "Exhibition of Italian Renaissance Woodcuts." *Metropolitan Museum of Art Bulletin*, November 1917: 224–228.

"Questions and Answers with *Safe Area Goražde* author Joe Sacco." Official Fantagraphics website. Accessed September 30, 2002. http://www.fantagraphics.com/artist/sacco/sacco_qa.html.

Sacco, Joe. Chicago Creative Writing Workshop. University of Chicago, February 8, 2012.

———. Interview with Hillary Chute. Telephone. June 29, 2005.

———. "Joe Sacco and W.J.T. Mitchell." Public Conversation, May 19, 2012. Comics: Philosophy & Practice conference, Chicago, IL, May 18–20, 2012. Rpt. in *Critical Inquiry: Comics and Media*, edited by Hillary Chute and Patrick Jagoda (Spring 2014): 53–70.

———. "Joe Sacco: Presentation from the 2002 UF Comics Conference." *ImageText* 1, vol. 1 (Spring 2004). Accessed May 17, 2017. http://www.english.ufl.edu/imagetext/archives/v1_1/sacco/.

Said, Edward. "Homage to Joe Sacco." In *Palestine*, by Joe Sacco, i-v. Seattle: Fantagraphics, 2001.

Sneddon, Laura. "Stripped—Joe Sacco: Conflict Comes in a Lot of Guises." *The Beat*, August 15, 2013. Accessed May 17, 2017. http://www.comicsbeat.com/stripped-joe-sacco-conflict-comes-in-a-lot-of-guises/.

Tuhus-Dubrow, Rebecca. "Joe Sacco: *January* Interview." *January Magazine* (June 2003). Accessed May 17, 2017. http://januarymagazine.com/profiles/jsacco .html.

Wright, Bradford. *Comic Book Nation: The Transformation of Youth Culture in America*. Baltimore: Johns Hopkins University Press, 2001.

WHY QUEER?

"The 100 Best Books of the Decade." *Times* (London), November 14, 2009. Accessed May 22, 2017. https://www.thetimes.co.uk/article/the-100-best-books-of-the -decade-952h76nd689.

Atwell, Elaine. "'Lumberjanes' is the Comic for the Little Queer Girl Scout in Your Heart." AfterEllen.com. May 13, 2014. Accessed May 18, 2017. http://www .afterellen.com/books/217284-lumberjanes-is-the-comic-for-the-litt le-queer-girl -scout-in-your-heart.

Bechdel, Alison. Address. Museum of Contemporary Cartoon Art Annual Convention. June 23, 2007, New York City.

———. "Alison Bechdel and Hillary Chute." Public Conversation, May 19, 2012. Comics: Philosophy & Practice conference, Chicago, IL, May 18–20, 2012. Rpt. in *Critical Inquiry: Comics and Media*, edited by Hillary Chute and Patrick Jagoda (Spring 2014): 203–219.

———. "Cartoonist's Introduction." In *The Essential Dykes to Watch Out For*, xii–xviii. New York: Houghton Mifflin, 2008.

———. "How." *Fun Home: A Family Tragicomic* press DVD. New York: Houghton Mifflin, 2006.

———. *The Indelible Alison Bechdel: Confessions, Comix, and Miscellaneous Dykes to Watch Out For*. Ithaca: Firebrand, 1998.

———. "PEN/Faulkner Event with Lynda Barry and Chris Ware." Washington, D.C., November 9, 2007.

———. "Talking with Alison Bechdel," Houghton Mifflin Press release, June 2006, 7–9.

Brunetti, Ivan. *Cartooning: Philosophy & Practice*. New Haven: Yale University Press, 2011.

Chute, Hillary L. "Alison Bechdel." In *Outside the Box: Interviews with Contemporary Cartoonists*, 154–175. Chicago: University of Chicago Press, 2014: 154–175.

"Comics Magazine Association of America Comics Code 1954." Reprinted in Amy Kiste Nyberg, *Seal of Approval: the History of the Comics Code*. Jackson: University Press of Mississippi, 1998.

Crocker, Elizabeth. "'To He, I Am for Evva True'": Krazy Kat's Indeterminate Gender." *Postmodern Culture* 4, vol. 2 (1994). Accessed May 21, 2017. http://www.pomocul ture.org/2013/09/24/to-he-i-am-for-evva-true-krazy-kats-indeterminate-gender/.

Cruse, Howard. "Editor's Note." In *Gay Comix 1*. Kitchen Sink, 1980.

———. "Preface." *From Headrack to Claude: Collected Gay Comix*, 5. North Adams, MA: Nifty Kitsch Press, 2009.

DiMassa, Diane. Hothead Paisan official website. Accessed May 21, 2017. http://web .archive.org/web/20110728132535/http://hotheadpaisan.com/

Emmert, Lynn. "Life Drawing: An Interview with Alison Bechdel." *The Comics Journal* 282 (April 2007): 34–52.

Flamecon.org. "About." Accessed May 18, 2017. http://www.flamecon.org/about/.

Johnston, Lynn. "Lawrence's Story." For Better or For Worse official website. Accessed May 18, 2017. http://www.fborfw.com/features/lawrence/index.php?page=five.

Jusina, Teresa. "Greg Rucka Confirms Wonder Woman is Queer." *The Mary Sue*. September 28, 2016. Accessed May 18, 2017. https://www.themarysue.com/rucka -queer-wonder-woman/.

McGonigal, Mike. "Matt Groening: Master of Rabbits." *Chemical Imbalance* 6 (1987): 26–33.

Paul, Alan. "Life in Hell." *Flux* 6, September 30, 1995.

Robbins, Trina. "Sandy Comes Out." In *Wimmen's Comix* 1 (November 1972): n.p.

Spiegelman, Art. "Calling Dr. Godot." *New York Times Book Review*, November 11, 2016. Accessed May 18, 2017. https://www.nytimes.com/interactive /2016/11/11/books/review/13spiegelman-review.html.

———. *Comics as Medium for Self Expression?* Cover, *Print* (May-June 1981). Rpt. in *Co-Mix: A Retrospective of Comics, Graphics, and Scraps*. Montreal: Drawn & Quarterly, 2013.

Sturm, James. "To Hell With You, Matt Groening: A Tribute to *Life in Hell,* with Comics by Alison Bechdel, Tom Tomorrow, and Others." *Slate*, October 10, 2012. Accessed May 4, 2017. http://www.slate.com/articles/arts/culturebox/2012/10 /matt_groening_s_life_in_hell_a_tribute_in_comics_by_alison_bechdel _tom_tomorrow_and_others_.html.

Thomas, June. "Is American Ready For a Musical About a Butch Lesbian?" *Slate* October 8, 2013. Accessed May 18, 2017. http://www.slate.com/blogs/out ward/2013/10/08/fun_home_is_america_ready_for_a_musical_about_a _butch_lesbian.html.

Wachowski, Lana. "Preface." In *No Straight Lines: Four Decades of Queer Comics*, edited by Justin Hall, n.p. Seattle: Fantagraphics, 2012.

Wertham, Fredric. *Seduction of the Innocent*. Laurel, NY: Main Road Books, 2004 [1954].

Wilsey, Sean. "The Things They Buried." *New York Times Book Review*, June 18, 2006: 9.

"Wonder Woman Appointed UN Honorary Ambassador for the Empowerment of Women and Girls." *UN News Centre*, October 21, 2016. Accessed May 18, 2017. http://www.un.org/apps/news/story.asp?NewsID=55367.

CODA: WHY FANS?

Clowes, Daniel. Interview with Hillary Chute. San Diego, CA, July 24, 2017.

Cole, Teju. "The Superhero Photographs of the Black Lives Matter Movement." *New York Times Magazine*, July 31, 2016: 16.

Romano, Tricia. "Fantagraphics Artist Daniel Clowes Takes on Gender Inequality in Comics Establishment." *Seattle Times*, January 7, 2016. Accessed May 18, 2017. http://www.seattletimes.com/entertainment/books/fantagraphics-clowes -boycott/.

Scott, A. O. "My Costume? Critic. What's Yours?" *New York Times*, July 19, 2015: 14.

INDEX

Page numbers in *italics* refer to captions and illustrations.

ABOUT THE AUTHOR

illary Chute is an expert on comics and graphic narratives, professor of English and Art + Design at Northeastern University, and the author of *Graphic Women: Life Narrative and Contemporary Comics*; *Outside the Box: Interviews with Contemporary Cartoonists*; and *Disaster Drawn: Visual Witness, Comics, and Documentary Form*. She is also the associate editor of Art Spiegelman's *MetaMaus*. She lives in Cambridge, Massachusetts.